WOMEN, WORK, AND POLITICS

WOMEN, WORK, AND POLITICS

Belgium, 1830–1914

PATRICIA PENN HILDEN

CLARENDON PRESS · OXFORD

1993

Oxford University Press, Walton Street, Oxford OX2 6DP

Oxford New York Toronto
Delhi Bombay Calcutta Madras Karachi
Kuala Lumpur Singapore Hong Kong Tokyo
Nairobi Dar es Salaam Cape Town
Melbourne Auckland Madrid
and associated companies in
Berlin Ibadan

Oxford is a trade mark of Oxford University Press

Published in the United States
by Oxford University Press Inc., New York

British Library Cataloguing in Publication Data
Data available

Library of Congress Cataloging in Publication Data

Hilden, Patricia;
Women, work, and politics : Belgium 1830-1914 / Patricia Penn Hilden.
p. cm.
Includes bibliographical references and index.
1. Women—Employment—Belgium—History—19th century. 2. Women—
Employment—Social aspects—Belgium—History—19th century.
3. Women and socialism—Belgium—History—19th century.
4. Feminism—Belgium—History—19th century. 5. Belgium
History—1830–1914. I. Title.
HD6158.H55 1993 93–19419
331.4'09492—dc20
ISBN 0–19–822883–X

1 3 5 7 9 10 8 6 4 2

Typeset by Datix International Limited, Bungay, Suffolk
Printed in Great Britain
on acid-free paper by
Biddles Ltd.,
Guildford & King's Lynn

Dedicated to Timothy J. Reiss
He knows why.

It appears a resumé of Europe, the little country of Belgium, with its working people, its noisy mills, its mines, its railways tracking away on every side . . . [Yet] it is a little *foyer* of contrary opinions . . .
There exists no other country where intellectual and social life include such numerous, profound contrasts . . . so medieval, and yet so revolutionary, so clerical and conservative, and at the same time so torn by doubt and so full of destructive elements.

<div align="right">Jens Thiis, 1915</div>

Acknowledgements

There are two people who head the very long list of those who have helped with this social history of Belgium: Timothy Reiss and Jonathan Steinberg. What Timothy has done over the years goes far beyond what anyone has the right to expect, as he knows. Jonathan Steinberg, too, has supported this effort every step of the way. He has been much more than a stimulating (and tireless) reader; he has also been friend, confidant, teacher, and enthusiastic writer of references for all the grants and fellowships necessary in our line of work. I cannot thank him adequately.

Moreover, it is thanks to Jonathan that I have had a 'room of my own' in which to write. It was through him that I met Nigel Chancellor. And it was Nigel Chancellor who offered me an office for the year, a characteristically generous gesture which brought with it not only space, but also months of companionship and conversation, and I am grateful.

I must also thank the Master and Fellows of Trinity Hall, Cambridge, for once again welcoming me amongst them, and, I hope, forgiving my writer's unsociability throughout the year. Win Steere was one of the few people who managed to drag me away from my typewriter for our weekly 'setting the world to rights'. I shall miss her companionship greatly.

During my first research year in Belgium, supported by the Fulbright Foundation, I met two friends who also write about that country, Alexander B. Murphy and Janet Polasky. They, along with Susan Gary and Sallie Berringer, made our mutual Fulbright year something to remember. Janet Polasky, moreover, not only introduced this French historian to the labyrinth that is Belgium, but she has continued to read the work in progress, noting errors, disagreeing with the more tendentious points, and suggesting useful revisions. Her own work on Émile Vandervelde has, I hope, nuanced much of my analysis of the Belgian socialist movement. With Alec Murphy I shared a table in the Bibliothèque Royale for many profitable, and entertaining, months. Furthermore, it was he who first led

viii *Acknowledgements*

me to the numerous, important photographs of Walloon working women at the Musée de la vie wallonne in Liège. I owe much to both friends.

Jacques and Micheline Dubois have made work in Liège a delight. To Jacques Dubois I owe not only suggestions of books and ideas, but also access to key archives. It will please me very much if he likes the results.

José Lambert, in turn, introduced me to Leuven, and to the Flemish side of Belgium. He, too, gave me many suggestions and ideas, as well as a place to live in Leuven's Groot Begijnhof. Again, I can only say thank you.

In the course of the research, I have been fortunate to have enjoyed the help and advice of several friends and colleagues. They include: Christine Adams, Patrick Allitt, Elizabeth Cocke, Clare Collins, Duncan Forbes, Irena Grudzinska-Gross, Tony Judt, Temma Kaplan, Shigehisa Kuriyama, Amy Shrager Lang, Frank Lechner, the late Timothy Mason, Jonathan Prude, Julio Ramos, Judith Rohrer, Jonathan Schneer, Maarten van Delden, Bonna Wescoat. I owe special thanks to three graduate students who worked as research assistants: Enrique Garcia, Julie Kubala, and Sarah Ogilvie. I hope, too, that some of Akinyele Umoja's insights into mass politics have found their way into the text. There are also two very special librarians in the inter-library loan department of Emory University's Woodruff Library who were always ready to fulfil my many requests: Julia Jones and Margaret Whittier.

I should also like to express my gratitude to those scholars who have written on my behalf: Olwen Hufton, Roderick Kedward, Richard Evans, Jane Caplan, and Robert Brentano. Their efforts helped bring support for this project from the Fulbright Foundation, the American Council of Learned Societies, and the National Endowment for the Humanities. I am indebted both to them and to these institutions.

Various archivists and librarians in Belgium have proved more than willing to help. These include Nadine Dubois at the Musée de la vie wallonne, and the staffs of the Archief en museum voor de socialistische arbeidersbeweging, in Ghent, the Musée de la photographie, in Charleroi, and the Corning Glass Museum and Library, in Corning, New York. The Institut Royal du Patrimoine Artistique in Brussels also gave me willing assistance. And in many local archives and communal museums all over Belgium I found people willing to help. I also owe an intellectual debt to several of Belgium's historians. B.-S. Chlepner's work first interested me in the country. The efforts of Denise De Weerdt and Denise Keymolen suggested that it was possible to re-discover Belgium's women. Marcel Liebman, Jean Puissant, Claude Desama, and, most particularly, Jean Stengers, have all written stimulating and provocative studies. Their work,

as well as that of many, many other Belgian historians, deserves as much attention as that more usually given (in the English-speaking world at least) to historians of France.

Lastly, I have been extremely fortunate in having a tolerant and generous family. In addition to their father, both Suzanna and Matthew Reiss now know far more about Belgium than they ever expected to. Matthew was forbearing during the years of research; Suzanna has put up with the writing. I don't know which was worse, but I thank them both. Anne and Bruce Hamilton have also helped make the writing possible; I hope they, too, like the results.

P.P.H.

Cambridge

Contents

List of Abbreviations

The following list gives the short forms used to refer to various archives and reports; full details are found in the select bibliography

ADM	Archives générales du Royaume, Administration des Mines
AEL	Archives de L'État, Liège
AEM	Archives de L'État, Mons
AGR	Archives générales du Royaume
BTNG/RBHC	*Belgische Tijdschrift voor Nieuwste Geschiedenis/Revue Belge d'Histoire Contemporaine*
Documenten	Wouters, H. (ed.), *Documenten betreffende de geschiedenis der arbeidersbeweging (1831–53)*
Enquête—1846	Commission instituée par arrêté royal du 7 sept. 1843, *Enquête sur la condition des classes ouvrières et sur le travail des enfants: Lois, arrêtés, règlements, et législation étrangère concernant les classes ouvrières*
Enquête—Gand	Mareska, J. and Heyman, J., *Enquête sur le travail et la condition physique et morale des ouvriers employés dans les manufactures de coton à Gand*
Enquête—1886	Commission du travail, Institutuée par arrêté royal du 15 avril 1886, *Questionnaire relatif au travail industriel*
Enquête de la femme	*Éléments d'enquête sur le rôle de la femme dans l'industrie, les œuvres, les arts, et les sciences en Belgique*
Fonds Chambon	Corning Glass Museum, Corning, New York

Grèves ouvrières	Dauby, J., *Des Grèves ouvrières: Aperçu sur l'état économique et social actuel des classes ouvrières en Belgique; causes et caractère des grèves; moyens de les diminuer ou de les supprimer; conditions d'application et d'exécution*
MAE	Archives générales de l'État, Ministère des Affaires Étrangères
Kuborn's *Rapport*	Kuborn, H., *Rapport sur l'enquête faite au nom de l'académie royale de médecine de Belgique par la commission chargée d'étudier la question de l'emploi des femmes dans les travaux souterrains des mines*
Mémoire	Ducpétiaux, É., *Mémoire sur le paupérisme dans les Flandres*
Munby Collection	A. J. Munby Collection, Wren Library, Trinity College, Cambridge
Nouvelles Recherches	Schoenfeld, M., *Nouvelles recherches sur l'état sanitaire, moral et social des houilleurs pendant la période actuelle de salubrité des mines en Belgique: Discours et études sur le travail des filles dans les charbonnages*
PdE	Archives générales du Royaume, Police des Étrangères
PG	Parquet général: Cours d'appel, Brussels
Rapport de l'Union	l'Union des charbonnages, mines et usines métallurgiques de la province de Liège, *Du Travail des femmes dans les mines: Rapport presenté par une commission spéciale et approuvé par le comité permanent de l'Union des charbonnages . . . de la province de Liège dans sa séance du 10 mars 1869*
Revue du Travail	Royaume de Belgique, Ministère de l'Industrie et du Travail, Office du Travail, *Revue du Travail*
Travail des femmes	Van Bastelaer, D.-A., *La Question du travail des femmes et des enfants dans les houillères en présence de la statistique officielle: Discours prononcé dans la séance du 6 nov. 1869 de l'Académie royale de médecine de Belgique pendant la discussion du rapport de M. Kuborn*

Vleminckx's Vleminckx, J. F., *Lettre à l'Academie royale de médecine à*
Lettre *l'occasion de la publication de l'enquête ordonnée par M Le*
 Ministre des travaux publics sur la situation des ouvriers
 dans les mines et les usines métallurgiques de la Belgique,
 26 mars 1870

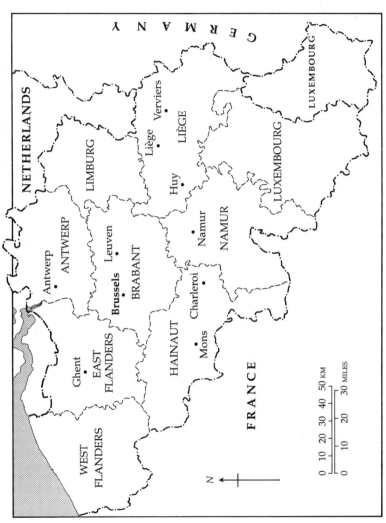

BELGIUM

PART I

Introduction

1

The Problem

In Belgium, women do all the work.[1]

However evident at the turn of the nineteenth century, the extent of women's contribution to Belgium's industrial prosperity has almost entirely vanished from the historical record. Despite their singular importance to the success of Belgium's Industrial Revolution (second only to Britain's in the nineteenth century), their central role in national debates over the social responsibility of the young government, and their active participation in the organized labour movements of the second half of the century, working women have been persistently marginalized from the centres of historical enquiry.[2]

It is a phenomenon familiar to all historians of nineteenth-century working women. Few histories of Europe's labourers during the period of industrial transformation have paid more than scant attention to the female workforce. Even those historians who have cited women's work have commonly consigned it to the margins of historical narrative, designating it 'ancillary', or 'temporary'. A few have extended women's putative ancillary economic status to their political and social identities, rendering them equally secondary. For such historians, whatever collective identity women enjoyed was grounded not in their relations to production (usually adduced to describe male workers' public roles) but rather in their reproductive, domestic lives.

Given the extent and nature of Belgian women's work—and political activity—in the period from Independence in 1830 to the Great War, it is especially startling to discover a near-universal neglect of that country's *ouvrières* and *werksters* in most social histories. In such works, they appear but briefly, if at all—as one element in the background against which

[1] Boulger, D.C., *Belgian Life in Town and Country* (New York, 1904), 262.
[2] Examples are legion and appear throughout the text. One recent study, otherwise exhaustive, which gives short shrift to women's political efforts in the 19th century, is Els Witte and Jan Craeybeckx, *La Belgique de 1830 à nos jours: Les tensions d'une démocratie bourgeoise*, trans. Govaert, S. (Brussels, 1987) esp. p. 120.

men's work and organizational struggles played themselves out. Moreover, most histories of the organized workers' movement of the second half of the century ignore working women entirely.[3] And as with their absence from social history, this, too, is unjustified. Such historiographical neglect overlooks, amongst other things, the socialist-feminist movement created by Ghent's women textile-workers in the 1880s and 1890s—an effort that was one of the most radical and far-reaching found anywhere in the Second International.

This work, then, has as its primary task the rectification of these errors. It concerns the rediscovery of Belgium's working women, recreating—as far as is possible—the everyday lives of millions of hitherto silent women labourers. At the same time, however, women's collective history illuminates other elements key to understanding the broader social history of the nation in our period.

First, the book demonstrates that Belgian women had a relationship to waged work unique in industrializing Europe. Contrary to patterns of women's employment elsewhere, Belgian women commonly worked in so-called 'men's occupations', most striking in coal-mining, but also in glass-making, transport, and even stone-quarrying. And they did so throughout the period before 1914, virtually unrestricted by the labour legislation that drove females from many occupations in other European countries during the second half of the nineteenth century. This does not mean that there was not a prolonged mid-century struggle to remove women from 'unseemly' work. But Belgium's government (in contrast to every other Western European government) refused to act. And herein lies a second problem for historians of nineteenth-century Belgium: why was almost no labour legislation aimed at excluding women from coal-mines, glass-works, docks, and so on?

Part of the explanation lay in yet another peculiarly Belgian phenomenon: women in that country had for centuries formed such an essential part of the labour-force that efforts to remove them from the public world

[3] Early pioneers of women's history in Belgium are Denise De Weerdt and Denise Keymolen, whose works are cited throughout. Many other scholars have since joined them, many of them working with two important feminist institutions in Brussels; the Université des Femmes (which publishes *Chronique* and supports efforts undertaken in the francophone community), and ROSA, which is Flemish-speaking. Two journals which feature scholarly work on women in Belgium are *Les Cahiers du Grif* and the Dutch feminist publication *Jaarboek voor Vrouwengeschiedenis*. In addition, many women are currently working on Flemish women's history at Ghent's Archief en Museum der Socialistische Arbeidersbeweging (known as 'AMSAB'). There are doubtless many others, some cited in footnotes, below, but Belgian scholarly presses and journals unfortunately appear reluctant to publish work on women, and much work remains in the form of unpublished theses and dissertations.

of work encountered deeply entrenched traditions. Many working women, were, in fact, widely celebrated in local and national folklore, including, as we shall see, in popular representational images of cities such as Liège and Ghent. Such women had, not surprisingly, developed a strong occupational identity from which they derived the same sense of their social and economic importance as labour historians have long attributed to their male colleagues, particularly those employed in dangerous or physically difficult occupations. Given this time-honoured link between certain Belgian women and essential manual work, the possibility of restricting their access to the industrial labour-market was considerably more limited than it was in those countries where the public was accustomed to women of the popular classes playing a more 'feminine' economic role.

A predictable corollary of this point emerged in the latter half of the century, when working women claimed a role in the organized struggles of their class. From the earliest days of mass strikes in the late 1850s, through the years of the abortive First International (dead by the end of the 1870s), to the ultimately successful organization of the Parti Ouvrier Belge/Belgische Werkleiden Partij, working women played a significant role, although they were less numerous than their male comrades. Some, indeed, became leaders—of both women's and mixed-sex clubs, unions, and political groups.

In the extent of their political activities, Belgian women again failed to conform to patterns evident in other countries. In that tiny country, moreover, working women's politics, their organizations, and their collective goals, also differed markedly from region to region. The striking localism of Belgian popular culture was as essential to women's politics as it was to the politics of virtually every other social or occupational group.[4] Only this fact explains problems such as why textile-workers from Verviers developed a political practice and ideology that completely contradicted those created by the *werksters* of Ghent's textile-mills. In Verviers, in other words, what is today labelled 'essentialism' (i.e. feminism grounded in women's biological and social differences) emerged as working women's dominant strategy, while Ghent's women based their claim for liberation on arguments for equality—at work, in politics, and in workers' private, domestic lives.

In addition to demonstrating the limitations of the present historical record, the story of Belgium's *ouvrières* and *werksters* also helps illuminate

[4] Belgians either retreat into a quiet local isolation or look outward—towards Paris in the case of many Walloons, or towards the Netherlands in the case of many Flemings.

the broader divisions and disputes, within Belgian society as a whole. From the first, members of the thriving bourgeoisie engaged in heated debates about women's work. These public discussions took several forms. In the years following independence, many leaders were committed to positivist efforts to build a social analysis grounded in the careful collection of 'scientific' facts and figures. Headed by Adolphe Quetelet (the 'father of statistics') this group attempted to shape state policies with the help of extensive data painstakingly gathered in numerous public and private *enquêtes*. So influential were these proto-social scientists, that government-sponsored enquiries quickly became the dominant official response to every social and economic crisis of the turbulent nineteenth century.

At the same time, other members of the nation's small ruling élite viewed women's widespread industrial participation as a shameful measure of Belgium's backwardness, especially by comparison with neighbouring France, where ideology, if not practice, had begun to assign French women to a highly restrictive, biologically prescribed sphere, inside the domestic world. Most important amongst this group of French-inspired reformers were Belgium's physicians. Organized into the Royal Academy of Medicine, they dominated mid-century efforts to legislate women out of unsuitable industrial work—especially coal-mining.

The doctors' efforts came to naught, however. Belgium's economically self-interested government remained unwilling to pass any legislation that restricted the country's free labour-market. Still, this debate over women's work was not without consequences. The doctors' efforts (and those of their opponents) helped focus considerable public attention on women's collective relations to the economy. They also demonstrated the extent to which most Brussels-based officials were unwilling to draw their ideological models from Paris, whatever the often-strident claims of some francophone Belgians to linguistic and cultural links with France.

The struggle to develop a social policy with regard to female workers also highlighted conflicts between the two main political *tendances* of the nineteenth century: economic liberalism and Catholicism. Within both groups were reformers whose efforts to convince state officials to intervene to lessen the exploitation of Belgium's workers were repeatedly stymied. Belgium remained, throughout our period, Karl Marx's 'paradise of capitalists'. Whatever their particular political loyalties, all reformers soon discovered that no number of investigations, speeches, pamphlets, or books sufficed to move their stubbornly pro-industry government to ameliorate the plight of Belgium's notoriously underpaid and overworked labouring classes.

At the same time, successive governments were far from reluctant to use state power on behalf of industrial progress. Indeed, a consistent state-policy kept Belgium's labour-market completely free, not only to allow the employment of children and women, but also to prevent any workers' efforts to organize to resist their own exploitation. A number of strict laws were enforced to prevent workers even from discussing possible remedies for their conditions. Draconian penalties effectively blocked most such efforts until the end of the 1850s.

Moreover, Belgium's workers had no direct access to the political life of the country until the 1890s, when male workers gained partial suffrage. In the words of B.-S. Chlepner, 'vers le milieu du siècle passé, les masses ouvrières se trouvait dans un état d'infériorité patente au point du vue politique, au point de vue juridique, et au point de vue de leur organisation propre'.[5] And very little had changed when our period came to its abrupt end in August 1914. In that year, Belgium had the dubious honour of remaining the only European industrial nation almost entirely bereft of legal limitations on the exploitation of the nation's workers. The reasons for this disgraceful neglect of those upon whom Belgium's prosperity rested provide the third theme of this study.

THE REGIONAL FOCUS

To investigate these questions, this book examines five geographical areas in the industrial heartland of Belgium, one in the centre of the Flemish-speaking north ('Flanders'), and three in the French-speaking southern half of the country (known as 'Wallonia'). These areas include the textile city of Ghent, the two coal-producing areas of Charleroi and the nearby Borinage, plus the two cities which once lay in the independent Bishopric of Liège: the wool city of Verviers, and the more mixed industrial city of Liège itself.

It was in the Flemish city of Ghent that Belgium's Industrial Revolution had its beginnings, marked by the return from England of one prominent citizen, Lieven Bauwens, who carried the 'borrowed' cotton machinery with which he launched Ghent's transformation. The city proved an ideal

[5] Chlepner, B.-S., *Cent ans d'histoire sociale en Belgique* (Brussels 1979), 17. See also Denise De Weerdt's remarks on women's legal and political invisibility in 'Zoë, Isabelle, Louise et les autres. . .', in *Vie des femmes, 1830–1980*, catalogue from the Éxposition: Banque Bruxelles Lambert, 16 Oct.–30 Nov. 1980, 91.

venue for such a change. Here, in the heart of the province of East
Flanders, thousands of workers had long been engaged in producing
Belgium's famous linen cloth. In an extensive 'proto-industrial' system,
workers had for centuries grown, harvested, prepared, and spun flax—and
woven it into linen.[6] In addition, flax yarn furnished the raw material for
Flanders' other product of international renown, lace. Skilled lace-makers,
mostly, but not exclusively, female, toiled in their thousands, both in the
cities and all over the Flemish countryside.

Ghent, then, was accustomed to the production of textiles, albeit
primarily in a domestic setting, where working patterns were shaped by
nature and by working people's choices, rather than by the harsh de-
mands of the factory system. The imposition of the latter, as we shall
see, was not without difficulties. But although some Ghent flax- and
linen-workers proved reluctant to accept the new discipline of the mills,
Bauwens and his fellow industrialists quickly found a second source of
local labour amongst the hundreds of unemployed poor who crowded
the streets of the city in the aftermath of the French Revolution.[7] Out
of a workforce composed of both groups, Ghent's textile *patronat* soon
built a vast cotton industry, serving millions of new consumers in the
French Empire.

The second and third areas treated in our narrative are contiguous.
The first includes both the city of Charleroi and several small communes
dotting the hills surrounding the city. Nearby, to the west, lies the
second coal region, a cluster of towns and villages located to the south
and west of the city of Mons. These several coal communities were

[6] The concept of 'proto-industrialization' is controversial. I am using it here, *pace* Donald
Coleman ('Proto-Industrialization: A Concept too Many', *Economic History Review* 36 (1983),
435–48), as it was used by Hans Medick, in 'The Proto-Industrial Family Economy: The
Structural Function of Household and Family during the Transition from Peasant Society to
Industrial Capitalism', *Social History* 3 (Oct. 1976), 291–315. In Belgian historiography, the
term is often used as short-hand for the family production of finished goods. See, *inter alia*,
Craeybeckx, J., 'Les Débuts de la révolution industrielle en Belgique et les statistiques de la fin
de l'empire', *Mélanges offerts à G. Jacquemyns* (Brussels 1968); Mokyr, J., *Industrialization in the
Low Countries, 1795–1850* (New Haven, Conn., 1976); Van Der Wee, H., *De Industriële
revolutie in Belgie, historische aspecten van de economische groei* (Antwerp, 1972); and Devleeshou-
wer, R., 'Le Consulat et l'empire: Période de "take-off" pour l'économie belge?', *Revue d'histoire
modern et contemporaine*, 42 (1970), 610–19. See also Polasky, J., 'Revolution, Industrialization,
and the Brussels Commercial Bourgeoisie, 1780–1793', *BTNG/RBHC*, 10 (1979), 205–35, esp.
the author's copious notes.

[7] See Dhondt, J., 'Notes sur les ouvriers industriels gantois à l'époque française', *Revue du
Nord* 36 (1954), 309–24. The coincidence of new machines and new industries, the opening of
an enormous, unrestricted French market, plus the poverty and displacement that filled the
cities with a ready labour-force of unemployed poor during the Napoleonic wars help to
explain Belgium's prosperity throughout these years.

together known as the Borinage, peopled in legend by militant, often 'barbaric' or 'primitive' coal-miners, the Borains. Although geographically and administratively linked—both Charleroi and the Borinage lie in the province of Hainaut—each locale was, characteristically, quite distinct. Workers in each had different work patterns, different social and cultural traditions, and separate regional identities. In addition, although coal continued to shape the working lives of most of Charleroi's working class throughout our period, a second major industry developed in that city which eventually proved influential in shaping class politics as they emerged in the latter decades of the century: that industry was glass.

Lastly, the Liège region, which had lost its special independent status in the French annexation of 1795, employed thousands more women and men, not only in the industrial production of coal, heavy machinery, steel, and wool (the latter centred in the city of Verviers), but also in an extensive artisanal system. The most famous export of Liège's artisans was guns, but craftsmen and women also won fame for their ornamental ironwork and luxury glass. (Val-St-Lambert, which became an important exporter of fine crystal during the course of the century, was headquartered in Seraing, on the outskirts of Liège.)

Most significant for our purposes here was the fact that Liège boasted one traditional form of women's work which was universally celebrated—in song, painting, poetry, and popular myth. This women's work provided transport for Liège's products from the city centre to outlying areas—as far away as Maastricht, now part of the Netherlands. The army of women who carried Liège's coal and other products were known as *boteresses*. They were a familiar sight along the highways and roads of the region, instantly recognizable by the great straw baskets strapped to their backs and foreheads, their large wood walking sticks, their distinctive headscarves, and their sturdy clogs. By the opening of the nineteenth century, the *boteresses* held a special place in local folklore.

The fame of the *boteresses* quickly spread to other women whose industrial work supported the region's increasing prosperity, and whose working clothes made them as noticeable. These included women coal-miners, uniformed for work in costumes even more distinctive than those worn by *boteresses*, as we shall see.

Nearby Verviers, astride the Vesdre River, provided the venue for Belgium's second textile revolution. Here, the *émigré* Englishman John Cockerill launched the process that transformed the small city into Belgium's wool capital. Cockerill was also the first to build an integrated

industrial system, including machine workshops, steel-mills, and even coal-mines.[8]

These five areas, then—Ghent, Charleroi, the Borinage, Liège, and Verviers form the geographical focus of this work. Of course, events and developments elsewhere in Belgium affected these localities, and will come under analysis in the course of the narrative. But it is the women workers of these regions who are our main protagonists throughout the study.[9]

THE STRUCTURE OF THE BOOK

Chapter 2, the second chapter of this introductory part, has a single, broad contextual purpose. Given the widespread ignorance amongst non-Belgians of the general history of Belgium in the nineteenth century, it provides a brief narrative of that country's social and economic development after 1830. Considerations of space limit this task, and I shall concentrate on those key events and legislative and political actions which had significant consequences for generations of female workers.[10]

Part II, 'Women, Work, and the Bourgeois Ruling Class', includes four

[8] Cockerill's production rapidly expanded to include products not used in the wool industry, including most famously the railway locomotives which soon rivalled Britain's in the continental market.

[9] To the obvious question, 'Why not Brussels?', there are two answers. First, Brussels' working class was primarily engaged in the sweated production of luxury articles throughout most of our period. Neither the factory system, nor the politics developed by industrial workers had much significance in the capital city until the early 20th century. Second, as with France, historians of Belgium have until recently focused so much attention on the nation's centre that they have neglected the periphery—arguably much more important in understanding the social history of 19th-century Belgium.

[10] Examples abound. Marcel Janssens was surprised to discover some programme notes published for the 1978 staging of a play by Hugo Claus which noted, 'Hugo Claus was a prolific Flemish author who wrote poems, novels, and plays in Dutch, Flemish, and Belgian'. Janssens added, 'That must have been the most inane statement on the linguistic situation in the Low Countries ever printed in Great Britain'. (See Janssens, M., 'The Two Literatures in Belgium since 1830', in Lijphart, A. (ed.), *Conflict and Coexistence in Belgium: The Dynamics of a Culturally Divided Society* (Berkeley, Calif., 1981), 95, n. 8. More recently, an announcer for the BBC programme 'Songs of Praise' described César Franck as 'that famous French composer'. A few days later a reporter for the *Guardian* denounced Belgian unwillingness to join the Gulf War as historically determined because 'Belgium has twice declared itself neutral, in both world wars, in order to avoid fighting'. This criticism would, no doubt, have surprised both those 19th-century Belgian politicians upon whom neutrality was forced—by Britain, amongst other Powers—as a condition of Independence, not to mention the stalwart Belgian army ('the plucky little Belgians' of World War I fame) who held out against the advancing Germans for a surprising period in 1914 before the latter occupied—and devastated—the small country. (See 'Songs of Praise', Christmas, 1990, and the *Guardian*, 21 January 1991, p. 1.)

chapters. The first, Chapter 3, treats women working in the textile-mills of Ghent and Verviers during the mid-century decades. Chapter 4 provides a similar look at women working in Belgium's 'black country' in these same decades, tracing women's work first in Charleroi, then in the Borinage and Liège. Because they concern the decades when the nation was engaged in the process of discovering and solidifying its social, political, and indeed national identities, these chapters are primarily social narratives of women's very difficult public and private lives.

Chapter 5, on the other hand, takes a different tack, examining the entry of what came to be called 'the woman question'—focused on women coal-miners—into public debate in Belgium. Because those who set the terms of the discussion were members of the country's tiny ruling élite, their voices, raised in strident argument over the propriety of women's work in coal-mines, reflected the often bizarre and always highly imaginative roles women coal-miners played in the bourgeois imagination during the 1860s and 1870s.[11]

Chapter 6, the final chapter in Part II, investigates the spread of female industrial labour during the decades around the turn of the century. It not only outlines—albeit briefly—women's employment in the many new occupations available as the process of industrial transformation continued, but also undertakes to describe women's participation in the lively social and political life of our regions. Because of extensive social unrest in these final decades of our period, bourgeois attitudes toward women's work grew still more extreme, exacerbated by the mass explosion of working-class resentment in 1886. Following the mass general strikes of that year, bourgeois reactions focused even more narrowly on the roles played by the nation's *ouvrières* and *werksters* in industry.

This chapter is primarily compensatory. In other words, it offers consider-able documentation for the argument that working women continued to play an essential and active role in the political work of their class, their communities, and their neighbourhoods. It also demonstrates that argu-ments about working women's essentially private, apolitical lives, com-monly employed to explain women's behaviour elsewhere in Europe, have no basis in the Belgian case. Moreover, it underscores one key aspect of the implied argument of the entire work: that without working women, Belgium's labour movement would have been, at the very least, impover-ished.

[11] An outline of this important debate is found in my 'The Rhetoric and Iconography of Reform: Women Coal Miners in Belgium, 1840–1914', *Historical Journal* 34/ 2 (1991), 411–36. See also Ch. 5, below.

Part III, 'Women and Politics', falls into two periods. The first, explored in Chapter 7, concerns the first organized working women's movement in Belgium in the era of the ultimately ill-fated Association Internationale des Travailleurs. Here, women textile-workers—together with their male comrades—launched a genuinely grass-roots 'feminist' movement (though the term is an anachronism), complete with an ideology of women's place. They grounded the latter in popular ideas of female biology, and claimed for themselves a purely domestic sphere. At the same time, they insisted on a prominent public role in the class struggle. Though such a working women's movement was not entirely unknown in this period—the women workers of the Jura Federation and the women textile-workers of Geneva were both active First Internationalists—it was a rare phenomenon. More-over, the Verviers movement has been almost entirely ignored by historians—of Belgium, of the First International, and indeed, even of Verviers itself.[12]

Chapter 8, 'Working Women in the Second International', takes up the story of working women's efforts to create their own movement within the wider politics of their class. Following a brief narrative of such activities in our Walloon regions, the chapter concentrates on the story of Belgium's most remarkable socialist feminists, the textile *werksters* of Ghent. Led by the textile-worker Emilie Claeys and her friend Nellie Van Kol, the women of Ghent articulated a surprisingly radical feminism.[13] Their efforts had important consequences for the politics of Ghent's Second International socialist movement, popularly known as Vooruit ('Forward'), and even more significantly, for the successful organizational tactics of Belgium's largest textile union, the *Vereenigde Vlasbewerkers en Bewerksters* ('United Men and Women Flaxworkers'). Although not all working women's politi-cal efforts have been explored by historians of other European countries, the work that does exist (including my own) suggests that Ghent's women were unique, not only in the extent of their success (e.g. in convincing

[12] There are historians working on the extraordinary Verviers working class, including Claude Desama (see e.g. *Population et révolution industrielle: Évolution des structures démo-graphiques à Verviers dans la première moitié du 19e siècle* (Paris, 1985), and El Kefi-Clockers, C., 'Population féminine active de l'industrie textile verviétoise . . . 1856', Mémoire de license (Liège, 1976)). But general histories of Belgium in the First International—or of the International in Europe—offer no record of the Verviers women's movement.

[13] See e.g. Keymolen, D., 'Feminisme in Belgie: de eerste vrouwelijke arsen (1873–1914)', *Bijdragen en mededelingen betreffende de geschiedenis der Nederlanden* 90 (1975), 38–58, and Romein, J., and Van Werveke, H. (eds.), 'Vrouwen emancipatie, 1844–1914', in Van Haitte, J. A., Niermeijer, J. F., Presser, J., *Algemene geschiedenis der Nederlander*, xiii (Amsterdam, 1978), 66–76. See also van Praag, P., 'Emilie Claeys, 1855–1943', *Tijdschrift voor Social Geschiedenis* 11 (June 1978), 177–96.

local male leaders that 'the personal was political', which meant that men's daily actions had to reflect their public pronouncements), but also in the originality and far-sightedness of their feminist analysis.[14]

These women have a corresponding importance in explaining the nature of the socialism that ultimately emerged from the congeries of local efforts. That their highly successful early efforts finally played no role in the so-called socialist women's movement created by the Brussels-based Parti Ouvrier Belge after the turn of the century had two important explanations. First, Ghent's women were Flemish, and thus significantly hindered in their relations with what was primarily a francophone party leadership. Secondly, they were working class—and thus, as subjects for analysis, exotic and unfamiliar creatures to the *bourgeoises* chosen to lead the party's official women's movement. The lack of comprehension with which those *bourgeoises* attempted to attract working women to the movement not only doomed it to failure but also exemplified both the class divisions and the cultural/linguistic conflicts that plagued Belgian socialism in the years before 1914. Here again, in other words, the particular history of working women illuminates the wider history of Belgium in these years.

The final part of the book is its conclusion: a short analytical chapter designed to retrieve the many thematic strands of the narrative and to weave them into the larger context of Belgium as a whole. In addition, Chapter 9 has a second purpose: to suggest directions for further research. As will be obvious from the choice of only five locales for this work, much more remains to be done. Both the key cities of Antwerp and Leuven, for example, witnessed the development and spread of working women's politics in the last decades of the nineteenth century. Furthermore, the women of each of our regions deserve closer examination, including, not least, Belgium's millions of rural working women. These women, employed in agriculture both as farmers and as waged workers (in migrant work-gangs or as hired help), deserve their own study. Like Liège's *boteresses*, and Belgium's women coal-miners, rural women became the subjects for dozens of nineteenth-century painters, sculptors, and photographers, as well as for the country's poets and novelists.

Furthermore, women's extensive and essential work in Belgium's 'sweated trades', work that employed both the rural and urban populations, remains unstudied. The celebrated women shrimpers, dockers, and fishwives

[14] See *Working Women and Socialist Politics in France: A Regional Study, 1880–1914* (Oxford, 1986). See also a recent study that finds many similarities between Scotland's working women and those in France, Gordon, E., *Women and the Labour Movement in Scotland, 1850–1914* (Oxford, 1991).

of Belgium's coastal cities and towns—also visible in numerous paintings and drawings of the period—equally continue to be 'hidden from history'. A cursory examination of extant documents suggests that here, too, lies a rich source of information about the political participation of thousands more Belgian women who have been consistently ignored by social historians. Lastly, many of Belgium's urban women—the *petit bourgeois* shop-owners, street merchants, and workshop *maîtresses*—remain unresearched. And this is particularly problematic, as evidence suggests that as a group such women shaped their politics around the organizations almost entirely ignored by industrial workers through most of our period: the Catholic trade unions. Such lacunae in our historical understanding surely cry out for further research into women's place in the social history of Belgium.

A NOTE ON SOURCES

'Rien n'a pu cependant égaler la faculté d'incompréhension des Belges eux-mêmes lorsqu'il s'agit de leur propre passé'.[15] Jean Stengers's harsh judgement finds considerable support in the dismal condition of the country's archives. Until quite recently, in fact, key materials remained without inventories or organization. Two of those who have helped rectify the problem, Léon Linotte and Jeannine Bayer-Lothe, have recorded their initial shock upon entering the unorganized archives of Liège and Namur, respectively. Linotte recalled dismay: 'La tâche que nous avions entreprise s'avéra des plus pénibles: impossibilité de s'orienter dans ce pêle-mêle'.[16] Fortunately he did not succumb to despair—and it is thanks to him, and to Bayer-Lothe and others, that historians now possess essential keys to some important archives.

A second problem, however, defies solution: during two German occupations important archives were destroyed. Natural disasters—fires and floods—have done equal damage, as have decades of human neglect. By comparison to equivalent French archives and libraries, to use only one European example, Belgium's repositories are virtually empty. Records are

[15] Stengers, J., 'Le Vocabulaire national dans le Royaume des Pays-Bas (1815–1830)', in *Colloque historique sur les relations belgo-néerlandais entre 1815 et 1945: Acta, Bruxelles 10–12 déc. 1980* (Ghent, 1982), 11.

[16] Linotte, L., *Les Manifestations et les grèves dans la province de Liège de 1831 à 1914: Inventaire sommaire des archives de la sûreté publique de la province de Liège* (Leuven, 1964), p. vi, Bayer-Lothe, J., *Documents rélatifs au mouvement ouvrier dans la province de Namur au XIXe siècle, IIe partie, 1849–1886* (Leuven, 1969), p. iv.

sparse, incomplete, and dauntingly random. Hundreds of neatly labelled *cartons* in both national and provincial archives contain little material—and what there is is often of little importance.[17] Complete runs of local or national newspapers and journals are rare. Even the national socialist paper, *Le Peuple*, must be read in several different libraries and archives in order to avoid missing issues. Hundreds of key government documents have evidently disappeared.[18]

If these problems were not sufficiently daunting, historians of women face many other vexations familiar to historians of all European working women in this period. They bear repeating, both because they have proved to be as relevant to the Belgian case as they are to other countries, and because many who have never attempted to research working women imagine the existence of heretofore untapped archival riches which they believe would make possible a different kind of history. In other words, some believe that the kind of women's history one can write for the 'scribbling classes'—including literate middle- and upper-class women of the nineteeth century—is equally possible for the history of their lower-class sisters.

Sadly, however, this is not the case. The kind of records left by women of the élites—letters, diaries, novels, stories, poems, and so on—are exceptionally rare for working women. There is a handful of documents that record some working women's views in our period. In uniquely literate Verviers, for example, there are letters written by *ouvrières* to the press. One collection of documents from Charleroi (housed in Corning, New York) includes a poem by a woman glass-worker. But the great mass of Belgium's working women remain silent. To see them, to discover the

[17] Often e.g. a *carton* labelled 'Enquête—1866' will contain half a dozen blank copies of the form sent to potential witnesses—and nothing else. In the mine archives, 'inspection' reports rarely recorded essential details such as the name of the mine, the date of the visit or accident, or the nature of the work observed. Instead, there are long lists of hundreds of injured workers, some designated by name, some by age, a few by sex, or marital or parental status. None resembles any other: worse, there was no order to the rules followed by inspectors. Decades, moreover, separate the reports. It is not possible, therefore, to discover the accident history of any particular region or mine—or even to be certain of ages, sex, or even occupations of injured miners. These problems in the mine archives are replicated in similar documents concerning other industries.

[18] Two German invasions, as well as the general neglect of documentary materials, have meant the disappearance of essential documents. In addition until recently the Bibliothèque Royale was without adequate storage for its materials. To complicate matters further, Belgian law protects the privacy of individuals—including those long dead. Thus permission must be obtained to see any police records. Such permission is only granted for records of named individuals. Social and labour historians cannot read through materials searching for women leaders whose names are not known from other sources. Because records of women's meetings are stored in the dossiers of leaders, ignorance of key leaders' names effectively causes many women to become invisible.

details of their harsh and often abbreviated lives, it is necessary to rely on creative detective work through newspapers, public and private *enquêtes* (fortunately numerous), police reports of suspect workers' activities, the assessments of their female colleagues by more frequently literate male workers, and visual sources, common both in élite and popular culture in Belgium in the last century. Detailed, if heavily biased, portraits of Belgium's working women also exist in the abundant writing of that country's would-be reformers. These latter, however, tended to view working women only as extreme examples of their particular points of view—either as anathema to the 'civilized' world, or as heroines of labour, or even as prime representatives of Belgium's liberal social order, in which they exemplified the 'freedom to work', a right of all Belgians.

A further source for historians of working women are the travellers' tales that emerged in the course of the century. Belgium attracted foreign visitors—not least those fascinated by the economic miracle wrought in the tiny country by a relatively small population. The stories told by such travellers, accustomed to the social situation of their home countries, where women's work was much more clearly gendered, invariably included descriptions of females involved in 'untraditional' work. Women coal-miners and dockers drew particular attention, and admiration from male observers awed by their 'manly' abilities.

At the same time, however, many foreigners proved unable to detach themselves from stereotypes of women's natures when they undertook to explain the behaviour, rather than the work, of Belgian women. Thus, for example, when the British Fabian, H. Seebohm Rowntree, visited Belgium to observe its 'land and labour', he was perplexed by some workers' evident preference for what he saw as the onerous, exploitative, low-paid work of the out-putting system over the much better paid, more secure work of the factories.[19] Typical of most Britons of his time, however, he soon found an explanation for women's choice of sweated labour:

As we have seen, [women's] earnings are usually subsidiary to other sources of income. Doubtless there might be openings in factories for a number of the girls [sic] who are making lace in the Flemish villages, but to take advantage of them would mean a very early start each morning to catch the work*men*'s train, and a return late at night, and it is not surprising that their parents prefer them to continue the old occupation at home, even if the remuneration is less.

Although circumstances were changing, women were not: 'The goods which were once made by hand, such as lace, are now increasingly made

[19] Rowntree, H. S., *Land and Labour, Lessons from Belgium* (London, 1911), 97–8.

by machinery and hand-spinners and weavers can no longer hold their own, although they will attempt to do so longer than the men, because, as a rule, they are not wholly dependent on their wages'.[20]

In Rowntree's mind, four factors, grounded in prevalent beliefs about females and their proper social roles, provided sufficient explanation for women's preferences. Women were averse to personal effort—long train rides and early mornings—fearful of the dark, subject to parental controls, and economically dependent, earners of 'ancillary' wages. Men, on the other hand, demanded a much more complicated explanation for what was identical behaviour. First, Rowntree insisted that men's (never 'boys') wages were primary—not only for their own support, but also for that of their 'dependents'.[21] So their obvious reluctance to enter the mills confounded the Englishman's efforts at understanding. However, he ventured two possibilities. On the one hand, men might have been 'too old' to undertake factory labour; or, perhaps they were too accustomed to the independence of domestic work. Male out-workers, Rowntree noted, 'need not begin on the stroke of the factory bell. [They] may smoke and talk at work, or have a chat with a neighbour, or stop and drink a glass of beer.' 'Probably for these advantages', he concluded, '[they are] willing to make some financial sacrifices'.[22] In striking contrast to the volitionless actions of Rowntree's 'girls', these men chose their occupations in order to satisfy two perceived needs: autonomy and sociability.

Such gendered explanations coloured many contemporary accounts, including, of course, those of Belgians themselves. Thus the work of historical retrieval requires not only a struggle with sparse and incomplete records, but also a painstaking attention to what might be termed the 'sexual discourse of texts'.

The task of rescuing our subjects from the historical *oubliette* is, therefore, complicated. The dogs that failed to bark are, unfortunately, plentiful. Still, as Sherlock Holmes discovered, there is truth to be found in the silence. And, I am arguing, discovering that truth—hearing the silences—means not only re-discovering Belgium's lost women workers, but also illuminating the history of the country as a whole.

[20] Ibid. 97.

[21] It might be noted here that Rowntree's assumption that the 'family wage' was common amongst the Belgian working class stemmed from his experience of Britain. Amongst British workers of the time, such a wage was both a demand and an expectation. It was, however, rarely mentioned in Belgium, where women, as this work demonstrates, expected to earn their own way.

[22] Rowntree, *Land and Labour*, 97.

2

Belgium, 1795–1914

By common consent, the area which accepted earliest and with the greatest ease the gospel of industrialization emanating from Britain, and which came closest to the British model, was the Sambre-Meuse region, together with the Scheldt Valley of Belgium and northern France. . . . The Belgian industrial belt contained early and successful examples of all the key industries of the industrial revolution period.

Sidney Pollard[1]

THE FRENCH PERIOD

The Belgian territory annexed by France in 1795 was already well on its way to the industrial prosperity it would enjoy throughout most of the nineteenth century. Alert to this fact, the French did nothing to hinder the region's economic progress. Indeed, the years from 1795 until Waterloo proved advantageous to the expansion of Belgian industrialization in three key ways. First, the French government enlarged Belgian territory, swallowing both the independent Liège Bishopric and a large area south of Liège (most of which is today Luxemburg). These borders endured until 1839, when a newly independent Belgium, at the behest of the Great Powers, reluctantly relinquished some of the land.

Secondly, annexation offered a vast new market—of some 40 million potential consumers—to Belgian producers. And it was an open market, unrestricted by duties and customs.[2] Belgian industrialists—facing no

[1] Pollard, S., *Peaceful Conquest: The Industrialization of Europe, 1760–1970* (Oxford, 1981), 87.

[2] For this early period, see Polasky, J., *Revolution in Brussels, 1787–1793* (Brussels, 1987), esp. the abundant footnotes citing important works of economic history. See also Mokyr, J., *Industrialization in the Low Countries, 1795–1850* (New Haven, Conn., 1976), esp. 229 ff.; Van Neck, A., *Les Débuts de la machine à vapeur dans l'industrie belge, 1800–1855* (Brussels, 1979); van der Wee, H., 'De Industriëlle revolutie in Belgie', in van der Wee (ed.), *Historische aspecten van de economische groei* (Anvers-Utrecht, 1972), 168–208. Good general surveys include Coppejans-Desmedt, H., 'Economische opbloei in de Zuidelijke Nederlanden', in Van Houtte, J. A., Niermeijer, J. F. N., Presser, J., Romein, J., and Van Werreke, H. (eds.), *Algemene*

French competition in these years—were quick to seize their opportunity. Thirdly, some revolutionary policies proved equally beneficial to Belgium's emerging entrepreneurs. For one thing, lingering guild restrictions disappeared. Property and land seized from the Church also provided a boon both to speculators and to those in search of ready-built factory premises.[3]

Many Belgians benefited from these developments. Two, however, led the pack: John Cockerill and Lieven Bauwens. In Verviers in 1802 Cockerill founded what soon grew into an industrial empire. Beginning with the manufacture of wool machinery—copied from models brought from his native England—Cockerill soon transformed the region's extensive proto-industrial production of woollens into a factory-based system. In addition, the Englishman began to produce various other goods, including, eventually, rails and railway locomotives, and even coal. Soon, his multi-faceted company rivalled its British competitors throughout the growing European market.[4]

In Ghent, English cotton machinery revolutionized local textile production after Lieven Bauwens successfully smuggled the first equipment across the Channel at the end of the eighteenth century. In only a few years, several of Bauwens's colleagues in Ghent had joined the rush to establish cotton-mills. Soon, their red-brick factories dotted Ghent's ancient skyline, and 'Belgium's Manchester' was born. Like their British counterparts, Ghent's mills initially employed mainly women and children (many as young as 5). In these early years, they provided some 70 per cent of cotton-mill operatives. Most of them—as well as a majority of the remaining 30 per cent of adult male workers—came not from amongst the thousands of hand textile-workers of the city (most of whom worked in the traditional linen industry) but rather from Ghent's

geschiedenis der Nederlanden, viii (Amsterdam, 1955), 273–80, and Dhondt, J. and Bruwier, M., 'The Low Countries 1700–1914', in Cipolla, C. (ed.), *The Fontana Economic History of Europe: The Emergence of Industrial Societies, i* (London, 1970), 329–66.

[3] Of course it is all much more complicated than this (as Jonathan Steinberg would remind us), and has provided the subject for many works cited throughout this work. It is interesting to note, however, that the many monasteries and convents of the Liège Bishopric were readily turned into glass and arms workshops. Hans Seeling observes as well, that 'Les usines et les hauts fourneaux de Seraing ... s'installent sans façon dans les bâtiments et parcs de l'ancien domaine des princes évêques de Liège': see *Les Wallons pionniers de l'industrie allemande*, trans. Pauquet-Dorr, J. (Liège, 1983), 25.

[4] In addition to the works cited in fnn. 1 and 2, above, see Le Brun, P., Bruvier, M., Dhondt, J., and Hansotte, G., *Essai sur la révolution industrielle en Belgique, 1770–1847* (Brussels, 1979); and Pollard, *Peaceful Conquest*, 149.

ready 'reserve army' of unemployed and starving 'beggars and vaga-bonds'.[5]

At first, the new cotton-mill hands earned relatively high wages—albeit for exceedingly long hours. For 13 or 14 hours of work, for example, mill hands drew between 5 and 8 francs.[6] But even such high pay did not ensure a disciplined workforce. Indeed, amongst these first workers, collective indiscipline soon prompted local industrialists to impose an elaborate system of regulations and punishments aimed at transforming this rag-bag army into a disciplined factory workforce. In the process, the *patronat* discovered the efficacy of controlling workers' activities beyond the factory gates, and Ghent's obliging officials began to monitor life in the city's poorer quarters. Potential trouble was reported to mill-owners and to the city council—often the same men. (Here, too, Bauwens pioneered, serving as Ghent's *burgemeester* from 1800 to 1802.)

To facilitate such policing, the city government passed several laws which allowed the unemployed to be arrested and confined, initially in public workhouses or prisons. Soon Bauwens recognized an opportunity for profit, and founded the first private workhouse. City officials obligingly sentenced convicted indigents to Bauwens's textile-producing institution, where they were forced to work for extremely low wages. Bauwens explained the low pay by claiming that his inmates received free board and lodging![7]

As Ghent industrialized in the early decades of the nineteenth century, class relations began to assume the asymmetrical shape that prevailed throughout most of our period. Ghent's ruling class of textile-owning families established their control of city life quite early on. However, this pattern was not immediately imitated elsewhere in Belgium during the French years. Instead, much of the industrial landscape of Wallonia was ravaged by the battles of the Napoleonic wars. In the coal country of

[5] Dhondt, J., 'Notes sur les ouvriers gantois à l'époque française', *Revue du Nord* 34 (1954), 313, 310. See also 'Avanti' (Oscar Roelandt), *Een Terugblik. 2de herziene en aangevulde uitgave met bij voeging van de toestanden tot 1931* (Ghent, 1939). Dhondt's article, though the work of a major Belgian historian, contains another striking example of the way in which even the most fair-minded historian sometimes unthinkingly marginalizes women. He notes that the new Ghent workers were 'not all adult *ouvriers*'. In cotton, 'adult workers'—meaning men and boys over 18—comprised only 30 of the labour-force. 'Le reste', he adds, 'étant constitué de femmes et d'enfants des deux sexes âgés de 6 à 16'. Worse, Dhondt implies that women did not even make their own decision to enter the new textile factories. Instead, a male worker 'accepte évidemment les hauts salaires qu'on lui offre, il ne voit sans doute aucun inconvénient à faire travailler aussi sa femme et ses enfants' (p. 316, emphasis added).

[6] 'Avanti', *Een Terugblik*.

[7] Reported in both Dhondt, 'Notes sur les ouvriers', 316, and Avanti, *Een Terugblik*.

Charleroi and the Borinage, especially, many coal-pits were damaged or destroyed, and production halted. As a result, workers of the Black Country suffered several years of harsh economic misery. Indeed, one economic historian has described mine-workers as that era's 'miserable under-proletariat'. Emblematic of their lowly condition was their illiteracy: in 1815 only about 5 per cent of the entire population of the region could read or write.[8]

After Napoléon's final defeat in 1815, prosperity began to return to the *pays noir*, driven both by the continued thirst for coal in France and Belgium, as well as by the opening of a new market in the Netherlands. New and larger mines soon replaced smaller pits, especially those ruined by war. Moreover, as large companies digested smaller competitors, numbers of miners grew and work rules were standardized. By the early 1820s a relatively small number of mining companies employed many thousands of workers in Charleroi and the Borinage, all of whom found themselves subject to uniformly onerous rules and regulations. (In 1822, for example, there were 30 mines in the Borinage, each employing about 480 workers.)[9]

In Liège, on the other hand, mining continued in its 'proto-industrial' form throughout most of the French years, untouched by the war. Dozens of small mines continued to function as they had for generations: families, headed by a 'master miner', worked together, digging, hauling, and even selling the coal.[10] Still, change was in the air in Liège, too, by the final years before Waterloo. Several master miners had begun to buy other mines, and to enlarge their own, and these new capitalists soon discovered the need to discipline their new workers. To that end, they imported the *police des mines* from France in 1813. The mine police instituted the most restrictive working rules in Belgium, including a prohibition of 'Saint Monday', the cherished tradition which allowed miners to avoid work on Mondays.[11] By the close of the French period, Liège's coal-miners found

[8] Le Brun, *et al., Essai sur la révolution*, 336. See also Wellemans, Y., 'L'Analphabétisme en milieu urbain belge au XIXème siècle: Méthode et resultats', *BTNG/RBHC* 10 (1979), 183–7.

[9] Watelet, H., *Une Industrialisation sans développement: Le Bassin de Mons et le charbonnage du Grand-Hornu du milieu du XVIIIe siècle* (Ottawa, 1980), 169.

[10] One depiction of such 'artisanal' coal-mining is 'La Houillère', painted in the late 18th century by the Liège artist Léonard Defrance. The picture hangs in the *Musée de l'art wallonne* in Liège.

[11] See Neuville, J., *La Condition ouvrière au XIXe siècle, i. L'Ouvrier objet* (Brussels, 1976), ch. 2; and Le Brun, *et al., Essai sur la révolution*, 369. It should be noted that not all the new regulations were hostile to workers. One established a minimum age of 10 for underground mining. Of course some mining families—and doubtless some children as well—saw this as an infringement of their freedoms.

their working lives nearly as regulated as those of Ghent's cotton-mill hands.

After the end of the period of French rule, industrialization in Belgium was well under way. In the process, workers found their independence increasingly at risk as the *patronat* discovered how to use its strength to control the labour-force. Indeed, the emergent Belgian industrial bourgeoisie grew bold as they discovered their collective power to shape every aspect of social, political, and economic life. Furthermore, they consolidated their social dominance by intermarrying with Belgium's hereditary aristocracy, a group already actively involved in the industrial, intellectual, and professional life of the nation. Moreover, many Belgian capitalists were themselves ennobled; by the second generation, at least, most of Belgium's great entrepreneurial families bore a title given by the king. Distinctions amongst those in Belgium's upper classes grew increasingly vague. As one writer has put it, 'toute la Belgique n'est qu'une grande bourgeoisie et que ce qu'un Français qualifié d'"esprit bourgeois" prévaut dans toutes les classes de la societé, y compris les plus hautes'.[12]

Their new Dutch rulers proved equally anxious to maintain continued industrial growth in their southern territory. To that end, Willem II attempted to stimulate the Belgian economy by extending the transport network (already the most extensive on the continent). Belgian industry was thus soon linked to markets all over the Netherlands—a boon to Belgian industrialists faced with stiff English competition. In 1822 the Dutch king supported the creation of the Société Générale de Banque, a financial institution which provided capital for new industries. (The Société became the Banque de Belgique soon after Independence.) Willem II also launched the first of what soon became a treasured tradition of self-congratulation, the industrial exposition, the first mounted in Ghent in 1820.[13] Held regularly thereafter, these exhibitions manifested the growing

[12] Henrot, T., *Belgique* (Paris, 1958), 102.

[13] See Watelet, *Industrialisation sans dévéloppement*, 268. Mokyr's *Industrialization in the Low Countries* offers a summary of the debate over the efficacy of Willem II's development policies in the southern Netherlands. As for the question of why Belgium was able to compete with Britain—whose goods flooded the continent after Waterloo—the explanation lies in Belgium's industrial precocity, as well as in the fact that its transport network (quickly extended by the Dutch king) allowed it to continue dominating the European market for coal, iron, and key artisanal products (such as arms). Its textile exports faltered briefly, but cotton and wool

self-satisfaction of Belgium's industrial bourgeoisie. In vast halls, often purpose-built, the products of Belgium's factories, workshops, and mines went on display, while prizes and medals celebrated the best in dozens of categories.[14]

Of course such industrial growth exacted a social price. Unrest spread alongside the expansion of the factory system. In these Dutch years, thousands more of Belgium's once-independent artisans and proto-industrial workers were driven into an increasingly rigid pattern of discipline and surveillance. As they resisted their loss of autonomy—usually by staying away from work, arriving late, and working slowly—industrialists' complaints multiplied. In 1828 one mill-owner explained that he and his colleagues had begun to hire only the youngest workers, who were more malleable than their elders: 'I see with satisfaction that we can form workers much more easily if we hire young people between 16 and 17 years old', wrote one Flemish textile-mill owner.[15]

And yet, in the short term at least, textile-owners had little cause for concern: the loss of the French market, coupled with the resistance to technological improvements of linen production, soon produced a terrible economic crisis throughout Flanders. All over the countryside, growers, spinners, weavers, finishers, and lace-makers engaged in a desperate struggle for survival. Those who found work in the expanding cotton labour-market counted themselves fortunate. But these were few; most linen-workers faced a misery that reached its nadir in the terrible famine that struck in the aptly named 'hungry forties'.

For miners and mine-owners, on the other hand, Dutch rule brought a brief period of unusual prosperity. Beginning in the mid-1820s, after most mines had recovered from war damage, a high demand for coal (in Belgium itself, as well as in France and the Netherlands), plus a shortage of local labour, forced employers to offer high wages. Desperate mine-owners also lured potential workers with company housing, baths, schools, and even dance-halls! At the vast Grand-Hornu mine in the Borinage, owners even

goods could be produced cheaply in Belgium—and of course the new Dutch market helped replace that partly lost in France.

[14] These are described in *L'Art verrier en wallonie de 1802 à nos jours: Éxposition organisée par les villes de Charleroi, Liège, Mons, et Namur* (Charleroi, 1985), 28, and Pirenne, H., *Histoire de Belgique: De la révolution de 1830 à la guerre de 1914, vi* (Brussels, 1932), 80. After Independence, these expositions continued at regular intervals, starting in 1835. Most were held in the capital, easily reached by Belgium's extensive railway network. Eventually, 'national expositions' became 'international', as the spoils of empire took their place alongside the 'spoils' of industrial capitalism.

[15] Quoted in Bologne, M., *De Proletarische opstand van 1830 in België* (Leuven, 1979), 76.

added a public library. (It should be noted, however, that the crisis did not last long enough to see the opening of this library—or the baths built at the same time.)[16]

Mining's 'golden age' ended abruptly once mine-owners discovered a new source of abundant labour: women and children. These new workers, together with adult men convicted of vagrancy, soon satisfied mine-owners' needs. As a result, wages once again dropped, and benefits disappeared. By 1830, in fact, Belgium's miners had begun to suffer the first indications of what soon became an extended period of immiseration.[17]

INDEPENDENCE

When Belgium broke away from Dutch rule in the 1830 Revolution,[18] the broad outlines of the country's social relations of production—which remained in place throughout our period—were drawn. At the top of the social pyramid sat Belgium's prosperous bourgeoisie. In Henri Pirenne's words, they comprised 'une bourgeoisie à tendances libérales, infatuée de son importance'.[19] Below—quite a distance below—Belgium's urban and rural masses clustered together; upon their unceasing toil rested the growing wealth of their masters. Not surprisingly, the new bourgeois government did nothing to disturb this social structure. In fact, the country's new constitution set class divisions in concrete, first excluding all but a handful of male property-owners from government and then legislating extremely strict controls of workers' activities.

From the workers' point of view, the most important manifestation of the new government's social attitudes was the penal code. Articles 415 and 416 quickly earned opprobrium, not least because officials proved ready to enforce every breach of the new laws. These articles—copied from earlier

[16] Le Brun, *et al., Essai sur la révolution,* 369.

[17] This period is detailed in Hasquin, H., *Une Mutation, le 'pays de Charleroi' au XVIIe et XVIIIe siècles: Aux origines de la révolution industrielle en Belgique* (Brussels, 1971), 67 ff., 166 ff., and in Watelet, *Industrialisation sans dévéloppement.*

[18] Several books treat the 1830 Revolution: see, *inter alia,* Bologne, M., *'L'Insurrection prolétarienne de 1830 en Belgique* (Brussels, 1929) (Flemish language version noted in fn. 15, above); Church, C., *Europe in 1830* (London, 1983); and an extremely abbreviated overview in Witte, E., and Craeybeckx, J., *La Belgique politique de 1830 à nos jours: Les tensions d'une démocratie bourgeoise,* trans. Govaert, S. (Brussels, 1987), 3–9. Janet Polasky has argued that women played only a minimal role in the events of 1830 in 'From Stone Throwers to Hearth Tenders, Women in Revolutionary Belgium', *History Workshop Journal* (spring, 1986), 87–105. Although evidence is sparse and contradictory, I would dispute her argument.

[19] Pirenne, *Histoire de Belgique,* vi, 50–1.

French measures—forbade any workers' *coalitions*. They further demanded that every worker carry a *livret*—a passbook which recorded each individual's work history. The code's language expressed the contempt with which Belgium's new rulers viewed the nation's working class. The law stipulated, for example, 'Le maître est crû sur son affirmation: pour la quotité des gages, pour le payement du salaire de l'année échué et pour les accomptes donnés pour l'année courante'.[20] Thus was an owner's word law.

Under the new constitution all women, of whatever class—noble, bourgeois, or proletarian—were equal (as they had been during the French empire, when the Napoleonic code excluded them from the *pays civil*). Here, Belgium imitated virtually every other constitutional state. Class lines disappeared; all women shared a legal position with minors and 'irresponsables'. In Denise De Weerdt's words:

'La femme mariée ne pouvait exercer un travail professionnel sans l'autorisation de son mari. La femme était doublement gommée puisqu'elle appartenait à une classe sociale à qui elle-même n'avait rien à dire. Comme sa consoeur bourgeoise, elle ne jouissait d'aucun droit civil ni politique. Son apanage était le droit au travail. Mais dans quelles conditions!'[21]

Although Belgium's tiny ruling élite thus codified existing class and gender relations soon after its accession to power, the existence of a constitution did not prevent several years of political and social experiment, as leaders sought to find their ideological and political feet. In fact, the wider history of the nation from 1830 to the First World War suggests that the process of inventing a state was a lengthy one. Although it is arguable, following Jean Stengers, that most inhabitants shared a strong national identity, a clear sense of their 'Belgianness', few were able to translate it readily into the terms required by a modern state. Successive governments involved themselves in the effort to 'invent Belgium' for the nation's people. Most historians divide the process into three general periods: 1830–50, 1850–84, and 1884–1914.[22]

[20] Chlepner, B.-S., *Cent ans d'histoire sociale en Belgique* (Brussels, 1979), 24. See also Neuville, *Condition ouvrière*, i, ch. 2, and Le Brun *et al.*, *Essai sur la révolution*, 369.

[21] De Weerdt, D., 'Zoë, Isabelle, et les autres . . .', *Vie des femmes, 1830–1930*, catalogue from the Éxposition: Banque Bruxelles Lambert, 16 Oct.–30 Nov. 1980, 21. See also Polasky, J., 'Utopia and Domesticity: Zoë Gatti de Gamond', *Proceedings of the Eleventh Annual Meeting of the Western Society for French History*, 3–5 November 1983 (Lawrence, Kan., 1984), 273–81.

[22] It is important to separate national sentiments, such as Stengers argues were shared by most Belgians in the 19th century, from a functioning nation-state. Stengers argues very convincingly that the former pre-dated the state. See his 'Belgian national sentiments', in Lijphart, A. (ed.), *Conflict and Coexistence in Belgium: The Dynamics of a Culturally Divided Society* (Berkeley, Calif., 1981), 46–60.

EXPERIMENT: 1830–50

Belgium's new rulers faced three immediate challenges in the 1830s: first, the choice of governmental form; second, the writing of a constitution (acceptable not only internally, but also to the wary Great Powers); and third (consequent upon their choice of a constitutional monarchy), the selection of a ruler. The resulting constitution (modelled both on that of the United States and on Britain's unwritten constitutional practices) declared the people 'sovereign and equal', and guaranteed Belgian citizens a range of rights broader than any in Europe. Citizens were free to assemble, to associate (except to form workers' *coalitions*), to speak, and to worship. Not all, however, were free to participate in government. Property qualifications limited access to the body politic to a tiny minority of Belgium's inhabitants. In 1847, for example, just before the revolution-wary Belgian government enlarged the franchise to encompass more male property-owners, only 46,630 males owned sufficient property to qualify as electors. 'Quant aux femmes', B.-S. Chlepner has remarked, 'on n'en parlait même pas'.[23]

Although such material restrictions on political participation, bolstered by narrow laws constraining workers' activities, should have made clear the unrevolutionary character of the oligarchy that ruled the new nation, apparently they did not. Instead, many European leaders saw Belgium's extensive freedoms as potentially very dangerous. In 1832 Pope Gregory XVI condemned what he saw as Belgian radicalism. A few years later Metternich warned, 'I see what they're aiming at. They want to make Belgium a city [*sic*] of refuge for the Jacobins of neighbouring countries. We shall not allow it!'[24] Despite such fears, however, Belgium's rulers soon proved that they were very far from being the youthful revolutionary firebrands imagined by their European colleagues.

This is not to say, however, that Belgium's new leaders were in any sense ideologically homogeneous, rather, they held a variety of views. There were radicals—including both Saint-Simonians and a few liberal-minded Freemasons. (Most Belgian Freemasons, unlike their counterparts

[23] Chlepner, *Cent ans*, 18–19. See also Legasse, C.-E., *Les Institutions politiques de la Belgique* (Louvain-la-Neuve, 1988).

[24] The Pope's criticisms are quoted in Chlepner, *Cent ans*, 18. See also Gérard, J., *La Vie quotidienne au temps de Léopold I* (Brussels, 1965), 35–6. Hislaire, R., 'Political Parties', in Goris, J. (ed.), *Belgium* (Berkeley, Calif., 1945), argues that the encyclical had little effect, even on the nation's Catholic leaders, who announced, 'The encyclical is not binding upon us in political matters' (95).

elsewhere in Europe, were very conservative.) There were some young social Catholics, as well as an increasingly influential group of economic liberals, strict believers in the benefits of the free market. The Saint-Simonians included several future prime ministers, Charles Rogier, for example, and some who soon became social reformers, most famously Édouard Ducpétiaux. That *tendance* (for such it was in this era before political parties) also included the statistician Adolphe Quételet, who eventually founded Belgian social science. (The Belgian women's rights campaigner Zoë Gatti de Gamond, was part of the group as well, but her sex prohibited any political role.)[25]

Despite the radical potential of their youthful commitment to the ideas of Saint-Simon, however, this group proved far from radical once in power. Although they did not hesitate to condemn the deep inequalities and injustices of their society, they failed to use their power or influence to alleviate either. Instead, they devoted their energies to studying social problems. Government and private investigations proliferated—the first in 1840, followed by a detailed government study of women's and children's work undertaken in 1843. These official *enquêtes* in turn prompted two important private investigations: one in 1845 and another published in 1850.

But despite the vast quantity of facts and figures gathered to document Belgium's deep social problems, the government failed to act in any but the most restrained manner. Information about the hideous sanitary conditions in most workers' *quartiers*, for example, led the state to sponsor a public health initiative which created health committees in localities throughout the country. It also led to the foundation of a Royal Academy of Medicine, an organization which tried desperately, though mostly unsuccessfully, to play a major political role in the second half of the century, as we shall see. But these proved to be little more than gestures. On the whole, officials remained quiescent in the face of most social ills throughout most of the 1830s and 1840s.

Only the revolutions of 1848, which broke out all over Europe, finally stimulated government action. The fear that the revolutionary germ might spread to uninfected Belgium (especially across the permeable French border) drove the authorities not only to extend the franchise to most male

[25] See Bartier, J., *Naissance du socialisme en Belgique: Les saint-simoniens* (Brussels, n.d); Neuville, J., *La Condition ouvrière en Belgique, ii. L'Ouvrier suspect* (Brussels, 1980), 84 ff. Denise De Weerdt has described Gatti de Gamond's 'salon', which these leaders attended in *En de vrouwen? vrouw, vrouwenbeweging en feminisme, 1830–1960* (Ghent, 1980), 20. See also Polasky, 'Utopia and domesticity'.

property-owners (thus solidifying bourgeois control of the state), but also to increase public security. Dozens of new regulations governed all political activities, as we shall see below in Chapters 3 and 4, which include a closer examination of the events of 1848. In addition, officials decided to attempt to dampen workers' suspected revolutionary ardour by offering them the opportunity to 'own property'. To that end government-funded workers' savings banks were created. Money-minded bourgeois expected that such institutions would ensure social stability. Workers with property, officials reasoned, would be loath to risk its loss by participating in any rebellion. But the ruling class failed to notice an essential flaw in their logic: few workers earned sufficient money to pay for their needs, let alone to place in workers' banks. Not surprisingly, these savings institutions remained moribund.

A second change also aimed to control the lower classes during these years of revolution. Reform, grounded in the positivist tenets of Belgium's emergent social science, transformed the nation's penal system. Symbolic of the extent to which the country's reformers believed that 'function followed form', the new prisons were designed to order and regulate prisoners' lives by shaping the space which imprisoned them. When they emerged, they would be fit for the ordered and regulated lives demanded by the factory system.

The first new prison was built in Ghent. It had an octagonal shape, with a guardhouse in the centre. Each of the wings housed a separate 'class' of inmates; each group was thus spared possible contamination by another. Categories included three types of criminal, all beggars, and all women. Édouard Ducpétiaux, who was in charge of the nation's prisons, applauded this 'sanitary separation'. His language suggests the nature of 'crime' in mid-nineteenth-century Belgium. In such prisons, wrote Ducpétiaux, 'poverty' would no longer 'mingle with mendacity', or 'illness reside with the weak'. Moreover, 'the blind and the elderly' would no longer 'have their misery insulted by vagabonds'. Once separate, each group was more easily trained for future work. 'All those detained are occupied', he concluded. 'They are thus inspired with the habits and the love of work. . . . When they leave prison, they have been given the means to live honourably'.[26]

One of Ducpétiaux's colleagues proposed to regulate social life by

[26] Quoted in Neuville, *La Condition Ouvrière*, ii, 65. These developments, similar to those analysed in Michel Foucault's *Discipline and Punish: The Birth of the Prison*, trans. Sheridan, A. (New York, 1977), have been documented in the USA and Britain for this period but not, as yet, in Belgium.

enclosing previously ungoverned public spaces—again, ostensibly for the benefit of the poor. It was J.-B. Nothomb's conviction that Belgium's extensive common lands (including both woods and fields) were going to waste. Thus he proposed that such lands be enclosed—sold, or even given outright to the unemployed. In the face of many objections, including those of Ducpétiaux, Nothomb and his young colleagues[27] succeeded in abolishing thousands of hectares of common fields and forests. By the end of the 1840s, only about 163,000 hectares of common land remained in Belgium—and these mostly in the non-industrial areas of the Campine and the Ardennes. Workers who had once supplemented their incomes by grazing animals on the commons, or by gathering kindling in the forests, were thus stranded, and even more dependent upon the whims of the labour-market. (The process continued unabated: by 1860 a further 30,000 hectares had been enclosed.) Women, whose work had traditionally included pasturing animals and gathering wood, were hit particularly hard, and of course their legal inability to own land meant that they were not even eligible to receive any part of the enclosed areas, whatever their needs. (As elsewhere in Europe, almost no enclosed land ended up in the hands of the poor. Instead, speculators and wealthy land-owners used Nothomb's initiative to extend their holdings.)[28]

The 1840s, then, despite the desperate crisis that devastated Flanders and the revolutionary wave that engulfed the rest of Europe, were years devoid of significant social legislation in Belgium. Indeed, even the actions of Belgium's neighbours, who began in these same years to regulate industrial work (primarily with regard to the labour of children and women) prompted no imitation. Thus although England, Prussia, Bavaria, Austria, and France passed child-labour legislation during the 1840s, Belgium did nothing. Even the increased numbers of women and children mining coal provoked no action—not even after would-be reformers attempted to prompt a competitive spirit by pointing to Britain's legislative prohibition of women working below ground.[29]

Of course official Belgium was in no sense the totality of 'bourgeois Belgium'. The nation's élite included those outside government—those

[27] Many were very young. Paul Devaux, for example, was only 29 in 1830; J.-B. Nothomb was a mere 25. See Mabille, X., *Histoire politique de la Belgique: Facteurs et acteurs de changement* (Brussels, 1986), 103.

[28] See Neuville, *Condition ouvrière*, i, 148–51. Nothomb's efforts, of course, forced many working families to abandon their semi-rural way of life. No longer able to pasture a few animals or gather wood, the poor were forced to provide still more conscripts for the reserve labour army that served Belgium's industries.

[29] The information was officially noted. See MAE, 'Questions socials', D2311. I (1830–50).

who owned the means of production directly, the *patronat*. These men (there were still some women directors of major industrial firms in the 1840s, but no longer any owners) formed alliances with politicians from time to time, but more often remained aloof from national government, satisfied if that government did nothing to hinder their accumulation of wealth. Indifferent to politics, most were single-mindedly committed to the pursuit of profit. As their new king, Léopold I, put it in a letter to his friend Metternich, 'any reduction of income inflicts tortures on them'.[30] And their primary means of capital accumulation was industry. Sidney Pollard has noted that this Belgian ruling class had 'fewer agrarian interests than any other in Europe', and thus their 'pursuit of commercial and industrial progress was unobstructed'. What they expected (and obtained) from their rulers was 'support for capital'. Both they and the government kept 'all signs of labour emancipation down with remarkable single-mindedness, so that wages, already held down by rapid population increase and the Flemish disasters, were kept down in relation to productivity, well below those of the rest of Europe'.[31]

Their new king, imported from Saxe-Coburg in 1831, had quickly grasped the overwhelming materialism of his subjects. In the words of Émile Cammaerts, 'Léopold I soon realized the practical and businesslike character of his subjects and devoted his energy to furthering their international prosperity'.[32] At the same time, the king rejected many of the constitutional limits placed upon the monarchy. Instead, he extended and consolidated royal power, fashioning the Belgian monarchy into the form it retained until the Second World War. Léopold's was an interventionist rule, albeit one that followed Belgian custom by acting with careful, unprepossessing diplomacy, and always in favour of continued economic prosperity.

The king was successful because he understood 'his' Belgians' materialism and their deep distrust of radical change. Caution, indeed, was deeply

[30] Quoted in Émile Cammaerts, *The Keystone of Europe: History of the Belgian Dynasty, 1830–1939* (London, 1939), 77–8. Donald Cowie in *Belgium: The Land and the People* (London, 1977), remarked that the king suited his people perfectly. 'Léopold I', he wrote, 'had the mind of a tycoon in the body of a king' (243). Marguerite Yourcenar offers a description of an ancestor that suggests this characteristic Belgian materialism was very old: in *Dear Departed: A Memoir*, trans. Ascher, M. L. (New York, 1991), she writes, 'His grandson Adrien, another patriarch, had the more galling distinction of being among the 6 citizens of Charleroi ordered to pay, within two hours, a tribute of 10,000 francs each to the Jacobins who occupied the city in 1793, an obligation almost as agonizing as being guillotined' (101).

[31] Pollard, *Peaceful Conquest*, 93.

[32] Cammaerts, *Keystone of Europe*, 77–8.

embedded in Belgian culture, even at the popular level. Proverbs, learnt by every school child, included, 'Haast en spoed is zelden goed' ('Haste and Speed are seldom good') and 'men kan geen paard al loopen beslaan' ('No horse can be shod while running').[33] Léopold I learned to imitate his subjects—acting only when everyone within the ruling class agreed it was necessary. He had at his command two powers: the right to avoid signing legislation into law (in American terms, a 'pocket veto'), and the right to issue 'royal decrees'. Although the earliest government officials did not expect either power to effect any real change, Léopold I proved skilful at using them to his own ends, as we shall see.[34]

Through most of the period of experimentation, the Belgian political class failed to assume a clear ideological or party identity. Leaders identified with various groups, changing loyalties and alliances as the situation warranted. Only by 1850 were ideological lines clear. When the liberals took power in that year, they quickly instituted the policies in which they believed, and Belgium's age of pure economic liberalism began. These liberals held on to power, virtually without interruption, until 1884.

LAISSEZ-FAIRE BELGIUM: 1850–84

These 34 years comprised Belgium's 'age of high capitalism', to borrow Eric Hobsbawm's phrase.[35] The period was characterized by the most purely *laissez-faire* system anywhere in the industrializing world. At mid-century, Belgium offered an ideal type of classic capitalism as defined by Stanislaw Ossowski:

The classic period of capitalism was . . . the period when economic power was at its peak. It was a period in which economic dependence dominated other forms of human relations to a degree never previously encountered. Money seemed to be able to buy all kinds of real privileges; the exploitation of labour was effected almost exclusively by means of the privilege of possessing the means of production,

[33] Other such popular sayings included 'Time won, much won', 'Who chooses, loses', and 'Birds who sing too early get caught by the cat'. All in Tratsaert, J. (ed.), *National Proverbs: Belgium* (London, 1915). Translations are both mine and his.

[34] Léopold I's mastery of compromise has not been lost by later generations of Belgian monarchs. Recently, Baudouin prevented a possible constitutional crisis by abdicating for one day so that legislation legalizing abortion, which he opposed, could become law without his signature. Had he not abdicated, his refusal to sign would effectively have vetoed the measure.

[35] See Eric Hobsbawm's *The Age of Capital 1848–1875* (London, 1977).

and the state was coming to be regarded ... as an executive committee of the ruling class.[36]

Such was Belgium, at least from the liberal accession to power to the death of Léopold I in 1865. During the late 1860s, however, the political scene began gradually to shift, as workers' mass strikes prompted a new labour policy. The arrival of a new monarch on the Belgian stage also changed matters, as he struggled in his turn to create an even larger power-base within the constitutional system.

Particular events of these years which affected industry and industrial workers are detailed below. Suffice it to say here, however, that the period saw a continued growth and spread of industrialization: thousands more women and men, girls and boys, entered Belgium's factories and mines. Moreover, the tiny ruling echelon continued to strengthen its sense of well-being, directing a self-righteous indifference at the plight of the growing proletariat. Protected in luxurious cocoons, most even managed to ignore the loud and insistent voices raised in the late 1850s against women's employment underground in the mines. Most members of Belgium's bourgeoisie in this period mirrored the typical nineteenth-century bourgeois described by the Dutch historian, Johann Huizinga: 'Le bourgeois', he wrote, 'devient le responsable de toutes les misères sociales. C'est lui, par son odieux égoisme, qui perpetue dans le monde toute injustice et toute inégalité'.[37]

Towards the end of the 1850s, however, the calm surface was broken by the first mass strikes seen in Belgium. When thousands of the nation's workers walked off the job, government officials and influential industrialists suddenly sat up and took note of the situation they had so long and so blithely ignored. From these strikes, too, the first 'proto-union', the Broederlijke Wevers, was born in Ghent. Soon, this all-male group was joined by a female counterpart, the Zusters Genootschap der Weefsters. From these two modest beginnings grew what became the largest and most successful workers' organization in Belgium, though this development was postponed by the arrival in Ghent of the cotton crisis provoked by the American Civil War.

But this crisis-driven respite did not spread to other industrial areas. In 1861 Belgium's miners struck, protesting new work rules. Coming on the heels of the mass textile strikes, the mine actions prompted several official

[36] Ossowski, S., *Class Structure in the Social Consciousness*, trans. Patterson, S. (New York, 1963), 126–7.
[37] Quoted in Verstaelen, J., *Introduction à l'histoire du mouvement ouvrier*, trans. Fiévez, M. (Brussels, 1949), 95. See also Witte and Craeybeckx, *La Belgique politique*.

reactions. First, Charles Rogier introduced the first protective labour legislation into the Chambre. Although his bill failed to pass, it did provoke a major public debate about women workers' role in Belgian industry, focused on those working below ground in the mines. Second, the king issued two royal decrees, one instituting mine inspections, and a second establishing the practice of awarding medals for heroism in mine accidents. Neither had much immediate effect: inspectors were few and careless, and medals failed to lessen the appalling number of mine accidents. But these acts were a sign that some in Belgium's government had begun, at least, to recognize some responsibility for social unrest.

Léopold I died, and was succeeded by Léopold II in 1865. The new king encountered a rapidly changing Belgium. There were several indications of a shift in social concerns, both amongst the bourgeoisie and in the ranks of the working class. One indication that many influential Belgians had started to acknowledge the seriousness of the country's deep social inequalities was a series of conferences held by prominent Catholics in the 1860s. At these events, leaders debated various social issues. Some amongst them, those identified as 'social Catholics', proposed several social programmes. They were unsuccessful in convincing their more conservative fellows, however, and their social initiatives were ignored until much later.

A second sign appeared in Léopold II's 'speech from the throne'. In his first address to the nation, the new king described his concern for Belgium's working class and promised to ameliorate their miseries. This, too, signalled no immediate change, but it did suggest that the blinkers behind which both the monarchy and the government had protected themselves for so long were developing holes.

The years from 1865 to the middle of the 1870s witnessed much more activity, on both sides of the social divide. In 1865 Ghent's workers, building on their earlier organizations, founded Vooruit, the movement that gradually grew into the largest socialist 'parallel' society in Belgium. Their initiative was soon imitated, and all over industrial Belgium, similar groups, meeting in 'Workers' Houses', sprang up. Many of these small groups, moreover, quickly discovered the existence of an international workers' movement, and Belgium saw its first member groups of the Association Internationale des Travailleurs (the AIT, or First International). By the end of the decade, AIT members were active everywhere. The International's Belgian headquarters was Verviers, where the movement's newspaper, *Mirabeau*, was published. This Verviers organization (along with some others in Belgium) included a group of 'proto-feminists'—

women textile workers who created the first programme for working women's emancipation in Belgium.

Such activities finally drove the government to act. In 1866 the hated articles 415 and 416 were abolished, and replaced by a new law which allowed strikes and workers' groups. This law, article 310, looked at first as if it constituted an essential reform of Belgian labour practices, but workers soon discovered that their optimism was misplaced. Article 310 included several key restrictions on workers' freedoms, such as a prohibition of any 'interference with the free exercise of industry or work'. Those found guilty of such interference were liable to stiff punishments: eight days to three months in prison, and/or a fine of between 26 and 1,000 francs. The law further forbade any 'violences', injuries, or threats. Gathering near a place of employment in any way that might restrict the free movement of labour (e.g. the movement of 'scabs' into strike-bound factories or mines) was punished by the same penalties.[38]

Still, article 310 did allow both strikes and organizations, and workers leapt to take advantage of their new rights. In 1868 miners walked out all over the Black Country, starting a strike which lasted many months. Their action provoked harsh reaction from the government, which immediately sent mounted troops to control crowds of strikers. The resulting bloody clashes between troops and workers branded Belgium for years after —particularly after Friedrich Engels published his condemnation of the 'Belgian massacres'.

By 1871, when the Paris Commune struck still more fear into bourgeois hearts, workers all over Belgium were both organized and restless. Aware of this, the government increased surveillance of workers' groups and activities. Catholics evinced their concern about social stability by organizing the first Church-sponsored women's groups—aimed at bringing women of all classes together to learn their prescribed responsibilities as Catholic wives and mothers. These enjoyed almost no success amongst working women, even in Catholic Flanders. But they were the seeds of groups that later attracted thousands of working women to Catholic women's unions in the early years of the twentieth century.

In 1873 another economic crisis struck, and textiles were again hardest hit. Mill-workers reacted with dozens of strikes, many of which prompted harsh government repression. This, in turn, stimulated the birth of still more Maisons du Peuple, by now a common sight in every industrial town or city. The First International continued to flourish as well, despite its

[38] See Chlepner, *Cent ans*, 91; the new law remained in force until 1921.

precipitous decline virtually everywhere else in Europe. (The AIT never really died in Belgium; remnants of its underlying ideas, as well as its political practices, survived in Verviers and Antwerp, even after the socialist party had unified the workers' movement in 1885).[39]

UNDER THE CATHOLICS: 1884–1914

As Belgium's working class grew increasingly organized, the bourgeoisie found itself caught up in two of its own internal struggles: one over the secularization of the country's schools, and another over language. In the case of the former, Catholics grew so hostile to the liberals that they refused to participate in the massive public celebration of Belgium's half-century anniversary in 1880. Their solidarity paid off: in 1884, Catholics assumed control of the government—a control they retained until the war.

The language quarrel, between a Flemish-speaking minority within the Belgian ruling classes (even those members of the governing élite who were Flemish by ethnic origin often preferred to speak and write in French) and the French-speaking majority began to effect major changes in the *fin de siècle*. Dozens of artists, painters, and musicians began increasingly to identify themselves as 'Flemish' or 'Walloon', founding many ethnically identified groups, most with their own journals. The story of the linguistic battles of these years was a complicated one, however, and remains beyond the scope of this work. Suffice it to note here that full equality between speakers of Flemish and speakers of French did not occur until the 1960s. The language conflicts of the turn of the century served more to divert the attention of key members of Belgium's ruling bourgeoisie from the more immediate threat to social peace—the growing socialist movement—than to move toward inter-ethnic equality.[40]

Thus Belgium's governing class was taken by surprise when, in 1886, workers all over the country went on strike. (Indeed, what became a mass general strike caught most socialist leaders off guard as well, as we shall see below.) The details of what became known as 'l'année terrible' are recounted in later chapters. It is sufficient to note here that the event had two immediate consequences. Following the repression of the strike, the

[39] All these events are detailed below.

[40] Discussions are numerous. See the essays collected by Lijphart, *Conflict and coexistence*, as well as Murphy, A. B., *The Regional Dynamics of Language Differentiation in Belgium: A Study in Cultural-Political Geography* (Chicago, 1988). I learned most of what I know about the problem from Drs Murphy and Polasky during our year of research in Belgium.

Catholic-led government launched a massive public investigation of work-
ing conditions in industrial Belgium—an *enquête* published in four giant
volumes.[41] That public enquiry, replete with horrifying details of life in the
nation's working-class regions, proved the telling blow to those who had
so long argued against protective labour legislation. In 1889 the legislature
finally passed Belgium's first labour law, to take effect in 1892.

The new law, however, was extremely limited. Only children and
women working underground in coal-mines were affected: children were
prevented from working below ground below the age of 10 if they were
males, or at all, if females. Only women—and girls—already working
underground in 1892 had the right to continue such employment. More
than a few avoided the law by pretending to be men, but women gradually
disappeared from most pits over the years, until only about 30 were
legally working below ground in 1914.

From that point on, Belgium's rapidly disappearing women coal-miners
increasingly became the subjects of public approbation. Indeed, from the
1880s, representations of Belgium's *hiercheuses* (the generic title shared by
all those women who worked in the pits) multiplied. The image became so
common, in fact, that it was chosen to represent both cities (Charleroi and
Liège, for example), and the country as a whole, as we shall see below.
Ironically, the fewer the women actually working below ground, the
greater the cultural and artistic attention they received.

Two other events marked the 1890s: a partial suffrage was finally won
by Belgium's unpropertied males (in 1893), and social Catholicism received
a boost from the Pope, who published the encyclical *Rerum Novarum* in
1891. Written by Léo XIII, who had earlier served as Bishop of Brussels,
the encyclical instructed Catholics to take cognizance of the industrial
poor, and to ameliorate their earthly conditions as much as possible.
Belgium's Catholic reformers heard the Pope's warning, with ears already
filled with the criticism of influential foreign visitors. The result was the
organization of several Catholic trade unions, no longer disguised as
religious groups. These emerged first in the more religious areas of
Flemish-speaking Belgium, but soon included groups in key Walloon cities.
Although these more openly economic bodies initially had as little success
as earlier Catholic efforts (particularly, as we shall see, amongst working
women) they did provide an alternative for some workers who chose not
to join socialist or independent groups.

Not all bourgeois efforts to lessen the costs of industrialization were so

[41] *Enquête—1886*

positive, however. Worried about continuing strikes and walk-outs, as well as by the growing strength of the socialist movement, the government decided to create a Civil Guard in Belgium, whose duty was to control workers. From 1894 these 'blues', as they were quickly dubbed, earned a bloody reputation similar to that enjoyed by civil guards elsewhere in Europe.

In the early years of the twentieth century, the Catholic government faced a new opposition: an alliance of liberals and socialists. They pressed for further labour reforms, as well as for complete male suffrage. At the same time, officials found themselves faced with the problem of what to do about Léopold II's private African empire in the Congo. This undertaking, launched by the king in the 1880s, had long enriched Léopold, while at the same time earning the world's opprobrium because of the heinous labour practices imposed by Belgian colonial officials. For several years, Léopold's notorious exploitation of Africans had elicited strident criticism—especially from those he had initially gulled into supporting his African conquest by pretending concern over indigenous slavery. (The American writer, Mark Twain, added his voice to the near-universal criticism in a sharp satirical work called 'King Leopold's Soliloquy', published at the end of the nineteenth century.)[42] To their collective discomfiture, Belgian politicians found themselves faced with the necessity of assuming ownership—and thus responsibility—of the Congo, when their king defaulted on a government loan. Ultimately, they decided to accept the African colony, and it formed the basis of Belgium's empire until the wave of independence movements of the late 1950s and 1960s engulfed its inhabitants.

In 1909 Léopold II died. Almost from his first moments on the throne, his heir, Albert, supported—or at least did not hinder—social legislation of various kinds. Universal male suffrage appeared first, followed by scattered efforts to shorten working hours and ameliorate the most egregiously dangerous labour conditions. This reform period was short-lived, however. As war ravaged Belgium, German occupiers worked to widen social divisions (between classes, as well as between ethnic groups).

At the same time, the experience of occupation finally turned the nation's inhabitants into Belgians as the majority of the population (led by their king and queen) resisted the Germans with courage and fortitude.

[42] Mark Twain (Samuel Clemens), *King Leopold's Soliloquy* (New York, repr. 1971). See also Ascherson, N., *The King, Incorporated: Léopold the Second in the Age of Trusts* (London, 1963); Slade, R., *The Belgian Congo* (London, 1960); and Stengers, J., *La Place de Léopold II dans l'histoire de la colonisation* (Brussels, 1950), and his very important revisionist work, *Combien le Congo a-t-il coûté à la Belgique?* (Brussels, 1957).

When the war ended, national unity was sufficient to allow the post-war government to pass a variety of radical social reforms, which together eventually transformed the most socially backward nation in Europe into one of the most socially progressive countries in the world.

But that is another story. Our tale is the much bleaker one, of raw, unrestricted exploitation of one class by another—against the background of which Belgium's men and women workers began to organize their resistance.

Women, Work, and the Bourgeois Ruling Class

3

Women in the Textile Mills:
Ghent and Verviers

THE INDUSTRY

Long before the onset of the Industrial Revolution in the eighteenth century, Belgians were spinning and weaving cloth. In Flanders woollens drove the medieval markets and supported herds of sheep and their shepherds in the countryside. Not surprisingly, most Flemish town centres were marked by a cloth hall, where merchants and middle-men and -women traded in one of the region's major exports. From the busy ports of Bruges and Ghent, wool yarns and cloth travelled throughout Europe.

In the course of the eighteenth century, however, linen gradually replaced wool as a major Flemish export. Through the Lys River valley sprawled flat, broad fields of yellow flax, the raw material from which the famous golden linen of Flanders was spun and woven by skilled artisans. Many linen-producing families shaped their lives around the rhythms of flax production: in spring they planted, in summer they tended, in autumn they harvested. Through the long winters, they spun, wove, and finished linen cloth. With the finest linen threads, many women and men also crafted the intricate lace for which Flanders was equally famous.

When the French invaded Belgium at the end of the eighteenth century, they found a highly prosperous linen industry with ready markets for its products both in Flanders itself and in Spain and South America.[1] So dependent was the region on the production of linen that a popular proverb warned, 'Cut off the thumbs of the linen *spinsters* and Flanders will starve'.[2]

[1] A brief outline of the history of textiles in both Ghent and Verviers is also found in Dhondt, J. and Bruwier, M., 'The Low Countries, 1700–1914', in Cipolla, C. M. (ed.), *The Fontana Economic History of Europe* (London, 1973), 329–55.
[2] Quoted in Mokyr, J., *Industrialization in the Low Countries, 1795–1850* (New Haven, Conn., 1976), 247–8.

Still, it was not the famous linens of Flanders that eventually formed the basis of the industrial transformation of the region. Instead, the more readily mechanized cotton assumed that role shortly after Lieven Bauwens, carrying his smuggled machinery, arrived home from England. Linen's close identification with Flemish wealth meant, however, that many manufacturers, especially those in Ghent, shunned the new cotton trade, and continued seeking a means to mechanize linen production in order that it might begin to compete successfully with what was soon a booming cotton industry. But they were doomed to disappointment: technological difficulties proved insurmountable until the end of the 1830s, foreclosing any possibility of a race. When machine production of linens finally came to Ghent, at the end of the 1830s, it was too late to rescue linen's extensive artisanal workforce which for decades had been sinking into profound poverty. For many, even new jobs in the linen-mills provided no remedy. Because cotton was both more easily produced and far cheaper, flax-mill owners competed only by keeping wages extremely low and hours long. This they did by depending heavily on a low-paid female workforce. Their extraordinarily low wages and long hours—in a country notorious in Europe for its appalling working conditions—ultimately earned Ghent's women linen-mill operatives the dubious reputation as the most immiserated industrial workers in Belgium.[3]

In Belgium's other major textile centre, Verviers, wool production continued its reign uninterrupted from its beginnings in the fifteenth century through the process of industrial transformation. The workplace and working conditions, of course, altered dramatically. The small, artisanal workshops of traditional wool manufacture gave way to large factories and hand-work yielded to machines. Although some skilled hand-wool workers—carders, combers, spinners, and weavers—continued to work in small villages and towns around Verviers, most of that city's proletariat were minding machines in wool factories by the middle of the nineteenth century.[4] Because Verviers lacked alternative employment, almost all Verviétois earned their bread in one of the increasing number of mills built

[3] Machine-produced cotton fabric was not only softer—and thus more desirable for clothing—but it was also easier to dye. Moreover, it could be printed in colourful patterns—an undertaking already under way in Ghent before mechanized spinning and weaving. Lastly, cotton was easily laundered. When linen was finally mechanized at the end of the 1830s, its quality was rougher than that of handmade linen. Ghent's mechanized linen industry, therefore, tended to concentrate on producing large quantities of 'low-quality' linen cloth—commonly used for bags, rough-work clothing, and other non-luxury items.

[4] See Le Brun, P., Van Houtte, J. A., Niemeijer, J. F., Presser, J., Romein, J., and Van Werveke, H. (eds.), *Essai sur la révolution industrielle en Belgique, 1770–1847* (Brussels, 1981), 652.

along the Vesdre River which flowed through the city's centre. By the mid-1840s, some 15,000 citizens of Verviers worked in wool.[5]

TEXTILE WORKERS AND THE RULING CLASS

Given the importance of the industry to the young country's increasing prosperity, it was not surprising that government officials paid much attention to textile manufacture in the 1840s and 1850s. Of most concern to them—as well as to the textile *patronat*—was that production remain uninterrupted by labour unrest. Thus it was Belgium's textile workers who first felt the heavy hand of governmental control.[6]

Those who held power over Belgium's workers in mid-century did not constitute a homogeneous ruling class. The country's eligible electors, its ruling oligarchy, included members of many competing groups: the urban intelligentsia (so crucial to the success of the 1830 revolt), members of the liberal professions, aristocratic landholders, and major industrialists. Catholics vied with secularists in each of these groups. In addition, the élite contained influential Saint-Simonians, scattered Fourierists, and even a handful who flirted (albeit briefly) with the communal utopias of Étienne Cabet. Furthermore, some propounded a rigid economic liberalism grounded in a United States-style constitutional government. Amongst this group, too, lurked disagreement: between those who supported a constitutional monarchy and others who were convinced republicans. Catholics, in their turn, quarrelled over the monarchy, as well as over the role of the Church in the social affairs of Belgium.

Crossing all these contradictory categories were competing cultural identities. Usually designated simply as 'Flemish' or 'Walloon', it is more accurate to emphasize the strikingly local character of most nineteenth-century Belgians' social and cultural personae. In other words, although the people of Charleroi (known as 'Carolingians') inhabited Wallonia and spoke French (or, amongst the popular classes, *wallon*), they considered themselves quite distinct from their neighbours in Verviers or Liège—or even, indeed, in the nearby Borinage. Flemish-speakers in Ghent, in their turn, found only minimal common ground with inhabitants of Antwerp or Leuven—and, in fact, a distinct dialect of Flemish was spoken in each city.

[5] Cited in Kruithoff, J., 'De Grootte van het Belgische proletariaat tijdens de eerste helft van de negentiende eeuw', in Dhondt, J. (ed.), *Geschiedenis van de socialistische arbeidersbeweging in België* (Antwerp, 1960), 53.

[6] There are many descriptions of factory discipline in Belgium in the early 19th century. See e.g. Neuville, J., La Condition ouvrière au XIXe siècle, ii. L'ouvrier suspect (Brussels, 1980), ch. 3.

Despite such powerful local claims on Belgian cultural life, however, every member of the nation's ruling élite shared one essential bond: language. All educated Belgians, Walloon or Fleming, spoke French. Moreover, most inhabited a highly 'frenchified' culture. Because of the unchallenged hegemony of the French language, problems latent in the linguistic divide remained in the wings, out of public view throughout most of the nineteenth century.[7]

This francophone ruling class paid close attention to intellectual change in Paris, and when positivism began to attract French intellectuals, dozens of influential Belgians heard the siren-song of the new social science. Indeed, Belgium's intelligentsia so readily adopted positivist ideas and methods that it soon became the dominant mode of thought, rivalled only by a nearly moribund Cartesianism to which only a handful of influential Belgians continued to cling. The aspect of positivism that most attracted Belgians was its underlying premiss that social analysis should grow not out of speculative thought, but rather out of a Gradgrindish attention to carefully gathered—and preferably quantified—facts. Belgian positivists, led by Adolphe Quételet, soon transformed the theory into a scientific, statistics-gathering practice.

A method of amassing evidence before shaping social analyses carried more than simple intellectual appeal. For positivists in successive governments, it bought time in moments of social crisis. The appointing of commissions, the designing of their mandate and methods, required months—sometimes even years—during which problems usually lessened or even disappeared. The ubiquity of this government tactic in the face of every critical *conjoncture* during the course of the nineteenth century allowed Belgians to avoid imitating their industrial neighbours, most of whom were driven by social unrest to provide labour reforms. So successful were the Belgians at avoiding such government intervention, that the nation entered the twentieth century with virtually no legal restrictions on the exploitation of labour.

Capturing and taming social rebellion by undertaking extensive *enquêtes* also allowed the bourgeoisie to salve its public conscience. Words substituted for acts, while the time-consuming method provided a political practice that often successfully masked potentially divisive differences

[7] This is not to say that there was no movement toward Flemish equality, of course. There were many orangeists, who longed for unification (or, they would have said, 'reunification') with the Netherlands, as well as other Flemings content to be Belgians, but equal Belgians, with a right to their own language. A recent study of the problem is Murphy, A. B., *The Regional Dynamics of Language Differentiation in Belgium: A Study in Cultural-Political Geography* (Chicago, 1988).

amongst the ruling class itself. In other words, government officials wisely chose members of varying political, religious, and linguistic tendencies for each new investigating committee.[8]

The many enquiries which resulted from the Belgians' whole-hearted adoption of positivism in the 1840s and 50s provide essential materials for historians. Taken together, they not only offer extensive factual data about working and private life amongst the nation's poorer classes, but they also lay bare the skeleton of values and beliefs that upheld the striking 'opposition between wealth and misery' that to most foreign visitors distinguished Belgium from other European countries.[9] Moreover, they expose the developing and changing attitudes of Belgium's bourgeois ruling class toward the nation's workers.

THE ENQUÊTES

There were four key public and private investigations of Belgian society undertaken in the two decades. These included a government-sponsored enquiry into the state of workers' housing in 1840; the multi-volumed 1843 *Enquête sur la condition des classes ouvrières et sur le travail des enfants* (published in 1846); an 1845 publication, *Enquête sur le travail et la condition physique et morale des ouvriers employés dans les manufactures de coton à Gand*, sponsored by the Royal Academy of Medicine; and *Mémoire sur le paupérisme dans les Flandres*, an 1850 study undertaken by Belgium's leading social reformer, Édouard Ducpétiaux.[10]

These particular *enquêtes* recommend themselves to our attention for several reasons beyond those noted above. First, each contains within it a sub-text, in which the intellectual undercurrents shaping Belgian life in these years can be identified. Most flowed from neighbouring France and England, but some came from across the Atlantic. In this secondary

[8] This is one of the historical roots of the more recent Belgian claim that they are particularly suited to occupy the compromise-creating centre of the European Community.

[9] Richard Mather, writing in 1900, concluded 'Almost nowhere else is the opposition between wealth and misery as striking as in Belgium': quoted in *Art et société en Belgique, 1848– 1914*, Catalogue from the Éxposition: Palais des Beaux-Arts de Charleroi, 11 Oct.–23 Nov. 1980, 75.

[10] The first, missing for decades from the Bibliothèque Royale, is detailed in Kuborn, H., with Devaux, A., Dupont, E., Laho, U., and Vandervelde, G., *Aperçu historique sur l'hygiène publique en Belgique depuis 1830* (Brussels, 1897), 59 ff. *Enquête—1846* was published in Brussels in 1846; *Enquête—Gand* was published in Ghent in 1845; *Mémoire* in Ghent in 1850. Ducpétiaux's research was sponsored by another newly-created institution, the Académie royale des sciences, des lettres, et des beaux-arts de Belgique, of which he was a member.

discourse, the insecurity of many Belgian intellectuals towards indigenous ideas and practices was often reflected in an obsequious deference to foreign ideas about society and politics. Most importantly for our purposes, however, these *enquêtes* detail prevailing attitudes about women, both those who worked for wages and those who did not. Through these public investigations, what came to be known as 'the woman question' began to make its way into public debate. In these early decades, it was focused on the thousands of women and girls who laboured in the nation's textile mills.

In addition to government backing, many enquiries found support from newly established positivist institutions. In 1841 a Royal Decree founded a second body committed to social research, the Royal Academy of Medicine. (The first was a centre for statistical research, headed by Adolphe Quételet.)[11] Mandated to investigate the health and social welfare of Belgians, the Royal Academy embraced its task with keen self-interest. According to Carl Havelange:

Dans la foulée de la nouvelle théorie positiviste de la connaissance, l'élite scientifique, par la voie de l'Académie Royale de Médecine, pris une avant-garde professionnelle combative, par la voie de la presse et des associations médicales vont attribuer à la médecine un stature que jamais elle n'avait connu auparavant.[12]

The organized physicians claimed broad responsibilities, asserting boldly that it was their 'divine mission . . . to regenerate and reorganize society'.[13]

Such grandiose claims disguised a more practical purpose. As Havelange argues, these organized physicians understood that the more space they were able to occupy, the less remained for competitors. Thus they successfully marginalized most other health-care workers, including traditional midwives and some female clergy, who were relegated to serving the unprofitable poor.[14]

One last group of Belgians found that investigating commissions pro-

[11] This institute was staffed by graduates of the new Université Libre de Bruxelles, founded as an anti-clericalist reaction to the fact that Belgium's two main universities, at Mechelin and Leuven, were both Catholic. It also marked a shift away from the periphery to the centre. Intellectual life was soon concentrated in French-speaking Brussels.

[12] Evelyn Bernette Ackerman argues in *Health Care in the Parisian Countryside, 1800–1914* (New Brunswick, NJ, 1990), that French doctors began to play a similar role after their Royal Academy was founded in 1820. See Carl Havelange's stimulating 'Quelques aspects du discours médical pendant la seconde moitié du XIX^e siècle; L'exemple de la province de Liège', in *BTNG/RBHC*, 6 (1985), 175.

[13] Ibid. 178, 179, 181.

[14] Ibid. 194. The term 'female clergy' includes not only nuns, but also lay members of Belgium's many *begijnhofs* or *béguinages*.

vided a rare opportunity to participate in the nation's public life. These were Belgium's *bourgeoises*, who, 'trapped in mental corsets' (to paraphrase Denise De Weerdt) enjoyed few chances of escape from the narrow domestic sphere to which nineteenth century mores increasingly assigned them.[15]

These extensive investigations into the state of Belgium's poorer classes, then, provide much of the evidence for a portrait of textile-workers' private and working lives, and of the bourgeois attitudes towards them in these years when they occupied 'centre stage' as the nation's most numerous, and most rebellious, industrial labourers.

INVESTIGATION AND INACTION

The first government examination of urban workers' private lives was launched by two ex-Saint-Simonians, Charles Rogier and J.-B. Nothomb. Although no longer the revolutionaries they had once been, both government officials retained their youthful positivist faith. Thus when confronted by criticism of Belgium's squalid working-class slums, they set out to investigate the facts.

They published their results in 1843, in a document that painted a bleak picture of urban proletarian life. Behind the prosperous bourgeois façade of Belgium's industrial cities, the investigators had discovered shocking neglect. In unusually harsh words they concluded:

The lure of easy profits has driven many landlords into a shameless exploitation of people's lives and health. . . . They have, for example, converted some narrow and unproductive land in Ghent into labyrinths of tiny, miserable, obscure houses, where feet tread in a mud formed of putrefying detritus.

How profitable was such housing? In 'Triste Batavia', Ghent's most notorious workers' district, speculators enjoyed an impressive 17 to 18 per cent yearly profit on their investment![16]

This first official investigation led Rogier, then Interior Minister, to propose a public health law, establishing a bureaucracy charged with overseeing health conditions all over Belgium. He organized the office of public health by province, each supervised by a committee of local doctors. In 1849 these provincial groups joined together to form the *Conseil*

[15] De Weerdt, D., *En de Vrouwen? Vrouw, vrouwenbeweging en feminisme in Belgie, 1830–1960* (Ghent, 1980), 22, 199.

[16] See Kuborn *et al.*, *Aperçu historique*, 61, and *Enquête—Gand*, 124.

supérieur d'hygiène publique. Despite the potential of such a group, however, it soon became clear that it would do little more than follow the pattern already established by the government at large. The Council commissioned models of 'ideal' worker housing, wrote reports, gave speeches, collected facts. But actual changes were minute: by 1866 their efforts had produced only 2,768 workers' houses, most built by coal company owners prompted less by health concerns than by a severe (and temporary) labour shortage.[17]

Although neither the 1843 report nor the resulting health committees effected significant improvements in workers' lives, both did signal an important ideological shift amongst the country's ruling élites. Where once bourgeois officials had prescribed a return to a pre-industrial, rural idyll, where the poor learnt the virtues of village life, gardens, and family wage-earning, they now began to link proletarian improvement to the ownership of private property. The emphasis, in other words, shifted from a romantic belief in the beneficial effects of nature to a more properly capitalist faith in the virtues of property. 'The well-housed worker', wrote Nothomb, 'once proprietor of his house, master of his *foyer*, ceases to be an object; he becomes someone, he is freed, he is free'. Though neither Nothomb nor his colleagues realized it, this new discourse of property depended not only on the rhetoric of capitalism, but also on a new version of patriarchy, in which a male workers' 'freedom' was bought not only with the price of a house, but also at the cost of most women workers' autonomy. The newly proud, property-owning 'master' required a wife for his *foyer*. In Nothomb's discourse, male workers' transcendence of their objectification under capitalism—as unpropertied workers—depended both upon the ownership of property and the exercise of 'paternal authority'. Both property and patriarchy quickly became watchwords of bourgeois reform efforts.[18]

Such changes also heralded a shift in bourgeois attitudes towards women's social role. As reformers increasingly prescribed property as the remedy for male workers' moral ills, they similarly began to emphasize propriety amongst proletarian women.[19] This dichotomy was nowhere more apparent than in the language of two Ghent doctors, J. Mareska and J. Heyman, who published their investigation of local textile-workers in the mid-1840s. Although titled 'Inquiry into the work and the physical and moral conditions of *ouvriers* employed in the cotton manufactures of Ghent', their real

[17] See Kuborn, *et al.*, *Aperçu historique*.

[18] Ibid. 159.

[19] The property–propriety debate is discussed in Poovey, M., *The Proper Lady and the Woman Writer* (Chicago, 1984).

subjects were, instead, *ouvrières*. Working women's morals—reflected in their bodily attributes—were the doctors' chief concern.

The conclusion of the physicians' report, as we shall see, justified the liberal government's policy of non-intervention by claiming that in fact work in textile-mills—if consistently disciplined by watchful employers— was beneficial to working women's moral, and even physical, health.

But despite such assurances, life for the industrial working class continued to worsen, especially in Flanders, where the continuing linen crisis spread famine and disease through poor districts. So yet another commission was appointed to study the problem, this one by the government. The conclusions, published in three volumes in 1846, were more detailed than those in Mareska and Heyman's study, but no less anodyne. No action was demanded; none occurred.

In this 1846 report, the indifference of industrialists and business-people was immediately evident in the fact that few bothered even to return the investigating committee's elaborate questionnaires. Only 61 factory owners from East Flanders replied. Liège province's industrialists returned 168 questionnaires—better, but still only an unrepresentative fraction. And the fact that owners chose to return their forms to the commission did not necessarily mean that they felt any obligation to be thorough. Most, in fact, supplied only minimal information—unadorned numbers or laconic remarks. A typical questionnaire, from Ghent's Chamber of Commerce, noted that mill work was 'fort léger'. 'For kids', they opined, 'the factory is better than the street'.[20]

The nation's physicians, by contrast, proved enthusiastic respondents. Virtually every local and provincial board of health supplied abundant information, as well as judgements. Most admitted that problems existed: 'The scrofulous, rickets-ridden, and atrophied state of our factory children's bodies . . . is scarcely better, and not less deserving of criticism than that of factory children in France and England'. But who bore responsibility? It was working-class parents, whose 'misery, ignorance, misconduct, indifference, intemperance and depraved morals' ensured their children's suffering.[21]

One group, Ghent's medical society, levelled criticism at factory owners as well as at workers themselves. The former, they wrote, 'consider workers as instruments with which they serve themselves, without consideration'. They 'reject them without pity once they are used up'.[22]

[20] *Enquête—1846*, 40.
[21] Ibid. 344.
[22] Ibid. 307.

Worse, women were left to do the hardest and most dangerous work in the mills, and the outraged (male) doctors called for government action to reform women's working conditions.[23]

On the other hand, these physicians did not absolve these women from responsibility for their children's misery. Because factory work 'dissolves their morals', women operatives 'abandon children' who then crowded Ghent's streets, hungry and poor. Like Lieven Bauwens before them, the doctors concluded that such children should be gathered into the city's mills. 'From an early age', they wrote, 'they would be subjected to work, to order, to discipline. Every moment would be counted'. Once 'living by the clock, under constant supervision', the children would become like machines, 'in continuous and regular movement, with no distractions or excuses . . . Commanded, they would obey'.[24]

However novel such solutions, the practical results of this report were, once again, nil. Life for Belgium's working poor remained bleak; in fact, conditions worsened after 1846 as poor harvests and epidemic diseases ravaged Flanders.[25] In both Flemish provinces, hunger mowed a wide swathe. Between 1846 and 1848 nearly 15,000 Flemish people literally starved to death.[26] But despite hunger and despair, Belgian officials continued to do nothing but talk.

In 1848, however, revolution swept Europe, prompting fear of a potentially rebellious industrial working class. One official warned, 'to any sensible man, it must be profoundly clear that the situation of workers in our country is inseparably attached to the maintenance of order. . . . We do not want to offer the hope of better things and then say to the labouring classes "resign yourselves, you will not go much further"'. But what would ensure social peace? This writer prescribed 'a vast system of institutions devoted to raising the child of the people to the duties of social life'.[27]

[23] Ibid. 311.

[24] Ibid. 468.

[25] It is interesting to note that the horrors of the decade did have one long-term effect. The papal nuncio in Brussels, Mgr. Pecci, witnessed them first-hand, frequently discussing them with his friend, the king. Many years later, his experiences of Belgian industrialization helped shape his papal encyclical, *Rerum Novarum*, which, as Pope Léo XIII, he issued in 1891. It called upon Catholics to take responsibility for relieving some of the miseries of the industrial working class. Mgr. Pecci's sojourn in Belgium is discussed in Émile Cammaerts, *The Keystone of Europe: History of the Belgian Dynasty, 1830–1939* (London, 1939), 91.

[26] Such conditions stimulated the understated humour of the Flemings. One widely sung chorus went, 'Koeien-pataten en pellen van visch/Eten de boeren als 't kermis is!' ('With cow chips and fish-skins, the farmers are eating as if at a kermesse!') Quoted in Avanti (Oscar Roelandt), *Een Terugblik: 2. herziene en aangevulde uitgave, met bij voeging van de toestanden tot 1931* (Ghent, 1939), 107.

[27] Official quoted in *PdE*, no. 125; extract from *Le Moniteur Belge*, Mar. 1848.

The government, however, chose a different strategy to contain unrest amongst the working class. In April of 1848, it narrowed the requirements for entry into the *dépôts de mendicité*, that final refuge of the starving. Henceforth, people could not voluntarily admit themselves. Only those arrested for criminal offences were eligible. One historian has noted with irony that the immediate effect of this change was not a decrease in the numbers admitted to the *dépôts*, but rather an increase in arrests. Both individuals and sympathetic local police were conspiring to thwart the new law. When Brussels officials discovered this duplicity, however, they centralized the *dépôts*, thus transforming them from informal, community-controlled institutions into veritable prisons for the hungry—those convicted of the crimes of 'begging and vagabondage'.[28]

In addition to attempts to restrain any would-be proletarian revolutionaries, the 1848 government also expelled the political exiles who had long enjoyed refuge in Belgium. Karl Marx, who was to become the most famous of the group, was arrested and driven from the country shortly after he and his friend Friedrich Engels finished writing *The Communist Manifesto*. (Their workplace was a café—The Swan—in Brussels' Grand' Place.) Further, officials acted to defuse any revolt from those members of the bourgeoisie left out of the *pays politique* by the 1839 constitution by reducing the amount of taxes necessary to qualify as an elector. The government thus enfranchised 25,000 property-owning men, increasing the ruling oligarchy to 80,000.

Of course such minimal changes might not have sufficed to stifle revolt elsewhere in Europe. Given the extent and violence of revolutions nearly everywhere else, they do not entirely explain Belgium's anomalous calm. Historians have tackled this apparent conundrum, most adducing several interlinked explanatory factors. Amongst these are the fact that Belgium had already undergone its 'bourgeois revolution' in 1830. The results of that successful battle for independence from the Netherlands had included a constitution granting extensive civil—though not social—liberties to Belgium's population, liberties which elsewhere comprised essential revolutionary demands in 1848. Moreover, those who had led the revolt in 1830 (with the exception of women) were happily ensconced in a government of their own creation. Had they wanted further improvements in their political conditions, they had only to make them.

As for Belgium's poor—those who might have provided the street crowds that made Paris's revolution possible, for example—most fell into

[28] Jacquemyns, *Crise économique*, 319.

one of two groups, neither of which could easily have followed a
revolutionary leader, had one existed. On the one hand, the great mass of
Flemish people—whether urban or rural—were sunk in debilitating misery,
faced with starvation and struggling to survive. Those amongst them who
had jobs—however awful, however poorly paid—did not risk losing them
by staying away from work. On the other hand, workers and peasants all
over Wallonia—whether miners, farmers, steel-workers, or artisans—re-
mained isolated from the politics of Brussels. Revolutionary ideas, inchoate
at best, evoked little enthusiasm in Liège, Charleroi, or the Borinage in
1848—not least because Belgium's few would-be revolutionaries had not
as yet discovered any way to link their utopian goals to workers' more
practical desires for shorter hours and higher wages. Intellectual life, such
as that which stimulated Lewis Namier's German revolutionaries, was lived
far from the industrial centres of southern Belgium, by men already a part
of the nation's ruling élite. Moreover, the single issue around which people
of various classes united in Germany, nationalism, was highly problematic
in the Belgian context. In 1848 no one was certain what it meant to be a
Belgian—rather than a Walloon or a Fleming, a Borain or a Liégeois. At
the same time, no bourgeois wanted to rock the comfortable economic
boat by investigating the issue. Instead, most of Belgium's bourgeoisie
preferred to avoid any unseemly revolutionary scenes. As one government
official put it, 'Liberty *may* henceforth go 'round the world, but it need not
pass through Belgium'.[29]

A thoroughly satisfactory explanation of 1848 in Belgium is, needless to
say perhaps, more complicated than these various generalizations suggest.
Much of that year's history, as we shall see, is buried in the quotidian facts
of daily life in that country's urban centres in our period—not least the
constant ravages of disease and starvation. But intriguing as this vexed
historical problem remains, its satisfactory solution remains beyond the
immediate scope of this work.[30]

Having successfully negotiated the minefields of 1848, Belgium's ruling
class returned to its preoccupation with making money by ensuring the
continued quiescence of the nation's industrial labourers. Aware that
misery continued to stalk the textile districts and countryside of Flanders

[29] See Lewis Namier's classic study, *The Revolution of the Intellectuals* (New York, 1964).
The quotation comes from Marchal, L., *Histoire de la Wallonie* (Brussels, 1952), 271.

[30] A few *bourgeoises* were unhappy about their exclusion from political and civil life, but
there was no Belgian women's rights movement comparable to the vast movement of women
which was involved in the French revolts of 1848. See Polasky, J., 'From Stone-Throwers to
Hearth Tenders: Women in Revolutionary Belgium', *History Workshop Journal* (spring, 1986),
87–105.

unabated, the Académie Royale des Sciences, des Lettres, et des Beaux Arts followed the lead of the nation's organized physicians by commissioning their own study—of the increasingly visible, and thus worrying, phenom-enon of pauperism. They chose an Academy member, Édouard Ducpétiaux, to head the investigation, and published his results in 1850.

By the time he undertook this research, Édouard Ducpétiaux had abandoned the Saint-Simonianism of his 1830s' youth. Instead, this son of a prosperous Flemish lace merchant had returned to the faith of his Catholic boyhood—although with a decided social edge. At the same time, he had not forgotten the positivism he had learnt during his student years at the Université de Liège. His *Mémoire sur le paupérisme dans les Flandres* thus combines the compassion of a social Catholic, the 'social scientific' observa-tions of a positivist, and the stern moral judgements of the official church.

The *Mémoire* began by defining pauperism. In Ducpétiaux's words, it was 'a misery that is permanent, hereditary, chronic'. In the late 1840s, the condition afflicted 1 of every 5.89 inhabitants of East Flanders, and 1 in every 3.87 in West Flanders. All paupers depended, in whole or in part, on public charity. In these years, such public institutions offered only scant amounts of money, plus some clothing and an occasional sack of food or coal.[31]

Ducpétiaux was scornful of such meagre gestures. Officials, he wrote, claimed great devotion to the poor whilst doing nothing to alleviate their misery. He was particularly scathing about the deception practised by members of the Cabinet. He cited their collective declaration of principle:

Animated by a feeling of distributive justice for all interests and all classes of society, the Cabinet believes that the attention and the actions of government must concentrate particularly on the material and moral well-being of the needy and laborious classes. . . . There lies the honour of Flanders; there lies the honour of the country and of the government.

'What hypocrisy!' sniffed Ducpétiaux.[32]

At the same time, the author was unsympathetic to efforts by the poor to gain some advantage over those with wealth. 'Since 1846, particularly, bands of starving women and children have poured into the cities from the surrounding countryside, aiming to get arrested'. Once in the cities, they sank rapidly. 'At night', he noted with horror, 'little bands of girls and boys

[31] Ducpétiaux's *Mémoire*, 4, 17, 27. By comparison, Liège province counted 1 in 7.89 inhabitants as 'paupers'.
[32] Ibid. 10–11.

... take refuge in granges where the two sexes mix and mingle. We do not wish to recount the disgusting scenes which occur in these retreats. Suffice it to say that many girls in our prisons have brought infants into the world about whose fathers they are ignorant'.[33] Once successfully locked in a *dépôt de mendicité*, the situation grew direr still. There, 'misery changes a person's nature; she loses her initiative, the struggle ceases, the spring is unwound; this abasement shows itself by the signs that characterize pauperism'.[34]

Seeking solutions, Ducpétiaux drew on the ideas of Thomas Malthus. Following Malthus, he argued that in the 1840s, Belgium had reached the crisis when the working classes were producing more children than society could support. (Curiously, Ducpétiaux appears to have been ignorant of the steep drop in fertility, which plunged from a steady rate of 9.1 births per 1,000 people in Flanders in 1831 to only 4.3 per 1,000 in 1846. It did not begin to rise until 1866.)[35]

What was this Catholic reformer's remedy for overpopulation? 'Habits of prudence, the exclusive purview of the leisured classes, must be inculcated amongst the poor classes and working women' through education and 'a revival of religious feeling'. 'Values of duty and sacrifice', he continued, 'must be promoted, and gross and sensual appetites discouraged'. Then, 'the proletariat will be abolished with one stroke'.[36] A novel form of Malthusian Catholicism, to say the least! Practising Catholics amongst his readers might have noted that the church—Ducpétiaux's church—defined women's 'duty' rather differently—as the willingness to bear an unlimited number of children.

Still, Ducpétiaux remained convinced that too many poor children lay at the heart of Belgium's social problems. Until prudence could be instilled amongst profligate workers, he offered a temporary solution: inmates of reform schools should be taught some useful skill, then exported! His chosen destination was the United States, where ex-reform school boys could ply their trade of clog-making (amongst people who did not wear clogs), while their female counterparts practised their skill with the needle.[37]

[33] Ibid. 43, 46.

[34] Ibid. 4.

[35] Ibid.

[36] The similarity between this Belgian discourse and that common in the United States in that era is striking. Belgium, however, has since progressed into a more clearly social democratic approach, whilst political approaches to the existence of poverty in the USA remain frozen in the last century; see ibid. 220. Ducpétiaux doubtless used 'proletariat' as interchangeable with 'the poor'.

[37] Ibid. 253.

Whether or not the government instituted such an export policy, adult indigents should—above all, Ducpétiaux insisted—never be allowed to register as indigents. 'Once they do', he concluded, 'they never try to regain their independence'.[38]

His report showed Ducpétiaux to be a man of his bourgeois times, committed to self-help, to the virtues of struggle, to the exercise of self-control. Character, in his mind, was the essential ingredient in any recipe for change. He advised Belgium's paupers to imitate the seventeenth-century Dutch, who had found success in their struggle with a larger and richer Spain because of their willingness to fight. That this national will had been essential was demonstrated, moreover, by the sad decline of the Netherlands in the nineteenth century, when they had 'stagnated, . . . mired in tradition'. The 'crucial Darwinian struggle' had been neglected; Dutch 'greatness' paid the price.[39]

Although the liberal government that took power in 1850 included men committed both to social Darwinism and to Malthusian precepts, their greater loyalty was to the comfortable bourgeois status quo. Thus despite its intellectual appeal, Ducpétiaux's *Mémoire* joined other neglected enquiries, and commenced gathering the dust of indifference. The new liberal government reiterated their principled devotion to 'non-intervention', but of course it was humbug. The new liberal state proved just as willing as its predecessors to defend its own class interests, as we shall see. The parliament, 'a bourgeois body dominated by the narrowest class spirit', in the words of B.-S. Chlepner, proved especially untiring in its efforts to minimize workers' collective resistance.

Occasionally they admitted as much. One prominent liberal, Charles De Brouckère (in his youth, also a Saint-Simonian revolutionary) justified his colleagues' steady allegiance to class in an 1851 book, *Principes généraux d'économie politique*. He explained,

There are thus two great categories of industrial people: one is composed of entrepreneurs who direct production, the other of workers who execute it and immediately receive the price of their work, the wage. There is competition within the categories, and the most meritorious, the most economical amongst the second leave the ranks, and join the first, and once there, increase the competition. But there is no competition between workers and entrepreneurs. The status of the first is completely different . . . Education, intelligence, order, and perserverance are

[38] Ibid. 275.
[39] See ibid., and see also Gubin, E., 'L'Industrie linière à domicile dans les Flandres en 1840–1850: Problèmes de méthode', *BTNG/RBHC*, 14 (1983), 370.

necessary for directors, whilst usually only *adresse* or strength suffices for work-ers.[40]

From 1850 such men remained in almost uninterrupted control of the state. Of course their insistence on non-intervention in the social ills of the nation did not mean that problems did not multiply. Indeed, so grave were the working and living conditions of Belgium's proletariat that two very different groups, Catholic intellectuals and some workers themselves, were driven to seek remedies in the 1850s. The former (who included Édouard Ducpétiaux amongst their leaders) organized a series of congresses to discuss social issues, whilst the latter began—modestly—to organize, as we shall see below.

Only the *coup d'état* of Louis Napoléon brought the liberals out of their self-satisfied stupor. With the memory of the French invasion of 1795 still fresh, the liberals feared another Napoléon's intentions. Officials sought to ensure the loyalty of Belgium's poor by increasing public charity and even, in one case, by deploying the royal family. These, the government's heavy artillery, toured Ghent in 1856. Textile-workers were given a day off, and encouraged to greet the king and queen in 'traditional Flemish costume'. Factory owners provided armbands in the royal colours, and taught their hands the following greeting song:

> 'Onze Koning is in Gent
> Laet ons vrolijk zijn en zingen
> Laet ons dansen, laet ons springen
> . . .
> Vivat, vivat
> Vivat Leopold den eersten
> Viv, viv . . .[41]

Whether the city's thousands of textile workers obliged mill-owners by singing this song remains unknown. However, it soon became clear that the royal visit had not fulfilled officials' hopes. Instead, in the latter half of the 1850s, a number of strikes signalled a change in Ghent's industrial relations.[42] Charles Rogier, for one, noted the differences with concern. As

[40] Quoted and discussed in Chlepner, B.-S., *Cent ans d'histoire sociale en Belgique* (Brussels, 1979), 15–16. See also De Brouckère, C., *Principes généraux d'économie politique* (Brussels, 1851), 655.

[41] See Chlepner, *Cent ans*, 80, and Mission, A., *Le Mouvement syndicale: Son histoire en Belgique de 1800 à 1914* (Namur, 1921), 28–30. Official reactions are found in MAE, D. 2311-II.2: 'Questions sociales et ouvrières (1851–1870)'.

[42] Reported in the catalogue from the *Exposition—Gand: Une siècle d'histoire sociale*, 18 Feb.–19 Mar. 1931 (Brussels, 1939).

Prime Minister, he proposed the first protective labour legislation, a reform aimed at limiting women's and children's hours to 12. His 1863 proposal, like all those preceding it, came to nothing, however: legislators discussed and debated, but took no action.

Shortly thereafter, Léopold I attempted to lessen the social danger by decreeing that factory work inspection, hitherto virtually unknown, should begin, under his direct control from the palace. Again, however, the gesture proved empty. Although a few inspectors were appointed, they had no authority; real factory inspection, backed by health and safety laws prescribing sanctions, was still a long way in the future.

There was a brief hiatus in the long history of bourgeois indifference to workers' plight just after Léopold II ascended the throne in 1865. The new king startled the nation by acknowledging the miseries of Belgium's proletariat. In his speech from the throne, he declared, 'It is our duty to all to continue to occupy ourselves with everything that would favour the material and moral betterment of the working population.' He singled out several aspects of working-class life for attention, including poor housing, the absence of public education, and the deleterious effects of anti-coalition laws. Such an unusual *Discours du trône* seemed at first to herald a sea-change in the nation's class relations. But alas, Léopold II soon proved no less indifferent than his predecessor. The liberals continued in office: non-intervention remained the order of the day.[43]

Thus Belgium's thousands of textile-workers found no relief from their suffering despite repeated investigations of their harsh conditions. What were these conditions? We turn next to the 'view from below'; first, in a look at workers' experiences of private life in Ghent and Verviers, and then in a portrait of their daily labour in the mills.

LA VIE INTIME

Although reliable information about the private lives of Beligum's textile operatives in mid-century remains scant, it is possible to recover a little of the texture of everyday life for those who worked in the cotton-, linen-, and wool-mills. First, however, it should be remembered that although the focus throughout is on working women, the textile industry—like most other Belgian industries—did not separate male from female workers in

[43] Kuborn, *et al.*, *Aperçu historique*, 160 ff.

any definitive or predictable manner. There were a few 'gendered' jobs, noted above, but in every textile-mill, boys and girls, women and men, mingled freely throughout their working days. (Indeed, 'promiscuity' in the mills became a prime target of reformers' complaints.) Similarly, life beyond the factory gates showed few important gender distinctions. Given housing conditions, separating the sexes in private life—as increasingly prescribed by bourgeois mores—would have been impossible. All textile-workers, whatever their sex or age, lived in very close proximity.

At the same time, their sex did shape key aspects of working women's lives. First, they were the particular focus of bourgeois reformers' attentions, especially as society grew increasingly attached to a highly restrictive idea of 'women's proper place' in the course of the nineteenth century. Second, women's lives were constricted by near-constant pregnancy and childbirth, as well as by the fact that custom assigned them the primary responsibility for all domestic chores, including child-care. Like working women all over Europe, Belgium's *ouvrières* and *werksters* effectively worked two jobs, only one of them waged. This double burden, together with the health problems that commonly accompanied the combination of maternity and factory work, restricted their freedom in ways unfamiliar to their male counterparts.

Still, there was a bright side to working women's dual role. In Belgium, at least, women who worked for wages enjoyed a status unique in the industrializing world. Perhaps because women of the popular classes had always earned their living, and because they and everyone else had always expected them to do so, there were but few Belgian voices raised against the idea of women industrial workers. The cry heard all over bourgeois France in these years, that industry was 'tearing women from their homes' was heard in Belgium only when French travellers ventured across the border. As a result, Belgian working women were widely and openly admired—to the extent, indeed, that nationalists amongst the ruling élite commonly pointed to them as emblematic of Belgian pride.

Of course some of this admiration was little more than the familiar self-interested humbug: fine words hiding the fact that most industrialists depended on women to keep wages low and factories full. Moreover, officials were aware that factory labour provided an essential solution to the 'problem' posed by Belgium's large population of single women, most of whom belonged to the poorer classes. Belgium discovered its 'monstrous regiment' of lower-class single women even before Britain, where the problem of 'surplus'—i.e. unmarried—women was not uncovered until the 1851 census. As early as 1840, Belgium's assiduous researchers had found that between 15 and 20 per cent of all 50-year-old Belgian women had

never married![44] Legislating such women out of the industrial workforce, as was increasingly demanded by bourgeois reformers elsewhere, would have cast a very large number of women, many without other resources, into an extremely limited welfare system—and at the same time, punished labour-hungry industrialists.

Nevertheless, it will become clear that as the women textile-workers of Ghent and Verviers struggled with their difficult existences, they did so against a backdrop of at least partial public approval. When they came to organize their own political movements, in the 1860s in Verviers, in the 1880s and 1890s in Ghent, this sense of public approbation would prove significant.

GHENT

Ghent's textile proletariat lived a precarious existence throughout our period. Peter Scholliers has argued, in fact, that they never enjoyed more than the most basic necessities of life at any point in the years from 1830 to the war. Rapid population growth (the city grew by 106 per cent between 1784 and 1846, to a population of 103,000) intensified the dire effects of low wages and overlong working hours. Workers' districts in the old city, already densely-packed in 1830, grew still more crowded with each passing year.[45]

In most lower-class quarters, three kinds of housing were available. For the poorest, there were dank cellars, open to the street by a single 'hatch' set into the pavement above. One step up the social scale meant a single room, often inhabited by a large family. A few enjoyed the luxury of a two-room dwelling, one room usually used for sleeping, the other for all other domestic activities. At the top of this precarious social ladder were those few working families able to rent a tiny house. Such houses usually boasted only two rooms, but one was upstairs, offering a modicum of privacy. Most such houses were crushed together inside Ghent's notorious *enclos*, small courtyards, hidden from public view by surrounding taller buildings. These usually blocked any sunlight, even when it managed to break through the grey cloudy sky of Flanders. Because these *enclos* were

[44] The phrase 'monstrous regiment of women' was coined by John Knox in the 16th century. It was used by British census-takers when they discovered Britain's 'oversupply' of single women in 1851. It was used later to denigrate mass suffrage demonstrations. These Belgian figures are found in De Weerdt, *En de Vrouwen?*, 22.

[45] Scholliers's argument is persuasive: see 'Verhuivingen in het arbeidersconsumptie patroon, 1890–1930', in *BTNG/RBHC*, 13 (1982), 273–312.

unseen by most passers-by (noticed only after the crisis of the aptly named 'hungry forties' drove researchers to seek them out), visitors were typically horrified. In 1846, one described these *enclos* as 'a second city within the city; on the one hand, air, space, and the provisions of health; on the other, everything that poisons and shortens life, the crowding of houses and of families, the darkness, contagion, damp'.[46] Ghent's 'second city' was far from small. Of the city's total of 14,372 houses, 3,506 were built inside these secret courtyards. Between a quarter and a third of the city's total population lived jumbled together in these tiny buildings. A further 226 families (each with an average of 5 members) inhabited Ghent's dark, cold, perennially damp cellars.[47]

Breeding sickness and misery, these *enclos* shocked and mystified bourgeois visitors. Mareska and Heyman, familiar with their city's workers' districts, warned outsiders not to venture thither without a guide. 'Although native to Ghent', they wrote, 'we were obliged to have the help of M. Hensmans, doctor to the poor of the Saint-Pierre *quartier*, even to discover the numerous *enclos* which shut off that part of the city'. Another contemporary described *enclos* dwellings as 'narrow, damp, cold, confining'. Repelled, he added, 'there are no drains, and waste water mixes with the earth of the street to form a nauseating mud'.[48]

If these conditions were not sufficient to discourage bourgeois visits, there were the communal toilets—holes dug in the muddy ground, usually at one end of the courtyard and sometimes hidden behind a rough wooden fence. Some, but not all, sported primitive roofs for protection from the ubiquitous Flemish rain. Nothing disguised the stench, of course, not even the diligence of the female occupants of the *enclos*, who bore the reponsibility for the cleanliness of their courtyards. (And, most observers agreed, they achieved a remarkably high standard despite the daunting conditions—in keeping with Flemish tradition.)

Each tiny room housed many people. In some of the worst cases, avaricious landlords produced minuscule dwellings by sub-dividing existing small rooms and renting each to a separate family. When these new spaces were created out of low-ceilinged sleeping lofts, the new adult inhabitants found themselves unable to stand upright in their homes.

In the most notorious of Ghent's workers' districts, known as 'Batavia', each of 585 residents inhabited an average of 3.4 metres of space. In that area, they ate, slept, and even bathed. The most fortunate owned straw

[46] Quoted in *Enquête—1846*, 386.
[47] Ibid. 387; see also *Mémoire*, 54.
[48] Quoted in *Art et société*, 28, and *Enquête—1846*, 386.

pallets, which they spread on the floor for sleeping. But many had not even that luxury, and slept curled up on the bare floor. For such habitations, workers paid a large percentage of their incomes. In this era, when three-quarters of all the wages paid in Belgium ranged between 50 centimes and 2 francs a day, Ghent's workers were renting their *enclos* dwellings for between 1.09 and 1.63 francs a week. They paid these rents every Sunday morning (Saturday was payday in the mills), to police agents, hired by fearful—perhaps conscience-struck—landlords.[49]

Such housing incubated disease. One visitor characterized Ghent's *enclos* as 'agglomerations of kennels ... stigmatized by the name "fever nests"'. A second added, 'the risk of death in workers' dwellings is far greater than it was on the field of Waterloo'.[50] Both adults and children died prematurely. When parents died, orphaned children either resorted to life on the streets—which soon earned them a place in the city's workhouses—or found refuge with sympathetic neighbours. Fortunately, Ghent's working class demonstrated the traditional stereotype about the generosity of the poor; several visitors remarked the high number of working class families who counted 'abandoned children' amongst their own.[51]

For Ghent's poor, life expectancy was short. Mareska and Heyman reported that a Ghent male aged 7—of any social class—could expect to live to 47.52 years, whilst his female counterpart could look forward to 2 additional years.[52] For workers, needless to say, the figure was adjusted downwards. As everyone agreed, those working in textile-mills suffered particularly poor health, due to exceptionally long working hours and terrible working conditions. The worst aspect of daily life in most mills was the combination of extreme heat and high humidity, which soaked workers soon after their arrival at their machines. Ghent's damp, northern climate meant that workers journeyed home after a 12- to 16-hour day, exhausted, wet, and shivering. Few owned coats. Most men made do with 'overshirts', donned at the end of the shift over their wet clothes. Women wrapped their shoulders in 'their sole luxury', woollen shawls. These shawls, which at 25–30 francs each cost more than most women's monthly wage, offered, noted one writer, 'the sole means they had to protect

[49] *Enquête—1846*, 387–8.

[50] Ibid. 389, and D. Lebon, of Nivelles, quoted in *Art et société*, 28.

[51] See *Enquête—1846*, 367, and remarks by Walter Thibaut, *Les Républicains belge, 1787–1914* (Brussels, 1961), 74.

[52] *Enquête—Gand*, 137. The figures for Belgium as a whole were—at age 5–47.1 years for females and 46.5 years for males. In France, life expectancy for 5-year-olds of both sexes was 51.5. See Pereira-Roque, J., *La Démographie de la Belgique au XIX* siècle* (Brussels, 1974), 24.

themselves against the rain, the sudden change in temperature, and other vicissitudes'.[53]

Money was always short in textile families. A typical weekly budget for a linen-producing family in the 1840s, painstakingly constructed by Georges Jacquemyns, suggests the extent of the poverty. This representative family included eight members, four of them wage-earners. Together, they brought in 12.90 francs a week. Their diet, mostly of rye bread, potatoes, lard, some milk, butter, and coffee (laced with the traditional chicory) cost 8.40 francs, while their rent was a further 1.60 francs. For all other necessities, including laundry soap, heat, cooking fuel, light, and clothing, the family spent 3.20 francs. This total of 13.20 francs left a 30 centime deficit. Because they never had any surplus, this family owned neither beds nor other 'luxuries'.[54]

When Édouard Ducpétiaux made his way into Ghent's *enclos* in the late 1840s, he discovered extensive, hopeless poverty. In one case, he visited three adults, a sister and two brothers, who shared two rooms. All three worked in the domestic out-putting system, turning raw flax into linen cloth. One room, reserved for the brothers, held a loom and one bed. The other, where the sister slept, contained a kitchen and a spinning wheel. The three worked long hours every day, usually from 5:30 a.m. to 10 at night. (Such hours were typical of 'proto-industrial' textile work.)

Ducpétiaux also visited a more typical working-class family of eight. The father worked in a nearby textile-mill, while the mother and her two oldest children passed long days hand-spinning at home. All eight shared a single room, furnished with two spinning wheels and 'one narrow bed'. 'I was afraid to ask where the six children slept', Ducpétiaux confessed.[55]

'Many of these Flemish folks imitate the Imperial Guard: they die, but they don't complain', wrote one local official. And in the 1840s, they died in their thousands. Mareska and Heyman diagnosed a special disease suffered by Ghent's working poor, the 'maladie des Flandres'. It was characterized by the slow wasting away of the victim's body, which, according to another physician, 'absorbed itself, slowly'. In reality, of course, there was nothing mysterious about this illness: Ghent's workers were simply starving. In the single month of December 1846, for example, '165 individuals arrived at Ghent's hospital, of whom most were in a

[53] *Enquête—Gand*, 117.

[54] Jacquemyns, *Crise économique*, 210–11.

[55] *Mémoire*, 81.

desperate state because of hunger; 20 could not even stand the nourishment offered them, and died of inanition'.[56]

As though the fates were not content with starving the poor, typhoid swept through Ghent in 1847: in that winter 338 inhabitants fell ill with the disease and 94 died. In the area just beyond Ghent's city walls, the toll was much higher: in 35 communes 7,820 caught typhoid and 1,578 died. (In Belgium as a whole, between 1846 and 1848, 11,900 people died of the disease.) A few months later, that other scourge of urban poverty, cholera, ravaged the city's poor quarters. In 1849 that disease killed 4,438 people in the province of East Flanders alone. (In Belgium, in a 12-month period between 1848 and 1849, cholera claimed a total of 22,441 lives.)[57]

Because such epidemic diseases might spread from workers' *quartiers* to more affluent districts, their progress was carefully monitored by local officials. But the far more common deaths from general ill-health, hunger, and poor sanitation received considerably less attention. Indeed, on the rare occasions that authorities undertook to investigate conditions in the city's *enclos* and cellars, their methods were random and casual. One team of investigators approached their task simply: they assembled 1,000 male textile-workers and 1,000 female textile-workers and questioned them about their health. The results revealed more about the differences in men's and women's attitudes towards their physical well-being than about the objective state of textile-workers' health. Of the 1,000 men, for example, 782 testified that they enjoyed 'perfect health'. The rest complained of a variety of symptoms, including respiratory problems, 'gastralgia, scrofulous, migraine, headaches, and parasites'. Each sufferer cheerfully detailed his problems, many at length.

The women, by comparison, were laconic: 893 said only that they enjoyed 'good health'. Of the remainder, 107 admitted to 'mediocre' health, but declined to provide details. Only after the researchers pressed them did they confess to 'lung problems' (41 claimed them), headaches (17), 'conjunctivitis' (10), 'chronic pneumonia' (9), consumption phythisis (8), dyspepsia (8), and unspecified consequences of child-birth (7). All of the interviewed workers, male and female, admitted to having experienced at least one 'serious illness' during their lives, though the men claimed to have suffered twice as many as the women.[58]

[56] Remarks are quoted in *Art et société*, 29, and Jacquemyns, *Crise économique*, 331, 340, 342, resp.

[57] Figures in Jacquemyns, *Crise économique*, 346–9 (typhoid), and 351 (cholera). The devastation of such epidemics is part of the explanation for the absence of urban revolt in Belgium in 1848.

[58] *Enquête—1846*, 427.

In addition to the visible signs of disease, many of the 2,000 textile mill-hands also bore the marks of work accidents. Ghent's textile-mills were extremely dangerous, and so it was not surprising that 210 of the men and 194 women testified that they had survived at least one serious accident: 69 men and 57 women showed 'traces of the injury', while 19 men and 24 women retained 'permanent deformities'. Though the report did not specify the nature of such 'deformities', common textile injuries included fingers, hands, and forearms crushed in heavy spinning gears.

The differences between men's and women's answers surprised the investigators. In spite of the 'popular belief' that 'women are the weaker sex', their research suggested the opposite: 'women endure mill work just as well or better than most men'. They went even further in a footnote: 'This fact is confirmed by an observation one of us made at the local house of detention. Women resist the influence of imprisonment better than men'.[59]

Intrigued, Mareska and Heyman continued their research, eventually concluding that textile-mills actually ensured women workers' good health: 'Factory life, which exercises so powerful a depressive action on the man, is far from acting with the same force on woman's organization'. They asked, 'How can it be that woman, so mobile, so strongly impressionable, shows less susceptibility than man?' The answer lay in nature, which had assigned 'woman' a different 'moral destiny'. That destiny, to reproduce, had caused important physical 'modifications in her organization', changes that allowed her to withstand factory labour.

By contrast, man was destined for production. 'Wise nature' had thus given him both 'physical strength' and the need to use it. Unlike his female co-workers, he 'naturally preferred hard, and preferably dangerous work . . . His courage', they concluded, 'challenges the perils', whilst woman was content with 'sedentary occupations, domestic life'—a world mirrored by 'the cloistered life of the factory . . . with its monotony and tranquillity . . . far distant from the tumultuous life outside'.[60] The physicians were confident: 'We can thus regard it as a demonstrated fact', they noted smugly, 'that despite widespread opinion about the delicacy of her organization and her inaptitude for work, woman supports the influence of the manufacturing regime better than man'.[61]

In addition to these putative physiological differences, the physicians discovered that their female informants were far less likely than men to

[59] Ibid. 437, and n. 1.
[60] *Enquête—Gand*, 170–2, 175.
[61] *Enquête—1846*, 40.

have experienced even rudimentary schooling. In the few years before they entered the mills, girls were almost always condemned to share their mothers' domestic burdens whilst their brothers often managed at least a few years of primary school. This bleak fact of proletarian life helps explain the educational disparity (admittedly slight) discovered by investigators amongst their 2,000 informants. Of the men, 790 had had no education. 'A little reading and writing' were claimed by 101 men, and full literacy, plus the ability to figure, by a further 48. 61 others confessed that they had once known how to read and write, but had forgotten. Of the women, only 88 said they could read and write 'a little'; 12 said they had forgotten what they had once learnt; but a full 900 told the interviewers that they had never been to school at all. The doctors were shocked: 'Never has the ignorance of workers appeared as immense and as hideous as it does today!' they exclaimed.[62]

Education improved slightly as time went on. From this nadir, literacy (measured by the ability to read 'a little') increased—to 36.9 per cent of Ghent's male textile-workers and 40 per cent of female workers by the 1860s. Of those totally illiterate in the later period, however, females continued to predominate: 8 per cent of males in the mid-1860s were completely unable to read or write, whilst a full 16 per cent of females confessed to the same state.

According to Denise De Weerdt, who has investigated the later period, the explanation for the improvement lay in the spread of primary schools. The most successful were built inside textile-mills, where children could attend during work breaks. In addition to schools, a few lending libraries sprang up where older workers could continue their reading. Some mills, especially those with their own primary schools, included libraries on their premises. And by the late 1860s, workers' own organizations—the 'proto-unions' mentioned above—also began to lend books to members.[63]

Even without formal education, Ghent's textile-workers created an elaborate cultural and social life in the first half of the nineteenth century. Indeed, their exuberant *joie de vivre* was much remarked by outsiders.[64] Their favourite entertainment was indubitably marionette shows, the 'policinelles', where Punch and Judy played the traditional war between the sexes on tiny stages set up on every street corner and in most café-bars. On

[62] The emphasis is in the text, found ibid. 452.

[63] De Weerdt, D., *De Gentse textielbewerkers en arbeidersbeweging tussen 1866 en 1881* (Leuven, 1959), 135.

[64] According to Pierre MacOrlan, *Le Bal du Pont du Nord: La nuit de Zeebrugge* (Paris, 1950), 33.

Saturday or Sunday evenings, shows were crowded by men, young children, and—when they found free time—women.

Small, spontaneous street fairs, known as *kermesses*, broke out constantly in Ghent's workers' *quartiers*, to the consternation of factory owners, whose hands were wont to abandon work at the first sounds of merriment.[65] A few *kermesses* were more formal affairs; the most elaborate, indeed, were full-blown religious *fêtes*, sanctioned by owners, who provided a day off. In Ghent, the two most important *fêtes* marked the second day of Pentecost and the Feast of the Assumption. Such holidays, together with an annual three-day work break, constituted workers' only formal relief from the mills. But to some local bourgeois, even these five days seemed unnecessarily profligate. One official complained that these five days, plus the many unofficial days of *kermesses*, added up to a life of unwonted luxury. Ghent's textile-workers, he wrote, 'enjoyed the equivalent of 74 full days of recreation every year'![66]

To strengthen their criticism of workers' excessive leisure, many pointed to textile-hands' notoriously heavy consumption of alcohol. It was true that all over Flanders working people ended each day drinking in hundreds of modest café-bars—known as *estaminets*—which dotted the landscape. Such tiny cabarets provided workers' main form of sociability. In their 'locals' they found not only drink, but also warmth, friendship, talk, entertainment, and even romance. Certainly they found alcohol, too. Virtually every textile-worker drank, often in the mistaken but widespread belief that alcohol (especially gin) helped 'chase the textile dust from their lungs'. To the consternation of bourgeois critics, entire families found refuge in *estaminets*. 'Woman is also, to a great extent, caught up in these vices', wrote a shocked visitor.[67] His horror at the sight of women drinking reflected a very traditional double standard. As Denise De Weerdt has noted, with some acerbity, women did equal work in the mills, plus an unequal amount of work at home. Why should they not enjoy the same modest pleasures available to men? 'And alcohol, especially genever, was cheap'.[68]

[65] The word comes from two Flemish words: *kerk*, church and *messe*, mass.

[66] *Enquête—1846*, 369.

[67] Quoted in De Weerdt, *Gentse textielbewerkers*, 135. The word *estaminet* is said to have originated during the Spanish re-conquest of the southern Netherlands, when Spanish soldiers wanted to pause for a drink at roadside cafés. What the Flemish people heard them say to one another became *estaminet*. Charles De Coster notes this origin in *The Legend of the Glorious Adventures of Tyl Ulenspiegel in the Land of Flanders and Elsewhere*, trans. Whitworth, G. (London, 1918), 9. On the other hand, French dictionaries cite an origin in the Wallon word, *stamine* meaning 'wooden posts'—as in café-bars with timbered walls and ceilings.

[68] See De Weerdt, *Gentse textielbewerkers*, 136.

Such common sense rarely intruded upon the unequal judgements rigorously applied to Belgium's women in the nineteenth century, however. Working women bore the brunt of moral criticism. Reformers measured their immorality by counting illegitimate births. In the early 1840s, Ghent's medical society claimed that 1 of every 4.91 live births in the city, as well as 1 of every 91.70 still-births, were illegitimate. This rate, they sighed, was 'three times' that of Belgium as a whole. 'It is generally recognized that the big cities are more immoral than the countryside, so this fact is not particularly surprising'.[69]

Assuming that the medical society's count was accurate, it would appear that illegitimacy fell during the course of the next 15 years. Denise De Weerdt has calculated that in 1866 there were 3,684 legitimate births in Ghent, plus eight 'acknowledged births' (i.e. the father was known). In that same year, there were 500 'unacknowledged births', and two 'found' infants. Thus by the 1860s, the illegitimacy rate stood at about 1 in 8 live births.[70]

Many single mothers, obviously, worked in Ghent's textile-mills. According to Mareska and Heyman, the cause of this phenomenon was that machine-tending weakened the morals of many 'filles de fabrique', whom they spotted lingering in the café-bars all over the city 'in full public view'. Still, true to form, they were unwilling to condemn textile factory work outright. After all, they added, it could have been worse. 'Their sensuality is not as bad as that of prostitutes.' Indeed, 'it isn't even the debauchery common to female servants, dressmakers, or many others working in small industries'. In fact, 'a typical textile-worker tends to know the man to whom she gives herself; he belongs to her class, and she views this father of her children as her future husband'.[71]

At the same time, the doctors were leery of those women able to earn an independent living in the mills. Articulating an opinion that became increasingly widespread in the patriarchal late nineteenth century, they argued that women's waged work gave them an autonomy that led them to reject their proper role. In the mills, working side by side with men, they learnt 'unwomanly independence'. On their days off, they 'mixed with men' in cabarets, 'paying for their own drinks'. Worse, their wages allowed them to 'reject paternal authority'. Complete social collapse threatened.[72]

[69] *Enquête—1846*, 463.
[70] De Weerdt, *Gentse Textielbewerkers*, 136.
[71] *Enquête—1846*, 470.
[72] Ibid.

Ghent's Mills

Clustered near the city centre, Ghent's red-brick textile factories were visible to every inhabitant or passer-by. Not surprisingly, they achieved a certain notoriety in the course of the century. Camille Lemonnier, for example, was driven into a frenzy of mixed metaphor and purple prose by the sight of the city's sprawling factories: 'The Ghent mill is a quasi-human organism, its stomach the furnaces gorged with coal, its lungs, tall chimneys, breathing and exhaling air, its muscular system the drive-belts, transmitting rotation and life to every part . . . For arterial blood, steam, projecting the sense of turbulent power everywhere'. The organism was 'a minotaur', devouring both people and material. Inside the belly of this beast,

—in a suffocating and fatal dust—the residue of the worked materials—the enormous vaults spread out as in a cathedral's nave, set upon their cast iron columns amidst a tangle of pulleys, bars, trapezes . . . a complicated machine, whose every movement is a striking bludgeon, a crushing hammer, a lashing claw, its limbs attached to the great trunk of the monster, which snorts and groans in this underworld Church.

'Here, too,' he concluded, 'a whole dark, glistening population is enslaved, sweating its marrow for the blind god of money—a god who would have for paradise some Hades, whose spirit, expressed in thunder and lightning, would be manifested in a hurricane of perpetual anger'.[73]

Lemonnier's 'slaves' were numbered in their thousands. In 1858, for example, the largest cotton-mill employed a total workforce of 11,000 men, women, and children.[74] Linen mills were less crowded, but most observers found them even more hellish than Lemonnier's cotton factories. The socialist leader Édouard Anseele, in fact, employed similarly over-wrought prose in his description of Ghent's linen industry:

Think of a city enveloped in a thick and stinking fog. Such a fog reigns in the spinning workrooms; the hanks of flax must be boiled before they can be spun; the water in which they boil is heated with steam, which is sometimes so thick that the *fileuses* can see only 2 or 3 metres away. Water, or rather a liquid mud, falls from the ceiling, drop by drop, on to the bare necks of the spinners; the machines throw more filth on them; the ground is muddy, and the girls [sic] are often barefoot in that mud. Their work makes them so dirty that not even their mothers can recognize them.

[73] Lemonnier, C., *La Belgique* (Paris, 1888), 268–9. I am grateful to Timothy J. Reiss for help with the translation of this convoluted prose.

[74] Kuborn, *et al.*, *Aperçu historique*, 157.

But filth was not the worst of it. 'The painful work ... has disastrous consequences ... The *fileuses*, especially, are prone to convulsions. ... It is a fact widely known in Ghent that amongst the infants born to those who work in the spinning mills, there are a great number of still-births. It is in Ghent that Belgium's infant mortality is highest'.[75] The lives of Ghent's textile workers, then, clearly met the Hobbesian criteria. But what of women's lives in Belgium's other textile centre, Verviers?

VERVIERS

'The things I have noted about the lower classes of Liège', wrote a visitor at mid-century, 'can be applied [to Verviers] up to a certain point, but with this difference: cleanliness is much sought after, and these classes are much more hard-working'.[76] This judgement of Verviers's working people was widespread. They shared much in common with the steoreotype of Ghent's working class—toiling long hours in the mills, struggling patiently for hygiene, against heavy odds, at home.

The two cities shared certain characteristics. At mid-century, for example, both were entirely industrial, but unlike its Flemish cousin, Verviers was a one-industry town. Moreover, the production of woollen yarns and cloth employed not only thousands of the city's residents, but also a considerable number of workers in surrounding towns and villages, including Dison, Hodimont, Andrimont, and Ensival all of which were caught up in wool workers' political rebellion of later years. In the 1840s and 1850s, a handful of these rural working folk commuted daily into Verviers to work in the city's mills, but most continued their traditional work in a vast out-putting system.

In the 1840s there were 50 textile companies in Verviers. The two largest, Biolley and Simonis (both founded early in the century), dominated the industry, employing fully half the total textile workforce by 1850.[77] Their hands, like those in the city's smaller firms, came primarily from families long involved in wool production. Some of their parents had been home-working artisans; others had already entered the mills.

[75] Quoted in Keymolen, D., *Vrouwenarbeid in België van ca. 1860 tot 1914* (Leuven, 1977), 37. This work is an invaluable collection of carefully annotated documents.

[76] Quoted in Neuville, J., *La Condition ouvrière, i. L'ouvrier objet* (Brussels, 1976), 97.

[77] See Desama, C., 'Démographie et industrialisation: Le modèle Verviétois (1800–1850)', *Revue du Nord*, 63 (1981), 150–1.

Unusually for Belgium—Lowell's first generation of 'mill girls' was not dissimilar—Verviers's first wool mill-hands were predominantly young, single, and female. As a result, the city boasted an 'excess' of single women aged 15 to 24, and the local marriage age was unusually high.[78] These factors would eventually shape women's politics in the city—a politics that assumed a form strikingly different from that of women textile-workers in Ghent, where the textile workforce was more evenly distributed by age and sex.

Like Ghent, Verviers had grown rapidly in the first half of the nineteenth century. A town of only 12,000 in 1784, Verviers doubled in size by 1846. New housing crowded along the narrow river valley near the mills, and workers quickly filled any new *quartier*. Because of the local predilection for building along the river banks, rather than up the valley's sloping sides, workers' districts grew more and more densely populated as the years wore on. The growth was not entirely due to the immigration of new factory workers; despite its relatively late marriage age, Verviers had a very high birth-rate. In the 1840s, in fact, the city boasted the highest birth-rate in Belgium: 38.02/1,000, compared to 34/1,000 elsewhere in Belgium. Even during the starvation years of the late 1840s, when the birth-rate dropped steeply almost everywhere, Verviers continued its lead with a rate of 30.98/1,000, compared to only 27.2/1,000 in the nation as a whole. Through the 1850s, the birth-rate continued to rise.[79]

This high birth-rate did not signal an excess of single mothers. Verviers, widely known as 'the most moral city in Belgium', saw little illegitimacy. In 1842, for example, there were only 50 illegitimate births in a total of 676 live births. Still births showed a higher rate: 17 out of 60.[80] But married or not, Verviers's women experienced near-constant pregnancy. As in Ghent, many workers' children in Verviers did not survive infancy. In 1846, in fact, some 40.6 per cent of all Verviers children died before reaching the age of 5. Those who survived their perilous early years continued to face the possibility of early death: 4.2 per cent of all children aged between 6 and 14 were also lost.

Adults perished at a high rate as well. Between 1830 and 1842, for example, the death-rate in the city was 1 in 26.39, compared with the nearby town of Huy, where 1 in 47 died. In 1846 one horrified visitor to

[78] Le Brun, *et al.*, *Essai sur la révolution*, 237, 240.

[79] Figures found *ibid.* 588; *Art et société*, 29; Desama, C., *Population et révolution industrielle: Évolution des structures démographiques à Verviers dans la première moitié du 19ᵉ-siècle* (Paris, 1985), 92–3.

[80] See Desama, *Population et révolution*, 98; and *Enquête—1846*, 56, 57. This still-birth figure may well have included abortions.

Verviers wrote, 'mortality here is terrifying', more frightening, he wrote, than in the far more notorious city of Glasgow.[81]

This high death-rate was partly explained by the prevalence of factory work. Women especially went to the mills in droves. Claude Desama has determined the numbers of females of all ages employed in the wool industry at mid-century. His figures show the following percentages of Verviers females working in mills at various ages:

Age	Percentage
12–14	19.2
15–24	50
25–34	48.3
35–44	34.4
45–54	28.6
55–64	22.5
over 65	14.4

These high percentages show that Verviers had few unwaged 'house-wives' amongst the city's mid-century working class. Only in the age-group 55 to 64, after a significant number of *ouvrières* had died, were there many women not working in the mills. Desama's figures show, therefore, that 'housewives' as such could only have comprised some 24.2 per cent of the city's females. Moreover, as Desama cautions, even this quarter of the female population included a number who were not actually unwaged, but rather earned money in the industry's notorious 'reserve army', now working in the mills, now in the extensive 'sweating' system.[82]

Housing in Verviers's worker districts differed from that in the older, more densely populated city of Ghent. Verviers was not a walled city, and new building sprawled willy-nilly along the valley. Initially, new workers' houses included small plots of land, and many mill operatives planted tiny gardens. As the years wore on, however, the population increase swallowed such excess space, as more and more people crowded into less and less space. By 1846 each Verviers dwelling held an average of 11 or 12 inhabitants—and many held far more.[83]

As in Ghent, workers lived together. Three workers' *quartiers* clustered along the eastern bank of the Vesdre were known by their nicknames,

[81] Desama, *Population et révolution*, 112; and *Enquête—1846*, ibid.
[82] Desama, *Population et révolution*, 227, 215.
[83] Ibid. 64, 165.

'Chick Chack', 'Basse Grolte', and (surely not without some irony) 'La Dardanelle'. These areas, like their more affluent neighbouring districts, were without charm: Victor Hugo recommended that travellers avoid seeing Verviers by daylight. At night, the dark hid the worst aesthetic offences, and indeed, the city's gas lighting even gave Verviers 'the charming air of a city *en fête*'. Harsher daylight revealed 'just one long, wide road, where the houses represent rather exactly the proportion of wealth in the society; 20 poor houses against 1 rich'. Everywhere, with little regard for social distinctions, Hugo saw 'hens pecking unchecked between the cobbles'.[84]

The climate was similarly discouraging. 'Colder than the coasts of Norway', concluded one Frenchman. Worse, this visitor thought that workers did not make the best of things by moving near the city's 'sole attraction', the Vesdre River. Instead, he wrote, 'they prefer houses set right up against factory walls. The women', he explained, 'prefer to live in the same crossroads with other textile families, in order to satisfy their need for social life and their thirst for conversation'.[85]

A local medical society, on the other hand, refused to hold workers responsible for their poor housing. They blamed local government instead, for demonstrating 'neither the will nor the means to clean and widen the city's streets especially those which serve as the refuge of the working class'. On the other hand, they admitted that many Verviers workers were reluctant to move house, because of 'indolence', or 'lack of time'.[86]

As in Ghent, textile-workers lived in several kinds of houses. The poorest inhabited cellars and attics—similar to those in Ghent. One Liège doctor described such dwellings as 'one badly-lit room, a few feet square, in a narrow and crowded street or in a damp gorge'. 'Whole families', he continued, 'including the sick along with the healthy, a wife, a husband, children of both sexes, and even domestic animals' shared the room. Inevitably, 'everyone shared the family bed ... usually only a straw pallet'.[87] When they could afford it, working families rented 'bigger, drier rooms' and slept on 'a better straw pallet'. But they, too, lived in 'crowded and unsanitary conditions'. Only a handful of Verviers's workers enjoyed relatively decent and clean houses, in 'wider, less-populated, less sombre streets'. Amongst these fortunate few were some who even managed to

[84] Hugo, V. and Dumas, A., *Guide du touriste en Belgique* (Brussels, 1845), 152.
[85] De Seilhac, L., *Le Lock-out de Verviers* (Paris, 1907), 11.
[86] *Enquête—1846*, 515, 591.
[87] Ibid. 574.

rent a whole house, where they lived, according to another outsider, 'with a certain air of propriety'.[88]

For Verviers's many thousands of single working women, the choice was between staying in such homes with their parents, or moving, sometimes with children, to a single room. For their single rooms, women paid rent of about 1 franc a week.[89]

In general, workers' rents were similar to those in Ghent, but living expenses in the wool city were higher. Verviers taxed all kinds of essential goods, including soap, cooking oils, butcher's meat, herring, rice, tobacco, butter, cheese, eggs, straw, coal, charcoal, and candles! Of course most working-class families were accustomed to doing without many of these items, but necessities such as soap, coal, and candles were not easily relinquished. Thus living costs were considerable: tight budgets were stretched only by food grown by workers lucky enough to have a small garden, or eggs from some of the chickens whose heedless peregrinations so annoyed Victor Hugo. More commonly, workers' diets were limited to bread, potatoes, and chicory-laced coffee.[90]

All the diseases that afflicted Ghent's textile workers struck their Verviers counterparts, including 'scrofula, tuberculosis, and phthisis'. Women suffered additional problems: amenorrhoea and chlorosis were common, as were miscarriages and still births. Of course it is not surprising that textile-workers shared similar kinds of illness and debility. What is surprising is that physicians in Verviers concluded that women there were less, not more, able to withstand factory labour. One doctor, in fact, directly contradicted his Ghent colleagues, arguing that it was the sedentary nature of mill work that was particularly hard on the female organism! In his view, this lack of exercise caused *ouvrières* 'to grow pale and fall into a languorous state, leaving them peculiarly susceptible to disease'.[91]

Every working-class family faced crises—brought on by injury or disease, or by sporadic unemployment in the mills. On such occasions,

[88] El Kefi-Clockers, C., 'La Population féminine active de l'industrie textile verviétoise . . . 1856', Mémoire de license (Liège, 1976), 93. This is an important and painstaking piece of work on a hitherto neglected subject: it deserves publication. See also Fohal, J., *Verviers et son industrie: Il y a quatre-vingt-cinq ans: 1843* (Verviers, 1928), 33. Verviers possessed no housing laws of any kind in the 19th century. Many of those fortunate enough to have company housing worked for Raymond Biolley, who built small houses complete with gardens and courtyards, amenities he recalled from his rural childhood.

[89] El Kefi-Clockers, 'Population féminine', 93. From this group would eventually spring some of the leaders of the Verviers women's movement of the 1860s and 1870s.

[90] Fohal, *Verviers et son industrie*, 30–1; *Enquête—1846*, 575; and Lis, C., *Social Change and the Laboring Poor: Antwerp, 1770–1860*, trans. Coonan, J. (New Haven, Conn, 1986), 100.

[91] *Enquête—1846*, 63.

textile-workers turned to the local *bureau de bienfaisance*. That institution provided a modicum of financial aid: in 1843, for example, it recorded payments totalling 50,572.05 francs (*sic!*) to 985 local families. Although a large total sum, it did not amount to much for each family. The 2,583 individuals helped received an average of only 19.5 francs each. To bolster such aid, some of Verviers's poor—if judged morally worthy—found help at the local branch of the Royal Philanthropy Society. In 1843 the organization aided some 3,000 Verviétois. (They estimated that their regular rolls listed a full 15.5 per cent of the population.)[92] Although such charity was undoubtedly welcome, it was not always offered in its most useful form. Private charities especially were prone to distribute goods rather than money. Baby blankets and foodstuffs were the most frequent choices of the givers. Like the Maheu family in Émile Zola's *Germinal*, Verviers's poor often found themselves the recipients of discarded clothing or baby bedding when what they needed was food or coal, or money to pay the rent.[93]

A very few working-class children found space in Verviers's single *crèche*, run by 'dames bienfaisantes', or local *bourgeoises*. For older children, the city boasted one *école gardienne*, which offered care and supervision from 6 or 7 a.m. to late evening. When children reached the age of 7, school age in Verviers, they either entered one of the scarce free primary schools or, more commonly, followed their parents and older siblings into the mills. Most children had no access to organized care in the years from birth to 7, and wandered the streets and alleys of workers' *quartiers*, sometimes supervised informally by neighbours too old or too ill to work. Although the sight of such children always aroused bourgeois criticism—and sometimes even suggestions for more child-care institutions—nothing significant was ever done.[94]

In Verviers (as in Ghent), one remedy that was not suggested was that women should quit their jobs in the mills to stay home to care for their children. Indeed, when they heard that such ideas were circulating elsewhere

[92] Fohal, *Verviers et son industrie*, 33. The number of royal societies and academies mentioned here is only the tip of a substantial iceberg. Belgium's bourgeoisie were 'joiners'—as, indeed, were all Belgians. This tendency remains—in stark contrast to their non-joining French neighbours!

[93] See Zola, É., *Germinal*, trans. Tancock, L. (New York, 1991), ch. 2. Lis condemns this kind of charity in *Social Change*, 130–2. She argues that much of the charity distributed in Antwerp consisted of 'crucifixes, holy prints, paternosters, and religious medallions'. Such efforts, moreover, were supported by secular members of Antwerp's bourgeoisie because they recognized their function in helping to quell class unrest.

[94] *Enquête—1846*, 91. The Liège commission suggested that *crèches* could be built inside mills and factories so that working women could nurse their babies on work breaks. Such *crèches*, they thought, should be supervised by mill-owners' wives.

in Europe, some local bourgeois worried aloud that if women were allowed to leave work for any period of time they would 'lose the taste for work, or forget their skills'. Moreover, they argued that asking women to give up their jobs because of the birth of a child would be grossly unfair, since the new family member only increased the need for their wages.[95] Most such rhetoric was motivated by self-interest, of course, but it does suggest the extent to which bourgeois ideas about women's 'proper' sphere were reshaped to fit Belgium's important *ouvrières*. Workers, in other words, continued to inhabit a different moral world from that which constrained ladies of the ruling élites.

Throughout the early nineteenth century, Verviers's textile-workers created and sustained a vital, tight-knit community life, which more than one outsider described as 'impenetrable'. 'Solidarity evenings are frequent', observed one visitor. 'One could, in fact, say that Verviers is the city of association'. Underpinning this pattern of exclusive sociability was the fact that Verviers's workers were—uniquely in Belgium—mostly literate. According to one bourgeois inhabitant, his city's proletariat bought and read more books than workers anywhere else in Belgium.[96]

The explanation for this phenomenon remains hidden. Certainly schooling was no more available to that city's working-class children than to those growing up in Ghent or other industrial centres. Perhaps it was the case that Verviers's small size, together with the fact that its inhabitants retained both rural ties and a semi-rural pattern of life in the early decades of the industrial transformation, helped ensure that parents and grandparents taught children to read—as they would traditionally have done in the region's villages. And the exceptionally close ties carefully maintained amongst the city's working people also encouraged the sharing of literacy. Verviers's working class must surely have placed an unusually high value on reading—a value obviously passed down through the generations. Certainly the unusual proliferation of workers' political newspapers and journals throughout our period attested to workers' collective enthusiasm for the printed word![97]

Both their uncommon solidarity (strengthened, no doubt, by the ubiquity of their experience of factory life) and their anomalous literacy shaped the

[95] Ibid. That such arguments contradicted those used elsewhere to restrict women's access to industry is more support for the argument that Belgium was an exception to many rules.

[96] See de Seilhac, *Lock-out de Verviers*, 7; and Lemonnier, *Belgique*, 659. See also Fohal, *Verviers et son industrie*.

[97] A wonderful history of the Verviers press is Joris, F., *La Presse verviétoise de 1850 à 1914*, (Leuven, 1982). Unfortunately, while the number of papers and journals analysed in the text provides evidence of widespread literacy, the book does not offer any explanation for it.

politics that began to emerge in the 1860s. This combination of factors was unique to Verviers, as we shall see. But the city's wool-workers did share one habit in common with their comrades in Ghent: everyone socialized in local café-bars, where political discussion, as well as less serious talk, took place out of the sight or hearing of the *patronat*.

Again in common with Ghent, alcohol consumption was high. In Verviers, both gin and brandy were cheap and plentiful, and as the textile workforce increased, so did the amount of spirits sold in workers' bars. The 17,000 litres of gin and brandy consumed in 1833 grew to a staggering 250,000 litres only a decade later.[98] Despite women's equal participation in this mass drinking, however, what shocked most bourgeois visitors to the workers' *quartiers* of Verviers was not the sight of women drinking but rather the fact that the café-bars were full of children drinking alcoholic beverages. And not only did local children drink side by side with their parents in every humble café, wrote a startled Victor Hugo, but they also 'smoked', in imitation of their fathers. He described one little 6-year-old 'worker', sitting in a Verviers café-bar, calmly puffing on his very own pipe.[99]

Verviers's Wool-Mills

The city's wool factories were large and built of the customary red brick. In the late 1840s, there were 50 wool companies with mills in the city proper. These employed about 7,000 workers. In that decade, most textile-hands—nearly 5,000—lived within the city limits, in segregated workers' districts. But as the city grew, and the demand for labour increased, more workers began travelling into the city from outlying areas, frequently undertaking a daily journey of an hour or more.[100] Soon, a few mills sprang up beyond the city limits replacing dozens of artisanal workshops.[101]

Whether they worked in small workshops or factories, male workers consistently earned higher wages than females. In 1843 men averaged between 1.50 and 2.50 francs a day, whilst their women co-workers earned a daily average of only 75 centimes. Adolescents of both sexes—the figures do not distinguish—earned about 80 centimes. Young children brought in a further half franc or so every day. All worked an average of 12 and a half hours per shift.[102]

[98] Mathieu, J., *Histoire sociale de l'industrie textile de Verviers* (Verviers, 1946), 91.

[99] Quoted in ibid. 94–5.

[100] Mokyr, *Industrialization in the Low Countries*, 43. These figures do not agree with figures offered in many other sources, but such discrepancies are typical.

[101] Fohal, *Verviers et son industrie*, 18.

[102] Ibid. and Mathieu, *Histoire sociale*, 99.

For a handful of women operatives, maternity brought a few years of respite from the mills. Even then, however, they did not cease earning wages; most found work in an extensive system of domestic out-putting, where they earned minuscule pay producing some 45 different kinds of goods.[103] For such women, the change from factory to home—a small, dark, cold home, of course—offered no improvement in their working conditions. By mid-century there were hundreds of local women workers who never entered factories. Much of the work of preparation and finishing was still done outside the mills, and by hand. Many tasks were traditionally 'women's work', including picking, cleaning, and washing raw wool, and finishing woollen cloth returned from the mills. These domestic outworkers learnt of factory discipline only second-hand, if at all, from mill-working husbands, brothers, sisters, or children.[104]

At this time the wool industry was still undergoing mechanization, but the days of artisanal out-working were numbered. Indeed one key 'men's job' had already been transformed by technology, and in the process, shifted from expensive, skilled male workers to much cheaper women. This was the work of shearing sheepskins when they arrived at the mill. Once work requiring considerable strength, shearing became a simple, lighter task with the introduction of powered shears. When it became clear to owners that women could readily do this work, and at a much lower wage, it was theirs.

This process of 're-gendering' was not good for men's wages, of course, but it was good for their health. Raw skins (like much imported sheared wool) carried a variety of diseases, transmitted through the air to those who handled the wool before it was cleaned. Once women began shearing, they fell victim, although one health official thought they were less vulnerable than men because they had 'smaller noses, which inhaled fewer particles'![105]

POLITICS AND TEXTILE-WORKERS

Despite draconian, enforced laws against organizing, workers in both

[103] See El Kefi-Clockers, 'Population féminine', 40, 50: the author includes a list of these occupations. The Musée de la vie wallone in Liège has displays of some sweated work, as well as an extensive picture library.

[104] In addition to the description provided ibid., see Mathieu, *Histoire sociale* 91, 88–9. It might be noted that a few women founded and ran wool companies in the first half of the century, including Mme J. F. Biolley, an 'industrial genius', who established the first Belgian mill working prepared wool in 1822. When she died in 1833, she was widely-known as 'La Grande Madame'. Another Verviers *entrepreneuse*, Mme Peltzer, built Peltzer, Mayor et Cie. She died in 1847. See El Kefi-Clockers, 'Population féminine', 43.

[105] Ibid. 223.

Verviers and Ghent did not accept their exploitation placidly. Both cities witnessed small, evanescent strikes and even a few mass demonstrations through the 1830s and 1840s. In the latter decade, moreover, a handful of scattered workers' groups emerged. Of these, those that clearly reflected bourgeois values—including savings banks, mutual aid societies, funeral and pension funds—were allowed to develop unchecked. Only later (at the end of the 1850s in Ghent, for example) did it become clear to authorities that many such groups had hidden potentially dangerous 'proto-unions'.

On the whole, however, radical politics in the first twenty years after Independence belonged not to Belgium's new industrial proletariat, but rather to young bourgeois radicals, who provided the sole opposition voice to the liberal chorus. Such young men and women found no dearth of targets for their criticism of bourgeois society. Moreover, they benefited from the presence in Belgium of political refugees from all over a turbulent nineteenth-century Europe. At mid-century, Belgium harboured not only Karl Marx and Friedrich Engels, but also a large group of French and Russian political *émigrés*, preaching every sort of progressive idea, from anarchism to the extremes of utopian socialism.

These foreign radicals and their Belgian followers attracted little working-class participation, despite valiant efforts. Yet they did plant certain key ideas that later bore fruit within the workers' movements of later decades. It is important, therefore, to outline these early movements of young bourgeois radicals in both Ghent and Verviers, paying particular attention to ideas concerning women's social roles.

Ghent

The capital of East Flanders was home to one of Belgium's first young leftists, Jacob Kats, who founded the first newspaper aimed specifically at arousing Belgian workers to revolt. Because of Ghent's high illiteracy, *Volksvriend* attracted only a handful of working-class readers. Nevertheless, the paper promoted several ideas influential in the later movement, not least amongst them a demand for women's 'complete equality', based on equal education of male and female children.[106] In his speeches, Kats took care to address 'brothers and sisters', and to include women in his various political goals. His efforts met with some success: Ghent's police consistently reported the presence of women at his public lectures. (In 1839, for

[106] Grounding women's emancipation in new educational practices had a very old history. From the Enlightenment to early Utopian thinkers, writers interested in women's liberation discussed methods of equal education for boys and girls.

example, a typical report noted '6,000 men, women, and children' at one of his speeches.) By 1843 police were aware of a Kats-led 'Peoples' Society', the *Volksmaatschappij*, which counted a number of working-class men and women amongst its members, though not amongst its leaders.[107] A few years later, authorities reported a 'Société de Jacques van Artevelde' (which may, of course, have been the same group). This *Société* promised 'to end the unjust oppression of workers, and to educate workers in their own interests'. In this group, too, women formed part of the membership.[108]

By the close of the 1840s, Ghent's radicals were sufficiently active to attract the notice of Karl Marx. In 1848, together with two Ghent socialist leaders A. Picard and Louis Jottrand, he wrote:

Ghent's position is decisive for the ensemble of the workers' movement of the country. It is this that permits us to believe that the participation of the workers of this Belgian Manchester in the renewal of a purely democratic movement may be considered as the signal of the adhesion of the totality of the Belgian proletariat to our cause.

Such optimism was premature; but it would prove to have been prescient. When Marx's 'cause' did finally engulf Belgium's working class, beginning in the late 1860s, Ghent's textile-workers were at its centre.[109]

In 1848 Ghent's officials, like those everywhere in Belgium, increased their vigilance, seeking any signs of revolt. Authorities in the Flemish city were convinced that rebels from nearby Lille would easily infect local workers with revolutionary fervour and warned that 'French events' would soon appear on the horizon. Officials also identified potential local radical leaders, and documented any expression of pro-French feeling. With this increased surveillance, police uncovered yet another group of local rebels. Led by a republican couple called Huet, this group first appeared in November 1848. Their goals were the overthrow of the Belgian monarchy and the establishment of universal (male and female) suffrage. Their new republic, they promised, would offer free and obligatory schooling, free legal services, and the right to organize. Threatening the bourgeois social order directly, the Huets planned to eliminate private property and 'establish the absolute equality of the sexes'. Noting these goals, one police spy

[107] Avanti, *Een Terugblik*, 13–15.

[108] See no. 496 '. . . het onafgewezen proces tusschen de vlas spinsters en het gouvernement of de Zaek van Verlindemuller, te koop bij C. Bangoethem, boekverkooper op de Koornmerkt te Gent, april 1846'; no. 518 'Oproep tot een hongeroptocht naar Brussel, 14 april 1846', both in *Documenten*, i.

[109] In Marx, K. and Engels, F., *La Belgique des insurrections* (Paris, n.d.), 190–1.

commented that Mme Huet herself not only professed sexual equality, but experienced it within the movement, where she was 'as exalted as her husband'.[110]

This couple attracted large crowds in Ghent throughout 1848 and 1849, as did many other republican speakers. In January 1849 an official warned the Minister of Justice that these constant republican meetings should be taken very seriously because 'Ghent has become a city where the working population is very considerable [and] the dangerous class of society so numerous'. Locals took a hand in trying to break up such subversive meetings. In the same month, the city's police commissioner reported a huge pro-suffrage republican meeting which ended in a great brawl, accompanied by the 'cries of the women'.[111]

One prominent Ghent republican—a member of the Huet group— attempted to explain women's enthusiasm for this movement. 'It happens', he wrote, 'that in the commercial and industrial classes [women's] role increases along with their participation in business. Charged with work nearly as demanding as that of their husbands . . . they become exemplary for their intelligence and courage. [They] elicit respect from those who know woman only as an idle creature'.[112] This link between women's equal participation in economic life and their political equality was not new to Belgium, as we have seen. But it was highly unusual elsewhere in mid-century Europe, where the exclusion of women of all classes from public life of any kind was increasingly mooted by intellectuals and reformers, as well as by conservatives.[113]

In addition to these local groups, there was one that spread beyond Ghent's city walls. In the course of the 1840s, Wat Wij Willen ('What We Want'), a republican radical group led—again—by van Artevelde, founded

[110] See Pirenne, H., *Histoire de Belgique vii. De la révolution de 1830 à la guerre de 1914* Brussels, 1932), 63. See also PdE, 131, 'Tentatives de troubles dans la Flandre Orientale, 1848–49'; 'Cour d'appel de Gand, 29 juillet 1848'; 'Parquet de la Cour d'appel de Gand à la ministère de justice, Gand, 21 mars 1848, 22 mars 1848'. The latter describes a police visit to Dlle Jospin, whose house was searched for evidence of her radical brother. See also no. 907. 'Een politie commissaris van Gent aan Ganser, procureur-generaal, 12 mei 1848', in *Documenten*, i and no. 1037, 'Statut of gedrag onderwijzingregel van de vredzame volksverbroedering van Thienin, 30 okt. 1848'; no. 31044, 'De Jaegher, provincie gouverneur van Oost-Vlanderen, aan Rogier, minister van binnenlandse zaken, 9 nov 1848'; and no. 1051, 'Principes van een democratische confederatie, 26 nov. 1848', all in *Documenten*, ii.

[111] Reported in no. 1122, 'Een politie commissaris van Gent aan de procureur de konings, 29 jan. 1849', and no. 1124, 'Ganser, procureur-generaal te Gent aan De Haussy, minister van justitie, 30 jan. 1849', ibid. ii.

[112] See remark of J. Moke, quoted in Keymolen, *Vrouwenarbeid*, 34–5.

[113] This Belgian exceptionalism was crucial to the shape of workers' politics in Ghent in later years.

groups in several neighbouring towns. This organization had two key goals: a republic, and women's full equality.[114] Wat Wij Willen attracted considerable official attention. The governor of East Flanders, De Jaegher, warned Charles Rogier (then Interior Minister) 'since the cotton industry was founded in Ghent, no coalition of workers has before had this breadth, this character, or this form of organization'. In fact, he argued, Wat Wij Willen was responsible for 'that cotton strike in which workers first realized their potential power'.[115]

In Ghent in the 1840s, then, there was a serious opposition movement that included at least some workers amongst its adherents. The two elements that ultimately proved significant to the future shape of women's politics in the city were a demand for women's equality and a determination to organize the rank and file of textile workers. That Ghent's workers were learning from this bourgeois-led opposition was underscored by De Jaegher in 1849. Describing what he characterized as 'the first socialist strike', he wrote: 'The workers have demonstrated a remarkable spirit of solidarity, a tested discretion, and a discipline that gives cause for reflection'. The strike, moreover, was entirely local in origin. No 'outside agitators' bore responsibility. According to the governor, the strike was led entirely by textile-workers. One of their first gestures was to start a newspaper aimed, aptly, 'at those who cannot read'.

Although his reports were warnings to the Brussels government that Ghent's workers posed a danger to the social order, De Jaegher was not entirely hostile to the city's struggling mill-workers. Indeed, like many local and provincial officials of the era, he was uncomfortable about the extent and nature of the hegemony exercised by Belgium's industrial bourgeoisie. Thus one of his reports added: 'Fairness forces me to point out that the central government has long practised selective justice'. Although the law forbade all economic coalitions, only those organized by workers were ever punished. Meanwhile, 'the owners are free to group together to exploit the workers'. Strikes and meetings were the consequences of the government's partisanship. By acting 'only against workers' interests', the Belgian government proved repeatedly that 'justice is rigorous only against the proletariat'.[116]

How harsh was bourgeois justice? Official figures for Belgium as a

[114] See Kuypers, J., 'Het Vroegsocialisme tot 1850', in Dhondt, J., *Geschiedenis van de socialistische arbeidersbeweging in België* (Antwerp, 1960), 143.

[115] Quoted ibid. 144.

[116] Quoted in two letters, both dated 23 Nov. 1849: see nos. 1204 and 1206, 'De Jaegher . . . aan Rogier, minister van binnenlandse zaken', in *Documenten*, ii.

whole show 1,611 arrests for 'strike offences' between 1830 and 1860. Of those arrested, 521 were acquitted, and 1,090 convicted. Of these, 946 went to gaol and 144 paid a fine; some suffered both penalties. Although figures are not available for Ghent alone, contemporaries complained frequently that in cases involving workers, Ghent's courts were amongst the most severe.[117] Despite imprisonment and fines (as well as other penalties: owners efficiently blacklisted troublesome workers) Ghent's textile operatives continued to organize and to rebel. In 1857 they launched the first mass textile strike. The degree of their organization was clear from the start: all the striking weavers went directly to their official meeting place, a cabaret known as 'Harmonie', whilst spinners headed for their *estaminet*, called 'De Kiezerin' ('Voters'). Perhaps because the authorities recognized that this was a carefully planned event, their reactions were harsh: forty-one leaders, including one woman, were arrested and prosecuted, and all received heavy penalities—prison, and/or fines. Nevertheless, the end of the strike saw the public appearance of two important groups: the Broederlijke Wevers (Weavers' Brotherhood) and the Zusters Genootschap der Weefsters (Weavers' Sisterhood).[118]

Two years later, the irrepressible Ghent workers struck again. This time, the issues were wages and the hated truck system.[119] Once more, city officials showed little patience: troops were summoned, and local police seized the strike fund of 850.24 francs. Left without resources, the strikers threw themselves on the mercies of their fellow workers. Collections were gathered in every workers' district—in *estaminets*, shops, homes, and on street-corners. The result was testimony to the extent of Ghent's working-class solidarity: the new strike fund was even larger than the first. Moreover, Ghent's city council took the strikers' side; they reclaimed the seized money from the police and returned it to the striking workers. The police, supported by the textile *patronat*, arrested 43 'strike leaders', all of whom were quickly tried and convicted. The court showed some leniency in sentencing the guilty: 39 were given only the minimum sentence of

[117] Figures from Mission, *Le Mouvement syndicale*, 24–5.

[118] Neuville, J., 'Il y a cent ans naissait le syndicat des Broederlijke Wevers', *Études Sociales*, ix, *La Pensée Catholique* (Brussels, 1957), 24.

[119] This was the name of a system that allowed mill- and mine-owners to pay workers in goods rather than money. The goods were often shoddy. Moreover, when wages were paid, workers were sometimes forced to shop in company stores or in shops kept by foremen's relatives. Here, again, quality was low and prices high. Credit was forthcoming, too, and thousands of Belgium's industrial workers ended up 'owing their souls to the company—or company-related—store'.

eight days, although those four identified as the leaders were sentenced to three months in prison.[120]

Although meetings and marches, newspapers and strikes, remained illegal, and the focus of intense official surveillance, Ghent's workers found other means of spreading the message of class struggle. Popular songs, for example, carried a social message. Sung in every *estaminet*, and in the streets of workers' neighbourhoods, such songs spread common complaints. One employed gentle irony, and begged the rich to 'spare a thought for working folk', not out of love for God, but because they recognized that without the 'werkvolk', there would be none of the riches 'which made them so proud'.[121] Another described those tragic workers who wove a 'shroud for starving Flanders':

> Together we must first weave a shroud
> A shroud for our starving Flanders,
> Weave! Weave! . . . let the shuttle fly quickly!
> But how the people fall! . . . And still—still the song drones on! . . .
> Have you more strength in your dead fingers?
> They stumble! . . . Ach, your dreary lives flee!
> I see on the ground the last kiss you gave!
> I see the numberless bodies, mother—naked on the ground!
> God! Let the sun weave a shroud to cover them!
> Merciful God! . . . Love our Flanders!

Lastly, one popular textile-workers' song told of a 'mill girl', the 'Fabrieksmeisje', stalked by consumption throughout her days in the mill.[122]

The presence of this generic 'mill girl' in the popular life of Ghent reflected—once again—the extent of female participation in working-class life. Women who played an equal economic role, and who knew it, claimed a place (albeit never an equal one) in the political life of their communities. In the 1850s and 1860s, Ghent's *werksters* joined all kinds of mixed-sex workers' groups, as well as women-only proto-unions, the best known of which was the 1860 Weavers' Sisterhood.

Of course here, as elsewhere, not every male workers' group welcomed female members—at least not initially. When one group, the Werkverbond, decided to follow local practice and open its membership to women, some members were unhappy. But their leader explained the group's reasons:

[120] Neuville, 'Broederlijke Wevers', 45.

[121] From the very interesting essay by H. Vandecaveye, 'Het Proletarierslied: een sociaal-kulturele verschijnings vorm van de socialistische arbeidersbeweging', *BTNG/RBHC*, 6/2 (1980), 171–204.

[122] Ibid.

Although this innovation is, for some men, no small thing, women's admission is a useful measure which in the future will bear fruit. Women, because of their lack of education, have long presented an obstacle to the founding of similar associations; thus it is necessary that they learn why people stand together, uncoerced, and what advantage there is for all of them.[123]

This gesture, however patronizing its presentation, became a model in Ghent.

A few years later, the largest local group, the Brotherhood of Weavers, published new rules admitting women. Conditions for joining were the same for both sexes: the minimum age was 16, and all prospective members had to demonstrate 'good character'. Women, however, were promised certain privileges. Because of their extra domestic responsibilities, women were not obliged to attend every meeting, nor were they fined for missing a vote.[124]

By the mid-1860s, Ghent's workers had founded yet another organization, the one that ultimately formed the nucleus of the Flemish socialist party. This food co-operative, called Vooruit (Forward), made no distinction between male and female members, and women played an active role from the outset. Very soon after its founding, Vooruit was the beneficiary of a shift in government policy, when in 1866 the liberal government, prompted by fears of unrest in mining country, legalized workers' organizations. At this point, Vooruit was in a position to grow rapidly, boasting a strike fund (of 676.75 Francs), a growing pension fund, an illness insurance scheme, and a savings bank. In a few years, the co-operative grew into a vast 'parallel society', rival to the hegemony of Ghent's ruling industrial bourgeoisie. By the end of the 1860s, then, the seeds had been sown for a later, bountiful, harvest.

Verviers

In Verviers, however, the situation was quite different. In that city, the workers' movement—which emerged much earlier than in Ghent—was grounded not in the socialist ideas that underpinned the Ghent workers'

[123] Quoted in Avanti, *Een Terugblik*, 214–15.

[124] Ibid. and in Neuville, 'Broederlijke Wevers', 53. Here, too, Belgium was an exception to European rules. French textile unions of the time often restricted membership to men—and when women were allowed to join, their membership rights were restricted. See my 'Women and the Labour Movement in France, 1869–1914', in *Historical Journal* (autumn, 1986), 809–32. These rules obliging members to vote were common to Belgian organizations of all kinds—and indeed, present-day Belgians are also required by law to vote.

efforts, but rather in anarchism. From the first, Verviers's workers rejected 'proto-organizations'. One historian has explained their antipathy to such groups by citing the city's lack of a corporatist past. With no historical memory of craft guilds, Verviers's workers cherished their independence. According to Joseph Mathieu, 'Jealous of their autonomy, the carder, the spinner, the weaver ... have never wanted to kneel before the ordinances and rules of a corporate craft organization'.[125]

They proved equally chary of savings banks and mutual aid societies, whatever their appeal elsewhere.

On the other hand, they did not lack rebellious feelings. Indeed, *émigré* revolutionaries found an enthusiastic audience amongst the city's working class. Moreover, the city produced many of its own youthful radicals in the 1840s, some of whom managed to attract attention from textile-hands. In the 1830s, disciples of Enfantin spread the Frenchman's curious version of Saint-Simonianism in Verviers, including Enfantin's commitment to women's equality and his search for a 'Mère'. What Verviers's workers made of such ideas remains unknown. However, officials noted that these Saint-Simonian meetings attracted numbers of 'working men and women'. But interest remained low; by the close of the 1830s, the group had disappeared.[126]

The 1840s brought another kind of radicalism to Verviers. Victor Considérant, a follower of Fourier, preached his message of sexual equality and social reorganization to large audiences. His ideas, like those of the Saint-Simonians before him, lingered on after his departure from Belgium at the end of the decade, as we shall see below.[127]

In addition to these exotic French ideas, a Belgian republicanism also found supporters in Verviers in the 1840s. Local officials expressed particular concern about the spread of republican symbols in their city. According to one, Verviers's republicans sang a Belgian version of the 'Marseillaise' which began: 'Allons enfants de la Belgique/Reprenez votre liberté/Formez vous une République/Le jour propice est arrivé ...' During the June Days in France in 1848, local republicans marched from Verviers to Ensival, singing, 'in chorus, the song of the Girondins'. The crowd, this reporter added, 'was composed in large part of women and children'.[128]

[125] Mathieu, *Histoire sociale*, 8.

[126] Kuypers, 'Het Vroegsocialism tot 1850', 143.

[127] Considérant's visit is mentioned in Bartier, J., *Naissance du socialisme en Belgique: Les Saint-Simoniens* (Brussels, n.d.). Like many refugees, Considérant never visited Flanders, where his inability to speak Flemish would have proved a serious hindrance. This history is part of the explanation for the differences in political ideas in Verviers and Ghent discussed below.

[128] No. 951, 'De Substituut van de procureur des konings te Verviers aan de procureur-generaal te Luik, 10 juni 1848', in *Documenten*, ii.

In 1849 Verviers saw the arrival of the first 'women's liberationist', identified only as 'Sophie R.' by police spies. Little is known of this woman, except that she attracted much attention and large audiences. Her speeches, according to officials, called for 'the political education of women', necessary because women were 'the directors of the household'. This domestic role made them 'the most influential in the struggle for the democratic republic'. Although Sophie R. quickly vanished from Verviers's records, these two ideas remained behind, and would later form the nucleus of women's demands at the close of the 1860s.[129]

The decade of the 1850s in Verviers must remain unexplored due to the loss of essential documents.[130] However, when evidence again becomes available, for the 1860s, it becomes clear that the early ferment of the 1840s had continued, probably unabated. By the end of the 1860s, in fact, an official announced that 'the socialist mind has made great progress amongst the Verviers working class'. As if to mark that progress, a textile-worker from nearby Dison published a widely-circulated brochure, 'Workers' Future', in 1869. It, in turn, provided the impetus for the founding of what became the largest First International group in Belgium, the Francs-Ouvriers.[131]

This narrative of Verviers's workers, together with that of their brothers and sisters in Ghent's textile-mills at mid-century, helps to nuance Henri Pirenne's oft-quoted judgement of Belgium's social relations in the middle of the nineteenth century: 'Amongst workers in the major industries', Pirenne wrote, 'there was no idea of revolt . . . If strikes broke out here and there, if misery sometimes pushed some to pillage shops or break windows, these were only momentary flurries, impulsive agitations without any tomorrow'.[132] It is now clear that the years immediately following Belgium's revolutionary separation from the Netherlands witnessed much more than Pirenne's untroublesome and evanescent eruptions of misery.

[129] No. 1136, 'Sophie R . . . aan Dr. Bayot te Flenu; Brussel 10 feb. 1849'; and no. 1137, 'Een andere brief van Sophie R . . . zonder vermelding van bestemmeling, noch datum'. These report her women's rights activities. No. 1156, 'Le Begue aan Chazal, minister van oorlog, Luik, 7 maart 1849' reports the latter remarks. All are found ibid.

[130] Léon Linotte discovered this lacuna in the Verviers archives, and noted it in *Les Manifestations et les grèves dans la province de Liège de 1813 à 1914. Inventaire sommaire des archives de la sûreté publique de la province de Liège* (Leuven, 1964).

[131] No. 340, 'De Bevelhebber van de rijkswacht van Verviers aan de procureur-generaal te Luik, 3 mei 1849' in *Documenten*, i.

[132] Pirenne, *Histoire de Belgique*, vi, 57.

4

Mining Coal

The miners . . . constitute a race apart from other labourers . . . and I
feel a great sympathy for them . . . The man from the depths of the
abyss—*de profundis*—that is the miner.

Vincent Van Gogh[1]

It is said of Liège that it is the hell of women, the purgatory of men,
and the paradise of priests; this last must be amended since 1793. But
the rest of the proverb has not ceased to be true.

Victor Hugo[2]

From the twelfth century Belgians mined coal. There, as elsewhere, coal-
mining was a trade redolent of cultural significance. Wrested from beneath
the earth's surface, the black coal carried an aura of secrecy and awe which
spread to its miners. Those who lived their working years underground
enjoyed a singular notoriety. Untamed, wild people, they were believed to
be as unknowable as the forces lurking in the earth's inscrutable core. And
yet Belgium's earliest coal workings were far from mysterious places. Most
were family affairs, where everyone but the smallest children helped cut,
break, and load the coal which was dragged or winched to the surface.
Almost from the moment they took their first steps, mining children joined
their parents and siblings in the mine, learning the work which they, in
their turn, would pass on to their sons and daughters.

Generally, no distinction by sex divided the work of these early miners:
strength and a knowledge of the coal seams were paramount considerations
in establishing the social hierarchy of the trade. Only in the coal country
around Liège was there an exception to this rule, one 'women's trade'.
Once removed from the earth, Liège's coal was transported almost exclu-
sively by women, the city's famous *boteresses*. Each morning, these teams of
women strapped heavy, coal-filled wood and straw baskets to their backs
and foreheads and set out for merchants in cities and towns all over the

[1] Van Gogh, V., *The Complete Letters*, i (Greenwich, Conn., 1959), 206.
[2] Hugo, V. and Dumas, A., *Guide du touriste en Belgique* (Brussels, 1845), 154. France
annexed the independent Bishopric of Liège in 1793.

region. (Their customers included sellers as far away as Maastricht, now in the Netherlands.) Once loaded, these vast baskets outweighed their carriers. Counterbalancing, *boteresses* adopted a slightly stooped posture, leaning on heavy walking sticks. The characteristic stoop, hands crossed on their sticks, their V-shaped baskets, and their distinctive head-scarves and aprons marked some of Liège's best-known workers. One proverb reflected their high status: 'Un Flamand bon pour deux Wallons, mais une boteresse pour deux Flamands'.[3] *Boteresses'* work continued through most of the nineteenth century, although coal-carrying canals and trains gradually diminished their numbers. (The 'last *boteresses*', very old ladies, were photographed by Gustave Marissiaux early in the twentieth century.)[4]

Coal-mining, however, once the purview of 'proto-industrial' family work units, underwent startling changes, beginning in the eighteenth century. Industry was hungry for coal, and new capitalists obliged, buying small family pits and hiring larger teams of often unrelated workers. At the same time, technological improvements allowed the deeper diggings necessary to find coal below exhausted, more easily reached shallow deposits. The new mines were thus both larger and deeper than those familiar in Belgium's coal country for so many centuries before.

By the middle of the nineteenth century, Belgium's mines employed many thousands of workers deep below ground. Most coal companies belonged to capitalists rather than to the traditional master-miners of an earlier age. Production was high: only Britain produced more coal. Where once small families of miners had lived in some isolation near their pits, mining towns and villages sprang up. By 1841 Belgium's coal-miners constituted an army of some 38,000 men, women, and children. Ten years later, mining employed 48,000, and the rate of increase continued: by 1860 there were 78,000 miners, by 1869, 92,000, and by 1875, 100,000.[5]

Miners' homes, whether in the miners' *quartiers* of older cities or in the 'new towns' that grew up around the newer pits, rapidly mirrored the crowded, squalid slums which housed Belgium's textile proletariat. In dark and damp courtyards and hovels, miners' lives unfolded in patterns that were sometimes similar, sometimes quite different from those of their

[3] Quoted in Havelange, C., 'Quelques aspects du discours médical pendant la seconde moitié du XIXe siècle: L'exemple de la province de Liège', *BTNG/RBHC* 16 (1985), 199.

[4] Photographs are found in the Musée de la vie wallonne, Liège.

[5] See *Grèves ouvrières*, 9–10, and Dumont, G.H., *La Vie quotidienne en Belgique sous le règne de Léopold II (1865–1909)* (Paris, 1974), 74. I am using the word 'miner' to indicate all those working below ground. Throughout most of the 19th century, various terms described underground workers; men were commonly *mineurs* or *charbonniers*, and women *charbonnières*, *houillères*, or *hiercheuses*.

textile-working neighbours. In the first place, miners' working lives elicited public reactions very different from those evoked by textile production. The miners' universe, deep below ground, intrigued and intimidated. A mine was a world 'turned upside down', where workers passed daylight hours in a dark blacker than night. Moreover, it was a world full of danger: floods, rock falls, and the dreaded explosion of firedamp marked the life of every man, woman, or child who dug Belgium's coal. Not surprisingly, coal-miners soon earned the reputation as Belgium's industrial infantry, soldiers on the front lines of the industrial revolution.

In Belgium, however, these soldiers were, unusually, a mixed-sex army. Coal-mining remained almost completely 'ungendered' until very late in our period. Thus the masculinity increasingly associated with coal mining in Britain, for example, did not universally colour Belgians' perceptions of the pits. As a result, whilst virtually every other industrial nation legislated female workers out of coal-mines (though not away from work at the mine-heads), Belgium remained unchanged. Indeed, until the final quarter of the nineteenth century, numbers of women working underground in Belgian coal-mines actually grew.[6]

Not surprisingly, Belgium's women coal-miners earned some significant portion of the public respect and reverence elsewhere given so readily to male coal-workers. And they enjoyed this image, boasting of their strength, their fearlessness, their *insouciance*, and their independence. As the century wore on and their numbers grew, they achieved that rarity amongst female industrial workers, a generic title. In the latter decades of the century, the term *hiercheuse*, initially describing only one group of female workers, became a proud title for all women working in coal. This chapter tells their story, including both their domestic lives in the *corons* and *impasses* of coal country, and their working lives underground. Both offer the backdrop against which their political efforts developed, beginning with the mining strikes of the late 1850s.[7]

[6] See Trempé, R., *Les Mineurs de Carmaux, 1848–1914*, i (Paris, 1971) for the French case. As the author notes, few women worked in French coal-mines, except in some northern mines. In Germany, after unification, some women continued underground, as the constant complaints of German mine union leaders attest. Similar complaints from Austrian male miners suggest that there, too, women continued working underground after the turn of the 19th century.

[7] The aim here is to capture 'the *cadre* of everyday life', in the words of Léon Fourmanoit. See *Des Luttes . . . des hommes . . . et du Borinage, 1910–1925 chronique* (n.p., 1981), 12. Unfortunately, this writer also succumbs to the practise of neglecting women in his narrative.

THE BLACK COUNTRY

Mining country is a moving and often murderous arena.

Camille Lemonnier[8]

Although none of Belgium's coal districts—Charleroi, Liège, or the con-
geries of tiny villages near Mons—differed significantly in the levels
of misery endured by their inhabitants, it was the latter, the infamous
Borinage, that garnered most public attention. Even other miners believed
that the Borains comprised the most unfortunate of the country's coal-
miners. One Liégeois, for example, called the Borinage 'that region of
misery and desolation'.[9]

Still, not all was sorrow and suffering. During his missionary sojourn in
the Borinage in 1878 and 1879, Vincent Van Gogh wrote to his brother
Theo describing evenings in the tiny mining village of Wasmes:

It was an intriguing sight to see the miners going home in the white snow in the
evenings at twilight. Those people are quite black. When they come out of the dark
mines into daylight they look exactly like chimney sweeps. Their houses are very
small and might better be called huts; they are scattered along the sunken roads
and in the wood, and on the slopes of the hills. Here and there one can see moss-
covered roofs and in the evening the light shines kindly through the small-paned
windows.[10]

The Dutch painter's scattered 'kindly lights' marked a semi-rural scene,
duplicated all over the Borinage, where the names of communes hinted at a
more bucolic past: Pâturages, Frameries, and Cuesmes, for example, all
evoked a peasant idyll very different from the industrial hell emerging by
mid-century.[11]

As everywhere else in industrializing Belgium, the Borinage grew
increasingly crowded and squalid. Belying its poetic name, Pâturages at
mid-century included one miners' district that rivalled Ghent's more notori-
ous Batavia. Ironically named after the patron saint of coal-miners, this
Quarter Sainte-Barbe provoked one visitor to write:

If one descends into the reality of the streets, the alleys, and the *impasses*, and if one
penetrates into the little white-washed houses, a disagreeable impression of need,

[8] Lemonnier, C., *La Belgique* (Paris, 1888), 452.

[9] Bonda, J., *Histoire anécdotique du mouvement ouvrier au pays du Liège* (Liège, 1949), 46.

[10] Van Gogh, *Complete Letters*, i, 183.

[11] See Fauviau, H., *Le Borinage: Monographie politique, économique, et sociale* (Frameries,
1929), 30.

of overpopulation, of ugliness and of the absolute absence of health sends one rapidly away . . . The houses, aligned with an imperative symmetry, are tumbledown and dirty. The ensemble inspires horror and disgust.[12]

The ex-miner, writer, and socialist deputy, Achille Delattre, recalled a typical Borinage miner's house from his childhood. It was shared by ten family members living in a single room. The room, measuring 4 x 4 x 2.5 metres, was floored with blue stone. Walls were whitewashed with 'a liquid, yellow chalk'. Unlike many textile-workers, these miners owned some furniture, including 'a modest wardrobe, a linen dresser, and table, a cradle, and several chairs'. Most Borains added a few decorations: Delattre remembered vases and one statue of the sacred heart, protected by a glass globe. A little *armoire* held cheese and butter; a copper crucifix hung above the fireplace. Covering the room's single window was a white lace curtain. After dark, the family lit their one gas-lamp. On the wall, an old clock ticked away the hours.[13]

Huddled close together, hundreds of such tiny houses formed 'a veritable labyrinth, bordering innumerable alleys and passageways', in the words of a contemporary. 'These miserable huts', together with 'a few dead trees, blackened by smoke, some bramble hedges, heaps of rubbish and ashes, mountains of coal waste', clustered around the coal pits. Every household kept rabbits, and a few fortunate families owned goats or lambs.[14] Any vacant land was planted by these once-rural people. Their tiny gardens, in fact, were often blamed for their unusual enthusiasm for strikes, since their survival did not depend entirely on their wages.

Daily life in the Borinage was shaped entirely by the coal-mines. The historian of the region, Jean Puissant, has argued persuasively that so compelling were the rhythms of the mines that newcomers were rapidly transformed into Borains. And indeed, they had little choice but to conform to the patterns of miners' lives: by 1866 15 of the 16 coal communes of the Borinage held more than 500 people per square kilometer.[15] On the other hand, crowding did not necessarily mean a high

[12] Ibid.

[13] Photographs, as well as written descriptions of miners' homes, show less of the emptiness of textile houses. Rooms included furniture—a table, a few chairs, washstands, stools—and some modest knick-knacks. There were curtains at windows, and flowered wallpaper on the walls. See photographs in the Musée de la vie wallonne. A good description is in Delattre, A., *Histoire de nos corons* (Verviers, 1953), 7.

[14] Duez, G., *Vincent Van Gogh au Borinage* (Mons, 1986), 24, 31, 33. See also Watelet, H., *Une Industrialisation sans développement: Le bassin de Mons et le charbonnage du Grand-Hornu du milieu du XVIIIe au milieu du XIXe siècle* (Ottawa, 1980), 151–2.

[15] Puissant, J., *L'Évolution du mouvement ouvrier socialiste dans le Borinage* (Brussels, 1982), 31, 32, 70.

level of public noise, such as that common to other industrial centres. In fact, some found the Borinage a curiously silent place. Van Gogh, for example, was perplexed by the 'desolate, deserted, dead air' of the villages when he arrived. But he soon realized the reason for the eerie quiet: 'Life', he wrote, 'is concentrated below the ground, not above'.[16]

Such silence was not characteristic of Belgium's two other coal districts. In Liège, by contrast, mining families often included members who worked in one of the hundreds of other industrial and proto-industrial occupations available there throughout the nineteenth century. Given the fact that Liège's workers' *quartiers* were every bit as crowded as those in the Borinage, the noise level was high. Such density also inevitably meant squalor. So tightly had speculators filled every corner of Liège's poor districts that workers' housing was 'repulsively dirty'. Not surprisingly, most miners preferred to live their lives 'out of doors', according to a local physician.[17]

The shape of workers' housing in Liège and Charleroi included both *corons*, identical to Ghent's *enclos*, and a second type, known as *impasses*. These were tiny, narrow, dead-end side streets, crammed with equally tiny, equally narrow houses—each divided into as many rooms as possible. 'The rooms are low,' wrote a visitor, 'obscure, smoky, dirty; the rubbish stagnates. The beds are a few disgusting litters'.[18]

Despite the willingness of speculators to build thousands of tiny, dark dwellings, the numbers of coal miners in Liège soon exceeded available housing in the city proper. Thus began lengthy daily commuting by miners, from the countryside surrounding Liège's mines. They travelled on foot; health officials worried constantly about the deleterious effects of the long trek to and from the coal pits. And the journey was made in filthy, sweat-soaked clothing, as no mines offered either bathing or changing facilities for underground workers until just before the First World War.

'The Miners' Return', immortalized in dozens of nineteenth-century paintings and photographs, marked daily life all over Belgium's *pays noir*. As the years wore on, and manners changed, more observers began remarking the fact that women and children were included in the daily journey. Their greatest concern, however, was not for the hardships or dangers faced by the objects of their attentions. Rather, they complained

[16] Quoted ibid. 64.

[17] *Enquête—1846*, iii, 140–1. (The speaker was Nicolas Peetermans of the Liège public health commission.)

[18] Kuborn, H., with Devaux, A., Dupont, E., Laho, U., and Vandervelde, G., *Aperçu historique sur l'hygiène publique en Belgique depuis 1830* (Brussels, 1897), 62.

repeatedly about the morals of female miners who returned home to change and even bathe in the presence of male family members!

So vociferous did bourgeois complaints grow that a few mine-owners—in Charleroi as well as in Liège—built men's and women's changing rooms at their mines. These, according to one mine engineer, were 'moral rooms', where workers were kept separate both before and after going down the mines. Some mine-owners, however, although willing to keep the sexes separate before and after work, provided changing facilities only to male miners. Most women, therefore, were forced to wear their work uniforms all the time. (These 'men's clothes', as they were called, horrified those who watched the women miners on their journeys to and from the coal pits, as we shall see.)[19]

Such improvements as changing rooms were scattered and few throughout our period. And as for baths, these remained virtually unknown in most of the Black Country. As late as 1910 baths were available to only 20 per cent of the nation's miners. (Most were in Liège, where 43 mines provided them. Still, some miners refused to use them, even when they were available: one health worker counted 16,650 miners who used the baths everyday, and 5,000 who did not.)[20] What reforms there were were not prompted by bourgeois concerns for health. Rather, most owners and officials saw a link between miners' dirt and public disorder and immorality. One typical reformer argued that if miners went home 'well-washed and properly-clothed, they would . . . be less likely to frequent the café-bars near the coal mines'.[21]

Life and Death in the Black Country

Daily life in mining communities changed relatively little in the course of the middle decades of the nineteenth-century, and its textures were common to all three of Belgium's mining regions. Life began with only the briefest of childhoods: girls' youngest years were replete with hours of domestic drudgery; boys, less burdened with housework and child-care, sometimes enjoyed a few years of schooling. Both boys and girls learned coal early, however, as they accompanied their mothers to glean on the high black mountains of waste that surrounded every mine. By the age of

[19] No. 140, 'Beaujean. Hoofdingenieur der mijnen, aan Jochams, directeur, 7 aug. 1868', in *Documenten*, iii.
[20] See ibid. and *Éxposition universelle et internationale de Bruxelles, 1910: L'Éxposition collective des charbonnages de Belgique* (Brussels, 1910), 134.
[21] *Éxposition universelle—1910*, 134–5.

10 most were at regular work in the mines. (Local minimum age laws varied, but the absence of legal sanctions or mine inspectors meant that almost no one obeyed child labour regulations, even where they existed.) Few children learned to read or write; illiteracy remained high in mining communities throughout the century.

For adult women miners, the birth of children usually signalled an end to work underground. From their mid- to late-20s, then, most adult women earned their wages at the surface. Some found work 'gleaning' for the coal companies (work available only at the largest mines where reclaiming saleable coal was profitable). A few left mining altogether, and earned their wages running small shops or café-bars, or selling various goods door to door. Still others took jobs in one of the many sweated trades that dotted coal country. Whatever their source of income, however, all women spent many hours in domestic labour. Miners preferred large families. One outsider ventured the opinion that their 'busy family lives' helped to 'balance the isolation' of work underground. Indeed, it was frequently said that a male miner would quite willingly marry 'an old lady' if she had many children, and it was the case that widows often married much younger men in mining country.[22]

Such constant child-bearing took its toll, as childbirth in mining communities was hazardous for both mothers and infants. In the 1860s a doctor reported that 20 of every 1,000 women who died in Charleroi had died in childbirth; figures for Liège were similar. (In Belgium as a whole, maternity was only slightly less risky: the rate was 18/1,000.) In an effort to counter such dangers, mining women practised what one historian has termed 'magico-religious' rituals during pregnancy. Amongst the most assiduously practised rites were those dedicated to two saints helpful to mothers, Saint Anne and Saint Catherine.[23]

Still births were common—though not so frequent as in textile towns. In 1865 these key mining communes showed the following numbers of still births:

[22] According to A. Duveau, a Liège mine engineer, see *Enquête—1846*, ii, 306. Mortality rates for males and females were high—due to mine accidents, ill-health, and for women, the hazards of childbirth. Miners of both sexes remarried because few could survive alone without the wages and services of a spouse.

[23] *Travail des femmes*, 26; and Dubois-Maquet, N. and Pinon, R., *Parures et métiers de la femme au XIXe siècle, Liège, 26 mai–30 oct. 1977*, Musée de la vie wallonne (Liège, 1977), 9.

Seraing	1 in 15 births
Châtelet	1 in 16
Pâturages	1 in 12
Montigny-sur-Sambre	1 in 12
Dour	1 in 10
Gilly	1 in 17.[24]

Most mining women gave birth without the aid of doctors. In the period between 1855 and 1861, for example, one coal community of nearly 36,000 people (3,600 of them working in the mines) had only 123 doctor-assisted births. Of these, 91 had 'required hand or instrument intervention'. Of the 91 women who suffered 'more or less painful manoeuvres' (in the doctors' own words), 32 were coal-miners. Eleven of their babies, and six of the women, subsequently died.[25]

Mining children were precious. Women miners rarely, if ever, resorted to abortion—although techniques were known and pharmacists were a common source of abortifacients.[26] Moreover, mining children were never 'exposed' or abandoned. Like most textile-workers, miners willingly took in orphaned children, and they were, sadly, far more common in mining communities due to the much greater likelihood of fatal work accidents.[27]

Another sign of miners' love of children was the low rate of illegitimacy. Pregnancy almost always led to marriage (or, more rarely, extra-legal, but permanent, unions). There were almost no single mothers in miners' *quartiers*. Despite the wishful claims of many bourgeois reformers, illegitimacy was far higher in rural districts than in purportedly 'immoral' mining towns. In 1846, for example, research showed that the rural communes around Mons had an illegitimacy rate 1.73 times higher than that in mining communes in the Borinage. In Cuesmes, the rate was 1 illegitimate birth in 25 live births, compared with 1 in 11 in Belgium as a whole. And the mothers of illegitimate babies in Cuesmes were rarely coal-miners; most were, instead, domestic servants or 'dailies'.[28]

Similarly, in the 1860s Seraing's rate was linked more to non-mining women than to those who worked in coal: of 97 illegitimate children born between 1866 and 1868, 46 were born to 'dailies', nineteen to 'ménagères'

[24] Fossion, N., *Réponse au rapport de M. Kuborn sur le travail des femmes dans les mines* (Brussels, 1869), 21.
[25] Kuborn's *Rapport*, 29.
[26] See *Travail des femmes*, 27. Van Bastelaer, a pharmacist, claimed that requests for abortifacients were common from non-mining women.
[27] Eugène Bidaut (Charleroy), quoted in *Enquête—1846*, ii, 291.
[28] *Rapport de L'Union*, 24.

(sic), nine to seamstresses, and eight to servants. Only three were children of coal-miners, with a further three born to shopkeepers, two to *cabaretières*, one to a glass-maker, one to a fruit-seller, and one to a prostitute.[29]

Women coal-miners' experience of childbirth drew considerable public attention in the course of the century—far more attention, indeed, than the more dangerous maternity of women textile-workers. Yet the diseases and dangers that more usually 'conducted them slowly but cruelly to the tomb', as one outsider put it, were ignored. A few noted the 'maladie des fosses'—a category that included all the respiratory ailments common to coal-miners everywhere—but none prescribed remedies. In addition to such work-related disease, miners shared other illnesses with all industrial workers, including tuberculosis, rickets, scrofula, and the epidemic diseases, cholera and typhoid.[30]

Ironically, perhaps, women coal-miners' generally better health did not prevent their vociferous complaints. One Charleroi mining doctor noted that they regularly lamented the pain they suffered with menstruation. Despite such pain, however, the physician noted that they were, in reality, far fitter than women workers in other industries because of their constant exercise. One sign of their good health was their height: statistics showed that mining women were taller than women in other occupations.[31]

A second witness, a Liège mine engineer, supported the doctor's conclusion. He wrote that mining women never showed 'the debilitation and cadaverous pallor' prevalent amongst factory workers. Women coal-miners were also cleaner than textile operatives, bathing at least twice a week. (Men miners, by contrast, limited their baths to one a week, though they, like the women, 'washed their hands and faces many times a day'.) The women also laundered the family clothes at least once every week.[32]

In addition to being cleaner and healthier than other industrial workers, miners were also more law-abiding. In the decade of the 1850s, in the province of Hainaut, only 1 person of every 27,198 inhabitants was arrested for a crime; Liège had only 1 in 35,864; in Belgium as a whole, on the other hand, the rate was much higher: 1 accused criminal for every 17,784 inhabitants.[33]

This low criminality rate, together with low illegitimacy figures, per-

[29] Ibid.
[30] N. Fossion in *Enquête—1846*, iii, 65, 60.
[31] M. Schoenfeld, ibid. 30, 32, 33.
[32] J. Gernaert, ibid., ii, 315.
[33] Figures from *Travail des femmes*, 34. The nature of these crimes is unknown. It should be recalled, however, that 'indigence', 'vagrancy', and 'begging' were usually classed as crimes.

plexed many bourgeois reformers who cherished a portrait of 'pariah' miners. Those who began increasingly to argue for the legal exclusion of women from underground mining doubled their efforts to find evidence of miners' collective immorality or ill-health. A handful of physicians claimed that doing men's work transformed women's reproductive physiognomy into male forms. Pelvises, they argued, narrowed, making childbirth nearly impossible. But unfortunately for them, both female midwives and statistics argued against this view.[34]

Still, they did not give up easily. One group of would-be reformers finally identified a key character flaw typical of miners. This 'vanity' was shared equally by male and female miners, driving them to indulge 'in black clothes, artificial flowers, and watches'. A Liège doctor added, 'Vanity is a powerful lever and makes male workers want beautiful, clean clothes'. They were all 'addicted to their Sunday costumes', which they bought 'even whilst lacking the most indispensable things of life at home'.[35] (These were the same people described by another contemporary as 'plunged in a gloomy silence and sapped by a slow fever from an early age'.[36])

Schooling

For children in mining communities in the mid-nineteenth century, education was rare. Only a few mining children (and those mostly boys), attended school at all. Fewer still stayed longer than 1 or 2 years: by the age of 10 most boys and girls were at work in the mines.[37] There were a few valiant souls who tried to teach mining children, but they struggled against public indifference to their efforts. One desperate *institutrice* wrote to the communal council of Wasmes in 1845 that she had received only 36 francs to pay for schooling 20 pupils. Although the local *caisse de prévoyance* had voted 800 francs for the education of miners' children, she had received none of the money. Several decades later little had changed: in the 1860s,

[34] Both quoted in Kuborn's *Rapport*, 24, 25–7. Dr H., of Charleroi, claimed that amongst females who went down the mines before puberty, 'pelvic problems are common ... [the pelvis] is often narrow in its "antero-posterieur" diameter'. A local midwife denied this claim, driving the doctor to note 'her declarations are not very precise and there is nothing conclusive'.

[35] De Bruyn (Liège), and Bidaut, both in *Enquête—1846*, ii, 82, 291, resp., and Fossion, ibid. iii, 87.

[36] Ibid. ii, 322.

[37] See, *inter alia*, Bidaut's testimony, ibid. ii, 285, and Marichal, H., *L'Ouvrier mineur en Belgique: De qu'il est, ce qu'il doit être* (Paris, 1869), 13; AEM,, Commune de Wasmes, no. 663; and Puissant, *Évolution du mouvement*, 73.

the city of Charleroi spent only about 10 centimes per worker's child on public schooling.[38] In the nearby Borinage in that decade, the *bourgmèstre* and *échevins* of Wasmes tried to remedy the sins of earlier neglect by establishing adult schools for miners. But by then it was too late, and few miners—exhausted after their days digging and hauling coal—chose to spend their evenings in communal schools.[39] (Not until the 1870s and 1880s did local schools appear—often run by nuns and priests. Even then, however, few mine-working children attended even the schools held on their day off from work.)[40]

The Standard of Living

In these years, Édouard Ducpétiaux, bourgeois Belgium's conscience, undertook to study workers' expenses. In a book published in the 1850s he concluded that a typical family of six needed the wages of at least four family members to survive. His calculations, based on a working year of 300 days, included the following:

$$\begin{aligned}
\text{father } 1.56 \text{ fr./day} &= 468 \text{ fr./year} \\
\text{mother } 0.89 \text{ fr./day} &= 267 \text{ fr./year} \\
\text{oldest boy } 0.56 \text{ fr./day} &= 168 \text{ fr./year} \\
\text{oldest girl } 0.55 \text{ fr./day} &= 165 \text{ fr./year}
\end{aligned}$$

The family total was, therefore, 1,068 francs a year. Ducpétiaux compared this yearly income with that spent by the Belgian government to support its military forces. Every sailor cost the state 1,828 fr., and every soldier, 1,475 fr. each year. Even prisoners enjoyed a higher standard of nutrition than the nation's workers. Each male adult prisoner, for example, ate 1,122 fr. worth of food per year—an amount an adult male factory worker could only dream about.[41]

Workers, of course, paid not only for food for several people, but also for housing, clothing, and other necessities. Thus most suffered badly by

[38] AEM, Commune de Wasmes, 'Lettre, Épouse Renoite à l'administration communal de Wasmes, 7 sept. 1845', and Marichal, *L'Ouvrier mineur*, 29.

[39] These documents are in AEM.

[40] See Wouters, C. and Deneubourg, P., *Réflexions sur le travail des femmes dans les mines* (Mons, 1870), 17–18. The women who did attend Sunday schools were much praised. One bourgeois observer wrote, 'these *charbonnières* use Sunday, very properly a day of rest, to form their minds and their hearts, as during the week they develop their bodies and their limbs'.

[41] See Ducpétiaux, É., *Budgets économiques des classes ouvrières en Belgique*, i, ii (Brussels, 1855). See also Bonda, *Histoire anécdotique*, 9.

comparison to conscripts or prisoners. But what of miners? As in most
countries, Belgium's miners earned higher wages than most factory workers.
For women especially, the wages they could earn underground were
considerably better than those available in the mills or workshops of
industrial centres. In the 1840s, for example, the following wages were
paid in the mines:

adult 'fit' men	2.34–2.61 fr./day
adult 'weak' men	1.60–1.70 fr./day
adult women	1.05–2.66 fr./day

(It was not clear why women's wages included both the lowest and the
highest wages paid in the industry.)

Comparative wages in other industries demonstrate the desirability of
mining pay:

	Wages (fr./day)	
	Women	Men
sugar-beet refineries	1.0	1.25
steel-mills	1.0	3.50
cotton-spinning mills	0.75	2.10
glass manufactures	1.70	9.0

For women, then, mining offered the sole hope of decent wages—
though only after very long, very hard, and very dangerous working
days.[42]

Wage-rates were never constant, in mining or in any other industry (nor
were figures necessarily accurate). One estimate of miners' wages in 1868
in Liège suggests, indeed, that at the upper levels, women's wages had
dropped whilst men's had risen since the 1840s. In francs per day, the
estimate showed the following:

	Underground work	*Surface work*
men	3.06	2.24
women	1.64	1.19
boys	1.43	0.83
girls	1.31	0.74

[42] See *Enquête—1846*, ii, 113.

These wages were earned on 12-hour shifts.[43]

The discrepancy in women's wages in the mines of the Liège area may have had less to do with changes over time and more to do with the fact that fewer women worked in the most laborious jobs—including 'hauling' and 'breaking'—which were, of necessity, more highly paid. Nevertheless, these 1860s estimates suggest that most mining families were barely scraping by in that decade. Even a family with the unlikely combination of four underground workers, working 300 days in a year, earned only 2,232 francs, nowhere near the figure necessary to feed the four miners as much as soldiers or prisoners were expected to eat.[44]

Miners' diets, then, depended on cheap food. Most lived on bread and potatoes, the latter often grown by the miners themselves in tiny gardens. Sometimes frugal families added a few vegetables and even some meat— though the latter was usually reserved for Sundays or holidays. They also consumed lard and some butter, as well as a little sugar. Chicory diluted their daily coffee. Women ate less than men and children, and when there were shortages, they were the first to go without. Achille Delattre recalled that when hard times struck his village, women often 'stopped eating altogether' so that other family members could have enough.[45]

Given the general scarcity of money in mining families, it was silly for the bourgeoisie to attempt to impose the same principles of property accumulation they prescribed for the nation's textile-workers. But they still tried. Savings banks were encouraged, and mine-owners frequently added their support by establishing insurance funds for their workers. In this case, owners withheld workers' voluntary contributions from their wages. The difficulty inherent in such a practice, however, soon became clear. By the final quarter of the nineteenth century, only 73,200 Belgian workers belonged to such schemes, each having saved only about 21 francs![46] Such tiny sums made virtually no difference to miners' ability to cope with emergencies. When they retired, moreover, their situation became still worse. Although the Borinage had a handful of miners' pension funds, they paid only derisory amounts. Jean Puissant has calculated that those who had worked 50 years in the mines, and who belonged to Mons' *caisse de prévoyance*, got a yearly pension of just 144 francs. This, Puissant adds, was

[43] Dumont, *Vie quotidienne*, 79.

[44] See ibid. 80.

[45] In Puissant, *Évolution du mouvement*, 67–8, Delattre, A., *Combat* (Brussels, 1949), and Rowntree, H. S., *Land and Labour: Lessons from Belgium* (London, 1911), 108.

[46] Figures from Puissant, *Évolution du mouvement*, 70, and *Éxposition universelle—1910*, 157–60.

less than the price of one loaf of bread a day.[47] And for miners in Liège
and Charleroi, there was not even that; no such *caisses* existed.

In addition to the daily struggle for existence, most miners also suffered
illness and premature death. 'The Borain earth was often a sorrowful
theatre', Delattre remembered.[48] Working children were easily spotted:
most had mutilated limbs, burn scars, and twisted bones. One Charleroi
mine doctor was plagued by 'constant sorrow' after years of amputating
mine children's arms and legs'.[49] *Pays noir* it was, indeed.

Popular Culture

Life was not unrelievedly grim, of course. Miners' towns and villages
regularly burst into life—during the annual miners' *fête* of Sainte-Barbe, and
on virtually every day off from the mine. Before detailing such events,
however, it is important to underline the highly regional character of
miners' sociability. The miners of Liège enjoyed festivals and rituals quite
different from those of their counterparts in the Borinage or Charleroi.

The extent of Belgian regionalism is particularly notable because most
non-Belgian historians treat the country not as a cluster of several distinct
regions but rather as a nation divided in half by language and culture.
Indeed, Jean Stengers has argued that this view has become dominant even
amongst Belgians themselves, who believe that 'there have long been two
"natural" groups, the Flemings and the Walloons, who were artificially
herded together [in 1830]'.[50] Yet such a binary division—while arguably
prevalent by the end of our period—was not significant during most of
the nineteenth century. No consistent 'Walloon' traditions characterized all
of French-speaking Belgium any more than 'Flemish' practices spread
uniformly across Flemish-speaking regions. Every locale had its own
customs, songs, styles—and even its own work uniforms. (This was
strikingly the case for women miners. A woman from the Borinage coal
pits would instantly have recognized a sister from Liège or Charleroi, as
we shall see, below.)

Women played an essential role in the community life of mining
quartiers. Girls and boys learnt the strict rituals of their trade when they
went down the mines at 10 or 11. When motherhood claimed most of the

[47] *Éxposition universelle—1910*, 155.
[48] Delattre, *Histoire de nos corons*, 7.
[49] *Nouvelles recherches*, 30, and Fossion, *Réponse au rapport de M. Kuborn*, 37, 43.
[50] Stengers, J., 'Belgian National Sentiments', in Lijphart, A. (ed.), *Conflict and Coexistence in Belgium: The Dynamics of a Culturally-Divided Society* (Berkeley, Calif., 1988), 46–60.

young women, they joined the above-ground army of workers, running tiny shops and *cabarets* (key sites of gossip and politics), and working door-to-door. Those who earned their wages in sweated work (sewing, embroidering, making lace, spinning) followed the Belgian custom and set up their lace-pillows, work tables, and so on on the pavements just outside their front doors. There, they were the guardians of virtually every aspect of community life.

Because they earned an equal membership in the highly ritualistic world of the coal-mines, women in Cuesmes or Pâturages, in Montigny-sur-Sambre, or in Liège, were never marginalized from the core of social life. Unlike those thousands of mining wives and mothers, whose tragic faces clustered at the pit-head in mine disasters almost everywhere else in the industrial world, Belgium's mining women were not only a black-veiled Greek chorus of sorrow, awaiting the bodies of their men. Instead, they, too, lived and died for coal—and local *pietàs* were as likely to include a father grieving over the lifeless body of a daughter killed underground as a more traditional mother and son.

Thus the world created by women retired from underground work reflected their experiences of the mines. And it was an active world; despite Van Gogh's impression of desolate, dead Borinage villages, most outsiders described a cacophony of street noise—children playing, merchants crying their wares, women chatting as they worked, and people singing on their way to and from the pits and slag-heaps. (As was customary amongst outside visitors, explanations for the high level of street noise focused on the mines. One contemporary explained it by claiming that it compensated for what he imagined to be an entirely silent world below ground.)[51]

Miners were addicted to ceremonies and formal practices that offered them at least a tenuous sense of control over the dangers that beset them. And here, again, women were central. In all the events that marked each individual life—birth, illness, first communion, marriage, death—it was the women who cared for, guarded, taught, and, at the end of life, buried their neighbours. Key in every mining town or village were midwives and healers—the first and last resorts for most poor mining families. Other important women were famous cooks, much sought after at every community celebration. Such women were believed to hold special powers, not unlike those traditionally linked to pre-industrial 'wise women'.

Miners readily mixed folklore and religion. Their lives, Vincent Van

[51] See Dubois-Maquet and Pinon, *Parures et métiers*, 11.

Gogh explained, rendered them particularly susceptible to the message of mystical suffering offered in the Bible. 'Those who work in the darkness, in the entrails of the earth ... are moved by the words of the Gospel', he wrote.[52] When neither Protestantism (widespread in the Borinage in Van Gogh's day) nor traditional Catholicism sufficed to satify their collective love of religious mysticism, thousands of Belgium's miners turned to an apocalyptic cult founded in the Liège mines in the final quarter of the century. This new 'healing' religion, led by an ex-miner called Antoine le Guerisseur, spread quickly; at the close of the century, 160,000 believers petitioned Parliament for official recognition of their 'Antoinisme'.[53]

For all Belgium's coal-miners, child or adult, female or male, the yearly festival honouring Sainte-Barbe marked the high point of the year. The saint's day fell in early December; preparations began weeks earlier as every mining family planned its celebrations. Several descriptions of the festivities exist, but the most evocative is that written by Marius Renard in 1924. Recalling the festival in the Grand-Hornu mine near Charleroi, he wrote:

In those days, the pit still had some of the look of old times. Working at sifting with a good will, the 'tions' [also called 'tchons', the *trieuses de charbon*] amused themselves roughly, tossing sorted pieces over the top of the hoppers into the laps of the tumblers. The wagons made a hellish racket on the stop blocks. And above all the blows and all the cries, there was also the eternal beating of the steam engine, releasing its vapour in great deafening thumps. On that eve of Saint-Barbe, I had descended to 700 metres. There was lots of movement, some songs, some 'bubbling' as one says in the pits and cuttings. Some of the winding girls (*sic*) looked busy, and here and there one cried out 'Vive Sainte-Barbe' but no more ... Then, towards four o'clock, at the moment when the day shift began to go up, there appeared out of the darkness into the clear light of the little lamps, a singular cortège; some 'd'jambots' [young women workers] in blue head scarves, some 'tions' appeared, carrying a morsel of wood ... carved by the miners' little hatchets and dressed in a woman miner's loose jacket, with a corsage and in a bright scarf that gave the illusion of a skirt. On the head, some paper flowers were pinned on a bit of mousseline to form a veil. My! the face was white! It was the Sainte-Barbe of our shift.

Girls and boys linked hands and circled the figure, singing,

One hears in the fields
The most charming echoes

[52] Quoted in Puissant, *Évolution du mouvement*, 75.
[53] Pierard, L., *En Wallonie* (Brussels, 1911), 50. The government ignored the petition and the cult died away.

> No, no, Sainte-Barbe is not dead
> She is living still, she is living still!

Renard remembered men leaning together against the wall, laughing at the children's antics, 'but with discretion, not out of respect for the puerile wooden divinity, but out of respect for ancient custom'.

When the dance ended, the young women placed Sainte-Barbe on to a waggon in the middle of a circle of miners' lamps. The workers took their places in other waggons, and the *Saquer* signalled for the ascent. 'It was all over but for the final singing'. Once out of the mine, the figure was carried through the village streets, led by a young woman dressed as Sainte-Barbe. As her lamp appeared in each *coron*, residents joined the procession, singing.[54]

This rudimentary wooden statue was not the only image of the miners' patron saint. In many of the larger pits, more sophisticated figures of Sainte-Barbe stood in alcoves, lit throughout the year by lamps placed nearby. From time to time, miners decorated these images with flowers and (unlit) candles, just as others might do in the above-ground cathedrals of their faith.[55]

However solemn the ceremonies attending Sainte-Barbe below ground, festivities outside the mines were noisy and gay. Achille Delattre described the annual *fête* as the high point of his childhood. The first day began with a visit to each family's 'local'. The Delattre family's neighbourhood café was kept by a woman called Rose, who marked the occasion with a small gift for everyone—cigars for the men, flowers for the women. Everyone drank, and 'sang and sang as alcohol ran and ran'. Soon, Delattre remembered, 'drunkenness spread through the men and women'. People began to wander from cabaret to cabaret, meeting up with friends from the pits. '*Hiercheuses and scloneurs*', he wrote, 'joined their ringing voices together, filling the *coron* with their laughter'. The day ended as everyone returned home, where the men in the family received 'a new pipe and a piece of spice cake'. After three such days, miners 're-entered the mine totally exhausted'.[56]

Sainte-Barbe was not the only festival in the miners' calendar. Indeed, *kermesses* were so frequent that many bourgeois observers complained that

[54] Renard, M., 'Souvenir de Saint-Barbe', *L'Aurore* (Dec. 1924), quoted in Fourmanoit, *Des Luttes*, 22, and Mahieu, R. G. W., *Les Hommes des fosses du Borinage* (Hornu, 1987), 20. Melléry, X., who usually painted factory workers, produced one picture showing young *hiercheuses* decorating a statue of Saint-Barbe while male miners watched.

[55] See Mahieu, *Hommes des fosses*.

[56] Delattre, A., *Chant de la mine* (Liège, n.d.), 39.

miners wasted most of their wages in celebrations. 'They work assiduously from morning to evening', wrote one official, 'but do they save for their futures? Not at all: a kermesse comes along, the patronal *fête* [and] you see them for three or four days running, promenading about in flag-decorated wagons, singing at the top of their voices and thus dissipating, in a few moments, their economies. Following these excesses', he continued, 'they fall into the deepest misery, obliged to . . . implore the masters (*sic*) of the poor for help'.[57]

Despite this writer's convictions, however, there is no evidence to suggest that miners regretted their profligacy—or grovelled before those who controlled local charities. Indeed, the contrary was more usually the case. Miners were notorious for their 'rash and rebellious' natures, and were believed to be 'opinionated, resolute, defiant of weakness'.[58] Van Gogh thought that most considered them 'a race of malefactors and brigands'.[59] And their collective insouciance was constantly remarked. Miners, everyone noted, sang all the time—at work and in the courtyards and roads of their towns. They usually sang of their work. One typical song went:

> 'Travaillez à la déchaine
> Et le jour de la quinzaine
> D'une main on va les chercher
> De l'autre, on doit les cracher . . .'

Another told of miners' cherished ties with the Belgian countryside, a link celebrated in another yearly *fête*, 'Escouvion'. 'À l'Escouvion', they sang, 'port panes [pommes]/Porte poires/Porte "chérises" toutes noires/À l'Escouvion . . .'[60]

As they did everywhere in working-class Belgium, puppets played an essential part in every miners' holiday. Here, however, the puppets came inside the ubiquitous cabarets of miners' quartiers, where they joined in the festivities. During the spring Escouvion, for example, a female puppet was enthroned on a table in the centre of the café. Women joined hands and circled the puppet, singing a 'Wallon' song—weighty with *double entendre*—which told of girls who carried sacks of grain to the miller. The chorus concluded:

> Toutes les femmes de Pâturages
> Elles on' bien d'la liberté.

[57] Testimony in *Enquête—1846*, ii, 27.
[58] Lemonnier, *Belgique*, 451–2.
[59] Van Gogh, *Complete Letters*, i, 65.
[60] Quoted in Delattre, *Histoire de nos corons*, 33, 10.

Others in the room beat time with their wooden sabots, while the men joined in the chorus.[61]

Although every corner of Charleroi or the Borinage had its marionettes, the most famous puppet of all lived in Liège. 'Tchantchès', the city's ancient mascot, embodied the irrepressibility of the Liègeoises. Even in nativity plays he was impertinent. 'Tchanchet', wrote one observer, 'spoke sharply to Mary, Joseph, or to the "Poyon" who came to be born'. In the nineteenth century, Tchantchès earned a reputation for industrial rebelliousness. Louis Pierard has claimed, in fact, that the people of Liège 'rebelled with Tchantchès', and the city's people clearly agreed. In the 1930s they erected a monument to the disobedient puppet—held aloft by a large figure of a female coal-miner.[62] (We shall return to the symbolism of this monument later.)

Although all Belgium's miners were highly sociable—like all Belgians they were indefatigable 'joiners' of clubs and groups of every variety—there were key differences in the way they lived their collective lives. The Borains, for instance, were more inwardly focused—perhaps because of their reputation as 'malefactors and brigands'. Outsiders agreed that they distrusted 'foreigners', and presented an impenetrably solemn mask to unwanted visitors to their *fêtes* and *kermesses*. Most who visited the Borinage, in fact, described a 'simple and moving fatalism . . . weighing on the Borains'.[63]

The miners of Charleroi were also viewed through the lenses of similarly distrustful stereotypes by those who ventured into the tiny villages circling every great mountain of black slag heaped around the city. However, some visitors found the Carolingians less inscrutable than their Borain neighbours. When the British traveller Arthur Munby visited Charleroi's mines, for example, he found the miners—and especially the women miners—to be practical, stolid people, but ready nevertheless to express both pride in their work and a deep sense of fun.[64]

The Liègeoises, on the other hand, inhabited the city widely considered

[61] Delattre, *Combat*, 126, 97. Jules Destrée, Charleroi's socialist deputy, later suggested that the great general strike of spring 1886 was prompted by miners' longing to celebrate nature: see Ch. 8.

[62] Pierard, *Wallonie*, 159.

[63] Ibid. 99, 158. See also Varlez, L., *Quelques pages d'histoire syndicale belge* (Paris, 1902), 87; Greer-Saussez, M. (ed.), *Le Borinage au temps de Vincent Van Gogh: Exposition organisée par l'office du tourisme de la ville de Mons* (Mons, n.d.), 16, 17; Puissant, *Évolution du mouvement*, 81–2, and Van Gogh, *Complete Letters*, i, 65.

[64] Munby's visit to Charleroi is recorded in his notes and diaries in the Munby Collection. See also Hiley, M., *Victorian Working Women, Portraits from Life* (Boston, Mass., 1980), 99–100. I am grateful to Clare Collins for this reference.

to be Belgium's Paris, and their collective *joie de vivre* (or rebellious-
ness, depending on perspective) reflected some of that French city's
reputation for frivolity and fun. A witness described Liège's miners'
'merriment and sentimentality'; they were 'at once full of jokes and rather
mystical'.[65]

Despite these differences in regional stereotypes, all Walloon workers
were believed by outsiders to differ more significantly from their Flemish
counterparts than from each other. Even a generally shared religion—
Catholicism—did not signal similar practices in the two regions. Louis
Pierard compared 'the fierce procession of hooded penitents in [Flemish]
Furnes to the amiable parades in the country of the Sambre-et-Meuse,
where one sees joyous marchers, all a bit tipsy, sporting authentic Napo-
leonic uniforms, escorting some pretty roman or gothic shrine, pulling as
though under fire whilst executing some wild *entrechats*'.[66] Whatever the
accuracy of this Walloon's observations, it was certainly the case that the
street life of Liège, Charleroi, and the Borinage was considerably livelier
and more frivolous than that of Ghent's bleak *enclos* and *impasses* through-
out the nineteenth century.[67]

WORK IN THE MINES

Here I sing the mine, I sing the miners
I sing our *corons* and their sombre atmosphere
The noise that signals miners' labours
And their tenacious gaiety and their brusque angers . . .
I sing the cutter who attacks the vein
I sing the hauler who crawls along the galleries
And the woman hauler as well, the 'galibot' who suffers,
The old man who drags himself along, clinging to the walls.[68]

Achille Delattre celebrated his former co-workers in dozens of poems and
stories, all reflecting the world of the mine. But Delattre was unusual; he
escaped the coal mines once past childhood. For most Belgian mining
children, the world down the mines quickly became life itself. In the words
of Georges Jacquemyns, 'Neither the men nor the women nor the "djam-

[65] See Varlez, *Quelques pages*, 87.
[66] Pierard, L., *Visage de la wallonie* (Brussels, 1934), 80.
[67] The differences, of course, had more to do with most miners' greater prosperity; textile-
workers' lives rarely included any luxuries.
[68] Delattre, *Chant*, 9.

bots" ever broke with tradition. Neither catastrophes nor painful working
conditions turned the Borains from the pits. The whole world was caught
up in their gears'.[69]

And for the people of the Borinage, this remained the case through
most of the nineteenth century. Until the end of the 1880s, some 80
per cent of the region's inhabitants worked in mining. Such homo-
geneity was not as typical of Charleroi or Liège, where other occupa-
tions were available to the working poor. But there, too, many
thousands mined Belgium's coal—in increasing numbers as the century
wore on.

Near the beginning of our period, in 1841, there were about 38,000 coal
mine-workers. By 1850 the number had increased by a further 10,000.
Throughout this period, female workers probably comprised about 16 per
cent of the total workforce. One count of coal miners in the Borinage
identified 1,146 adult women working below ground, together with 13,540
men, while a further 611 girls and 2,590 boys also worked inside the mines.
In addition, 1,066 women and 563 girls were employed—in the usage of
the period—'du jour', or at the surface.[70]

Coal production flourished and numbers grew, so that by the mid-
1860s, there were more than 87,000 workers mining coal: of these, about
50,000 were men, 5,200 women, and 3,700 girls (i.e. up to age 21) working
below ground.[71] The ratio of women to men varied from coal-field to coal-
field, though these figures were generally typical. More women, however,
worked below ground in the Borinage than anywhere else. One contem-
porary counted 20 women for every 100 men working inside Borinage
mines. In Charleroi in the same period, the numbers were slightly lower: 18
per cent were women. At the surface, the disparity continued: 32 per cent
of workers in Borinage were women and 22 per cent in Charleroi. In Liège
throughout our period, only about 7 per cent of the underground workforce
was female. On the other hand, many more women worked on the surface.
One source claimed that women comprised over 52 per cent of Liège's
above-ground coal-workers.[72]

The number of women working underground reached a peak in the
1860s and 1870s. The largest estimate counted about 14,000 women

[69] Quoted in Puissant, *Évolution du mouvement*, 59.

[70] Figures from *Exposition universelle—1910*, 171; Marichal, *L'Ouvrier mineur*, 7. Borinage
figures from M. Delneufcour, a local mine engineer, testifying in *Enquête—1846*, ii, 237. See
also testimony on p. 225.

[71] There are many contradictory figures. These come from Marichal, *L'Ouvrier mineur*, 7,
12. See also Kuborn's *Rapport*, 14–15.

[72] From *Rapport de L'Union*, 8.

below ground in those two decades. As for the ages of these women, there are no reliable figures. It does seem clear, however, that those female workers who went down the mines at 11 or 12 generally began to leave the pits in their twenties. (This was also the case for many women working at the surface—in all occupations except gleaning.)[73] (The fact that women provided only a fraction of the mining workforce did not mean that they avoided the bulk of reformers' attentions, however, as we shall see.)

Despite their smaller numbers, women's work was by no means 'ancillary' to the process of mining coal, though their tasks varied from district to district and sometimes even from mine to mine. Generally, in the older mines, women broke the cut coal into movable chunks which they next loaded into sacks (in the earlier decades) or coal-waggons. Other women attached the sacks or waggons to their bodies (by means of forehead- or waist-straps and chains) and hauled the coal from the seam to the point where it was removed from the mine. Their relatively smaller size made them ideal for this work because galleries from the coal face to the surface—or, later, to the staging-post of the cages—were kept as shallow as possible to save on timbering.

The work of breaking and loading at the coal-face was not any worse than that done by those who cut the coal from the seam, but the work of hauling was terrible. For hour after hour, children and women dragged the coal, sometimes great distances. The work improved slightly after wheeled waggons appeared in some mines—and still more when mine-owners laid iron rails. But even after women and children haulers finally became obsolete with the introduction of horse-drawn waggons, many Belgian owners chose to continue using human power in smaller, narrower passages. Only the 1892 legislation which began to control working conditions in the mines signalled a gradual end to the onerous work of the haulage women.

Technology did little to change the work of the *chargeuses*, who continued to work breaking and loading the coal in a small chamber just behind the mostly-male 'getters' or 'cutters'. Although their work was sometimes done by boys and men as well, it was almost always considered 'women's work', just as 'getting' was 'men's work'. In the second half of the century, language began to identify gender distinctions more

[73] Fauviau, *Borinage*, 160, 161. Unfortunately, accuracy is simply impossible. Owners scorned official interference and showed their contempt by refusing to answer enquiries about their workers.

precisely: '*mineurs*' were males; '*hiercheuses*', females. Both categories, more-over, wore publicly recognized work uniforms. The miners wore hard leather helmets, trousered suits, and wooden clogs. Miner's lamps usually hung from their belts, and picks rested across a shoulder. The *hiercheuses* were dressed in white linen suits of knee-length trousers and a buttoned, long-sleeved jacket. Below their trousers they wore dark-coloured stockings and sabots. They tied colourful scarves around their necks. And every *hiercheuse* covered her hair as completely as possible: either with a dark blue scarf, tied in a distinctive fashion (prevalent in both Liège and the Borinage) or with a straw cap. These latter, sometimes decorated with ribbons, proclaimed that their wearers worked in Charleroi.

Louis Pierard described one Liège group: 'Some *fillettes* [*sic*] with their hair hidden in a head-scarf which made them appear as *Tanagras*—mais oui! . . . pushed these carts toward the waggons where the coal is dumped'. Alfred Munby had these words to say about Charleroi's *hiercheuses*, whom he introduced as 'a novel form of female labour':

We came . . . to a group of girls, all drest in breeches and shirts . . . They were of different ages: some children of 12 or 14, some stout girls of 18, some grown young women, broad-shouldered and strong, and in their male dress, looking nobly robust. Two things struck me at once: the comparative cleanliness of these girls and their white clothing . . . I saw only one or two whose faces were really blackened, and the hands alone were black in all: and their good looks. Most of them were extremely pretty, and feminine too: scarcely one who looked like a man, even in trousers.

Munby went on to describe a young woman, who began her hauling work by

attach[ing] a harness over her clothes. A leather thong was fastened round each shoulder, and the two met behind, in a broad thick strap, as stout and large as the traces of a cart horse. This hung down the girl's back as she stood up, and to the lower end of it a strong rope was attached, with a chain and iron hook at bottom . . . her business was to draw the waggons, whilst a comrade pushes behind. She was a bonny lass, and stout. She said she would draw me back in one of the empty corves: so I clambered in and crouched down . . . It was a strange experience. I was at the bottom of a coal pit, in a waggon which was drawn by a woman in man's clothes, who wore the gear and fulfilled the function of a beast of draught.

But he caught himself: 'That, however, is sentiment: the fact was that the

two girls tooled merrily along, shouting to others ahead to get on, and finally brought me through the door ... As I got out, it was obvious to pat my steed on the shoulder and say, "Mais vous êtes un bon cheval!" and she laughed and looked pleased at the compliment'.[74]

These *hiercheuses* drew much public attention throughout our period, not least because of their distinctive work costumes. But women did other work in the coal-mines as well: below ground they dug new galleries, 'timbered' (propped up newly dug shafts with lumber), and filled in crevasses and holes with waste rock and earth. They also loaded and carried the waste—a mixture of coal-dust, earth, and useless rock—to the surface where it was dumped on the constantly growing mountains of slag.

All miners worked in shifts. One typical young woman, in Dour in the Borinage, told a reporter that she went down at 5 a.m. and returned to the surface at about 9 p.m. During the hours below, she loaded between 60 and 70 *chariots*, and pushed them a distance of between 50 and 180 metres. She also fetched empty waggons from the staging-post. In the largest mines, shifts were staggered to make the most efficient use of each team of workers. According to Jean Puissant, the usual order of descent in the Borinage saw the coal-cutters go down first, followed by loaders and haulers. The latter—who were both male and female—remained below ground until all the cut coal was hauled to the surface, sometimes a period of 15 or 16 hours. The cutters, on the other hand, were free to leave when their day's work was finished.[75] Until mid-century (and much later in smaller mines), workers went in and out of the mines via ladders. The climb out of deep mines was extremely arduous and the cause of numerous fatal accidents. Depending upon the depth of the mine, the climb down could take a considerable time. One miner estimated that a climb of 300 metres took 20 minutes down and 40 minutes up. (The average mine in 1856 was 381 metres deep, but mines in Charleroi and the Borinage were often deeper. By the end of the century, they were averaging between 605 and 703 metres—compared with Liège's much shallower 373-metre pits.)[76]

[74] Tanagra was an ancient Greek city near Thebes, where Hellenistic figurines were found by 19th-century archaeologists. These terracotta figures were popular with Victorian collectors. That many were female, and burial objects, made them an appropriate simile. See Pierard, *Wallonie*, 101. See also Munby Collection, diary, 1862, and Hiley, *Victorian Working Women*, 99–100. Hiley reproduces several photographs of Charleroi's male and female miners, taken by Prosper Bevièrre in the 1860s. Unfortunately, the Musée de la photographie near Charleroi does not know the whereabouts of this photographer's work. Munby's partial collection may be the only surviving Bevièrre portraits.

[75] Puissant, *Évolution du mouvement*, 69.

[76] See Le Brun, P., Bruwier, M., Dhondt, J., Hansotte, G., *Essai sur la révolution industrielle en Belgique, 1770–1847* (Brussels, 1981), 394, and *Exposition universelle—1910*, 84–5.

Alert to the dangers of the climb, adult miners put children between them, in the hope that fallers could be rescued. But it was a vain hope: climbing in near-pitch dark (lamps frequently blew out in the draughty tunnels), on slippery, wet rungs, many children fell to their deaths. (Adults, too, died; either from falls or from the firedamp explosions ignited as they tried to re-light their lamps with one hand.)

Technology intervened, however, and by the second half of the century, most miners enjoyed a ride down and up in a cage, lowered by a steam-powered winch. Although much less exhausting, the cages were almost as dangerous. Miners thus surrounded the experience of descent and ascent with various luck-preserving rituals. In Liège, for example, the signal to lower the cage was always given in precisely this form:

> A l'wade de Bon Dieu
> d' l'avierje, sin'Lina
> et sinte Bare![77]

Those above ground, of course, risked less, but women's work at the surface was at least as arduous, and much less well paid. They continued to break coal into saleable pieces, and to shovel it on to sorting belts. They also loaded and hauled the sorted coal and waste, in baskets or, later, in huge waggons. (The larger waggons employed two women to push them from one part of the mine to another; the smaller, however, had only one human motor. These smaller carts included those pushed to the top of the slag heaps and emptied.) Once on the wide belts, the coal was sorted by women and children. After a first sorting, the coal was washed, and sorted a second time. Then it was loaded (again, usually by shovel-wielding women) on to barges and freight cars. These were then weighed (by men) before being moved off to market.[78]

There was a hierarchy amongst women workers: the underground *hiercheuses* enjoyed a much higher status than the women working above ground. At the same time, there were a few surface occupations with status similar to that accorded women underground. These jobs included supervising the cages as well as working in the *lampisteries*, preparing and cleaning miners' lamps. This latter work was relatively new to coal-mining. Before the first 'safety' lamps appeared in 1830, miners burned candles attached to their hats! Even after the first lamps arrived, safety remained dubious:

[77] Quoted in Vanval, J., *La Houillère: La travail des mineurs du fond vers 1900* (Liège, 1975), 3.

[78] See Le Brun, *et al.*, *Essai sur la révolution* and *Éxposition universelle—1910*, Photographs of all this work are found in the Musée de la vie wallone, most taken by Gustave Marissiaux, and in the Munby Collection, Album 6.

lamps with enclosed flames often went out, and relighting them meant courting the dangers of firedamp. (The frequency of such accidents did not provoke any government action, however; no legislation controlled the use of open flames inside the mines until 1904!) The women who cared for the lamps—and distributed them—earned their status partly because their work was clean; no coal-dust soiled their faces, hands, or dresses, and thus they were able to indulge a taste for more feminine and colourful dresses and aprons than other mine women wore. They also enjoyed a certain responsibility: it was their job to keep careful track of who went underground, and as they handed each miner his or her lamp, they removed a numbered tag which hung on the wall until the miner returned safely. In times of accident, a quick look at the wall showed who was missing.

The women who supervised the raising and lowering of the cages had even more responsibility. These women, known as *'torteuses'*, were originally chosen for their physical strength, necessary because they cranked the loaded buckets up and down the shafts. 'They were solid women', wrote Achille Delattre, 'chosen expressly for this work. As there was little dust in this work,' he continued, 'the *torteuses* were not black and dirty like the other women at the surface, and they considered themselves an aristocracy of women mine-workers'. (It is interesting to note here that unlike male miners, women's status—at least above ground—depended on both strength *and* cleanliness.)[79]

All miners, whatever their specific work, enjoyed a high rank in the wider working world. And, as Jean Puissant has noted, they passed their pride down through the generations. Each older generation also passed their skills—from father to son, from mother to daughter, or sometimes, in the case of orphaned children, simply from older to younger. Delattre sentimentalized the first descent of an orphan in one short story. On his way to his first shift underground, Delattre's young central character is asked why he is walking alone, without his father. His questioner is the 'strongest worker in the *coron*'. When he tells his older companion that he has no father, the huge, powerful man called 'Cola' takes him in hand, with 'sweetness and tenderness and goodness' to introduce him to the world of

[79] See Puissant, *Évolution du mouvement*, 59. This question of the qualities upon which workers based their identity is discussed in Touraine, A., 'L'Évolution de la conscience et de l'action ouvrière dans les charbonnages', in Trenard, L. (ed.), *Colloque internationale: 'Charbons et sciences humaines'*, Université de Lille, mai 1963 (Paris, 1966), 251–62. It might be noted here that there was a clear gender distinction: male miners wore their dirt and coal dust with pride. See also Delattre, A., *Dans la Bourrasque* (Brussels, 1946), 26.

the mine.[80] Although highly romanticized, most contemporary sources suggest that such an act was by no means unusual in Belgium's close-knit mining communities.

As the century wore on, women's mine work drew increased hostility, as we shall see below. As Belgium's Victorian era sentimentalized bourgeois females into nearly helpless domestic creatures, women coal-miners stood out as distinctly aberrant. Attack brought counter-attack: one legislator defended women coal-miners on the grounds that their work was 'no worse' than that of Liège's acclaimed *boteresses*. Mine-owners added that women's coal work was 'not very different from other hard jobs', including the loading and unloading of ships in Belgium's ports, or 'working sewing machines in the fashion houses'.[81]

But even those most anxious to defend women's continued employment in coal could find little defence for the most miserable of female coal-workers, the *glaneuses de charbon*. These women, highly visible as they picked through the high black mountains of waste which dotted coal country, evoked only horror—from other miners as well as from passers-by. Every visitor described these hundreds of women, clambering like 'busy ants' amongst the filth. And when they climbed down from their work, they had more work: with full sacks tied to their foreheads, they carried their gleanings either to their homes, or, more usually, into nearby towns where they sold their pickings door to door. These *glaneuses* were frequent sights to travellers along the same roads; many of the latter described them moving slowly along, bent nearly double from the weight of their heavy black sacks. They evoked pity: when the French artist Cécile Douard painted their portraits in the last decades of the century, she depicted Macbethian witches with clawed hands, bent backs, rag-covered feet, and dark, sharp faces. Another contemporary drew this picture in words:

An avalanche of stones tumbles down in a river of dust from the flank of the slag-heap. Interrupted an instant, the *hiercheuses* [sic] avoid the projectiles, then, hoes in hand, a sack between their feet, they waddle their sombre duck-like silhouettes toward the black fodder that they rake and stir unceasingly in order to find a few morsels of the coal that escaped the sorting. With luck, seven or eight *sous* will reward the weariness of the daily drudgery of these familial heroes, too proud to beg for the daily crust.[82]

[80] Delattre, *Chant*, 45.

[81] Jean François Vleminckx, who was also a doctor, produced his own report: see Vleminckx's *Lettre* (Brussels, 1870) The first remark comes from p. 9. The ominous effects of sewing machines were predicted in *Rapport de l'Union*, 14.

[82] Fourmanoit, *Des Luttes*, 5. Cécile Douard's pictures are discussed in Chs. 5 and 9.

These, then, were the lumpenproletariat of Belgium's coal-mines. But although miserably rewarded for their terrible work, they generally risked less danger than their much higher-paid friends and neighbours working underground.

Accidents were common, and often fatal. The depths of Belgium's mines—some of the oldest and therefore deepest in Europe—plus the constant presence of the feared *'grisou'* (firedamp, or methane gas) and repeated floods contributed to miners' daily risks. And danger was one element that remained constant in miners' lives throughout most of our period, since no legislation concerning mine safety or even regular inspections was passed until 1906.

Mining was most dangerous in the Borinage. There, seams of coal were layered between rock formations, and coal was cut only by dint of hard and painstaking effort. Worse, the region's earth was highly friable; this fact, together with Belgium's wet climate, made fatal rock-falls and roof collapses common. These were also the mines where firedamp collected most readily. Such conditions produced, in Jean Puissant's words, 'a record of a long martyrdom'.[83]

Although the unusual absence of mine legislation in Belgium (as well as a general indifference to archival materials) ensured that no methodically collected records of conditions exist, accidents were usually recorded—albeit inconsistently. And these reports, frustratingly incomplete as they are, show that month after month, year after year, miners died. In 1850 in Quaregnon, for example, 76 died in firedamp explosions; in Elouge, in 1852, 71 died; in nearby Dour, 30 perished in a single explosion. Each year, the toll grew. One Borinage mine, 'Agrappe', achieved the dubious distinction of being the most dangerous mine in Belgium. It was widely known as 'le sinistre fosse', a play on the double meaning of 'fosse': 'pit', on the one hand; 'tomb', on the other. Between 1864 and 1879, 275 miners died in mine explosions and fires in that single mine alone. In all the Borinage mines, accidents killed 991 miners in the years from 1850 to 1880 (most from firedamp).[84] Behind these death statistics lay thousands of injured workers, not a few of whom died later of their injuries.

Given the incompleteness of accident reports in our period, extant documents offer no possibility of analysis. What they do offer, however, is a vivid impression of the experience of the mine. Hours below ground were hours filled with thoughts of the many dangers that lurked just out of sight in the semi-darkness of the pits. In addition to the ubiquitous, explosive methane gas—which collected readily in Belgium's deep, convoluted mine shafts—miners feared what were known as 'volcanoes', sudden

[83] Puissant, *Évolution du mouvement*, 14.
[84] Figures from Mahieu, *Hommes des fosses*, pp. 32–7.

eruptions caused by long-smouldering fires inside the mines and slag heaps. Rock-falls were common as well: huge boulders regularly tumbled from the gallery and passage-way ceilings, often carrying the entire roof down on the heads of the working miners. And a last 'natural' disaster came from floods. Like flash floods in the desert, these walls of rushing water appeared with little warning, engulfing all in their paths. There were also accidents which killed and injured only a few miners at a time. These included falls from ladders or cages (the latter due to snapped cables), burns from cauldrons of boiling water (the waste from steam engines), crushings from 'runaway' waggons, and falls from wet, slippery slag-heaps.

The fatal accidents suffered by female miners in the 4-year period between 1863 and 1866 included nineteen deaths in the Borinage and Charleroi caused by runaway waggons.[85] One typical event, in July 1863, occurred at 5 a.m. when Louise Trivière, 13, a *porteuse-lampes*, was killed by a coal-waggon hurtling out of control during a shift-change at the Agrappe mine. According to the investigating mine engineer, no one was responsible: shift changes, he explained, always 'caused a certain confusion'. In the same month, at the nearby Grand Hornu mine, a 16-year-old girl and her 19-year-old male co-worker were killed by a train of falling waggons. Soon after, at the Nouveau Fontaine mine in the Borinage, a 19-year-old *hiercheuse*, Marie Arnoud, was critically injured by another runaway waggon. Her arm was amputated immediately, but her injuries proved too extensive and she died a few days later. Arnoud, according to two nearby *hiercheuses*, had been pulling, rather than pushing, a waggon when she lost control. 'Tant pis', shrugged the investigating engineer.

Some gruesome injuries were not immediately apparent to victims or their co-workers, so that many miners continued working until they suddenly dropped dead. That was what happened to Marie Thérèse Deussont, a 16-year-old *hiercheuse* in Charleroi: she continued to work for several days after being run over by a coal-waggon. Her sudden death,

[85] Technological improvements exacerbated such accidents: in many mines in the 1850s, new steam machinery allowed several waggons to be raised and lowered at one time. Each trip, which took an average of $2\frac{1}{2}$ minutes, raised some 1,340 kg.—for a total of 385 tons per shift, compared with only 210 tons before. The weight and number of waggons made most accidental falls fatal to workers below: see Delattre, *Combat*, 115. All accident data and anecdotal evidence are found in *ADM* no. 896 (1852; untitled), and in no. 915, 'Procès-verbaux des contraventions et des accidents' (n.d.). It bears repeating that all these records are disorganized and far too unmethodical to allow any collation of meaningful statistics. Many records, moreover, are illegible due to water damage or deterioration. This material can only provide, as I have said, an impression of life in the mines. There are almost no reports from Liège, unfortunately, that identified the sex of victims.

needless to say, shocked her friends who had thought her unhurt. A doctor concluded that she had been injured 'internally' and had bled, slowly, to death.

In 1865 the reports of mine engineers began consistently to assess blame, but rarely did they find mine-owners or managers at fault. Rather, they stretched probability to its limits in their efforts to blame workers. One typically improbable judgement concluded a report of the deaths of Marie Thérèse Vanoverloop and Jeanne Rosalie Mettalijn, both *hiercheuses*. Whilst waiting at the bottom of a 433-metre shaft for the descent of empty waggons, they were crushed when the cable broke and tons of steel fell on them. The engineer described them as *imprudentes*, who had been 'standing in the wrong place when the waggons escaped'!

Another absurdity was recorded in the investigation of Marie Victorine Deprez's death. The 16-year-old was killed at Marchienne-du-Pont, near Charleroi, when she fell down a mine shaft. According to witnesses, she had been trying to put a de-railed waggon back on to its tracks. Failing, she signalled the young woman in charge of the winch to haul the waggon further up the incline to give her more room to manœuvre. Unfortunately, her clothing was caught in the waggon's wheels, and the *malheureuse* was dragged up the shaft. When her clothing finally tore free, she fell 150 metres—to her death. The investigator concluded, 'She should have done it another way'.

Particularly in the early years of our period, many fatalities occurred when workers fell from ladders during the exhausting climbs in and out of the pits. Children were especially vulnerable. At Pâturages, for example, Virginie Cautiau, 12, tripped and fell to her death because she could not get a firm hold on a high rung. Two women, 24 and 25, who had been climbing just below her told the mine engineer that distances between the rungs were too great for children. (The reporting engineer here ventured no judgement about responsibility.) Another fall killed Marie-Thérèse Vandeloise, a 14-year-old *hiercheuse*. On her descent, she began a song, but after only one chorus, Vandeloise slipped, falling to the bottom of the shaft, 'mortally wounded'. 'That fall is easily explained', opined the engineer, 'the child was imprudent or inattentive'.[86]

'Freak' accidents were not uncommon. One case, particularly troubling to her comrades, was that of Louise Duport, 16, an 'orphan' from Jemappes.

[86] One typical *hiercheuse*'s song is in Delattre, *Histoire de nos corons*, 121. It included the chorus: 'Mamie, faites-moi q'un bouquet/Qu'il soit bien fait, bien arrangé/Qu'il soit lié d'une cocarde/Où "riban" blanc/Que mes amours aussi les vôtres/Qu'ils soient dedans . . .'. This accident and all the others are reported in ADM, ibid. no. 915.

Duport disappeared suddenly during one afternoon shift. Because of her age, her workmates, all adult men, assumed she had stolen away from work to visit a *kermesse* in their *quartier*. Without searching for her, they finished their shift and went home. At 1 a.m. her worried guardians appeared at the mine seeking their ward who had failed to return home. A group of workers was assembled to search for the missing girl. After three hours they found her body—in a reservoir storing boiling waste water from the mine's steam-engines. They guessed that she had stopped to wash her hands and had tripped, falling in and drowning. A year later, in 1864, her accident was repeated at the Bonnefin mine near Liège. A 14-year-old girl had similarly slipped into a hot-water tank when she, too, had bent over to wash her face and hands. Margueritte (*sic*) Boverie screamed for help and was rescued. But she too was horribly burnt, and died three days later.

Of course in these cases responsibility was easily assessed: no one was forced to wash. But even when death resulted from events completely beyond workers' control, engineers usually managed to shift the blame in their direction. One typical 1866 report, for example, noted simply that Céline Destreberg's death from a falling boulder was 'to a certain extent her fault'.

Firedamp explosions, on the other hand, were too public, and far too tragic, to allow such frivolous judgements. Indeed, these all-too-frequent events produced the most widely-reproduced scenes of mining catastrophe. Pictures and descriptions of these tragedies became a familiar genre. Sobbing widows (bereft spouses were always depicted as female), waiting silently and forlornly at the pit-head, were surrounded by terrified children, clinging to their black skirts. Mothers and fathers ran about in panic, seeking news of their missing children. Lovers grieved whilst the mine sirens summoned still more frightened families to join the ominous wait.

Not surprisingly, outsiders' reports (unlike those provided by mine employees) featured highly emotional language. One typical 1865 document, published following a mine disaster in the Borinage, described the scene in these words:

At first, rescue seemed impossible. Smoke and fire filled the mine. Several workers went down anyway, to attempt a rescue. Some time passed. Then one miner emerged from the pit, calling out that there were others following behind him. Hope swept the crowd. Tears ceased.

Eventually, 65 miners emerged from the mine alive—accompanied by 57 corpses.[87]

[87] *Exposition universelle—1910*, 101–3, 105, and ADM, ibid.

Charity was forthcoming for the victims. A local newspaper collected nearly 244,000 francs in a public appeal, but no amount of charity halted the inexorable march of death in Belgium's firedamp-infested mines. Only a few years later, the notorious Agrappe mine blew again, killing dozens more. The *Journal de Mons* shrieked a familiar message: 'Frameries Catastrophe'. Chaos followed the first explosion, as screaming humans and horses crushed together at the pit-head. The noise of the horses drawing ambulances added to the cacophony; soon, more panicked neighing signalled the arrival of mortuary waggons.

All around were the anguished cries of survivors: 'Father, brother, sister, where are you?' one journalist heard. He saw one widow bend over two bodies, watched her face as she recognized her twin son and daughter, both 23. The young man was mutilated, 'his face a mass of shredded skin'. His sister's face, however, 'is intact and white as a candle. She was only asphyxiated'. Nearby stood 'a living statue of sorrow', a widow of a miner killed only a few years before, and mother of one son killed earlier that same year. She had come to identify the bodies of three more children. 'Five very young children' awaited her sad return home.[88] Tragedies such as these were common, as family members frequently died together. In April 1879, when Agrappe once again blew, 121 victims included many brothers and sisters, fathers, sons, and daughters. In one case a father died with two of his daughters, one 16, one 23. In another, a father perished with a son and a daughter. This 1879 disaster became famous, and soon came to represent all Belgian mine catastrophes in the public mind. There were several reasons for the notoriety. First, it was horrifyingly visible. For a prolonged period of several hours, explosions repeatedly rocked the mine, throwing 'stones, workers' clothing, and pieces of iron' high into the air. A column of fire, visible for 10 kilometres, rose in the sky. Secondly, the tragedy featured a sub-tragedy. Those waiting in panic at the pit-head witnessed the vain efforts of a grizzled, 'experienced ex-miner' to convince mine officials to search one part of the mine. According to his grandson, Louis Pierard, the old man's pleas went unheeded. When finally they did follow his advice, it was too late: 100 miners, who had survived the explosions just as he had predicted, were discovered suffocated, 'huddled in a narrow corner'.[89]

The drama did not end there. After five days of frenzied, evidently hopeless effort, rescuers found survivors deep beneath the earth. When

[88] Quoted in *Ami du Peuple*, 26 Dec. 1875. Newspapers shared stories, and one version often became standard.

[89] Pierard's story is quoted in Greer-Saussez, *Borinage*, 8–9.

these four men and one woman emerged from the mine with their rescuers, the waiting crowd met them with a wild joy. A local artist, Antoine Bourlard, immortalized the moment in his painting called *Rescapée*. And lastly, another artist also recorded these days for posterity. Vincent Van Gogh, working as a missionary in nearby Wasmes, volunteered to help Agrappe's injured miners. In a series of letters to his brother Theo, he detailed the terrible physical and emotional devastation of those evil days.[90]

In such catastrophes, males and females labouring below ground suffered and died. Risking the same dangers, female coal-miners earned the same status as their male colleagues, as well as the same pride. Inside the mines, sex did not relegate women and girls to secondary or marginal roles—whatever the implications of historical 'received wisdom'.[91] Women and men, boys and girls, shared the life condemned in bitter words by one ex-miner: 'Paradise would be to live a long time in good health, in easy circumstances, with control of one's time. ... Hell is the opposite. The mine was, therefore, hell—and those who have said that "work is health" are the devil'.[92]

REBELLION

Women coal-mine workers joined their brothers, fathers, and sons in the collective struggle to gain control of their difficult conditions. They did this despite a merciless official resolve to break every strike, dissolve every inclination to revolt—and thus here, too, they were arrested, wounded, and even killed alongside the men.[93] Detailed examination of every strike, every mine revolt in these years lies beyond the scope of this work. However, an outline of key events highlights the important part women of

[90] Letters quoted ibid. See also Delattre, *Histoire de nos corons*, 71. It was another Agrappe explosion a few years later that drew Constantin Meunier, who sculpted one common sight: a mother bending over a body in the instant before she recognizes her son. It is called, simply, 'Grisou'.

[91] It may be *de trop* to insist on this point, but the case commonly made for Britain, by Angela John and others, does not fit gender relations in Belgian mines. See John's *By the Sweat of their Brow: Women Workers at Victorian Coal Mines* (London, 1974). See also Burke, G., 'The Decline of the Independent Bal Maiden: The Impact of Change in the Cornish Mining Industry', in John, A. (ed.), *Unequal Opportunities: Women's employment in England, 1800–1918* (Oxford, 1986), 179–206.

[92] Mahieu, *Hommes des fosses*, epigraph.

[93] See the remarks about the state of affairs in Belgium in 'Addresse aux ouvriers d'Europe et des États-Unis', in Marx, K. and Engels, F., *La Belgique des insurrections* (Paris, n.d.), 285–6.

Belgium's mining communities played in the struggles of their class in the period from the 1840s to the watershed general strike of 1886.

In the 1840s, both strikes and their interpretation by worried officials suggested a society uncertain of its social identity. On the one hand, some officials blamed non-Belgians—primarily the French—for troubles in the mines. At the same time, however, still others complained that although strikers were Belgians, their actions placed them beyond the liberal world defined by the 'freedoms guaranteed in the constitution'. One typical criticism, for example, blamed the women who were trying to stop the march of scabs into the mines for 'interfering with the freedom precious to Belgians', i.e. the freedom to work. The critic, a local mine engineer, insisted that the Frameries women were animated with 'animosity and hostility' so great that even mounted troops could not discourage them.[94]

Ironically, however, the cause of the majority of mine strikes in the 1840s was an effort by the mine-owners—and their representatives in the legislature—to curtail, not extend, the freedom of miners. In that decade, legislation demanded that every Belgian worker carry a *livret*—a passbook recording work history and political activities. Unlike the nation's more docile textile-workers, the miners resisted on the grounds that *livrets* were 'unBelgian'. (They were, in fact, a legacy from the French.) Freedom for miners, they argued, included a right to pass freely from job to job without the burden of labels attached by mine-owners. *Livrets*, wrote one group of angry miners, were a 'symbol of a servitude odious to the heart of the true Belgian'.[95]

When vocal complaints had no results, miners walked out on strike. These *livret* strikes lasted a long time—often up to 6 weeks. They included many mass demonstrations—parades, marches, and so on—which usually brought immediate armed repression. According to many contemporaries, women played a key role in such activities. In one 'huge march', recalled by Achille Delattre, 'the cortège included women whose excitement was extreme. . . . Women', he added, 'join the strike parades, animating them

[94] No. 1297, 'Delneufcour, mijningenieur van het 1e district aan Gonot, hoofingenieur der mijnen, Bergen, 12 feb. 1841', and no. 1296, 'De Bevelhebber van de 4de territoriale divisie aan de minister van oorlog, Bergen, 12 feb. 1841', in *Documenten*, ii.

[95] Quoted in Puissant, *Évolution du mouvement*, 92. Many records were lost in a fire in the Mons Archives: in the summer of 1988, many documents were still wet—and rotting. See AEM, series F., 'Administration des mines', nos. 121–4 (1 and 2), and ibid. 'Archives communales: Jemappes'. See also van Kalken, F., *Commotions populaires en Belgique (1834–1902)* (Brussels, 1936), 50, which compares these miners' petitions to the king to those of Britain's Chartists.

and sometimes troubling them with their cries, their extravagances, or their violence'.[96]

Here, too, mining women took their place alongside male members of their communities. Delattre explained:

A miner's wife thinks as he does. She is as courageous as he is, bearing work, misery, and misfortune. She jokes, and never shrinks from badinage; often, from her poor house, nearly pure echoes of the rhythmic songs of the pit come flying. She appears to live on life's good side. But in reality, she feels the difficulties of existence more than her man because she has fewer distractions; she often shuts inside herself the pains of her hard life.[97]

But the prevalent image of mining women in the 1840s was not quite so sentimental. In fact, they were often portrayed as harridans, far more prone to violence than their male comrades, as we shall see in Chapter 5. So widespread was this stereotype that one male striker blamed his participation on a female neighbour—who had insistently routed him from his sleep, forcing him to join the strike![98]

Officials did not hesitate to use troops to quell the strikes. Karl Marx summarized a widely held European view of Belgian officialdom in these years:

There exists only one small country of the civilized world where armed forces exist in order to massacre striking workers, where every strike is seized with avidity and malice as an official pretext to slaughter the workers. This unique little country is Belgium ... As the earth makes its annual revolution around the sun, so it is that the Belgian government effects its annual massacre of workers.[99]

In one notorious event in the tiny Borinage commune of Dour, gendarmes ambushed a group of miners marching to protest about the *livrets*. They fired, and one striker was wounded. As a result, the strike grew, spreading rapidly to every commune in the Borinage. However, in these early years, miners lacked any organization that would have sustained such a strike. And thus, on this occasion, the strike ended, 'eroded by the misery which touched most working families', in the words of Jean Puissant.[100]

[96] Delattre, *Combat*, 51.

[97] Ibid. 197.

[98] No. 1284, 'Betoging tegen de werkmansboekjes in de Borinage, 10 feb.–14 feb. 1841', in *Documenten*, ii. When the police questioned her, she, in turn, blamed her male co-workers for 'forcing' the women to leave work on the night shift to go and rouse their sleeping comrades for the strike.

[99] 'Addresse aux ouvriers', in Marx and Engels, *La Belgique des insurrections*, 285–6.

[100] Puissant, *Évolution du mouvement*, 93. Jean Neuville claims that the strike lasted six weeks: see *L'Évolution des relations industrielles en Belgique: l'avènement du système des relations collectives*, i (Brussels, 1976), ch. 2.

Sometimes, women's prominence in these strikes served to reassure the authorities. One Charleroi mine engineer, for example, insisted that local events were of little importance because women dominated the 'few rare and insignificant coalitions'. He asserted that these coalitions were 'easily pacified, appeased, by the wisdom of the mine owners'.[101]

Still, it was more usually the case that women in the Borinage enjoyed a widespread reputation as *provocateuses* throughout this period. Theirs was the role of harassing would-be scabs, and threatening those reluctant to strike. In the anti-*livret* strike that broke out once again in 1848, mining women gathered at one mine that was on strike to taunt those trying to go underground. Of course violence soon broke out, as strikers and their supporters fought with scabs. One strike-breaker, whose beating received widespread attention because of her sex, was Célestine Musin, a young *chargeuse*. Police were particularly horrified that a female was treated in the manner common amongst males.[102]

Between 1848 and the great mine strikes of the 1860s, life in Belgium's mining communities remained relatively quiet. However, unrest had not disappeared. Official documents report persistent rumours of 'certain societies' emerging in mining towns. One police reporter noted that such societies often resulted from stories in 'subversive newspapers' which told of the seduction of women miners by supervisors and mine owners![103] But such groups shared the character assigned by Jean Puissant to the decade's strikes. Those events, in his words, 'present an impulsive, unorganized, hopeless character, suited to spontaneous uprisings. They break out suddenly, without prior agreement, in one workshop, one pit, one mine. And if they spread, it is, so to speak, by a natural contagion, carried by bands of strikers. Their growth corresponds to no premeditated organization'.[104] Such spontaneity encouraged, rather than discouraged, the active participation of women, who often found themselves marginalized when workers' activities became more organized. This eventuality was less common in Belgium than elsewhere—and when it did occur, it happened much later.

[101] See *Enquête—1846*, ii, 288, 316. A Liège mine engineer, in his turn, explained that geography provided the explanation for social unrest. Those who lived in 'unagglomerated communes' were far less likely to strike than those living in closer quarters.

[102] No. 1346, 'Delneufcour . . . aan Gonot . . . 20–23 mei 1848', in *Documenten*, ii.

[103] *Travail des femmes*, 29, 32.

[104] Puissant, *Évolution du mouvement*, 116. Pierre-Joseph Proudhon wrote in 1862 that he could find only 'one republican amongst 10,000 Belgians, and no socialist'. He is quoted in Cammaerts, É., *The Keystone of Europe: History of the Belgian Dynasty, 1830–1939* (London, 1939), 178.

But as long as workers' resistance remained 'informal', Belgium's *ouvrières* joined in freely.[105]

By the 1860s, strikes were a way of life in Belgium's Black Country. But by this decade, they had changed from small, sporadic, and usually evanescent manifestations of workers' anger into more organized, more serious events. The first major strike of the 1860s broke out in 1861 in the Borinage, in protest against an effort to standardize work rules in the area's mines. It was not that any mines did not already impose rules—they all had very strict ones: what upset the miners was the fact that uniform rules would inhibit their ability to protest at a particular mine's regulations by seeking work in another mine. Secondly, they feared that the standardization of rules signalled an end to the informality with which mining rules were usually applied. In many cases, for example, friendly supervisors simply overlooked infractions—or 'forgot' to collect fines from the guilty.[106]

Before calling a strike, meetings of 'male workers and of wives/women' (Jean Puissant uses—curiously—the ambiguous 'femmes' without further reference to the roles he is indicating) planned the events, which began at Agrappe in June. It spread quickly. By July all Borinage mines were closed. Strikers patrolled their communes, preventing strike-breakers from entering the mines. On their side, owners called in both gendarmes and troops. For a while, the two sides confronted each other without violence. But finally, at Pâturages, some strikers began to throw stones at mounted troops. The soldiers fired: one woman was killed and three men wounded. At Quaregnon a similar event left one young male worker dead and three others wounded.

This strike produced one very rare drawing—showing an attack on one mine. Preserved in an archive collected by a Charleroi glass-maker, the picture is mislabelled 'Glass Strike: 1886'.[107] But despite its title, the drawing shows an enormous crowd of miners and others massed at the foot of a hill, on top of which stands a large mine. At the front of the

[105] It was Tony Judt who first suggested that drawing a distinction between 'formal' and 'informal' mass activities might help illuminate women's political behaviour.

[106] The rules included: 1. *livrets*; 2. demonstrated knowledge of all the rules; 3. a 6-day work week with a 6-day warning before quitting; 4. an 8-day warning before workers were fired; 5. punctuality and excuses for absences; 6. a weekly quota of 9/10ths of the previous week's production; 7. wages fixed in advance; 8. owners free to fire anyone; 9. director always in charge; 10. workers fired for exciting comrades to stop work, insulting a supervisor, insulting any co-worker, and theft; 11. workers must respect all tools and pay for damage. The list is found in PG, 218:B, 1861.

[107] In Fonds Chambon: I am grateful to the Corning Glass musuem for allowing me to copy this document.

crowd, facing it, stands a lone female figure, arm outstretched. She is clearly addressing the would-be attackers.

The picture is interesting because it highlights women's participation in several ways. First, a single female is shown speaking to a crowd of hostile workers of both sexes. Secondly, female figures in the crowd include both miners—dressed here in skirts rather than trousers, but wearing their characteristic jackets and head scarves—who are clustered together in the foreground, and 'housewives',—standing with men and dressed in equally identifiable clothing. The grouped *hiercheuses*, moreover, signal their aggression by waving stout sticks over their heads. Their hairdos and dresses are in disarray, underscoring the air of violence.[108] One historian has interpreted this picture as showing that miners were so pacific by nature that they could be calmed by a single woman, and indeed, this is a plausible explanation. But the picture also shows, clearly, that women miners were not marginal in the rebellious activities of their class.[109]

Although this strike—and others—ended in failure, officials were worried about the levels of unrest evident in mining communities. One group of influential Catholic leaders called a conference to discuss the social problems that underlay such strikes and riots. Held at Mechelen in 1863, this conference included two schools of thought. One supported immediate legislation aimed at excluding women from working below ground—something these bourgeois men found 'unnatural', and therefore 'immoral'. Édouard Ducpétiaux was amongst this vocal majority. The other side, the minority, articulated what would come to be called 'social Catholicism'—a practice demanding that all believing Catholics take responsibility for industrial poverty and misery, and engage in charitable activities designed to alleviate the nation's social ills. But their views proved premature; the Catholic élites could, in fact, agree on only one resolution at Mechelen: calling for legislation to prohibit women from working below ground in the coal mines.[110] Belgium, however, was not ready to follow this advice—or indeed, the pattern long established in most other industrialized countries, where women were forbidden from working underground. Instead, this Catholic conference—and the two that followed in that decade—effected no significant change in social relations.

[108] The men are clothed as miners and glassworkers—i.e with helmets and picks or aprons and caps.

[109] Dhondt, J., 'De Strijd der arbeiders, 1856–1875', in Dhondt, J. (ed.) *Geschiedenis van de socialistische arbeidersbeweging in Belgie* (Antwerp, 1960), 279.

[110] See Mission, A., *Le Mouvement syndical: Son histoire en Belgique de 1800 à 1914* (Namur, 1921), 41–2.

Only the death of Léopold I in 1865 brought new circumstances. His successor, Léopold II, immediately supported the legalization of workers' organizations as well as group activities that were 'non-political' in their goals. His new law, article 310 of the penal code, contained a big stick along with the very modest carrot, however. As I have noted in Chapter 2, penalties for 'interfering with the absolute freedom to work', were strengthened. Anyone found guilty was liable to prison sentences and heavy fines. Similar punishments were inflicted on anyone 'inciting strikes'.[111]

In the following years, workers repeatedly tested the limits of the new law. Sometimes, officials found in their favour, when strikes or demonstrations were shown to be entirely 'un-political'. But mine-owners and most public authorities soon ran out of patience, and found pretexts for arresting anyone disturbing their peace. When arrests failed to discourage protestors, authorities resorted once again to armed repression. During one demonstration in Mons, for example, several women found themselves confronting armed gendarmes. Although three—Julia Dupont, Desirée Rémir, and Desirée Vanderwasse—were arrested for throwing stones and yelling (somewhat bafflingly in this context) 'Aux Pays-Bas!' at the gendarmes, no one on either side was injured.[112]

But such was not always the case. When one group of hungry, striking miners from Damprémy and Marchienne attacked a flour-mill, confrontation was certain. One eye-witness recorded the events:

Women and children noisily joined the demonstration. Men were armed with batons. Women brandished pitchforks. Some 2,000 people threw stones at the mill and at the soldiers gathered to guard it. Although the soldiers fired, the crowd succeeded in breaking in to the mill, where they threw papers everywhere and stole sacks of grain, carried off by women, by children, by men'.[113]

Only the arrival of many more soldiers finally sent the rioters fleeing—some, the witness thought, to the French city of Roubaix, across the border.

The worst strikes in these years ravaged the coal region in 1868. When a mine-owner near Charleroi abruptly lowered wages by 5 per cent, his workers immediately halted work. Joined by villagers nearby, they quickly formed a column and travelled through the area's pits, calling on other miners to join their strike. At some mines, the strikers threatened the

[111] Employers who 'menaced' workers were included in article 310, but none was ever prosecuted. The text of the new law is found ibid. 32.
[112] PG, 218:A Charleroi, 16 fév. 1867, and 218:B Mons.
[113] From *Grèves ouvrières*, 54–6.

workers in charge of the cages, promising to cut the cables if all under-ground workers were not instantly brought to the surface. The owners called the gendarmes, who successfully dispersed this first group. Soon, however, a second, more violent crowd gathered. As they marched, they began breaking windows. Reaching Montigny, this crowd attacked a mine office, doing considerable damage. Inevitably, mounted troops arrived, summoned by mine-owners and local officials. When the miners began to pelt them with stones, the soldiers fired. Twenty strikers were shot: ten, including two women, died, and many others were seriously wounded; forty were arrested, of whom half were quickly released. The remaining 20 were tried and—unusually—acquitted; five women were part of this latter group.[114]

Neither the shootings nor the arrests quelled the strikers' anger, however. Instead, the action spread, and in May, in Gilly, more strikers were arrested, including 'one of the women who had led a band of strikers'. In June, fourteen stood trial: this time, only one was acquitted, while all the others went to prison (for eight days to four months), and one was fined as well. Five more found themselves held without trial in 'preventive deten-tion'. At least 100 strikers were given their *livrets*—meaning they were fired—and blacklisted from the mines. (A sympathetic police reporter noted that this blacklisting ensured that some would 'die of hunger'.)[115]

By autumn the strike had assumed vast proportions. 'Big meetings' were held virtually every night, while parades and mass demonstrations filled the days. On one occasion, at least 500 women and men marched *en masse* to a meeting in Gilly, where speakers harangued them, condemning 'the king, the priests, and the owners'. In Hornu, a similarly 'enormous crowd' listened to radicals attacking the ruling class. This emphasis on the division of miners and owners in class terms spread throughout the region, as more and more meetings featured denunciations of Belgium's ruling bourgeoisie, and always, as one witness remarked, 'the women joined in'.[116]

Word of this bloody, violent strike soon spread through Europe. The Austrian ambassador described its origins in a letter home:

These immense workers' agglomerations are literally surrounded by the evidence of

[114] See PG, 218:B Charleroi, mai 1868; and no. 119, 'De Procureur des konings te Charleroi aan de Vavay, 19 juni 1868', in *Documenten*, i. The woman leader arrested was probably Philomène Bodart, who was described as 'a concubine with a young child' in the former document.

[115] No. 165, 'Lambert, hoofdingenieur der mijnen te Charleroi aan Jochams, directeur te Bergen, 9 okt. 1868', and no. 180, 'Uittreksel uit een brief van Tonbeau aan De Paepe, Hornu, okt. 1868', in *Documenten*, i.

[116] No. 180, ibid.

an outrageous wealth of which they are the producers, and which naturally excites their jealousy and their covetousness, especially when misery presents itself in a regular parade of heart-breaking sorrows and blind passions . . .'[117]

But his sentiments were not mirrored by Belgium's ruling class. When neither side yielded, the strike—and repeated bloody confrontations with troops and police—continued.

By 1869 strikers had begun to invent new methods to harass scabs whilst avoiding arrest, for example, by sending anonymous threats. One from Wasmes read 'L'ouvrier qui va encor au travail sera hâché comme de la paille même en pâte comprix. R.I.P.' (*sic*). Another warned 'Si tu n'est pas compagnons à ven' peux tu ceras brisé en poucier' (*sic*).[118] In Angleur, near Liège, the 'wives of strikers' (in the language of the reporting official) posted themselves at the entrance to the Angleur steel works (whose workers had joined the strike) and offered flowers to scabs. Elsewhere, playing on the fact that scabs were popularly known as 'red noses', strikers donned red paper noses and lined the roads to and from the mines.[119]

In addition to such semi-playful tactics, these strikers also began to devise strategies and methods that would protect their political actions in later years. Thus, for example, they avoided identification of leaders by holding all meetings after 9 p.m. Once everyone had entered the meeting room—usually a cabaret—lights were doused. All speakers remained anonymous. At the end of the meetings, lists of scabs, together with their addresses, were distributed, again in the dark. The lights were then lit, and the meeting broke up. (Using these lists, strikers broke windows and taunted scabs with cries of *jaune*, or *sarrasin*.)[120]

One last violent confrontation occurred before the strike ended in the spring of 1869. In April, with some 5,000–6,000 workers out in both Seraing and the Borinage, officials grew increasingly angry. Gendarmes and soldiers massed everywhere, awaiting the slightest sign of violence from the rebellious workers. When one group in the Borinage met mounted troops and police with batons, stones, and bricks, the troops charged. Seven were killed, including 'a poor girl who was watching the scene from a distance of 500 metres', and many more were wounded. This event, dubbed the 'massacres Belges' by Friedrich Engels, soon achieved

[117] No. 69, 'De Oostenrijkse ambassadeur te Brussel aan zijn minister te Wenen, 29 maart 1868', ibid.

[118] AEM, Commune de Wasmes. no. 522, 'Grèves'.

[119] Pierard, L., 'Grèves Générales', in *id.*, *Wallonie*, 273–9.

[120] Bonda, *Histoire anécdotique*, 157.

the status of a heroic myth in the collective history of the First Inter-national.[121]

From the end of the 1860s, class lines marking a divided Black Country were clearly drawn. The evident willingness of the 'haves' to deploy armed force to repress even the mildest protests by the 'have-nots' remained undiluted until the First World War. For their part, Belgium's workers were left fully aware of their status at the bottom of the Belgian social pyramid. For them, it was now clear that no petitions to the king, or pleas to the wealthy bourgeoisie would suffice to change their lives. And thus they began, slowly, to organize themselves for a long battle.

The story of this struggle is told below, in Chapters 7 and 8. First, however, it is necessary to detail one major reaction to the events of these years in mining communities. Like the Catholics, the liberal bourgeoisie were increasingly driven to view women coal-miners as social aberrations. And, again like the Catholics, some even saw their 'unnatural' work as destructive of the entire social fabric—an idea bolstered by women's obvious enthusiasm for strikes and mass action. Thus in the course of the 1860s, what was called elsewhere 'the woman question' entered public discourse in Belgium via the mines. The *hiercheuses* became the objects of a very curious, often bizarre, debate.

[121] Details in no. 288, 'Telegram van Coudroy aan Delesalle, Pâturages, 15 april 1869', and no. 293, 'De Hoofdingenieur te Bergen aan de minister van openbare werken, 16 april 1869' in *Documenten*, i. See also AEL, Sûreté Publique, VI. A. 1–155: 'Grèves'.

5

Women Miners and the Woman Question

Whoso doth the breeches wear, lives a life as free as air

French proverb[1]

As for the women, excepting the few days when their annual lying-in keeps them at home, they spend their lives as their husbands and children do . . . in the mines.

Henri Pirenne[2]

INTRODUCTION

Once the liberals assumed power in 1850, they began to turn their attentions to those internal threats evident—despite the absence of revolution in 1848—by the close of the 1840s. We have already glimpsed the troubled industrial landscape of the 1850s and early 1860s. By the end of the 1860s, worker unrest had begun to assume a more organized form as the first Belgians joined the *Association Internationale des Travailleurs*. Alert officials mounted extensive surveillance, intended to stifle any social revolt. But the movement towards organization continued unabated, and the number of confrontations between workers and the forces of public order increased.

In the process, would-be reformers focused increased attention on what many regarded as a primary social aberration: women's work in industry. And of Belgium's *ouvrières* and *werksters*, the most unusual were those women and girls who helped mine the nation's coal.

The debate about women industrial workers was played out against the increasing 'domestication' of bourgeois females, trapped in what might be termed the 'Victorianization' of bourgeois family life. The ideal *bourgeoise*,

[1] Quoted in Wheelwright, J., *Amazons and Military Maids* (London, 1990), 1.
[2] Pirenne, H., *Histoire de Belgique, vii. De la Révolution de 1830 à la guerre de 1914* (Brussels, 1932), 123.

whose image hardened as the century wore on, was the antithesis of an *ouvrière*. Her essentials are well-known: softness, passivity, beauty, and innocence when young, motherliness when older, and these linked to an underlying threat of emotionalism and irrationality. In France in this era, this stereotypical female grew increasingly decorative—the bearer of bourgeois ostentation, a showpiece of frivolity and luxury.[3] Such ideal types inhabited a clearly delineated sphere: the domestic world, where private life unfolded in tranquillity, untouched by the public rough and tumble of nineteenth-century capitalism. This idealized woman did, of course, venture beyond these confines—to 'visit' the poor, for example—but when she did, she carried with her a protective aura of class and gender difference.

For those Belgians anxious about women's proper social place, the stark contrast between real life *bourgeoises* and the nation's millions of working women—especially *charbonnières*—posed a problem. Were *ouvrières* like their bourgeois sisters, they asked themselves? If so, how could they be allowed to continue their industrial labour? If they were different, able to work in industry without physiological harm, were they 'naturally' different, or transformed early in life by industrial work? If the latter was the case, then all women, including those unlucky *bourgeoises* who lacked a male protector, were at risk. Such were the questions raised in the course of the second half of the nineteenth-century, as the numbers of women industrial workers grew.[4] All those concerned, however, faced a serious conundrum: if industrial labour was inappropriate for women, then clearly all should be excluded from the nation's mines and mills. But without them, the stunning industrial success of the nation was seriously threatened. What to do?

Gradually, and with much contradiction and conflict, Belgians shaped their own, unique images of two idealized females: one bourgeois, the other proletarian. They further refined the latter into three sub-categories: those whose waged work was entirely suitable for females of the lower classes, those employed in nearly appropriate occupations, and those few whose labour was entirely unnatural and highly dangerous—not only to the *ouvrières* and *werksters* themselves, but more importantly to the entire

[3] The formation of the bourgeois family is detailed in Poster, M., *Critical Theory of the Family* (New York, 1980). Other versions of this ideal female are found in Moses, C., *French Feminism in the Nineteenth Century* (Albany, NY, 1984), and Outram, D., 'Le Langage mâle de la vertu: Women and the Discourse of the French Revolution', in Porter, R. and Burke, P. (eds.), *The Social History of Language* (Cambridge, 1987), 120–35.

[4] More detail is provided in Hilden, P., 'The Rhetoric and Iconography of Reform: Women Coal Miners in Belgium, 1840–1914', *Historical Journal* (spring, 1991), 411–36.

social order. These groupings included first, women working at home, either as artisans or in the hundreds of sweated trades available nearly everywhere; second, women in industries identified as 'feminine', including, as we have seen, textiles; and last, women doing 'men's work'—especially mining coal. These latter became the most feared of Belgium's millions of female industrial workers in the final decades of the century. Indeed, they, together with children under 14, became the sole beneficiaries of the only protective labour legislation passed in Belgium before the First World War.

Even before the woman question (as it came to be called) entered public debate via women coal-miners, Belgians had reason to fear the potential for violence most believed lurked deep in the female nature. There were tales of women's lawlessness during the Brabant Revolution of 1795. Also well known were stories of women's valour in the revolutionary armies—where Belgian women soldiers were celebrated as *Amazones*. One 1790 manifesto, for example, demanded equal rights for Belgium's women, including the right to 'command an army'![5]

The French Revolution also featured a Belgian heroine. As anecdotes recounting her derring-do were told and re-told, Anne Joseph Théroigne de Méricourt's reputation spread through Europe. Both a Frenchman, Lamartine, and a Briton, Thomas Carlyle, described her as 'the fury of the Revolution'. Most believed that she had played a major role in that most emblematic revolutionary event, the storming of the Bastille, where 'la Belle Liègeoise commanded an army'.[6]

In Belgium's own revolution of 1830 stories of violent women abounded. One eyewitness to events in Brussels insisted that he saw a woman arriving from the Hainaut with 'her bosom full of cartridges'. Other women drove the food riots that accompanied the political revolt. One, Beatrix Saintenois, a 27-year-old *journalière*, was convicted of 'pillage and theft', and sentenced to a stiff two years in prison. At her trial, her defence argued that she deserved no punishment because such violence was 'characteristic of women of the people'![7]

[5] Cited in Smolar-Meynart, A., *La Femme et l'égalité, 1789–1989: De la dentellière à l'avocate*, Musée du costume et de la dentelle de la ville de Bruxelles, 24 Mar.–24 Sept. 1989 (Brussels, 1989), 6, 7. For the Brabant Revolution, see Polasky, J., *Revolution in Brussels, 1787–1793* (Brussels, 1987). One popular comedy of the revolutionary years, *Les Femmes Belges*, starred such 'Amazones'.

[6] See Seeling, H., *Les Walloons pionniers de l'industrie allemande*, trans. Pauquet-Dorr, J. (Liège, 1983), 31. A more cautious view of Théroigne de Méricourt's activities is found in Kelley, L., *Women of the French Revolution* (London, 1989), 11–12.

[7] Quoted in Bologne, M., *De Proletarische opstand van 1830 in Belgie* (Leuven, 1979), 98, and in *AEM*, Archives communales, Jemappes, II. 633, Hornu, 20–1 Oct. 1830.

One particularly gruesome event highlighted the extent to which females of Belgium's poorer classes symbolized subversion. On one tragic night in Brussels in 1831, a group of anti-revolutionary men spotted a woman walking alone near the Grand' Place. Assuming her to be a member of a revolutionary Saint-Simonian group they had attacked earlier in the evening, the men captured the young woman, stripped her, and tied her, naked, to the 'Tree of Liberty' planted in the square to commemorate the 1830 uprising. Then they whipped her bloody. In the chilling words of one historian, 'The police did not intervene'.[8]

Happily, such direct attacks on individual women were rare. But the belief that females, especially proletarian females, carried a proclivity for mob violence and political subversion remained widespread. 'Deux femmes, rivalité; trois femmes, complot; quatre femmes, bataille rangée', went a popular warning. In the turbulent nineteenth century, these words contained not only the traditional male belief in women's natural inability to get along, but also an implication that women in groups posed a political danger.[9]

In the 1840s a link began to be forged between women's industrial work—their direct economic role—and their tendencies toward fomenting social unrest. Even that most 'feminine' of occupations, lace-making, provoked this 1846 warning: 'As for skilled *ouvrières*, they display such an independence that far from commanding them, it is necessary to yield to their demands'.[10] One Charleroi mine engineer cautioned against educating working-class women. The more educated they were, the more 'turbulent' they became. Indeed, he insisted, leaders of strikes and riots were always 'educated women'.[11]

Of course these were women of the working classes, not *bourgeoises*. These latter were, in fact, nearly invisible to the public eye in this era. Even Belgium's vocal women's rights advocate, Zoë Gatti de Gamond, played but a marginal public role, despite her friendship with prominent government ministers. And even had Gatti de Gamond occupied a more public place, she would not have posed any threat to the domestication of Belgium's

[8] Smolar-Meynart, *Femme et égalité*, 7.
[9] A Liège saying, in Wallon, went, 'Ine feume, c'è-st-ine divise où dispute; treus feumes, c'è-st-on caquêt; qwate feumes c'èst l'diâle tot fait'. Both quoted in Dubois-Maquet, N. et Pinon, R., *Parures et métiers de la femme au XIXe siècle, Liège, 26 mai–30 oct. 1977* (Liège, 1977), 8–9. A Liège mine engineer expressed a similar view of groups of women in *Enquête—1846*, ii, 307.
[10] See ibid. 7.
[11] He was Eugène Bidaut: see ibid. 307.

bourgeoises: in this period she demanded only that 'woman be free to exercise in society those functions which define the duties of her sex'.[12]

Working women, then, not their privileged sisters, were the focus of bourgeois fears as the debate over women's social place unfolded after mid-century. As we have seen in Chapter 3, bourgeois commentators strove to define once and for all 'le sexe', in the language of the time. Although women textile-workers were the first focus of such bourgeois attentions in the 1830s and 1840s, their central position in public debates over women's work was lost to the far more anomalous women working underground, whose numbers increased during the 1850s and 1860s. Belgium's female coal-miners, garbed in their striking work uniforms, became the object of a public scrutiny that was far more searching than that directed earlier at textile-workers. Perhaps because coal was identified with proletarian masculinity in the course of the nineteenth century, or perhaps because female miners particularly affronted bourgeois sensibilities because of their relatively high, independence-giving wages and their 'manly' work trousers, Belgium's *hiercheuses* drew the ire of numbers of reformers intent on using legislation to exclude them from the mines. Unlike textile-mills—suitable venues for proletarian females—coal-mines were emphatically male.

The discourse of reform that began to emerge around women coal-miners in the late 1850s had two primary bases. One was the positivism of Quetelet's followers, already familiar from the textile debate. The second, which underlay the arguments of the Royal Academy of Medicine's doctors, was an anachronistic set of ideas borrowed from eighteenth-century French thinkers. For Belgium's organized physicians, Quételet's 'Baconian' methods of observation and generalization were far less compelling than the more metaphysical Cartesianism of earlier French thinkers. Most prominent amongst these was Pierre-Joseph-Georges Cabanis, an eighteenth-century ideologue whose misogynistic opinions were repeatedly quoted in publications of the doctor's society.[13]

It was Cabanis's view that every human being constituted a closed system. All behaviour was determined by the arrangement of every

[12] From Gatti de Gamond, Z., *De la Condition sociale des femmes au 19me siècle* (Brussels, 1834). This piece is excerpted in Keymolen, D., *Vrouwenarbeid in Belgie van ca. 1860 tot 1914* (Leuven, 1977), 34. For Zoë Gatti de Gamond herself, see Polasky, J., 'Utopia and Domesticity: Zoë Gatti de Gamond', *Proceedings of the Eleventh Annual Meeting of the Western Society for French History, 3–5 November 1983* (Lawrence, Kan., 1984), 273–81.

[13] Pierre-Jean-Georges Cabanis was the French ideologue most quoted or paraphrased by Belgian doctors in the second half of the century. His widely read work was *Rapports du physique et du moral de l'homme* (Paris, 1802).

element comprising this system. Any disarrangement produced the inevitable 'disorder'—evidenced by behavioural anomalies. To this basic idea, nineteenth-century Belgians added the notion that each such human system possessed an economic organization. In its ideal state, the human economy was in equilibrium. However, any loss to the system produced immediate imbalance—which lasted until some addition compensated. The female economy, they thought, was much more precariously balanced than that of the male. In 1846, one group of doctors noted: 'sous le rapport de la fonction la plus importante de l'économie de la femme, nos filles des fabriques rentrent également dans les conditions physiologiques.'[14] As the debate over women workers began to take shape in the 1840s, both approaches formed its underlying premisses, though positivism dominated the debate over factory life. Soon, however, most bourgeois observers agreed that Belgium's mills offered adequately protected environments, where women's 'natures' were undisturbed, and the focus shifted, towards the coal-mines.[15]

Mining proved altogether more problematic. As early as 1840, Dr Van den Broeck had warned:

Woman has not been created for excessive work, and to occupy her thus is to misunderstand the goal of nature, bringing upon her the dangers which nearly always result from an infraction of these laws. Moreover, there is a further disadvantage in allowing young girls to descend into the mine workings, that is the demoralization which, despite what certain people say, must necessarily be the immediate result.[16]

A Liège colleague added a twist: '*Le sexe*', he claimed, 'must be excluded from working underground because the constitutional weakness, the timidity, the carelessness and imprudence of woman all argue against her introduction'. He agreed with Van den Broeck that 'she often develops the germs of demoralization ... [This] ends by leading to that physical disorganization characteristic of those who yield to the imperialism of their passions'.[17]

In these early decades after Independence, a cacophony of discursive sounds surrounded the mining debate: economic imprudence, disease, disorder, and demoralization mingled together. Soon, however, one argu-

[14] See Société médicale de Gand, in *Enquête—1846*, iii, 422. This group's authorities included two Frenchmen, Jules Michelet and Dr Louis Villermé, one Englishman, Dr Boyd, and several Prussian phrenologists; see pp. 406, 423.

[15] Ibid. 424.

[16] Quoted in Kuborn's *Rapport*, 1.

[17] Peetermans, Liège, *Enquête—1846*, iii, 158. 'Imperialism' is apt here; such arguments were used to justify controlling the indigenous people of Europe's empires—the 'heart of darkness', in other words, was fraught with similar passions.

ment became louder and more distinct. Woman's destiny (females were always singular in this objectification) could be 'preserved' only if 'her organization remained static', in the words of one mine engineer. In mills, the female structure did remain intact and 'ordered'. But 'sojourning below ground' woman's organization was threatened. She became 'an ideal vessel for immoral germs' which in time 'degraded the race'.[18] By the middle of the 1850s, many of the essentials of what became a debate about women working underground were in place. Working women's physical nature (explored both as an idea and as a physical reality) provided the object for what soon became considerable public attention.

Women coal-miners were, of course, but a fraction of the huge female industrial workforce. This meant that supporting their removal from the mines diverted attention from the far more significant issue of women's industrial conditions in general. After all, excluding women from mining was far less economically threatening than restricting their work in textiles, for example. Of course mine-owners did not agree; but in fact their dependence upon women's work underground was not really significant. In many of the largest mines, and all over the Liège basin, women's jobs were often also taken by boys—and later, by horses.

The second, and more important, factor which drew so much public attention to women miners was psychological: the idea of the mine. Fear of the underground world—inhabited, after all, in almost every culture's myths, by demons, by anti-humans, by hell—had, needless to say, ancient roots. The connection between the human female and the earth was equally venerable. Persephone's annual journey below ground signalled winter, a prolonged semi-death for the earth. At the same time, the earth was 'herself' Mother—the great womb from which all life sprang: to be inside the earth was to be inside the mother's body. Tampering with Mother Earth, as in mining, was not unlike tampering with female reproduction, and coal-mining was digging into the earth: descending with picks and shovels, miners wrested the black coal from the rock, then dragged it from the depths into the light. Such acts ran counter to deeply held, if often subconscious, feelings about humans' proper relations with the planet.

Mines embodied a kind of terminal point, a 'bottom', for burial (alive, for miners), or a bodily end, the 'earth's entrails'. This grave, this hell, was everyone's nightmare. Camille Lemonnier's prose—driven to lofty heights by the textile-mills—grew even more luried when he described Belgium's mines: 'In the black cavities of the earth, in these regions of death and of

18 P.-J. Delneufcour, Hainaut, ibid. ii, 250.

darkness, where, as in the catacombs, are stilled the corpses of the centuries. . . .'[19] Those who daily braved this underworld enjoyed a distinct identity. As their numbers grew in the nineteenth century, their work underground was increasingly mystified in the public imagination.

What most provoked Belgians' horror was the confusion of gender in the nation's mines. This muddle occurred on several levels. On the metaphysical plane, if the earth was mother (or a female body) then she was the passive element, awaiting male intervention in her reproductive process. It was male seed she received each spring; and man's 'courage' and strength she awaited in the underground galleries. If attack on this female earth was necessary, in other words, it was rightfully man's work.

In the public imagination, coal-mines were highly erotic. The mine's darkness, its damp heat, its mysteries, and its dangers gave free play to fantasy. As the prose of both Émile Zola and later George Orwell showed, mining was highly sensual—at least amongst non-miners.[20] Not surprisingly, speculation about aberrant sexual activity underground was rife in the middle of the nineteenth century. In a typical passage, one Charleroi mine engineer enveloped himself in sexual predictions:

It is evident that individuals of the two sexes, in the effervescence of youth or in the force of age, placed in conditions such as those where miners find themselves in relation to one another, that is to say, often having a job which isolates them in couples in the midst of a profound obscurity, in a more or less complete disorder of

[19] Lemonnier, C., *La Belgique* (Paris, 1888), 454. Mikhail Bakhtin, in *Rabelais and his World*, trans. Iswolsky, H. (Bloomington, Ind., 1984) has explored this image of the underground: see p. 21. See also Jane Harrison's examination of the connections made by Greeks between women and the underground in *Prolegomena to the Study of Greek Religion* (New York, 1955), and *Epilogomena to the Study of Greek Religion and Themis* (New York, 1962).

[20] Zola's *Germinal*, published in 1885, was widely read in Belgium. The author was obviously intrigued by the sexuality he imagined flourished in the rare northern French mines which employed females underground. George Orwell's *Road to Wigan Pier* (Harmondsworth, 1972) reveals his fascination with the erotic physicality of Britain's male miners. See especially pp. 20–1, where the author waxes envious over male 'fillers', who aroused in him, 'a pang of envy for their toughness'. Their work was, of course, women's work in Belgium. By the second half of the nineteenth century, coal-mining in Britain was inextricably linked to masculinity. As Robert Graves put it, in *Goodbye to All That* (New York, 1957), his memoir of the trench warfare of World War I, 'But even a miner can't make a joke that sounds like a joke over a man who takes 3 hours to die, after the top part of his head had been taken off by a bullet fired at 20 yards' (p. 114). Such a close link between masculinity and coal-mining in Britain helps explain both the misogyny of British mining communities revealed in Campbell, B., *Return to Wigan Pier: Poverty and Politics in the Eighties* (London, 1984), and—to the extent that Britain continues to stand as the model for all 19th-century industrial nations—the neglect of Belgium's women coal-miners by most social and labour historians. In other words, if 'miner' automatically equals not only 'man' but 'superman', then historians might be forgiven for their failure to imagine 'superwoman' as well.

clothing, resulting from the nature or intensity of their work ... would not ... resist their passions.[21]

If such a world (however imaginary) were not sufficient argument against women miners, there was one sign of the occupation's unsuitability visible to every Belgian who passed through mining country: women coal-miners wore 'man's' clothing, i.e. trousers and a 'manly' jacket. Worse, they all covered what was their most visible secondary sexual characteristic, their hair—though Charleroi's *hiercheuses* deliberately allowed a fringe to show beneath their caps as a sign of their femininity. Most observers insisted that miners' hair-concealing scarves or caps were more evidence of their 'masculinization'.[22] Everyone was shocked. 'There was nothing more scandalous in this century', one historian has remarked, 'than to see a woman dressed as a man. In every case, the vestimentary inversion was a demonstration of the world upside-down.'[23] The *hiercheuses*' uniform—worn in a world that was already upside-down—constituted the outward and visible sign of an inward and moral disgrace, evidence of a role reversal that threatened a new species of 'man-woman'.[24]

As women miners' clothing demonstrated independence (and subversion) so *bourgeoises*' clothing increasingly showed their dependence, their marginalization. In the words of A. Smolar-Meynart:

The 19th century, paradise of the bourgeoisie, dug an abyss of exterior contrasts

[21] Bidaut, *Enquête—1846*, ii, 260–1. 'A sweet disorder in the dress vertical kindles in clothes a wantonness' was the way the English poet, Robert Herrick, put the principle.

[22] The proscription, which of course takes various forms, was recorded in the King James Bible in Deuteronomy 22:5, as 'The woman shall not wear that which pertaineth unto a man'. When Honoré Daumier and others caricatured French feminists of the 1840s, they dressed their female figures in clothing strikingly similar to that of Belgium's *hiercheuses*. Claire Moses provides several examples in *French Feminism in the 19th Century* (Albany, NY, 1984), 123–6. See also the fascinating study by Dekker R. and van de Pol, L., *The Tradition of Female Cross-Dressing in Early Modern Europe* (London, 1988). As for the link between hair and sexuality, many of the world's religions impose restrictions on women's hair on the grounds that it excites male lust.

[23] Dubois-Maquet and Pinon, *Parures et métiers*, 7. See also Barthes, R., *Système de la mode* (Paris, 1967). I am grateful to Jonathan Prude for discussions about working dress in the United States. See his forthcoming work, the working title of which is, 'The Appearance of Class: How American Working People Presented Themselves and were Perceived, 1775–1917'.

[24] This term 'homme-femme' recurs in much 19th-century political discourse. In 1872 Alexandre Dumas fils titled a book about women's oppression in marriage, *L'Homme-femme*. Simon Schama has described the 17th-century version of the 'battle of the trousers', as 'the masculine nightmare of men-women', in *The Embarrassment of Riches: An Interpretation of Dutch Culture in the Golden Age* (New York, 1987), 447. The tradition was very old: when Queen Artemisia's ship sank at Salamis in 480 BC, Xerxes remarked, 'My men have become women and my women, men' (reference from Timothy J. Reiss).

between the man and the woman. Man, in his austere, sombre, little-decorated clothes, incarnated every aspect reputed to be serious or important in society, politics, or business. By contrast, the vestimentary extravagances reserved to women were charged with signification. Fullness, luxury, surcharged décor, even the ritual of dressing acquired symbolic significance.

Heavily 'upholstered' *bourgeoises*, in this social world, wore their husbands' status, as well as their own subordination, on their backs. They became, in Smolar-Meynart's phrase, 'a symbolic image of *maladresse*, of fragility, of futility'.[25]

And what could be more different from this heavily-charged symbolism of bourgeois female fashion than the uniforms of Belgium's *hiercheuses*? No wonder, then, that so many contemporaries saw these women as embodying disorder and immorality. 'They willingly accept indecent proposals', opined one male contemporary, 'and do not always show the modesty suitable to women'. Added another, 'they are not intimidated by outsiders, unlike their male comrades, who are more fearful'.[26]

Clothing, of course, was not the only problem. Throughout these decades, many warned of the dangers inherent in women's economic independence. Women who did men's work, wore men's clothes, and earned men's wages might demand men's rights and privileges. Various proverbial adages suggested that the *hiercheuses* posed such a difficulty. A Walloon saying, 'Au tant fait enn' journée à fosse' meant one of three things: first, an exhausting encounter; second, any difficulty; and third, a cantankerous and demanding woman.[27]

By mid-century, then, the woman question, dressed in the distinctive trousers and jackets of Belgium's *hiercheuses*, had wandered on to the stage of Belgian public life.

LIBERALS AND WOMEN MINERS

In the 1850s women working underground provoked widespread public debate. Attacks by foreigners were especially virulent in the early years.

[25] Smolar-Meynart, *Femme et égalité*, 7.

[26] These remarks came from the Chambre de commerce de Mons, and Martin Schoenfeld, resp., both in *Enquête—1846*, iii 132, 28. Achille Delattre agreed that women were less frightened; he noted that 'they preceded men in marches, presenting demands with vehemence', in *Histoire de nos corons* (Verviers, 1953), 91.

[27] Found in Delattre, A., *Dans la Bourrasque* (Brussels, 1946), 45, 53. Another Wallon saying, 'Y wefe com'ee scloneus' (He works like a *scloneuse*), meant that someone worked especially hard. This echoed the saying about *boteresses*.

Karl Marx, for example, used the fact of women—and children—mining coal to indict Belgian industrial capitalism: 'Even in coal and iron mines', he exclaimed, 'workers of both sexes and all ages are consumed with a total "liberté", with no hours' limit. Of 1,000 people employed in mines, there are 733 men, 88 women, 125 boys and 44 girls under 16'.[28] Another foreigner transformed women coal-miners into figures more acceptable to his sensibility. In an adaptation (for British readers) of L. Simonin's study of Belgian coal-mining, H. W. Bristow identified a drawing of men and women miners underground as 'Pitmen and *their wives* in their working dresses at the collieries of Charleroy in Belgium'.[29] Thus relegated to their proper, subordinate domestic roles, the two female figures lost whatever subversive possibilities they might have suggested to Bristow's Victorian readers.

The illustration itself, interestingly, included two conflicting images of female coal-miners both of which circulated in Belgium in the 1860s. This posed underground scene (originally a photograph by Octave or Prosper Bevièrre), showed two *hiercheuses* and two *mineurs*. The central figure was a female, standing in the middle of the group, her lower body canted towards the pit wall behind, while her upper body faced the viewer. One hand rested provocatively on her forward-thrusting hip, palm open. The look, directed at the viewer, carried both bravado and sexual challenge.[30] Seated below this central *hiercheuse* was a male, posed in a similarly aggressive manner. Legs apart, hands crossed on his upright pick, he faced the viewer, frowning. Together, the miner and the *hiercheuse* embodied one image of Belgium's coal-miners: independent, irascible, erotic.

The second pair, by contrast, were far more familiar. Here the male figure, seated passively in the foreground, facing forward, was looking over his shoulder at the second female. She leaned forward, holding out his lamp—in a classic pose of a dutiful, helpful wife. Both the male and female miners in this picture, then, played the gender roles assigned them in the popular imagination. One female was *courtesane*, one *ménagère*, as Proudhon's famous and oft-quoted duality prescribed. The men, too, embodied opposites; on the one hand sat a potentially rebellious, independent, and

[28] In Marx, K. and Engels, F., *La Belgique: État constitutionnel modèle* (Paris, n.d.), 250–1. Marx was equally horrified by women working in steel-mills: 'In the blast furnaces, of 1,000 workers, 149 are women, 98 boys, and 85 girls'.

[29] This translation of female workers into wives is found in Simonin, L., *Underground Life or Mines and Miners*, translated and adapted to the present state of British mining, and edited by H. W. Bristow (New York, 1869), fig. 99.

[30] The clarity of the sexual challenge in both the expression and pose of the figure underscores the falsity of Bristow's perception of the two female workers as 'wives'.

sexually challenging single man, on the other a 'tamed', though still independent, married man.

Bristow's assumption that the only women underground were 'miners' wives' stemmed from his experience of British mines from which women had been excluded in the 1840s. From the moment Britain's 'pit girls' left work inside the mines, they began to disappear from the public memory—despite the fact that thousands continued to work at the surface, as 'pit-brow lasses'.[31] When Bristow's fellow Briton, Arthur Munby, visited Belgium's mines in the 1860s, he was stunned to discover the existence of *hiercheuses*. He had sought only 'pit-brow lasses' similar to those he had visited in England. When he asked a male clerk at one Charleroi mine where he should go to meet such surface workers, he was told there were no women doing such work at that particular mine. Disappointed, he was making for the door when the clerk added, 'But there are plenty of women working below'. Munby stopped. '"What", I said', he wrote in his diary, '"do you mean to say there are women down here—working underneath the ground where we stand?"' The clerk not only assured him that this was indeed the case, but further delighted his English visitor by telling him 'down in the pits, the number of women labourers exceeds that of men'.[32]

Unlike Bristow, Munby had no inclination to re-cast Belgium's *hiercheuses* in roles more acceptable to Victorian society. He was fascinated by women miners' 'unfeminine' qualities, their physical strength, and independent attitudes. At the same time, he noted their exceptional beauty: 'Most', he wrote, 'were extremely pretty and feminine too—scarcely one who looked like a man, even in trousers'. With still more admiration he described their work. Most appealing were the female 'getters'—those who cut the coal from the seam. One male miner bragged of Charleroi's female 'getters', telling Munby that 'he had known a strong young woman ... getter who did it as well as a man'.[33]

Munby met one such young woman, 'a fine, comely, peasant girl', he recalled, 'clean brown skin, thick apricot arms, clean broad brown hands with tough leathery palms and corns'. Intrigued, he told her, 'you've got a

[31] They continued to work on the surface, as 'pit-brow lasses', but they vanished from the public mind, not least because Britain's mines were far less accessible to most travellers than were those in Belgium. Railway passengers in Belgium could easily observe miners at work, as they passed Liège, or the Borinage, or even Charleroi. Moreover, in flat Belgium, slag-heaps—upon which scores of women laboured—transformed the 19th-century landscape, rising as new mountains all around the villages and cities of the coal basins.

[32] Information from Munby Collection, diaries, no. 33 and 36. Additional information found in Notebook 66, as well as in Albums 4 and 6.

[33] See ibid., and Hiley, M., *Victorian Working Women: Portraits from Life* (Boston, Mass., 1980), who also quotes this remark on p. 99.

good hard hand Juliette'. 'Aye sir', she replied, 'and I think it's hard to earn a better wage than I have!' She had worked below ground for eleven years and, she said, 'likes it much'. 'My work is hard, sir', she said as she prepared to go down for the night shift. 'I'm a sinker. I work the machine for boring along, with this sorry man, my mate'. The 'mate', in Munby's critical eyes, was 'not so robust as she. . . . Juliette strode and stood about like a navvy, and looked like one, a noble wench and quite womanly withal.'

Munby was fascinated by the contrast between the young women's 'femininity' and their 'masculine' work. Juliette and her friends all wore marigolds in their button-holes, for example.[34] At the same time, he noted the sharp distinction between the women coal-miners and a group of *bourgeoises* he observed nearby. 'Many ladies', he confided to his diary, 'in white and bright colours, carrying bouquets, [entered] a large garden of a grand house'. Close by stood 'a dozen collier girls . . . All in their coarse pit clothes and with black faces and black arms'. His judgement of the scene perfectly captured Belgian social relations of the era: 'They took no notice of the ladies, nor the ladies of them'.[35]

By the end of the 1860s, however, this mutual indifference had changed. Following many violent confrontations between miners, mine-owners, and troops, Belgium's ruling oligarchy had begun to take particular heed of the anomalous nature of women coal miners. Even that committed non-interventionist Frère-Orban decided to support state action, though he did so with great reluctance:

One would say that the painful work to which women and children are submitted . . . is work from which it is necessary to free them. But', he warned, 'it is the most imperious need which pushes women and children to seek the means to live. . . . The yawning abyss of the pit is there; it means descending into its depths. Most amongst us would recoil before the obligation to take ourselves into these unfathomable depths. Women and children do it courageously. Why? In order to have bread, in order to live! Here is the sole motive which impels them.[36]

[34] Although the Belgian women did not claim 'men's status', British women sometimes disguised themselves as men to go down the mines. In 1868 one Welsh woman told Munby that she had successfully hidden her sex in order to work below ground. 'Ah draved with best an "che-an"', she told him. Another Welsh woman boasted of her aptitude by claiming, 'I do as mooch as a two-an-tenpenny mon from me twenty pence': see Notebook 66.

[35] Quotation ibid.

[36] Quoted in Verniers, L. and Bonenfant, P., *Manuels d'histoire de Belgique* (Brussels, 1933–4), 72 as 'the heart of Frère-Orban's thoughts on the regulation of women's and children's work in the mines', pp. 179–80. Frère-Orban's opinion of women's motives highlighted the divide between members of Belgium's ruling élite—who could imagine no positive motives for mining coal—and workers.

Frère-Orban's liberal principles did not collapse immediately, however. Instead, the government employed their time-honoured method for postponing legislative intervention by sponsoring an investigation. In 1868 the Royal Academy of Medicine, headed by Dr Hyack Kuborn, undertook to study the problem of women coal-miners on behalf of the government.

Many physicians participated in the research, but the final report reflected the strong views of only one man, Hyack Kuborn, who showed himself to be both a rabid francophile and a misogynist. The report, therefore, quoted a myriad of French authorities to support the author's persistent fear of women. Given French bourgeois attitudes towards women's industrial work, and Kuborn's own pathological distrust of females, the report's unequivocal condemnation of women coal-miners was, to say the least, overdetermined.

The document's opening salvo outlined the terms of the discussion: 'Certain educations, certain works, some violent exercises can bring women morally and physically closer to the man. In tribes where roles are inverted, the husbands seeing to the domestic work whilst the women wage war, women have gained a few attributes—secondary ones, to be sure—that belong to men'.[37] Seeking 'first principles', Kuborn next argued that *'mulier propter uterum id est quod est'* (woman is her uterus). 'There', he declared, 'is the immutable characteristic which marks all woman's nature. It requires three essential functions: menstruation, generation, secretion of milk'. From these, woman had no escape. 'Her destiny is imprinted in every fibre of her body', wrote this physician, 'in the shape of her fingers, the spacing of her hips, her air of sweetness'. All provided visible evidence that she was the exact opposite of man, 'he of powerful shoulders, ample and sonorous voice'.[38]

Such physical features revealed the character hidden inside. Woman's body displayed an 'essentially nervous temperament', with 'exquisite sensibility and mobility of impressions'. It also disclosed 'the tender sentiments, goodness, compassion, timidity, patience, abnegation, delicacy, a penetrating mind'. 'She appears', he wrote, 'as a young tree reaching up seeking a tutor, the support of that proud and powerful being with commanding tones, persistent energy, less lively sensibility ... whose outward expres-

[37] Kuborn, *L'Emploi des femmes* pp. 6–7. This reference to women warriors probably pointed to the much cited women's army of Dahomey, which had defeated French troops in battle. They were usually called 'Amazones'. See Bay, E., 'The Royal Women of Abomey', PhD. thesis (Boston, 1977).

[38] Kuborn, *L'Emploi des femmes*, 8.

sion denotes a creature destined to intellectual effort, to physical struggle, to danger . . .'[39] From every point of view, woman was the antithesis of man. She was 'the stock of the human race'. Her proper function was 'to lie passively [Kuborn used "gésir", which also means to lie helpless or dead] in the grand act of reproduction, the *dépôt du germe*'.[40] Needless to say, these *dépôts* of man's 'seed' had no business working inside that other *dépôt du germe*, the earth.

Countering the arguments of some earlier commentators, Kuborn insisted that even before menarche, mining could turn the female body from its natural path. But once 'the reproductive organ acquires its maturity, woman belongs to the act for which she was created: conception. From then, she no longer belongs to herself, she belongs entirely to the being whom she carries in her breast (*sic!*)'. During pregnancy (Kuborn called it *troubles physiologiques*), woman was entirely claimed by the foetus, and after birth she continued her role. Because the infant imbibed both physical and moral sustenance from breast milk, woman must not wean the child too soon, lest she 'violate nature's laws'.[41]

Fourteen pages into such unfocused opinions, Kuborn reached the subject: women coal-miners. Here, too, he was unequivocally negative. Mining, he thought, irrevocably upset the female natures of all 10,000 women then working underground. Of course ostensible concern for reproduction hid other fears. On the one hand, Kuborn worried that most women miners 'acquired independence' because of their 'liberty and high wages'. It was pernicious: 'See our mine girls at *fêtes*, at *kermesses*: vanity, innate in women, is carried to its heights' because they could indulge their weakness for 'ornaments'. 'High pay and vanity', then, 'attract women to the unnatural work of the mines'.[42]

But Kuborn's greatest nightmare was sexual. His fantasy mine was riddled with debauchery, including seduction, rape, and sexual slavery. 'The prettiest girls belong first of all to the master workers', he argued. Worse, 'doing work foreign to her nature, in constant contact with men, exposed like them to all sorts of dangers, including floods, fires, rock-falls, asphyxiation, and injuries, far from the bosom of her family, dressed in men's clothes, she must inevitably assume something of his masculine

[39] Ibid.

[40] Ibid. 9. One cannot resist remarking the evident size of the author's ego.

[41] Ibid. 11.

[42] It should be noted that the total mining workforce was 87,000, including some 4,400 additional females working at the surface: see ibid. 14–15, 16.

character, losing her breasts'. As a result, 'She can be found sitting in a cabaret, smoking a pipe'.[43]

Those who continued the work eventually became monsters. 'When woman abandons the moral attributes that are the essence of her sex', he wrote, 'she becomes a hideous being, a virago'. Combining all his fears in a single hostile frenzy, Kuborn described unrest in the mines:

> See these mannish women, with dragging breasts, broadened hips, a knowing gait, and shrill words, accepting insolent looks and bold gestures.... These are they who most excite popular agitation, revolts, strikes; who, at Marchienne, Châtelineau, seized the riot banners and carried them, singing, at the head of a deranged crowd, breathing discord, pushing men to pillage ... men who, by the false shame of seeing themselves outstripped by women, finish by driving themselves to the last excesses.

Children were 'abandoned to their fathers' care'; not suited by nature to the task, fathers 'failed to offer tenderness and sympathy'.[44] It was a world turned both upside-down and inside-out.

All was not bleak in Kuborn's portrait of his country's industrial landscape, however. In stark contrast to the mines lay the equally economically important universe of textiles. In mills, women remained 'perfect mothers', because 'They come to work in sex-segregated groups, they work in such groups, they return home in them'. They practised 'mutual surveillance': no one was allowed to 'affront the group's morals with impunity'. 'Wonderful work, wonderful families, wonderful lives', Kuborn bubbled.[45]

Hyack Kuborn's cosmos included one industrial limbo. Between the hell of the mines and the paradise of the textile-mills stood Belgium's glassworks. There women shared some of the *hiercheuses'* risks. Not only did they work in mixed-sex groups, but they went home to miners' *quartiers*. Still, any observer could quickly distinguish women glass-workers from their mining sisters, because glass-workers were much better mothers,

[43] Ibid. 46. The French writer, Georges Sand, popularly believed to have represented liberated women, was often linked to pipe-smoking as well.

[44] Ibid. 46, 47, 38, 39, 54–5. Men miners, Kuborn added, were almost as depraved as women, being addicted to games, food, and drink. They frequently 'abandoned' wives and children. The latter inherited their immorality and in their turn, 'abandoned' elderly and disabled parents.

[45] Ibid. 65, 69. Kuborn discovered one other group of women workers whose morals were nearly as bad as those of their mining sisters. These were the *ouvrières* of the Val-St-Lambert glass works, who not only worked alongside men, but also lived in miners' communes, where they inhaled miners' pernicious morals. Significantly, Kuborn discovered only one 'ideal' industrial city, where no women worked outside their homes: Bleyberg, in Germany. As a result of women remaining in their proper sphere, he added, there were 'no strikes'.

much more willing to 'undertake nature's work'.[46] Kuborn in no way suggested excluding Belgium's millions of waged women from the industrial labour-force. Instead, he wanted only to concentrate women in tasks 'appropriate' to their sex. Amongst the most ideal work, he concluded, were 'little fruit and vegetable shops, dressmaking, laundries, ironing, cabarets'. Those women legislated from the mines who could not find work in such places might, he suggested, find work as maids.[47]

Following Kuborn's investigation, the Royal Academy proposed a law excluding all females and boys under 14 from underground work, to be effective from January 1872. Their resolution, however, had no effect in the legislature. The Royal Academy report did receive much public support in the form of books and essays. One such was published by Henri Marichal in the *Revue Trimestrielle* in 1869. Entitled 'The Worker Miner in Belgium: What he is, what he must become', the piece argued that mining communities housed two types of women: the good woman, 'the radiant centre of the family', whose housewifery made her 'the most active agent of progress and civilization'; and the bad woman: a 'detestable housewife', this latter woman was also an 'ungovernable shrew', who radiated 'disorder'. Needless to say, perhaps, all these characteristics stemmed from her employment underground in the coal-mines. Such women spread their evil beyond their households. Echoing Kuborn, Marichal insisted that they were 'the most ardent supporters of violence, or riots, and the most indomitable and most cruel in scenes of disorder'— especially when 'drunkenness has overexcited [their] coarse and wild nature'.[48] In Marichal's opinion, work in the mines was absolutely corrupting: 'The work of a girl in the coal-mine is a constant occasion of scandal and depravity which defy the imagination', he concluded. Strikes, and unrest were the consequences, 'the result of bad morals, bad judgement, no education'.[49]

Kuborn's and Marichal's attitudes were widely shared in the 1860s and early 1870s. However, women coal-miners had their defenders. One doctor, for example, attacked Kuborn's 'hypocrisy':

'You demand that the *ouvrière des fosses* be a good housewife, but do you demand this as well of the women working in the workshops of our great cities? Do you demand it of glass-factory workers . . .? Can you demand that the seamstresses and other daily workers be good housewives? Do you believe that these young

[46] Ibid. 78–80.
[47] Ibid.
[48] Marichal's article was published as a brochure in Paris in 1869.
[49] Marichal, H., 'The Worker Miner in Belgium' (Paris, 1869), 33, 36.

women, after their day, would be any more disposed than the women mine-workers to work inside the household? That would be a mistake! The workday finished, everything is finished, and the household is forgotten'.[50]

Dr Nicolas Fossion, a royal academician himself, criticized Kuborn's lack of 'science', and his 'ignorance of modern economic principles'. Fossion's own properly positivistic observations showed him that female miners

are well-shaped and of a great robustness: the figure of these women does not, assuredly, present the fine features of ideal women, or of those who work in sedentary occupations; but all the same, one finds those who are beautiful; they would only lose if they exchanged their trade for those of dressmakers or factory workers. It isn't a very hard job to shovel coal into the waggons or to slide them a certain distance over the rails. It is only exceptionally that one sees here and there still a badly directed coal-mine where women must drag the waggons with the aid of straps over their chest and breasts. The introduction of iron rails in the mines was for the 'hiercheurs' (*sic*!) a very great improvement.[51]

Hard physical labour was also good for miners' morals, because unlike sedentary work, it 'let off steam'. Furthermore, mines were much too busy to allow for any indulgence in immoral behaviour. Still, Fossion admitted, the general public's view of women miners was not always very positive:

Like all people who take to active work, the young woman of the pits is gay and jovial; it is this that suggests that she has manners that are a bit sharp [*délurée*]; despite the bawdy proposals she addresses to her workmates on the way out of the pits, she is not so accessible to seduction as one might suppose; and if she does give herself, she almost never sells herself. Finding in her work a secure means of existence, she would repudiate with contempt and derision any seduction proposals put to her.[52]

Whether the image was positive or negative, however, it was clear to everyone that women coal-miners bore little resemblance to the increasingly idealized *bourgeoises*, sexually innocent, weak, quivering, and fragile. The disjuncture between the ideal lady and the ideal *hiercheuse* grew more obvious as time went on. As bourgeois fashion prescribed increasingly restrictive female clothing—tighter corsets, larger skirts, heavy and un-wieldy capes, thickly-decorated hats, reticules, umbrellas, gloves, and so on—so the contrast with loose-trousered *hiercheuses* grew steadily more

[50] *Travail des femmes* 36; Van Baestelaer, the report's author, was a proponent of Quételet's methods.

[51] Fossion, N., *Réponse au rapport de M. Kuborn sur le travail des femmes dans les mines* (Brussels, 1869), 17.

[52] Ibid. 28.

striking. Nevertheless, economic imperatives (together with a generalized indifference amongst the ruling élite) prevented most Belgian reformers from suggesting legislation that might transform these female miners into working-class replicas of the domesticated *bourgeoises*. In fact, Fossion condemned working-class *ménagères*: 'The woman of the people who only cares for her household, and does not seek to earn her daily bread by her work, is habitually more restive, bad-tempered, depraved [*vicieuse*] than the honest *ouvrière*, who wants to contribute with her labour to the support of her family'.[53]

The Liège mine-owners' association soon entered the fray. They attacked Kuborn for writing about mines without visiting even one. 'It is necessary to know the mines', they wrote,

in order to judge what happens there. How many folks have we not seen depict the work of coal mines in the darkest colours without ever having put a foot in the mine? How many words . . . how much claptrap have people not written about this work, *done in the obscure entrails of the earth, far from the sun and from pure air* [their emphasis] . . . The miner comes from his (*sic*) work black like the coal he mines, and that suffices, it must be said, to make him the pariah of the working class.[54]

They denounced the French authority much cited by Kuborn and other critics of women coal-miners, Jules Simon. That French social thinker had condemned women's industrial labour, insisting that 'woman's place is in the home'. Like Fossion, the mine-owners were contemptuous of that pre-scription:

That doctrine has had currency for some time in America, where woman is literally confined to the domestic foyer. Thus the degeneration of the race in America can be attributed precisely to the forced repose that is today being considered amongst us as a panacea destined to cure all the physical and social evils at once.[55]

Instead, the owners' group suggested that 'outsiders' should look only at real women coal-miners in their research. If they did, they would see 'the air of health and good humour that characterizes most of our mining women'. Yes, they did spend money on fashion, but like their male comrades, 'they only compensate themselves for the week's privations'.[56]

The matter did not rest there. Increases in the numbers of miners virtually assured that the problem would remain at the forefront of public debate. 'Pro' and 'contra' pamphlets, brochures, reports, and so on, multi-

[53] Ibid. 30.
[54] *Rapport de l'Union*, 4.
[55] Ibid. 6.
[56] Ibid. 10–11, 14, 19.

plied as the number of miners—of all ages and both sexes—grew from 92,000 in 1869 to over 110,000 in 1875. The proportion of female workers may also have been growing: one source claimed that women comprised 16 per cent of the workforce in Hainaut mines in the 1870s.[57]

The first to defend Kuborn's work in the 1870s was the Brussels deputy, Dr Jean François Vleminckx. His report appeared in support of his introduction of a bill aimed at excluding women from work underground similar to that proposed by the Royal Academy years before. Generally, he echoed Kuborn's opinions. At the heart of his hostility to women's work in the coal-pits was his conviction that women's character was 'infected' in the mines by the 'germs' of masculinity. She lost the features of '*le sexe*', and gained 'the allures of independence and liberty, which later become the cause of disputes, of quarrels, and even of violent acts'. Worse, he believed that 'earning a rather high wage, she becomes prodigal and no longer knows the value of money ... Habituated to going out every day, her interior becomes a burden to her. These are some of the special causes which together lead her to become a bad wife, a bad mother, a bad housekeeper', he concluded.[58] Vleminckx's concerns were widely shared. A Liège mine official, for example, complained that women's work in the mines forced male miners to forego 'a pleasing, gay wife, clean and laughing children'. Returning from work, he did not find 'a warm house and well-served meal'. Instead, 'far from the light of the sun, buried alive in the entrails of the earth, bent over, blind', mining wives toiled underground 'alongside their husbands, their brothers, their sons'.[59]

In these same years, women miners found their most vocal defender in the positivist Martin Schoenfeld. Although this Charleroi mine doctor had testified against women miners in the 1846 *enquête*, years of work in mining communities, together with his commitment to a positivist recognition of facts, had changed his mind. By the 1870s he had become an enthusiastic supporter of women miners—and indeed, of independent women across the social spectrum. After reading Kuborn's report with which he disagreed, Schoenfeld—a member of the Royal Academy—asked

[57] The discrepancy with figures cited in Ch. 4 reflects contradictions in sources. Figures here from *Grèves ouvrières*. The growth in numbers accompanied an increase in Belgian coal production and profits. In 1875, Belgium's 280 mines produced 15 million tons, worth 230 million francs, according to Trempé, R., *Les Mineurs de Carmaux, 1848–1914*, i (Paris, 1971), 133. These were, of course, French francs.

[58] Vleminckx's bill remained undiscussed for six years before it died. See Vleminckx's *Lettre*, 11–12.

[59] Quoted in *Grèves ouvrières*, 184, 189, 11. There was some support for this view amongst male miners. See e.g. 'Appel à les ouvrières couturières de Liège', in *Ami du Peuple*, 28 Dec. 1873.

to respond at the group's next meeting, but he was refused permission. Angry, he wrote out his criticism of Kuborn's opinions, and published them privately.

Because Schoenfeld's defence of the women he had known well for decades was based on facts rather than on a reading of the 'French authorities' who supported Kuborn's opinions, he began his attack with the sarcastic observation that men like the much-quoted Jules Simon 'must possess a very marvellous telescope . . . which sees down inside Belgian mines all the way from Paris'.[60] But Schoenfeld did admit the accuracy of one of Kuborn's points. *Hiercheuses* were prone to want luxuries—such as 'buttoned boots to replace the nailed boots of former times'. But in this, he insisted, they were no different from all other Belgians, who in those times had become deeply materialistic. 'Vanity', wrote Schoenfeld, 'has perverted the minds of much of the world'. What mattered far more than such minor peccadilloes, he thought, was that women miners behaved as 'perfect wives and mothers'. How did he define such domestic paragons? As those who continued to contribute wages to the family's survival even if they left mining—by keeping small shops or working as 'dailies'.[61]

Schoenfeld's heated defence of Belgium's hard-working, independent women miners was detailed and moving. But what was most startling about his pamphlet was his equally strong support for the political and economic equality of all Belgian women. 'I content myself by thinking that the place of woman, especially in purely industrial localities, is anywhere she can honourably earn her daily bread and that of her family', he wrote. 'It is not the role of a *corps savant* like ours to change the conditions of existence of such a numerous class of workers'. But, he concluded,

the equality of rights inscribed in our constitution contrasts sharply with the inequality of conditions that we observe; from the point of view of equality and civil liberty, women are rather badly treated, and we also observe that women's emancipation and their participation in political life are part of the agenda of those who work in the social sciences'.[62]

For a Belgian physician of the era, and even for a committed positivist, this was a striking statement: even in France, where women's rights advocates were far more numerous and vocal, such a wide-ranging defence of women's right to complete equality was rare. But Schoenfeld insisted on the justice of his view, buttressing his case by referring to women's

[60] *Nouvelles recherches*, 21.
[61] Ibid. 23, 24.
[62] Ibid. 53, 71.

conditions across the Atlantic. In Wyoming and Illinois, he noted, women had already made great strides—and consequently, conditions had improved for all. 'The participation of women in public life becomes more and more frequent in America', he concluded, 'where the deep respect in which they are held, very different from French galantry, very naturally gives authority to their orders'.[63]

In Belgium, he continued, women ought to play a central role in any reform efforts directed at their communities. Rather than legislating from above, he wrote, 'it would be much better to hold meetings led by wives of coal-miners, together with engineers and colliery officials'. 'Women always have a great influence in all questions concerning social well-being; they more easily gain the audience's sympathies, and they often hold a view different from men's about social reforms that concern them'.[64]

It was time for Belgium to relinquish its ties to 'old Europe', Schoenfeld added, particularly to France and the Netherlands. Instead, Belgians should forge links with the United States, 'country of new times and new morals ... In our old Europe', by contrast, 'women live in a world apart, and haven't the right to see everything or to say anything'. The American type of 'emancipated woman' was altogether preferable.[65]

Schoenfeld's support of women's right to mine coal—and to participate in the political and social world of their time—provoked a vitriolic reaction from the Royal Academy, which immediately forbade him to publish under its auspices or to speak at future meetings! Still, his was not the sole medical voice raised in defence of women miners. Two other doctors, one working in Frameries and one in Cuesmes, lent support to his views, albeit cautiously. They wrote that their 'commitment to the truth and nothing but the truth' forced them to admit that mining had 'no ill effects' on women's general health or their maternity. Indeed, although they disliked women working below ground, they thought that forcing women to leave the mines of the Borinage would immediately cause widespread starvation

[63] Ibid. 72. Schoenfeld's information about the USA came from *Indépendance Belge*, a newspaper which carried stories about these events on the 5th, 19th, and 28th of March, and on the 30th of May in 1870. His phrasing was similar to that of Hubertine Auclert, the French feminist leader, who in turn shaped the words of Jules Guesde. See my 'Re-writing the History of Socialism: Working Women and the *Parti Ouvrier Français*', in *European History Quarterly*, 17 (1987), 285–306. Auclert's biographer is Stephen Hause; see *Hubertine Auclert: The French Suffragette* (New Haven, Conn., 1987).

[64] *Nouvelles recherches*, 74.

[65] Ibid. 72.

because there were no alternative sources of income for those they called the 'personnes du sexe'.[66]

As for mining women's morals, if going down the mine rendered them dissolute, then those of their comrades who remained at the surface should have been 'models of probity'. Yet they were not, and in fact, the morals of underground workers were far more protected. 'The underground orgies', dreamt of by many bourgeois critics, were 'mere fantasies', not least because miners were 'highly superstitious and deeply religious' and very careful about all their actions below ground. 'The miner', they argued, 'has a sacred respect for the pit'. Thus, they concluded, although

our girls are gay, open, provocative, even impertinent, [it is] usually only when they are in a group. On Sundays, they stroll together through the commune, or go together to the *ducasses* where they make merry, dance, sing, and frolic, but they return home in the same groups. Such occasions ... are scarcely propitious for forgetting themselves.[67]

Mine doctors were not the only defenders of women's right to work underground. Mine-owners argued against losing this key source of cheap labour. And at least one workers' newspaper also came out against excluding women from the mines, though their reasons were unique. Liège's *Ami du Peuple* asked would-be reformers,

Have you thought about this? You are worse than some revolutionaries. You already have the coal industry against you, and you will inevitably add the anathema of the women. Can you see what disorder you would create in households? This woman you see everyday, going so contentedly off to work because she has bread at home, this woman who earns between 1.75 fr. and 2 fr. a day, helping her husband or brother pay the family's expenses ... this same woman would be chagrined, tormented—physically, morally, and materially tortured: bread would be absent from her house ... A painful scene for any feeling human heart. ... This, progressives, is what you are guaranteeing—disorder in families, humiliation for yourselves.

'Women in the mines', they concluded, 'are not the cause—society is the cause of problems. Change society!'[68] Neither this writer, nor the other proponents of women's mining needed to have worried, however. All opposition, however strident, came to naught in the face of Belgians' collective indifference to labour reform. Thus when Vleminkcx finally

[66] Wouters, C., and Deneubourg, P., *Réflexions sur le travail des femmes dans les mines* (Mons, 1870), 9–10. The usage is revealing.

[67] Ibid. 12, 22.

[68] 'De Travail des enfants et des femmes dans les manufactures, mines, etc.', *Ami du Peuple*, 14 June 1874.

proposed a modest law restricting women's and children's work below ground near the end of the 1870s, it was immediately voted down by the Chambre. Léopold II then decided to act, but his Royal Decree made no mention of women. His only concern was to set a minimum age of 12 for boys and 14 for girls.[69]

Nevertheless, the close of the 1870s witnessed the first clear signs that attitudes toward women's work underground were changing. Partly as a result of the noisy public debate over their work, partly because their numbers had begun, gradually, to decline as a result of technological innovations, Belgium's *hiercheuses* began to assume a mythic status. By the end of the century, they would become favoured subjects for the paint-brushes, drawing pencils, and sculptor's chisels of dozens of the nation's most prominent artists.

At the same time, however, the spread of new technologies drew thousands more women into the industrial workforce. In the course of the 1880s and 1890s, women working all over Belgium's industrial landscape were drawn into public debates about women's proper sphere, as well as about the state's role in arranging or ignoring the social relations that accompanied industrial capitalism. The next chapter takes up these, and ancillary, questions.

[69] Dumont, G. H., *La Vie quotidienne en Belgique sous le règne de Léopold II (1865–1909)* (Paris, 1974), 84.

6

Ouvrières, Werksters, and Élites in
the
Fin de Siècle

[It was] ... a time when the élite were gorging themselves on
material progress (as well as on the profits it brought them) and
lulling themselves with the illusion of moral progress.

Marguerite Yourcenar

In the final decades before the century ended Belgium's bourgeoisie
experienced a paradox. On the one hand, they enjoyed an opulent
prosperity, and partook happily (Yourcenar might say greedily) in the
material excesses of Europe's belle époque. Like other *haut bourgeois*
Europeans, they revelled in the competition for possessions which flour-
ished amongst industrial nations, and they were smugly aware of their
continental pre-eminence. At the same time, however, a muted chorus of
discontent periodically assaulted their ears, as millions of disenfranchised,
disaffected, alienated workers began to find their collective voice. The
shouts of despairing individuals became the roar of mass strikes, marches,
and demonstrations which shattered the social peace.

As they had before, Belgium's ruling élite tried to distance workers'
unrest with words. Investigations and debates proliferated in these years.
But where earlier focal points had been women working in the two
primary industries of Belgium's economic transformation, first textiles, then
coal, researchers' vision broadened to include women working all over the
industrial and urban landscape.

By the mid-1880s, it was clear to most of Belgium's wealthy ruling class
that although production relations in most industries had assumed their
'modern' form, neither industrialists themselves nor their partners in govern-
ment had addressed the problem of how to ensure the steady reproduction
of those relations. Unlike their British neighbours, for example, the Belgians
had not learnt to deploy either reform legislation or ideology (public

education remained rudimentary) to strengthen the *status quo* and provide for its perpetuation. In the 1880s, pressed by widespread social crises, Belgium's upper classes opened a public discussion of these problems.

As was always the case in the industrial milieu of the nineteenth century, women's role was a subject of much attention. In these years, moreover, the abyss yawning between *bourgeoises* and *ouvrières* mirrored that between the bourgeoisie and proletariat, though here, issues of sex complicated the more straightforward issues of class. For one thing, *bourgeoises* did not belong to their class directly; moreover, like their working-class sisters, their lives were restricted both by law and by a myriad of social customs. Their roles—to over-simplify—included reproducing Belgium's male élite and, increasingly, consuming a significant portion of Belgium's material wealth.

Women of the people, by contrast, belonged directly to their class. Equal participants in production, they claimed a role in efforts to alter production relations. At the same time, however, they were women. And although many legal barriers against women's participation in Belgian society were of little concern to them (e.g. laws forbidding access to the professions) they did experience a distorted form of the ideology of 'women's place'. For most working women, this demanded that they accomplish two kinds of work, waged and unwaged. Moreover, the mores of bourgeois society pressed them to abandon the public working world in favour of the household work of Belgium's *ouvrières à domicile*. In these sweated trades, the clash between class and gender was spotlighted, as millions of exploited *ouvrières* and *werksters* slaved over the *articles de luxe* that marked and measured the social place of the *bourgeoises* who purchased them.

The interests of proletarian women repeatedly collided with those of upper-class women, as we shall see. Attitudes directed towards working women by Belgium's *bourgeoises* often reflected these differences. And yet, as these years witnessed the birth of a women's movement, many amongst Belgium's intelligentsia—including women—began to link women's waged labour with the social and political autonomy they desired. (In Belgium, Martin Schoenfeld was the first public spokesman of this view.)

There were also many women within the proletariat who openly disdained bourgeois conventions restricting women to the domestic *foyer*. They valued the autonomy that accompanied their economic independence. Of course they did not deny the extreme hardships of their lives, defined in those years not only by lifetimes of factory or sweated labour (or a combination of the two), but also by near-constant child-bearing and the heavy burdens of family life in Belgium's infamously squalid slums.

As the *fin-de-siècle* debate over women's work unfolded, attitudes towards work grew both more varied and more extreme. Some occupations—mining, textiles—were more clearly associated with one or the other sex. In the case of coal-mining, its association with nineteenth-century standards of masculinity helped encourage Belgium's legislature to restrict women's access to the 'male' world below ground. The link between textiles and femininity, on the other hand, may have been a factor in male union leaders' willingness to play a key role in union struggles for women's equality, a story told in Part II, below.

For working women, the identification of certain trades as 'women's work' meant that the complicated ideological system that controlled the behaviour of upper-class women suddenly applied to them more formally than hitherto. Women's occupations were sorted by moral standards. Milliners, for example, perhaps because they usually worked together with other women, were 'immoral', whilst hand lace-makers, working alone and usually in village settings, attained a kind of sainthood. Women in factories of all kinds experienced a bizarre mixture of contempt and admiration. Female agricultural gangs in their turn, who were visible to the travelling public as they laboured in the fields during planting and harvest, participated in the vast wave of nostalgia for a vanished rural way of life. As a longing for a romanticized past washed over Belgian society, these sturdy working women attracted much bourgeois approbation.

The unfolding of these various attitudes, their mutation and re-creation, can be read in many documents. *Enquêtes*, of course, were essential. Stimulated by the public outcry that invariably followed major social crises, these *enquêtes* provided Belgium's ruling class with opportunities to express opinions about the nation's labour-force. The largest *enquêtes*, not surprisingly, grew directly out of the worst social upheaval yet experienced by the young nation, the mass general strikes of 1886. (The year was quickly dubbed *'l'année terrible'* by the public.) It was the most extensive investigation of Belgium's working class ever undertaken, and the results, entitled *Questionnaire rélatif au travail industriel*, required four massive volumes, published over several months in 1887 and 1888.[1]

A second major source of evidence was the *Éléments d'enquête sur la rôle de la femme dans l'industrie, les œuvres, les arts, et les sciences en Belgique*, produced by a committee of Belgian ladies in response to a request from American women organizing a women's pavilion for the Chicago World's

[1] *Enquête—1886*; see also a review of the historiographical controversy surrounding the events of 1886 in 'Colloquia-Colloques, Colloque: "1886: La Wallonie née de la grève?"' in *BTNG/RBHC*, 19 (1988), 211–35.

Fair of 1893. These two *enquêtes*, as well as other investigations of women's work in these years, offer abundant information about the nature of Belgian women's participation in the labour-force between 1880 and 1914.

This chapter has two parts. The first briefly narrates changing bourgeois attitudes toward women's work in Belgium as they were represented in *enquêtes* and in other artefacts of the *fin de siècle* in Belgium. The second provides a survey of female labour in the years from 1880 to 1914, including work in both industry and in the increasingly visible sweating system. Incidentally, women's work in other key segments of the labour-market are examined, in order to round out this portrait of our protagonists.

Both parts—the view from above, followed by that from below— underscore the primary argument of this work: that nineteenth- and early twentieth-century Belgium was, to a considerable extent, a nation of working women. At the same time the secondary claim, that Belgium, 'paradise of capitalists', continued to meet the misery of its working classes with a stoic indifference, finds still more support in the evidence of these final decades. In other words, the most industrialized and richest nation on the European continent clung firmly to its reputation as the most hard- hearted. The brilliant *belle époque* enjoyed by Belgium's ruling élite only highlighted the plight of the nation's labourers—whom one French visitor compared unfavourably to 'Chinese coolies'.[2]

THE BOURGEOISIE

He has made the world in His image, which eliminates in these bourgeois Christians nearly every impulse toward social progress or reform.

Marguerite Yourcenar

Not the growing army of industrial workers, nor their crowded and malodorous slums, nor even increasingly frequent, bloody confrontations between soldiers and rebellious workers effected any significant change in the stolid, indifferent face those at the top of Belgian society turned towards the suffering masses below. The Belgian state continued to reject any reforms aimed at ameliorating workers' conditions—in or out of the mills, factories, and mines. At the same time, its justification for such

[2] Dauby, J., *De l'Amélioration de la condition des classes laborieuses et des classes pauvres en Belgique au point de vue moral, intellectuel, et physique* (Brussels, 1885), 87.

inaction, its claim to liberal principles of non-intervention, was demonstrably humbug. At no time in the *fin de siècle* did the state prove unwilling to intervene enthusiastically to repress workers or support industrial growth. Indeed, so active was the Belgian state in bolstering the nation's economic growth that one historian described the government as 'the most important economic agent'.[3]

This agent held no benefits for the nation's poor. In the period when other industrial nations undertook a variety of social reforms, Belgium remained inactive. The percentage of state spending designated for education, for example, rose by only 3.8 per cent in the years from 1846 to 1888. Spending on social welfare was even tighter: in 1846 such spending amounted to a mere 0.4 per cent of the state's total expenditure—a meagre figure which rose very slowly, to 0.2 per cent of a much greater total budget in 1880. Even after many years of organized socialist agitation (examined in Chapter 8, below), the percentage of state support for social welfare programmes reached a minimal 3.8 per cent on the eve of the First World War.[4]

In the middle of the nineteenth century, of course, such a Scrooge-like approach to the poor would not have startled most Europeans. Many years passed before most industrializing countries became sufficiently aware of their social problems to follow Britain's precocious example of regulating both work and housing conditions, but by the end of the century all had begun such activities, except Belgium. Why did Belgium, the first industrialized nation on the continent, lag so far behind its neighbours in social legislation?

To some extent, the newness of Belgium as a nation-state precluded the institutionalization within that modern capitalist state of those traditions that elsewhere shaped class relations in emergent industrial society—traditions of patronage, for example, or paternalism, which both helped shape Britain's response to urban, industrial labourers' problems. At Independence, Belgium had no such nation-based social traditions. There was, in other words, no equivalent to attitudes instantly evoked in England by such phrases as 'The duties of an English gentleman', or 'property has its duties as well as its rights' (however much such sentiments were honoured more in the breach than in the practice, as satirists from Dickens to Woolf have

[3] Yourcenar, M. *Dear Departed: A Memoir*, trans. Ascher, M. L. (New York, 1991), 109. The historian is Pirard, L., 'L'État et l'industrie, 1848 à 1913' in *Industrie en Belgique: Deux siècles d'évolution, 1780–1980*, catalogue from an Exposition, held in Brussels 30 Sept.–22 Nov. 1981, 105.
[4] Ibid.

demonstrated). It was, instead, little more than an amalgam of highly localized communities, knitted together by some amorphous historical memories of resistance to repeated invasions by foreigners, but without the essential, complicated ties provided by a shared national identity. In an important way, then, public life held within it no space where a national social conscience might grow. There was a good deal of flailing around, of course, as we have seen. The doctors of the Royal Academy, for example, attempted to articulate the outlines of a system of 'moral' relations. There were also the earnest efforts of leading Catholics—Édouard Ducpétiaux the most important amongst them—to create a religiously grounded reaction to poverty and class strife. But all these fragmented activities came to naught: Belgium was born bourgeois, motivated by the earnest pursuit of material wealth, which for Belgium's ruling élite provided the sole measure of the progress they cherished.

However, in the second half of the nineteenth century, several Europe-wide changes began to shake the reluctant Belgian ruling class out of its social torpor. Nationalism, for example, drifted over Belgium's borders from France and Germany. Once in Belgium, however, nationalism did not assume the shrieking chauvinism raging elsewhere. Belgians did not boast—in the German or British manner—of racial superiority (as a justification for imperial conquest). Unlike the French, few Belgians considered theirs an exportable civilization and culture. Indeed, the Belgian public infuriated their ambitious king, Léopold II, by evincing great suspicion of his adventures in the Congo in the 1880s. In Belgium's *belle époque*, in fact, the aggressive nationalism evident all over Europe, was strikingly rare.[5]

Nevertheless, Belgians did begin to consider their national identity. Collectively, the bourgeoisie found one major source of national pride: the economy. The 'economic miracle' wrought by the inhabitants of this new, tiny nation encouraged much self-congratulation in the final quarter of the nineteenth century. In Belgium many bourgeois triumphs were celebrated within elaborate eating rituals: around sumptuous banquet tables, company directors, stockholders, and prominent local officials marked their success in the market-place. Every guest was handed an elaborately decorated menu card, which illustrated the material wealth upon which their feasting depended. Each card was divided in half. The upper half detailed one key

[5] Belgians were quick to cite Julius Caesar's observation, 'Les Belges sont prompts aux combats et les meilleurs à cet égard . . .' Otherwise, however, by comparison to their more bellicose neighbours, Belgians remained rather modest. See one study of the 'national character', produced during the 1950s, when such studies were popular: Henrot, T., *Belgique* (Paris, 1958).

element of Belgian wealth: food. The lower half—significantly—illustrated the second: Belgian industry. At the top, garlanded with flowers and cornucopias of plenty, was printed a description of the meal's many courses. Below these detailed accounts of the evening's food, however, lay a startling contrast: a picture of workers at work. Every card featured a group of industrial workers or artisans, posed in their work-places wearing their dirty, torn, work uniforms and holding their tools. Miners—male and female, and all ages—were particularly popular. Other workers, identified for the banqueters by their distinctive dress and tools, included glass-blowers, steel-workers, dockers, and occasionally artisans: clog-makers, straw-plaiters, lace-makers, and so on. It is not clear what these cards were intended to show. Were appetites stimulated by the reminder of those whose labour provided the feast? Was gloating part of the message? We shall never know. But taken together, the two halves surely constitute a miniature study of the stark separation of class in *fin-de-siècle* Belgium.[6]

Rich banquet guests were not the only Belgians who enjoyed viewing scenes of industrial labour. Commercial travellers, or ordinary middle-class Belgians on holiday—at the seaside or in the Ardennes—sent home postcards featuring pictures of industrial workers. 'Romantic' views of miners, blackened with coal-dust and framed by heavy clouds of smoke pouring from looming mine chimneys were tourist favourites, sent not only from Charleroi or Mons, but even from Ostend or Zeebrugge.[7]

And a similar tendancy to romanticize Belgium's industrial workers was visible amongst the nation's artists and writers. Paintings and drawings, statues, books, even poems celebrated—or, less frequently, denigrated—Belgium's workers. In the closing years of the nineteenth century, public officials, both local and national, began enthusiastically to purchase, and even commission, representations of workers for museums, parks, and city halls. In this nationalism-driven process of aestheticization, the workers

[6] One Austrian ambassador was especially disgusted by the decadent luxury of Belgian industrialists: see no 369, 'De Oostenrijkse ambassadeur te Brussel aan zijn minister te Wenen, 29 maart 1868', in Wouters, H., *Documenten betreffende de geschiedenis der arbeidersbeweging ten tijde van de 1ᵉ Internationale (1866–1880)*, i (Leuven, 1970). Examples of these menu cards exist in the Musée de la vie wallonne, Liège, as well as in many *broquanteries* all over Belgium, where they are sold to collectors. There are also examples in *Art et société en Belgique, 1848–1914*, catalogue from the Exposition: Palais des Beaux-Arts, Charleroi, 11 Oct.-23 Nov. 1980, and *L'Art verrier en wallonie de 1802 à nos jours: Exposition organisée par les villes de Charleroi, Mons, et Namur*, catalogue (Charleroi, 1985).

[7] These are still available in shops in every industrial centre. I bought one showing working miners, sent by a travelling salesman who was visiting Charleroi on business in 1911. The shop also sold such cards sent from those on holiday at the seaside; examples are also illustrated in both the books cited in fn.6.

themselves were distanced and contained. 'Outcast Belgium'—at least in visual representations of its inhabitants—was tamed.[8]

But the workers themselves were very far from tame. Belgium's working class, increasingly organized into unions and political movements, was far more vocally and visibly rebellious in these years. Few officials failed to remark what they agreed was an ominous threat posed by the nation's proletariat.[9] The warnings contained in dozens of police reports, provincial governors' letters, and so on, spilled over into the public *enquêtes* of the era, as we shall see. However, no amount of such warnings—whether published in public enquiries or in other documents—slowed the growth of this curious nationalistic pride in industrial workers. Instead, there were two discourses running side by side: one which demonized strikers and demonstrators, the other which idealized the stoic, tireless workers of Belgium's mills and mines. In fact, the emergent ideal worker in many ways symbolized the stereotypical perfect Belgian: physically strong, proud, uncomplaining, skilled, and male. In this era, the language used to discuss industrial work—in most *enquêtes*, as well as in other official reports—grew increasingly gendered. One result was that where male workers were idealized, females, along with male children, were more uniformly vilified. In the 1880s and early 1890s, the primary objects of such hostility were still women miners. But by the end of the century, another group of working women, those working in the sweated trades, began to feel bourgeois opprobrium.

Of course attention focused on the small group of women underground miners allowed observers to avoid facing the much greater exploitation of women in Belgium's hundreds of factories, mills, brick-yards, docks, quarries, and so on. And when legislation finally restricted women's access to underground work, beginning in 1892, attention turned towards a second relatively less important segment of Belgium's labour-force: women domestic out-workers. This shift was marked in the rhetoric and structure of two major enquiries of these years, the first in 1886, the second undertaken in 1892.

[8] Apologies to Gareth Stedman Jones.

[9] There are many such documents collected in PdE, 33: 139–143 ('1894–1885', *sic*); 150–152 (1891). Typically, the archive lacks titles and most documents are without any order.

THE VIOLENT EVENTS OF 1886

Belgium's sole protective labour legislation, passed in 1889 and effective in 1892, grew directly out of two events: a mass general strike, which was followed by the most detailed investigation yet undertaken. The breadth and detail of this report provoked more public attention than had hitherto been stimulated by such government efforts. This document, coming on top of the mass fear unleashed by the strike, led a new Catholic government (elected in 1884) to make a gesture, at least, in the direction of legislative reform.

When the strike erupted, in the spring of 1886, the nation's frustrated Cassandras got their reward. Their constant warnings that such an explosion of class hatred was imminent abruptly came true. However, it was not solely an explosion of class hatred, exacerbated by an increasingly stark contrast between the opulent lives of the capitalist bourgeoisie and the struggles of the exploited proletariat. There were additional provocations. For one thing, wages had begun to fall all over Belgium in 1881, and sometimes the decline was steep. One mine official estimated that mine wages fell 10 per cent in the decade of the 1880s.[10] Moreover, many of the new unions, legalized after 1866, had grown sufficiently large to support a generalized collective struggle for better conditions. In 1885 in Charleroi, the union group most often credited with precipitating the strike appeared: the *Chevaliers du Travail*. These Belgian Knights of Labour, who borrowed the pseudo-Masonic rites and rituals of their United States progenitors, succeeded in creating a highly unified, disciplined, and loyal membership throughout the mining and glass-working communities of the city and its environs.

Furthermore, workers' groups in various industrial regions had begun to form ties with unions elsewhere. According to Jean Puissant, the Ghent socialist workers of Vooruit had cemented a friendship with Borinage miners in 1885 by sending wagon-loads of co-operative-produced bread—totalling 30,000 kilos—to support the Borains' hard-fought six-week strike.[11] When other food co-operatives, in Brussels, Antwerp, and Verviers followed suit, a workers' network began to form.

[10] Dethier, N., *Centrale syndicale des travailleurs des mines de Belgique: 60 années d'action, 1890–1950* (n.p., n.d.), 21.

[11] Puissant, J., *L'Évolution du mouvement ouvrier socialiste dans le Borinage* (Brussels, 1982), 207. See also Aron, P., *Les Écrivains belges et le socialisme (1880–1913)* (Brussels, 1985). Aron claims that various co-operatives aided not only the Borinage strikers, but also workers suffering from a drastic fall in wages, or unemployment, during the harsh winter of 1884–5. He

In addition to these factors, there was the coming of spring in that year of 1886. In the words of the Charleroi socialist leader, Jules Destrée, 'It was in seeing the sunlight shining on an earth waking from the dullness of winter, the blossoming green trees, the mounting sap, the pure air, so good to breathe, that made the miner dream vaguely of liberty and think of the labours of the fields and gardens'.[12] Whatever the contribution of nature, the 'bloody explosion of social hatred', as one historian has put it, erupted first in Liège, following a 'monster meeting' called on 18 March to commemorate the Paris Commune. The event spread from Liège to workers' districts throughout the region, including Verviers. Soon, Charleroi was involved. Everywhere the symbolism was clear: red flags flew, phrygian bonnets covered female heads, red cockades decorated coat lapels and caps.[13]

Local officials read the signs and trembled; everywhere, they called out the troops. In Liège, what began as a one-day parade quickly became a mass strike, as workers stayed away from mines and mills, crowding the city's streets. On 21 March industrial Seraing, on the outskirts of Liège, saw the first confrontations between troops and strikers, and soon the city was in a 'state of siege'. Violence broke out on 22 March, when dozens were wounded and many arrested.[14]

News of the events spread rapidly. On 23 March 'the *hiercheuses* and men of Liège', in one historian's words, massed into the streets to defy the troops, waving red flags, shouting 'Vive la République' and singing the *Marseillaise*.[15] By the 26th, workers were out all over the country, and at this point, the character of the strike changed. Where the initial violence had been limited to the troops and gendarmes, it now began to involve the strikers. There were many attacks on factories and owners' homes, but the most notorious occurred when miners and glass-workers in Charleroi attacked first the Baudoux glass factory and then the owner's château nearby. According to all witnesses, the crowd was extremely violent. They

suggests that the 'state within a state' that was Belgium's socialist movement was in place before 1886.

[12] Quoted in Houdez, G., *Les Troubles de Charleroi, mars, 1886: Vingt-cinq ans après* (Frameries, 1911), 3.

[13] van Kalken, F., *Commotions populaires en Belgique (1834–1902)* (Brussels, 1936), 80.

[14] Ibid. 97.

[15] There is much evidence of the continuing importance of the French Revolution, its imagery, ideas, and rituals, amongst workers in countries bordering France. See e.g. AEL, Sûreté Publique, pt. 1, carton 43, 1886: Dossier A—Manifestations, 441–506, and Dossier B. One report in this carton reported that workers shunned the Belgian national colours on the grounds that 'they belong only to the bourgeoisie'.

rampaged through the Badoux home, drunk on the wine found in the château's vast cellars; furniture too heavy to carry away was vandalized; the very luxurious clothes of the Badoux women were 'liberated', and many women wore the unfamiliar finery proudly throughout the remaining days of the strike.

Troops already stationed nearby charged the fleeing crowd, killing and wounding. Arrests and severe punishments followed: two leaders of a glass-workers' union were sentenced to 20 years' hard labour; others were given between 12 and 15 years in gaol. In Jean Neuville's words, 'Some entire families were sent to prison for many months and even years. In every "maison d'arrêt" in the country there were some of those condemned from Charleroi'.[16]

In all reports of these events, women figured prominently. The rumour that women strikers were a new incarnation of France's infamous *pétroleuses* spread quickly through Belgium's industrial centres. Some insisted that the world's best-known *pétroleuse*, the ex-Communarde Louise Michel, was on her way from Paris to lead a women's rampage.[17] The presence of women in the most violent events was noted with particular horror. One observer described women as 'utterly fearless', even in the face of troops: 'when [the strikers] were threatened with being shot, there were many amongst them, *even women*, who bared their chests'.[18] One workers' brochure 'Aux Femmes de Charleroi', called on the 'noble women of Charleroi' to free imprisoned strikers just as one woman had done after the storming of the Bastille.[19]

The strike continued for months on its bloody and violent path. Finally, however, the authorities won the day: the strikers' attempt 'to force the nation to care for them', as one contemporary put it, 'this grand demonstration of unfortunates tired of dying slowly' achieved no immediate amelioration of their conditions.[20] But the fear and uncertainty that spread throughout a stunned bourgeoisie cried out for explanation, and thus was born the 1886 investigation.

[16] Neuville, J., 'Il y a cent ans naissait le syndicat des Broederlijk Wevers', *Études Sociales*, ix. *La Pensée Catholique* (Brussels, 1957), 209.

[17] PG, 'Agitations politique et sociale, congrès, troubles, grèves, élections, attentats à la dynamite', no. 224, excerpt from *La Gazette*, 19 Mar. 1886. See also Bonda, J., *Histoire anécdotique du mouvement ouvrier au pays de Liège* (Liège, 1949), 88.

[18] Bonda, *Histoire anécdotique* (emphasis added).

[19] In Fonds Chambon: '1886: Les Grèves de Charleroi, mars 1886'; Cour d'assises du Hainaut—'Incendie et pillage de la verrerie et du château de M. Eugène Baudoux'. See also Destrée, J., 'Les Troubles de Charleroi', brochure, plus other reports in I. 3A–3C, and 4.

[20] See Houdez, *Troubles de Charleroi*, 6–7. The American journal, the *Nation*, 1 Apr. 1886, blamed 'French communists and anarchists'.

The Enquête of 1886

The views expressed by witnesses before the 1886 panel (as well as by commission members themselves) were couched in extremes, as one might expect after such a massive social uprising. In general, the bourgeoisie articulated opinions familiar from earlier years. Some witnesses called for intensified state and local control of the workforce—i.e. stricter laws, and more rapid reaction by troops and police. A handful of witnesses at the other extreme raised their voices in favour of reform. They grounded their arguments in a compassion rare amongst the smug bourgeois ruling class of Marguerite Yourcenar's youth. The majority of those testifying, however, occupied the centre. Fatalists amongst them sighed that social problems were simply an unchanging, albeit unfortunate, fact of modern life. Others blamed Belgium's working women once again for the nation's problems. These latter were numerous, and throughout the four volumes of the published *enquête*, *ouvrières* and *werksters* were particular targets of considerable bourgeois hostility.[21]

Amongst those convinced that more discipline was the key were mill-owners from Ghent, pioneers in the various techniques of social control. They offered their own practices for emulation. Hiring all the members of one family whenever possible, they told the commission, helped inculcate factory discipline outside working hours. Second, hiring 'fresh' workers—those who had never before worked in textile mills—meant that loyalty to the company could be instilled from the outset. Lastly, Ghent's mill-owners made it a practice to fire any worker who resisted discipline. How did they identify resistance? A common symptom was unmarried women's pregnancy: once discovered, the unfortunate women were quickly ushered from the mill's workrooms. (Married pregnant women were, on the other hand, perfectly satisfactory. Ghent's *patronat* allowed them to work until the birth, and to return to their work as soon as possible afterwards, usually within a matter of days.)[22]

Other mill-owners called for *bourgeoises* to play a role in controlling the proletariat. 'Ladies', said one group of witnesses, should 'spread bourgeois values' through charitable visits to workers' homes. One 'lady' described charitable calls paid by 'the principal ladies of Liège' on pregnant working

[21] The socialists declared a boycott of the investigation, thus ensuring that there were few witnesses willing to come forward from within the working class. Usually, only those with party membership—and protection—might have braved the blacklisting that resulted from testimony critical to owners.

[22] *Enquête—1886*, ii, 41.

women. 'If they find everything in order from the point of view of cleanliness and morality', she assured the panel, 'the "malade" receives children's clothing and food'.[23]

Such attitudes were familiar from other enquiries, of course. But 1886 had shown most bourgeois Belgians that neither charity nor discipline was sufficient to ensure the social peace enjoyed by Belgium's ruling élite through most of the preceding period. Thus this 1886 enquiry revealed a ruling class much less in agreement. Both panel members and influential witnesses occasionally broke ranks with their fellows to offer a contrasting view of Belgian life.

One of the most hostile confrontations occurred during hearings in Liège, where, unusually, a handful of workers appeared to testify. In a poignant exchange, an ex-coal-miner told of the mine accident that had cost him his arm. Because the company decided that the responsibility for the firedamp explosion was his, he was awarded no compensation. After months of searching, he found another mine job, but, unskilled, it paid only 1.5 francs a day. With six children to support, he told the panel, that wage was completely inadequate. This testimony infuriated the panel's president, who announced angrily that he did not believe a word of the tale. But another panel member, M Montefiore, defended the miner—and later offered him financial help.[24]

A similar (and similarly rare) moment of compassion came during the same hearings, this time in the testimony of a Verviers industrialist, Robert Centner. He condemned his 'uncaring' colleagues, amongst whom 'luxury reigns with intensity', so that the two classes in Verviers lived very separate lives. His solution was to bring the classes together by means of the 'soirées populaires' already begun in Verviers. These theatrical and musical evenings had already succeeded in drawing some bourgeois and

[23] Ibid. 102. Other charitable ladies appeared from Liège. They were so harshly critical of workers' morals that even the panel was sceptical. The Cercle des Dames of Liège testified that they offered advice to working-class housewives, and often hired them to 'do a bit of sewing'. This 'satisfied the women', though 'we give them only a little wage'. When asked how 'little', the ladies admitted that they paid only 35 centimes for a pair of men's trousers! In 1885 the Cercle claimed to have distributed 1.50 francs' worth of work to each of 1,353 families. They said they were motivated to do this by their 'love of all workers': see pp. 59–60.

[24] Ibid. 179–80. Later in the *enquête* some anti-semitic witnesses directed an attack on 'Montefiore-Lévi', from Liège. This would suggest that there was some anti-semitism in Liège in these years. E. H. Kossmann has noted that local Catholics organized an international Catholic congress where they heard Austrian and German 'social Catholics'. Kossmann writes, however, 'I do not know whether the Belgian audience admired the virulent anti-Semitism of some of the theories they applauded'. It would seem that some, at least, did. See Kossmann, E. H., *The Low Countries, 1780–1940* (Oxford, 1978), 481, n. 1.

proletarians together, he told the commission. In addition, he suggested 'mixed-class' mutual aid societies, pension schemes, and education. He also called for legislative restrictions on both women's and children's factory labour.[25]

Lastly from Flanders—from the linen city of Kortrijk—came a Jesuit priest. After painting a dark picture of life for workers in his locality, he explained his presence at the enquiry: 'I have come ... because I don't want the people to imagine that only socialists interest themselves in their well-being'.[26]

If this document was remarkable for the scarcity of social conscience, it was equally unusual for the number of witnesses who insisted that all was well. Some factory owners claimed unproblematic relations with 'their' workers, in fond paternalistic language. Others told the panel that complaints (occasionally from workers) were just 'lies'.[27] A few more were straightforwardly fatalistic. One Ghent witness, who claimed to have visited a mill, said, 'It is true that the girls (*sic*) are pale; the temperature is also higher than elsewhere; but there isn't, as some have claimed, a *real* rain falling on the women workers' naked shoulders'.[28] A mill owner insisted that the worst poverty was in the past. Where once women workers had owned only 'wool tippets', they now owned cloaks, and even 'fine dresses'.[29]

Similar examples are abundant throughout the four volumes. Most witnesses, evidently, saw it as their duty to whitewash the sepulchre that was (*pace* Joseph Conrad) Belgium.[30] The Comte de Hemptinne, who owned a textile factory in Ghent, summed up the capitalists' sanguine view of Belgium's working class: 'If the husband, wife, and children work together at the mill, they can live in perfect ease, and even realize some savings'.[31]

Attacks from the fourth category of observers, those who held women responsible for many social ills, were similarly plentiful, though much more

[25] The 'soirées populaires' continued to thrive throughout our period. While they attracted some better-off workers (e.g. artisans with their own workshops) they had little impact amongst the city's industrial labourers. See Kossman, *Low Countries*, 139.

[26] Ibid. 18; also *Enquête—1886*, i, 115

[27] *Enquête—1886*, i, 68, 132.

[28] Ibid. 51.

[29] Ibid. 17, 9.

[30] Ibid. 129, 148. Many factories placed toilets in workrooms in order to minimize time away from the machines. One witness testified that foremen guarded these toilets in order to 'prevent an abuse of another kind'. He did not elaborate. See Marlow's comment that Brussels in the *belle époque* was a 'whited sepulchre' in Conrad, J., *Heart of Darkness*.

[31] *Enquête—1886*, i, 2; see also 371, 377.

various. Amongst the most numerous were those who extended a stereo-
type common to *bourgeoises* of the era to working women, blaming them
for indulging a 'natural' love of luxury, and thus ensuring their family's
impoverishment.[32] One Liège session opened with this question from the
panel's president: 'I would like to hear from M. Marquet on the subject of
the luxuries of the worker's wife. In France it is generally the husband who
spends and the wife who is economical. In Germany it's the opposite . . . I
would like to know what it is in Belgium'. The witness, a local *négociant*,
replied, 'In our countries (*sic*) the woman likes to be well-dressed. Between
neighbours there is a dangerous rivalry which supports and spreads the
taste for luxury'. He suggested that 'men accompany their wives' shopping,
'the common practice in Liège', he assured his audience.[33]

Many other witnesses thought women wasted their money not on dress
but rather on drink, and most agreed that although drunkenness was a
problem for both sexes, it had a particulary evil effect on families when
women drank. Drunk women 'drove their husbands from their homes', into
cabarets, where the men drank still more. As a solution, one witness
suggested lowering wages.[34]

Virtually every woman's occupation came in for criticism in the course
of these hearings. In fact, as time went on, a competition arose to
determine which occupations attracted the most immoral women. Mining
still held the lead: one of the most lurid accounts of the effects of that
occupation on women came from a disgruntled worker, who described the
'repugnant scenes' underground which produced 'so many unhappy house-
holds in this country'. His reasoning was bizarre: immoral mining women
'abandon their husbands, their children, their household to follow a lover,
taking the family savings with them. When these are spent, the lover
departs; then they are forced, unhappy and lacking everything, to return to
beg the pardon of the outraged husband'. This witness did not believe that
the solution lay in restricting women's access to wage-earning. He thought
only that such wage-earning should be confined to the domestic *foyer*.
Women's work, in other words, should occur only inside a house, 'where
she can both work and watch her children at the same time'.[35]

[32] Luxury-loving *bourgeoises* were everywhere in the satirical literature of the *fin de siècle*:
see, *inter alia*, Lemonnier, C., *Le Fin des Bourgeois* (Brussels, 1986; orig. 1892).

[33] *Enquête—1886*, i, 194.

[34] Ibid. 1100. Workers had another solution: members of the socialist party were urged to
abstain, and socialist cafés and restaurants in the many *Maisons du Peuple/Werkershuisen* served
only non-alcoholic drinks. See socialists' remarks on p. 1105. (These socialist witnesses,
obviously, ignored the party's call for a boycott.)

[35] Ibid. ii, 72.

A Ghent legislator thought textile factories were far worse than mines. Inside the mills, he told the panel, 'women remove part of their clothing when they get too hot'. Others from that city argued that the peculiar nature of spinning 'excited immorality'. One thought that Belgium should 'copy France' and restrict spinning mills to men; 'immorality would disappear'.[36]

The 'Dames de St Régis', of Liège, offered a contrary opinion. In their view, the work-place was not the problem; rather, immorality was endemic to workers' *quartiers*, with their café-bars and dance-halls. In the latter, they told the commission, young *ouvrières* earned extra money for luxuries, including 'bad books' (these were probably the 'penny dreadfuls', romantic novels so beloved of late nineteenth-century working women). If this were not bad enough, they also learnt 'dirty songs' and read 'anti-social pamphlets'. 'The atmosphere of these cafés is saturated with immorality, by lewd songs which are dispensed there (*sic*), by obscene gestures', concluded the group's spokeswoman.[37]

Dozens more such condemnations of working women's lives dotted the pages of the *enquête*, but not one of them suggested the solution most frequently mooted elsewhere: that working-class women cease waged labour. Whatever the problems, no Belgian was willing to imagine a world without the cheap and abundant labour of Belgium's female proletariat. It was this acknowledgement of working women's importance to continued industrial prosperity that posed the largest barrier to any legislative reform aimed at improving women's working conditions. This, together with the continuing strength of the inertia which had long dominated the government's social policies, ensured that the events of 1886 produced no immediate results. One liberal deputy, Victor Arnould, expressed the frustration of reformers all over Belgium, condemning the whole 1886 enquiry in harsh words: 'Belgium appears [here] as it is: a prison. And the silenced horrors are more sinister even than those that result elsewhere from the gravest catastrophes'. The *enquête*, he wrote, had been characterized by 'an absence of pity, the gutless cynicism of those who profit from the methodical extermination of our people. Not a ray of humanity comes to lighten their gehenna. There is no pity, no light, no love, in their Dantean hell'.[38]

[36] Ibid. 28, 31; of course France had no such law.
[37] Quoted in Bonda, *Histoire anécdotique*, 97–8. An American reporter wrote, 'The commission of inquiry appointed by the government to ascertain the causes of the labor riots reached no real conclusions': see *Nation*, 1 Sept. 1887.
[38] In Bonda, *Histoire anécdotique*.

A German official agreed. Writing to his friend the Prince of Chimay, he warned of the dangers lurking within Belgium's extremely unequal class relations, and cautioned the prince not to 'blame workers' agitation on socialist manœuvres'. 'Foreigners know too well', he said, 'that the crisis hour is only advanced by the lack of legal dispositions aimed to protect workers and favour their well-being'. Even the Pope (who had experienced the Belgian situation first-hand several decades earlier) joined the warning chorus: 'A small number of very rich men have been able to lay upon the masses of the poor a yoke little better than slavery itself', he wrote in 1891.[39]

Such warnings, as well as the *enquête* itself, suggested that little had changed bourgeois attitudes towards the working class in the years since 1830 but two events were soon to shift relations between those at the top of Belgium's social pyramid and those below, albeit only slightly. First, the Catholic government—stimulated in part by attacks on women workers' morals in the 1886 report—passed a law restricting women's and children's work below ground in coal-mines, to take effect beginning in 1892. Of course the law affected only a fraction of Belgium's millions of waged women and children (estimates vary, but it seems clear that only a few thousand women and children remained below ground by 1890). Those still employed inside the mines in 1892 were allowed to continue.[40] Nevertheless, the number of *hiercheuses* dropped sharply, speeding the aestheticization of those working women into symbols of Belgium's labouring masses. At the same time, the legislation shifted attention away from mysterious women coal-miners, back to women labouring in much less romantic circumstances, in textile factories, in artisanal workshops, in agricultural gangs, or in the many sweated trades.

[39] See *Royaume de Belgique*, Archiefs van Buitenlandse, 186. II. Berlin, 8 juin 1887. (This archive contains several similar warnings from Germans and Austrians. Some of the former feared a 'spill-over' into Germany of Belgium's working-class unrest, despite that country's extensive social legislation.) See also Pope Léo XIII, *Rerum Novarum*, 'On the Conditions of Labor' (New York, 1939), 4. The effects of the encyclical were minimal in Belgium—though it did give support to a movement of social Catholics, the Ligue démocratique belge/Belgische Volksbond. Neither this movement, nor the efforts of local 'worker priests', such as Antoine Pottier in Liège, had much effect amongst Belgium's workers until just before the First World War. In the years after 1891, social Catholicism was mainly a movement of intellectuals and artists. And these were mainly young men, not elected officials. Kossmann quotes one prominent Catholic politician who said of the young social Catholics, 'Fuyez-les comme la peste': see Kossmann, *Low Countries*, 484, and discussion pp. 481 ff.

[40] As we shall see, this did not mean that women miners greeted the new restrictions without resistance. In addition to the evidence presented in Ch. 8, below, see a recent article by Chapelle-Dulière, J., 'Septembre 1893 au charbonnage de Bois-du-Luc: une grève au féminin?', *BTNG/RBHC*, 19, (1988), 247–67.

A second phenomenon affecting attitudes toward women's work was the emergence of a bourgeois women's movement in the final decades of the nineteenth century. Although of very modest size in the 1890s, the movement was nudged into collective action when the much more active middle-class feminists of the United States sent out a call to women leaders everywhere for information about 'women's participation in the national workforce', and in 'social, charitable, and philanthropic institutions'. The information collected was to be featured at the women's pavilion of the Chicago World's Fair of 1893. That display, the American women explained to their foreign counterparts, 'aimed to predict the future role of woman everywhere', and to answer the query, 'Is the world close to giving woman her intellectual and industrial independence?'[41]

The Belgian women's committee, composed entirely of aristocrats and *hautes bourgeoises*, responded with enthusiasm to the request, launching their own *enquête* in 1892 (it was published in Belgium in 1897).[42] This document is an interesting one, not least because it offers a rare glimpse of the collective opinions of several important 'ladies' of the era about women's contribution to Belgian social and economic life. What concerns us here, however, is not their general view of women's place in Belgium, but rather their attitudes toward their working-class sisters.

The committee's opening words were positive:

Women workers form an army which could be compared without disadvantage to the masculine army of labour ... One readily concludes that without the intervention of women, there would be no national work anywhere. ... They are everywhere, demonstrating their courage, their application, their perseverance.

Amongst these paragons, the committee listed, '10,000 in coal, 10,000 ... in linen, 6,000 in arms manufacture, 2,000 in paper-making and pottery, 150,000 in lace, 57,000 in agricultural work-gangs, plus 10,000 *fermières* and *cultivatrices*'. Woman, they added, significantly employing the singular, was also toiling in 'the black and flaming glass-works; in cartridge work-

[41] *Enquête de la femme*, 17. (1897)
[42] Ibid. The women included ladies-in-waiting to the queen, princesses, and so on. It should be noted, perhaps, that by the end of the 19th century, the hereditary aristocracy had intermarried so often with the *haute bourgeoisie* that there was little distinction to be made. 'Toute la Belgique n'est qu'une grande bourgeoisie', in the words of Thérèse Henrot. See her *Belgique*, 100 and ff.

shops; in the dangerous match factories.'[43] In the text that followed, the ladies' committee also examined women's work in factories producing candles, soaps, perfumes, ceramics, furniture, rag-pulp, brushes, hats, ribbons, shoes, boots, clogs, stockings, bricks, coffee, pipes, cigars, cigarettes, and refined sugar. Some detailed descriptions of sweated work—as well as work done in very small workshops—were included, particularly the making of artificial flowers, umbrellas, gloves, corsets, lingerie, dresses and suits, straw hats and baskets, bonnets, embroidered goods, upholstery, painted porcelain, and printed matter.[44]

They wanted it clear from the outset, however, that their abundant admiration for waged women did not turn their upper-class minds from women's most important work: 'In saluting the humblest *ouvrière*, an essential element in the public prosperity, we do not forget that the task of woman is twofold, and that whatever are the artistic and industrial marvels that come from her hands, her most beautiful work, after all, is the child'.[45] This duality, between production and reproduction, shaped the entire document. In detailed descriptions of dozens of women's occupations, the authors repeatedly found themselves unable to choose between admiring work or admiring motherhood, or between their consequences, independence or dependence. Moreover, the clash between their class interests and the collective interests of their sex coloured their attitudes throughout.[46]

A detailed analysis of this document lies beyond our purview. But the text makes clear that not only were women tangled between conflicting attitudes of class and gender, but they were also unable to decide on the relative virtues of various kinds of women's work in Belgium. In the view of some, the sweating system was ideal. After all, the work was done at home, 'women's special sphere' in bourgeois ideology, and here, too, the crafts themselves replicated the 'class' hierarchy of the larger society. One lady observed that *bonneterie* employed an *'ouvrière . . . classée au-dessus de ses compagnes . . . C'est parmi les occupations véritablement ménagères et familiales'*.[47] *Ouvrières* down the ladder elicited scorn: 'L'économie est tout à fait inconnue chez les trieuses de café', sniffed one writer.[48]

But even the most generous opinion underscored the width of the abyss

[43] *Enquête—1886*, ii 179–80.
[44] Ibid.
[45] *Enquête de la femme*, 16.
[46] I am grateful to Janet Polasky for a discussion of these issues in the context of *fin-de-siècle* Belgium.
[47] See comments in US Department of Industry and Labor, *Louisiana Purchase Exposition, St. Louis, Missouri, 1904*, pp. xvi, 19–20, and in *Enquête de la Femme*, 17.
[48] *Enquête de la femme*, 72.

dividing the classes. A particularly striking example was this idyllic portrait of a lace-maker's life:

Lace-making offers every advantage: it can be left and resumed, the lace cushion takes up little space, the needles even less; a single lamp suffices, if the worker uses a round bottle with white glass filled with water, forming a lens, which concentrates the light on her work. . . . From the age of 10, a girl can learn one or another kind of lace-making, either at school or at home.

And it was not unhealthy work. Although lace-makers commonly suffered blindness, 'It is no worse than that of needle-makers or seamstresses, embroiderers, and so on'.[49]

The members of the ladies' committee were, of course, consumers of the fine hand-made lace of Belgium, as well as of other luxuries made so painfully and so cheaply by thousands of working women. They saw their role as natural, and believed fervently in the value of the class system. True to their own interests, they directed special scorn at working-class women who ventured beyond their station. Schools, they thought, 'overexcited so many desires that cannot be satisfied'. Working women should, therefore, not be taught a desire for 'physiology and pianos' (in the report's curious language); instead, their schools should 'fit them for their duties: housework, farm work, and dairying'.

The temptation to dream beyond their humble stations lurked everywhere for unwary women of Belgium's lower classes. Even dressmaking, such a womanly art, had its pitfalls. A good dressmaker, one woman noted, had to be 'stylish' to do her work well, and thus many of the best dressmakers developed tastes woefully inappropriate to their class. 'Everyone knows the excessive taste of these *ouvrières* for the theatre: for them, actresses' *toilettes* are almost a professional study'. Inevitably, studying *coquetterie*, frivolity, love of luxury, and desire for pleasure', constituted 'the moral apprenticeship of the young *couturière*'. Riskier still was the moment when a young dressmaker was called upon to sew with gold or silver thread on fine cloth. 'If she makes ball gowns she'll want balls, if she makes carnival costumes, she'll want carnival . . .' were the dire predictions. But of course the ladies had to have such things, so what should be done? They suggested that only married women, working part-time, should be allowed to undertake high fashion dressmaking. These women would be too busy

[49] Ibid. 72–4. 'Lace-makers' schools', often part of Catholic orphanages, were notorious for exploiting little girls. They were forced to sit for long hours, stooped over their lace pillows, making a product that was then sold for profit by the institutions. Unlike some male apprentices, they derived no benefits from their work—and often suffered premature blindness and a back deformity known as 'lace-maker's hump'.

to be tempted into immorality. Furthermore, if their wages were kept very low—only supplementary to a man's pay—they would lack the means to satisfy any cravings induced by their trade.[50]

Throughout this enquiry, such censorious class judgements provided a persistent sub-text, even to the many more positive descriptions of Belgium's 'female army of labour'. In addition to valorizing their own class positions, these women also articulated an obsequious deference to their own subordination. Thus they frequently explained why working women should not be allowed to infringe upon 'men's work'. In the case of arms manufacture, for example, they explained that women 'deserved lower pay'—even for identical work—because 'if women were paid as much as men, men would always be preferred; in the making of arms there are no aspects in which women show themselves superior to men'.[51]

In general, the ladies' committee approved only two kinds of work for women: the most suitable was in agriculture; less appropriate, but still better than work in factories or mines, were the sweated luxury trades. Of women agricultural labourers the committee wrote, 'Although the lowest paid of all Belgian working women, [they] are the ones who earn the most relatively speaking because they have no idea of luxury and few temptations to spend'.[52]

Clearly class was paramount in the minds of these ladies. Even when paying a grudging respect to the special 'endurance' and 'strength' of, for example, women miners, cartridge-makers, or textile-factory workers, the committee unfailingly added a demand that legislation end such 'unwomanly' work.[53] Still, these ladies were deserving heirs of their positivist forebears, and their report, like that of 1886, was replete with facts and figures. Though gathered with different and often eccentric methods, the report's data are of considerable use in drawing a picture of working life in the decades around the turn of the century.

[50] Ibid. 98–103.

[51] Ibid. 112.

[52] Ibid. 130, 131. The ladies' persistent concern about spending suggests their main preoccupation!

[53] The enquiry's authors chose to include a remarkable, and admiring, series of drawings of women coal-miners by the French artist, Cécile Douard. These illustrations show strong women, hard at work or talking with their comrades on rest breaks. Their details suggest that Douard went down a mine—in the Borinage, as the titles show. Thus while the text expresses some concern about women's work underground, the pictures 'approve' it!

EXHIBITIONS

These two enquiries, and others like them, were not the only outlet for
bourgeois self-congratulation in these years. Large industrial exhibitions—
begun by Willem II—continued to flourish, and in the belle époque, they
reached their apotheosis.[54] The first great 'world's fair' held in Belgium in
these years marked the nation's 50th anniversary. In the vast 'Cinquan-
tenaire Park', Léopold II led the nation in celebrating his reign as well as
the nation's wealth. Industry was the watchword, and a huge exhibition
hall was packed with Belgium's famous machines, tools, locomotives, and
so on. Workers were brought in to demonstrate every kind of industrial
and artisanal trade to bourgeois visitors. The hit of the show was a
working dynamo.[55]

These 1880 events marked 'the age of high capitalism' in Belgium, an
era of bourgeois good feeling. Such exhibitions, of course, were ideal
venues for the mass self-congratulation of the time. To these theme-parks
of capitalism flocked millions of visitors, entertained by the visual boasting
of their own or competing countries, regions, or cities. Indeed, part of the
competitive spirit that drove the 'race for empire' also powered these
exhibits, as nations competed to prove that their machines were biggest,
best, loudest, most impressive. And just as displays of living 'natives'
(accompanied by exotic animals and products), boasted of empire, so
similar displays of living workers allowed Belgians to brag publicly of their
industry.

Even socialists got into the act. In 1886 the Second Socialist International
sponsored the first International Workers' Exhibition, in Paris, and used the
occasion to turn the tables on bourgeois ruling élites everywhere by
exposing the ills of industrial capitalism, juxtaposed against evidence of
workers' courage and fortitude.[56] But bourgeois hegemony was not so
easily shattered. Soon, every international exhibition included similar dis-
plays devoted to 'social concerns'. In the 1898 'Universal Exposition' held
in Brussels, for example, one entire section was labelled 'Social Economy';

[54] Several recent works explore this phenomenon: see, *inter alia*, Bowlby, R., *Just Looking:
Consumer Culture in Dreiser, Gissing, and Zola* (New York, 1985),Torgovnik, M., *Gone Primitive:
Savage Intellects, Modern Lives* (Chicago, 1990).
[55] See Robert Paxton's opening chapter, 'Europe at its zenith, 1914' in *Europe in the
Twentieth Century* (New York, 1975), 3–48. He quotes Henry Adams's comments on the Paris
World's Fair on p 36.
[56] See Dommanget, M., *Histoire du Premier Mai* (Paris, n.d.), 62.

its many displays included the results of numerous investigations: thousands of carefully quantified facts.[57]

Soon, the aestheticization of workers already under way amongst artists and intellectuals spread to the industrial bourgeoisie. When an International Exposition was held in Liège in 1905, organizers chose a *hiercheuse* as the fair's symbol. Posters depicted a buxom, rosy-cheeked young woman, hand balanced saucily on one hip, posed against the heavy machinery of a mine.[58] Obviously, fair organizers saw no social challenge in their choice. Yet inside the fair, in the hall devoted to photography, a series of photographic studies of real coal-miners—men and women, girls and boys—shocked the fair's thousands of visitors. They were the work of a Liège artist Gustave Marissiaux, who had earned a reputation as an art photographer, much admired for his misty pictures of Italianate ruins, Turneresque water scenes, and so on. Here, however, he had turned his lenses on the mines. Hundreds of workers had posed for Marissiaux's searching camera, and despite his evident enthusiasm for romanticizing and sentimentalizing his subjects—originals show that he frequently added a grimmer background to pictures of innocent girls or young women, for example—the photographer succeeded in forcing bourgeois Belgians to confront the myriad bleak details of daily life in the mines. Adding to the visual impact of Marissiaux's pictures was a collection of statistical data which documented, in a different way, life in Belgium's mines. Thus it was against a backdrop of a cheerful, healthy, and colourful young *hiercheuse*, whose face looked out from every advertisement, that many members of Belgium's smug middle class found themselves facing the harsh facts of mining life. Pity, sorrow, and even some public outrage were the results.[59]

Of course this was still Belgium, and these reactions produced only one collective response: investigation. Dozens of committees were appointed and studies launched. By the next International Exhibition, held in Brussels the year following the death of Léopold II in 1909, quantities of data were ready for display.

In the process of examining working life in Belgium in the early twentieth century, most investigators concentrated, again, on women's work. They soon discovered that those women documented by Marissiaux,

[57] See description in 'Zéo', 'La Cooperation et la mutualité', *Avenir Social*, (1898), 18, 24.

[58] A photograph of this poster is kept in the Institut de la Patrimoine Artistique, Brussels.

[59] See catalogue from the *Exposition universelle et internationale de Bruxelles, 1910: L'Exposition collective des charbonnages de Belgique* (Brussels, 1910), 133, which states that Marissiaux's photographs prompted dozens of studies of mining conditions. The Marissiaux collection of mine photographs is held in the Musée de la vie wallonne in Liège.

almost all working at the surface of Liège's mines, were far from the most immiserated women in Belgium. That honour belonged, instead, to the millions employed in the extensive sweating system. These women, in what was known as 'travail à domicile', were the object of study of a special committee formed of men from all three of the nation's political parties. There was a socialist, Camille Huysmans, a social Catholic, Father R. P. Rutten, and a liberal, director of the Office du Travail and mayor of Brussels, Adolphe Max.[60]

These three politicians produced a report that showed they knew their countrymen and -women. Rather than aiming at Belgians' guilt or social conscience, they aimed at their self-interest. Noting that sweated work was the source of most of the luxury goods favoured by Belgium's bourgeois consumers, the authors added this caution:

From the slums, where your indifference lets entire families die of illness and misery, emerge every day some tuberculars, who sew contagion in the streets where you will harvest it after their passages; from these slums as well, where some little ones lie germinating on pallets, strangled by diphtheria or shivering with some eruptive fever, come also some clothing, some ornaments, some games, which will enter your 'hôtels', introducing with them, like the Trojan Horse, colonies of infectious microbes which will take unexpecting victims.[61]

But alas, they did not know them well enough. Not even this appeal to the bourgeoisie's sense of self-preservation prompted any move towards reform.

The last major exhibition before the war was held in Charleroi in 1911, where once again a *hiercheuse* (painted by Pierre Paulus) provided the fair's symbol. Here again, there was a 'Palace of Women', as there had been in Brussels in 1897 and 1910, and in Liège in 1905. This time, in the industrial city of Charleroi, the emphasis was entirely on working women. Unfortunately, however, no one thought to include any 'real' working women in the organizing committee. Rather, it was once again members of the aristocracy and *haute bourgeoisie* who designed and planned this public celebration of the area's female proletariat.

This ladies' committee decided on a 'Fête des Travailleuses'. It was opened by the Comtesse John d'Oultremont (from Brussels), who began

[60] *Exposition . . . 1910: L'Exposition du travail à domicile—documents, monographies, statistiques* (Brussels, 1911) adds material to that collected in the catalogue cited in fn. 59. It is interesting to note that one of Brussels's main shopping thoroughfares today—where one might still buy goods made in the sweating system (though the system has mostly moved to the developing world)—is Boulevard Adolphe Max.

[61] In catalogue from the Exposition . . . 1910, p. xxii.

her welcoming speech by saluting the 'gracious *travailleuses*' in her audience. She continued in a muddle of class and gender bias: the basic concern of her committee had been not with women workers, but rather with 'the housewife, the base of the working class'. At the same time, they acknowledged that the wages of these 'housewives' were 'essential to the working-class family'.[62] But the committee's real interests were quickly apparent, as the Comtesse's talk soon switched, from the 'gracious women workers' to *bourgeoises*: 'Educate your daughters in their class responsibilities', she told them. 'Interest them in the conditions of the other woman, a "sister", dignified and meritorious, whose life is a long and monotonous succession of suffering and evil misery'. In a frenzy of *noblesse oblige* she assured her listeners, 'It is impossible not to love the *ouvrière* when one knows her' (*sic*).[63] Clearly bourgeois attitudes toward working women were somewhat muddled. On the one hand, *hiercheuses* were celebrated: figureheads on publicity posters, symbols of world's fairs; on the other, 'real' *ouvrières* and *werksters* were veiled in patronizing incomprehension.

These *enquêtes* and exhibitions, then, were important emblems of Belgian society in the period from the mid-1880s to 1914. They provide several kinds of pictures of that world. Most importantly for our purposes, they offer another set of contradictory views of women's waged work. But a very different view existed 'below stairs'. The lives of 'real' working women had little to do with Belgium's *belle époque*. And it is to the details of these lives that we turn next.

WOMEN'S WORK

In the final years of our period, women's participation in the waged labour-force increased steadily. Not only did every new—or newly-mechanized—industry employ vast numbers of women, but some old industries began to replace more expensive male workers with females. In addition, as industry spread throughout once-rural areas, men and boys gradually disappeared from the agricultural labour-market, leaving this field open to growing numbers of women farm-workers. There was, of course, one venue from which women rapidly disappeared after 1889, the coal mines. Women's gradual exclusion was due not only to legislation; there were also changes

[62] Drèze, G., et al., *Le Livre d'or de l'exposition de Charleroi en 1911* (Charleroi, 1911), i, 462, 403. The language of this report is stupefyingly patronizing.
[63] Ibid.

in the methods and tools of mining that rendered much of their traditional work underground obsolete. Thus, for example, the increased size of mine galleries and tunnels, coupled with the almost universal laying of iron rails, meant that the women's work of dragging coal waggons became that of pit ponies. Owners also discovered that boys could break and load the coal as well and as cheaply as girls and women and they did not attract the attentions of bourgeois reformers or the opprobrium of foreigners. Gradually, then, beginning in the mid-1880s, mine-owners and directors hired fewer and fewer women for jobs underground.

Of course many thousands continued to find work on the surface—sorting coal, and loading and hauling waggons, in work quite similar to that they had traditionally done underground. At the pit-heads, in fact, the numbers of women grew. Marissiaux's photographic studies of this group of female workers was the cause of many viewers' shock at the 1905 fair. But not all women simply 'moved upstairs', as it were. For one thing, pay above ground was about the same as women's pay in many other industries. Moreover, surface work never offered the status or the 'romance' that rendered the lives of underground workers more tolerable. It was far less dangerous, of course, and cleaner, but it was at the same time visible to passers-by. Such visibility de-mystified women's coal mining, and soon all women began to share the very negative image of those traditional *glaneuses* who had long horrified Belgians. Their very low status, in other words, soon spread to all surface *ouvrières*, and women miners' earlier pride in their trade vanished. This was one of the most important reasons why many thousands of women workers in Liège, Charleroi, and—to a lesser extent—the Borinage, who might once have gone down the mines, now sought other work.

As the 1892 women's *enquête* made clear, there were three broad categories of 'women's work' in the final decades of the century: heavy and light industry (in factories, mills, or mines), artisanal trades (sometimes sweated and done in workers' homes, sometimes truly artisanal, and done in small workshops), and agricultural labour (which included both those hired as individuals to work for a contractual period on a given farm, and those who formed part of migratory work 'gangs').

According to contemporary estimates, in 1893 a total of 1,489,174 Belgian women earned wages or salaries. These included the following (broken down in broad and relatively uninformative categories):

agriculture	452,451
industry	211,603
commerce	101,018
public employment	5,731
medical, arts and letters, intellectuals	186,383
servants and 'dailies'	353,871
registered prostitutes	1,386
professionals and 'independents'	54,000

Of those Belgian females not included, 1,082,747 were girls under 15. This meant that only 186,619 Belgian females—out of a population of 1,272,366—were 'unemployed' It was thus not surprising that 44 per cent of all industrial and commercial waged work was carried out by Belgium's women.[64]

In 1896 Belgium's office of labour published figures that divided women workers according to whether they worked 'inside' or 'outside' their homes. Officials counted 83,008 women working outside their homes, the largest number of these working in clothing manufacture. They were followed by women working in linen, wool, and cotton textiles (in that order), then by those in coal-mines and glass-works. Women working inside their homes numbered 71,123, and of every 100 such women, 40 were 'sweated'; nearly twice as many women as men worked in this sweating system.[65]

In 1910 the official census pursued rather different information. It counted workers in 'mines, quarries, factories, ship and construction yards, workshops, boutiques, stores, commercial enterprises, public transport, private transport, and communal (public) employment'. Investigators found 2,238,008 workers, of whom 676,974 were women—one female worker for every 2.3 males. Men dominated in the researchers' next category, 'the

[64] Benoit, M., 'Les Femmes qui travaillent', *La Ligue* (Oct. 1893). Here again there are figures that contradict other sources. In the same paper, in January 1894, Mme Hector Denis claimed that there were 484, 082 self-supporting 'ouvrières' in Belgium (plus 111, 532 non-working-class, self-supporting women): see 'De l'Indifférence que rencontrent les revendications féministes'. D. Keymolen's figures, in *Vrouwenarbeid in België van ca. 1860 tot 1914* (Leuven, 1977), 28, are different again.

[65] Published in *Revue du Travail* (1900), 824–41. The term 'sweated', often used but rarely defined, here differentiates between home work, over which workers had control (of raw materials, work speed, and ultimate sale of product), and work done by workers with little control. These workers, often women and children, usually processed materials given to them by a middleman or -woman, who then paid a rate per piece for the finished goods. The profits from these goods thus went to others besides the workers. In Belgium, the term 'travail à domicile' was often used to describe the sweating system.

liberal professions or ancillary agricultural work': 30,547 men worked alongside only 2,487 women. The census also listed figures by province. Working in industry (including as owners, directors, and other 'white-collar' occupations) were 166,959 men and 98,349 women in East Flanders, 306,275 men and 45,873 women in the Hainaut, and 205,792 men and 41,873 women in Liège province.[66]

In some key industries, women comprised the following percentages of the total workforce:

textiles	62.83
clothing	77.86
skins and leather	29.28
chemicals	20.67
tobacco	34.21
glass	14.23
paper	32.62
ceramics	10.03

Another source added a further 1,204,810 agricultural workers, nearly half of whom were women, plus 40,000 male lace-makers.[67]

Textiles

Despite the absence of any reliable data concerning the numbers of women working in the production of wool, linen, and cotton, as well as the less important jute and hemp, it was clear that women comprised more than half the total textile workforce in Belgium throughout these final decades of our period. They predominated in the most onerous work, linen production, and in fact, during the *fin de siècle*, linen mill-workers in Ghent and Liège became a national *cause célèbre*, amongst the most pitied workers in Belgium. Visitors were shocked at the sight of crowds of women and girls, moving rapidly back and forth working the huge machines, deafened by the cacophonous thunder produced during the mechanical production of yarn and cloth, soaked by clouds of steam mixed with their own sweat. Every mill was crowded: in the 1890s. Ghent's La Linière, one of the city's largest mills, employed more than 5,000 workers.[68]

The workforce, whose employment remained unrestricted by labour legislation, still included girls and boys as well as adults of both sexes.

[66] Ibid. (1914), 824–41.
[67] Ibid. 505, 139, 168, and 'Celles qui travaillent', in *La Ligue* (1912), resp.
[68] *Enquête—1886*, ii, 162.

More women worked with linen than did men, as did more girls than boys: one witness counted three girls for every two boys. All children started work at the age of 10. The socialist flax-workers' union newspaper, *Vlasbewerker*, numbered one flax-mill workforce in the following way:[69]

Age	Male	Female
under 13	90	118
13–15	295	480
15–20	412	1,256
20–40	751	2,644
40–50	253	171
50–60	185	48
over 60	79	15

One should not imagine that the drop in numbers of women working after age 40 indicated a retirement to a life of even modest domestic leisure. Although mortality rates for Ghent are unreliable for this period, those for the French textile cities of Lille, Roubaix, and Tourcoing show that the life expectancy from age two of a female who worked in textile-mills was only 32. Given the similarities in work and private life in these cities, it seems likely that Ghent's mortality rate might have been similar to that across the border.[70]

In linen mills men earned the higher wages usual in other textile factories. In one Ghent mill in 1892, men averaged 18 francs a week compared to women's 14 francs for the same 12-hour days. This was still higher than women's wages in Verviers, however. In the wool combing and carding mills of that city, 7,786 *ouvrières* earned an average of only 10 francs a week.[71]

In addition to low wages and long hours, all textile-workers continued to suffer the chronic diseases common in earlier decades. Ghent's linen-spinners continued to be those most at risk: in 1898 one doctor claimed that of the linen 'fileuses' at La Lys, 89 out of every 100 women working in preparation rooms needed medical attention for chronic skin ulcers; in spinning rooms, 98 out of 100 women needed treatment. Because they stood all day, every day, in deep pools of warm, filthy water, the ulcers

[69] *Vlasbewerker* (1896).

[70] See my *Working Women and Socialist Politics in France: 1880–1914* (Oxford, 1986). Most women linen-mill workers worked in Ghent—the city with the highest number of industrial workers of any Belgian city in this period: 21,850 males and 13,429 females, according to the PG, no.230, excerpt from the *Le Peuple*, 13 Mar. 1893.

[71] *Enquête de la femme*, 46, 52–4.

were especially prevalent on women's feet. Although they wore wooden sabots, these offered insufficient protection.

For those who worked in dry spinning rooms, conditions led to less immediately apparent, but more serious, disease: constant fine dust, which enveloped workers throughout their 12-hour shifts, caused every kind of serious lung disorder, including the deadly 'brown lung', the gradual deterioration of textile-workers' lungs, which in that era went under various labels, including 'consumption'. Not surprisingly all linen working women endured the death of many infants and young children: of the 293 adult women working in one Ghent linen mill, for example, 134 had given birth to 368 children, 62 per cent of whom had died!

Their daily lives remained as bleak as those experienced by their grandmothers. One typical factory worker in 1900 followed this daily pattern: at 4 a.m. this mother of three small children climbed up from her pallet to make the family's coffee and cut and butter the bread. Next she peeled the potatoes for the noon meal. The children were awakened, and she washed, dressed, and fed them. When they were ready, she took them to a neighbour whom she paid to watch them until school opened, and then to take them to school. At last, she grabbed her own bit of bread and ran for the mill, eating as she clattered along the cobbled streets. Once at her machine, she worked until noon, when she returned home, cooked the potatoes, added some garlic and water and made soup. Then she fetched the children from her neighbour. Back home, her husband awaited his midday meal, which she promptly served. The meal over, she washed up, sent the children back to school and returned to her mill, where she remained until 7.30 p.m. By 8.15, she had again picked up the children and returned home. There, of course, she had more cooking to do. Her husband soon arrived home, having stopped for a drink at his *estaminet* and the family ate their evening meal of bread and potatoes. At the table, the children often fell asleep, and she carried them off to bed. After washing the dishes for the second time that day, she turned to the household mending, sewing, or laundry. Finally, she dragged herself to join her husband, who was long since asleep.[72]

Such conditions drove women to seek other work. In fact, a shortage of women textile-workers developed in Ghent after the turn of the century, when alternative industries appeared in the city. Cheap railway tickets—workers' *coupons de semaine*—also allowed women to find employment outside the city. Complaints about the severe shortage of *werksters* multi-

[72] In AGR, Conseil Supérieur du Travail, Ministère de l'Emploi et du Travail, no. 38, 'Séance. 9 fev. 1898'.

plied, reaching one peak in the years from 1900 to 1907, and a second from 1912 to the outbreak of war.[73] One consequence of this unusual shortage was women workers' readiness to go on strike, as we shall see below in Chapter 9.

Coal

In coal, the focus of so much public attention, women's numbers underground, as we have seen, fell sharply after 1892. One 1892 document counted 11,134 women underground, out of a total coal workforce of 119,000. Another source listed only 3,170 women underground, together with some 945 girls. (A further 4,368 women and 2,763 girls worked above ground in that year.)[74] In these years, women's work included all their traditional tasks—though some were now much easier thanks to steam-powered machinery. As women disappeared from the pits, however, where they had long been the undisputed aristocrats of women's labour, a new hierarchy began to emerge. On the surface, women working in the *lampisteries* enjoyed the highest status, as was discussed in Chapter 5. Signs of their elevated position were their uncovered hair—worn in the high bun of respectable working-class housewives—and their dresses. Moreover, they did not leave work covered in black coal-dust, and work-aprons protected their skirts from any stray dirt: thus, once on the streets, their aprons left behind at the mine, they were indistinguishable from other women working in less exotic trades.[75]

For the few women still underground, work was both highly prized and very arduous. A typical work-day, described by a young woman of 17, began at 5 a.m. After loading and pushing between 60 and 70 coal-waggons back and forth—a labour interrupted by occasional breaks for rest and food—this young woman returned to the surface, usually between 9 and 11 p.m., depending on the speed of the other miners. Such days were, of course, numbered, as protective labour legislation took effect. By the end of the century, the youthful, singing *hiercheuses* of popular memory were gone. The remaining 424 women officially listed as working underground, all of whom had been working in the pits in 1892, were now older, and they would not be replaced. The chain linking mining mother to mining daughter was broken.

For these few women still working below ground, however, life was little

[73] Complaints and appeals found in *Revue du Travail* (1900–14).
[74] *Enquête de la femme*, 117.
[75] Ibid. 117–18.

changed from that of their mothers and grandmothers. One of the most eloquent descriptions of the life of Belgium's disappearing underground coal-miners was that given to her biographer by the socialist deputy, Lucie Dejardin, recalling her mother's life in Liège at the end of the nineteeth century. She remembered a mother who was 'always tired, always soaked with black water'. Like many other women coal-miners, Mme Dejardin gave birth in the pits—and returned to work 3 days later. When her daily work underground was finished (work 'mysterious' to her many children), Mme Dejardin faced the typical working woman's second job, looking after a household that included eleven children. The house had no running water, so the first task was to fetch the family's water, in buckets suspended from both shoulders by a wooden yoke. In those years, mine-owners required women to wear clean clothes every day, so the family laundry came next, before supper and the evening's sewing and mending.[76] From time to time, all the straw pallets had to be re-filled, necessitating a trip into the country to gather fresh straw. In addition, the Dejardins kept a small garden and raised chickens: it was Mme Dejardin's responsibility to supervise the garden and its animal occupants. When the family ran out of all other resources, it was also her job to pawn clothing and whatever other material goods could be spared at the local *Mont de Piété*. Did Lucie Dejardin's mother ever resent her 'double slavery'? Dejardin told her biographer that if her mother even realized it, she accepted it with 'an absolute fatalism'.[77]

Other Industries

Where did displaced mining women find alternative work? Some above ground, as I have said, but like women in textile cities, many more found work elsewhere. Shoe-making, for example, came to the previously mono-industrial region of the Borinage in 1889. By 1893, machine-made shoes were produced in factories at Frameries, Pâturages, Flénu, La Bouvière, Quaregnon, Eugies, and Wasmes. Women's work in these factories—most commonly adding buttons and 'finishing' boots and shoes—increased in

[76] One young woman's day is described in Fauviau, H., *Le Borinage: Monographie politique, économique, sociale* (Frameries, 1929), 189. Dejardin's story is in Chalmers, E. B., *Lucie Dejardin: Hiercheuse et député socialiste* (Huy, 1952), 32. See also, Citoyen Trillet, 'Rapport: Bassin de Liège', *Ouvrier Mineur*, Jan.-Mar. 1905 One tiny bronze statue, in a small cobbled square just outside the Cour de Mineurs in Liège, features a female figure carrying water-buckets suspended from a great yoke. This sight may have been what prompted the comparison with 'Chinese coolies' cited above.

[77] Chalmers, *Lucie Dejardin*.

the 1980s as more workers began to buy cheap boots and shoes to replace the traditional familiar wooden sabots.[78]

Boraines also found work in new silk-mills and ironworks—as well as in potteries, sugar refineries, and a few scattered glass-works. Some continued to eke out a living keeping cabarets or small shops, while still more continued women's traditional work gleaning on the slag-heaps. A handful found themselves in the work so dreaded by young *hiercheuses* of an earlier time: domestic service. With the new *coupons de semaine*, those women who found no work locally began to travel to work outside the Borinage. There are no data giving the number of commuters in our period, but it is suggestive that in 1928, two-thirds of all workers' train tickets sold in the Borinage were bought by women, who travelled each day to work near the French border.[79]

One of Belgium's fastest-growing industries offered work to women in Liège and Charleroi. This was the production of every kind of glassware, from the luxury crystals of Val-St-Lambert, to more humble table glass and industrial glassware, to large plate-glass used for windows and mirrors. Belgians also made a variety of other glass products: lamps, electric light bulbs, beakers and flasks for the chemical industry, and so on. The growth of art nouveau architecture in Belgium also demanded quantities of decorative glass, and the industry supplied it.

Women worked in every glass-making workshop. One set of data, which unhelpfully lumps women together with children of both sexes, shows the following percentages for this group out of all workers in 1899:[80]

crystal glassware	32.24
window glass	26.83
bottles	16.02
plate-glass	6.82

Women undertook various tasks in the numerous glass-works: in one Charleroi plate-glass factory at the end of the century, a typical work-team consisted of one male glass blower, two boy apprentices, and one 'reheater' of either sex. The re-heater's job was to return the glass to the furnace periodically during the blowing process. It required strength, but many women were employed in this work. Two more workers tended the furnace fire, and here, too, women worked alongside men.[81]

[78] Fauviau, *Borinage*, 110
[79] Ibid. 168.
[80] *Revue de Travail* (1899), 1224.
[81] Women were not usually big or strong enough to blow large glass objects. They did blow small objects, such as glass beads.

The resulting product was a large cylindrical glass 'canon'. Once completed and cooled, these canons were handed over to women who carried them to the cutting rooms. These *porteuses de canons*, famous for the strength and dexterity with which they moved two cylinders at a time, were another female 'aristocracy' of labour. Their working dresses—with distinctive short skirts, heavy aprons and gloves, and large leather wrist straps—identified them to all who saw them on their way to and from work. Not surprisingly, they were also favourite subjects for photographers, and appeared frequently on the picture postcards and banquet menus of the *belle époque*.[82]

Women also cut all kinds of glass, including plate-glass and mirrors. In the luxury trade, however, their work was limited to the less skilled 'rough' cutting and polishing of crystal. Men alone worked in the 'artistic' cutting and engraving of Belgium's fine crystal products. One observer explained women's exclusion by noting that such artistry 'demanded a certain *adresse* and much attention'—both, of course, stereotypically assigned to women in other occupations![83] (At the same time, such work required many years of apprenticeship, and few girls got such childhood opportunities.)

In table glass and bottle manufacture, women's work was 'hard and unhealthy', as well as long. One glass-works near Liège employed between 200 and 300 women, as well as 300–400 men and 150 children at the end of the 1880s. All worked 12-hour shifts. Women's work included not only the customary carrying, cutting, and polishing, but also sorting, packing, and loading glass for shipment. In some bottle factories, women also plaited and braided straw baskets into which the bottles were set—in the manner of contemporary bottles of Chianti wine.[84]

Although glass-work paid good wages, women were also attracted to the industry by the extensive paternalism practised by many owners. Val-St-Lambert, which employed some 3,000 men and women in the 1880s, was a model. For its Liège workers, the company provided housing, savings banks, insurance schemes, a food co-operative, various leisure societies, educational groups, and so on. The Namur branch also added a 'caisse de secours' for 'heads of families', the latter defined—

[82] 'L'Industrie de la gobeleterie belge envisagée du point du vue sociale' (n.p. 1950), Fonds Chambon. At the Steuben glassworks in Corning, NY, women remain concentrated in polishing and rough cutting. There are now, however, some women glass-blowers.

[83] Ibid.

[84] See *Enquête—1886*, i, 1046, and ii, 163.

188 Women, Work, and the Bourgeoisie

interestingly—as 'a father, a mother, a grandfather, a grandmother, or any single person who is considered thus by the community'.[85]

An important ancillary occupation also employed women. Made famous—or more accurately, infamous—by J. K. Huysman's 1876 novel *Marthe*, makers of imitation pearls filled tiny blown glass beads with a paste made from fish scales, ammonia, and water. The paste—which required years of tending before it reached the desired luminescence—was blown through a pipe into the balls. The worker, of course, began by sucking the paste into her blowpipe, sometimes drawing it into her mouth. Even when this did not occur, however, the woman inhaled the fumes. Once the glass object was full, it was 'washed' with 'spirits of wine'; according to Huysmans, 'she likewise breathes [the wine] in with her blowpipe'. Lastly, a 'few tears of virgin wax' sealed each ball.

In the fashion of his time and class, Huysmans painted a portrait of pearl workrooms overflowing with immorality and dissolution. In the novelist's words:

A workshop of women is the anteroom of Saint-Lazare. Marthe was not slow in becoming accustomed to the conversation of her companions. Bent all day over a bowl of scales, between the blowing of two pearls, they would chatter endlessly. . . . Such and such a girl was living with a gentleman . . .; she received so much a month . . . ; all were jealous of her . . . A girl is lost as soon as she sees other girls of this sort. The conversations of school boys are not to be compared with those of workwomen.

A view we have encountered before! Here, too, however, was the strange juxtaposition of a luxury product made for fashionable ladies and the bleak, exhausting facts of its production.[86]

Such work, ancillary to glass manufacture, existed wherever there were glass-works, including in Liège. But in that city, workers of both sexes had many other occupational possibilities. Gun-making, ornamental iron-work, and cigar-making employed hundreds of families, many working in a manner little changed by time. Entire *quartiers* in Liège housed the city's arms-makers. Camille Lemonnier has described these districts as constituting 'immense workshops, where the women, the men, the children all busy themselves filing, polishing, adjusting, rubbing up the steel, from dawn to nightfall'.

One estimate counted some 5,000 to 6,000 women working in arma-

[85] *Enquête de la femme*, 31; ibid. ii, 18, 25, 194.
[86] Huysmans, J. K., *Marthe: The story of a woman*, trans. Putnam, S. (repr. Bern, 1992), 15, 16–17.

ments manufacture in Liège. Their work included polishing, bronzing, varnishing, and so on. On average they earned between 1 and 2 francs a day. In most workshops, at least some of their co-workers were family members—thus helping to compensate for the relatively low individual wages. Work rhythms in this ancient craft remained less standardized, more relaxed than those endured by their comrades imprisoned in factories and mines.[87]

The related trade of cartridge-making, by contrast, was partially mechanized by the end of the century, and thus sited in large factory workrooms. Here women provided a majority of the workforce. In the last quarter of the nineteenth century, Liège's three largest cartridge manufacturers employed between 500 and 600 women. Throughout the local industry, women outnumbered men three to two.[88]

Another important women's job was, in fact, a continuation of the traditional practice of employing women to transport goods. In Antwerp, where the famous, much-admired dockers worked in tightly controlled guilds called 'nations', women were employed in all sorts of ancillary jobs. Paid directly by individual nations, women made sacks, cleaned docks, loaded, tied, and carried smaller hand-loads, and so on. In 1908 this kind of work paid between 1.80 and 2.25 francs a day (compared to the lowest male wage of 3.50 francs). Women also worked on Ghent's docks, although they were the 'dockers', loading and unloading the barges that carried that city's finished textiles and the industry's raw materials to and from sea ports.[89]

Ouvrières, as noted in the 1892 women's *enquête*, also provided a significant percentage of labourers in match factories, some of which were built in the Borinage, in Liège, and in Charleroi in the final years of the nineteenth century. One manufacturer explained why women and girls were so necessary in match production: they were more dextrous, and had 'thin, delicate hands'. He also believed that women were less susceptible to phosphorus poisoning because 'its poisonous fumes cling to men's beards'! Neater and cleaner than men, the women also tended to drink less, making them more reliable workers.[90] In the early years of the twentieth century,

[87] See *Enquête—1886*, i 1046, and ii, 18, 25, 163, 194; and *Enquête de la femme*, 31.
[88] *Enquête de la femme*.
[89] See de Seilhac, L., *Le Lock-out d'Anvers* (Paris, 1908), 21; *Enquête—1886*, ii, 35, and i, 19. In the latter, a witness from Grivignée testified that women's traditional work in his region, loading, unloading, and transporting an iron foundry's raw materials and finished products to and from the canal dock, had been superseded by the arrival of railroads, where only men were employed loading and unloading.
[90] *Enquête—1886*, ii, 61.

technology began to improve work in match factories. Machines now cut the matches, mixed the chemicals, and so on. Soon, women's work was confined to relatively harmless, if tedious, tasks: collecting and counting the matches, filling the boxes, and wrapping them for shipment. They worked 11-hour days, for which they earned between 1.50 and 2.50 francs a day.[91]

Another women's occupation that appeared in the final decades of the century was factory hat-making (as opposed to millinery or hand-hatting, skilled trades which continued to produce hats at the luxury end of the market). A character from Neel Doff's 1911 novel, *Jours de famine et de détresse*, called Keetje, described her first day in a hat factory:

I was led into a big workroom full of steam, where some women, nearly all young, were working, their sleeves rolled up, in front of long tanks full of hot water, to which vitriol had been added, I was told . . . They stopped for an instant to stare at me; then their heads bent over, their arms plunged back into the water, and work continued, feverishly.[92]

Each woman, working as fast as possible to earn a high piece-rate, soaked pieces of felt in the vitriol and water solution, from time to time pulling them from the hot liquid to heat them against a tablet hooked on to the vat. When the cloth became workable, it was passed on to others who shaped the felt into hats. Neel Doff's character noted that the women were bathed in sweat while the acid 'ate' their hands. Finger-nails vanished altogether after the first day, and everyone's hands swelled.[93]

These details offer some sense of life for most women factory-workers in Belgium in what was not for them a *belle époque*. Many of them, as we have seen, were caught up in the massive shift from hand to machine production of a wide variety of goods. In the process, both women artisans and sweated workers were effectively 'proletarianized'. Even such ancient crafts as lace-making, straw-hat plaiting, and knitting went into factories, transformed by machines. Often, artisanal trades that had once been men's work, were 'feminized' in the years before 1914. These included cord- and rope-making, for example, which moved from the countryside into urban factories, where women and men competed for jobs.[94]

[91] *Enquête de la femme*, 23. They were paid by the piece, the number of filled and wrapped boxes determining their wage.

[92] Doff, N., *Jours de famine et de détresse* (Paris, 1927), 161 (orig. pub. 1911). I am grateful to Jacques Dubois for knowledge of this novel.

[93] Ibid. 161–2, and *Enquête—1886*, i, 13.

[94] This general portrait comes from several sources, but especially from the two enquiries of 1886 and 1897, and from *Revue du Travail* (1899–1914).

Of course, not all trades were transformed by machines. And in many cases, hand-work remained the hall-mark of quality. Thus thousands of Belgian women continued to labour at low-paid sweated trades. After the turn of the century, these sweated workers moved closer to centre stage in the minds of bourgeois reformers, gradually replacing the miners and textile-workers of former times. Towards the end of our period, one contemporary summarized the dark circumstances of Belgium's sweated *ouvrières*:

This isolated woman's situation is one of the unhappiest chapters in this vast problem. . . . The idyll of the labouring household is no longer anything other than a sad irony; it is disenchanted work, a life which unfolds in a milieu without sun and without rest, in the centre of leprous *impasses*.

The writer cited the worst sweated trades: the making of toilet articles, children's games, paper sacks, and writing quills.[95]

In 1910 the government was moved by increased public attention towards the awful plight of the 118,000 workers who made Belgium's famous luxury goods to launch another investigation, where it was quickly discovered that the work was primarily women's work. Investigators explained this fact by noting that many of the trades, including, for example, glove-sewing and embroidery, were traditionally 'women's jobs'. But little remained of these 'traditions'. Where once women had worked in their homes, varying their hand-work with other tasks and working outdoors—often in sociable groups—they now toiled alone or with their children, crowded in the dark attics and cellars of Belgium's urban slums. They no longer controlled the pace of their work; worse, paid by the piece, most were forced to labour without stopping for as many hours as possible each day.

The researchers noted a fact unnoticed by those who, a few decades earlier, had made such work a political goal: however onerous factory work, it was almost always preferable to toiling alone, or crowded

[95] *Exposition universelle* . . . *1910: 'L'Exposition du travail à domicile*, p. xxxii. One French investigative journalist, the syndicalist militant Marcelle Capy, detailed these trades in France's domestic out-putting system in several reports. Her reports are published in *Bataille Syndicaliste*, and *Voix du Peuple* throughout 1913 and 1914. See also the work of Maximilienne Biaïs, another feminist reporter, whose efforts amongst France's working women were also described in both papers. Like Marguerite Yourcenar years later, Capy was particularly struck by the contrast between the lives of the producers in making their products, and the luxurious lives of those who consumed them. In *Dear Departed*, Yourcenar observes, 'Mme de C., although soft-hearted, has doubtless never given a thought to the conditions in which these women live; invisible, they weave and embroider, like the Fates, wedding gowns and infants' clothes', p. 24.

together with children, in squalid rooms. It was no wonder, they added, that significant numbers of working-class women chose the mills over the sweating system (*contra* H. Seebohm Rowntree!). In the mills, at least, they escaped their isolation and their appalling living quarters (as well as their children, though of course no one suggested such a thing).[96]

In addition to sweated *ouvrières*, working in the nation's urban centres, Belgium also employed thousands of semi-artisanal rural workers. In 1904 a socialist visitor found women and men in both provinces of Flanders still working in hand rope-making, hand-weaving, and hand-spin-ning. Many more were knitting, making clogs, sewing sacks, weaving baskets, and preparing skins and furs. Some sulphur and phosphorus matches were still hand-made, as were needles and lace. But despite their rural venues, none of these trades suggested the rural idyll of urban reformers' imaginations. Instead, this socialist visitor saw only 'hopeless misery': alienation was widespread in this vast region of rural outwork, 'as unknown to the majority of French-speaking Belgians . . . as Australia'.[97]

Given the extent of women's participation in both sweated and rural hand-work, it is impossible to describe it all in detail. But there were two important occupations in which technological change shifted work from men to women, in a pattern common in many occupations: the manufacture of cigars and cigarettes, and printing. These two trades, once the exclusive purview of Belgian men (though tobacco was not men's work in some other European countries), changed rapidly. After 1900 manufacture of cigars and cigarettes employed four women for every one man. In printing, women began to work alongside men as typesetters and correctors, as well as in their traditional role of *margeuses*. It is important for our purposes here to note that in neither trade was the change accompanied by the kind of male hostility common in other European countries. Male tobacco-workers reacted by demanding only that women be paid equal wages, so that wages on the whole would not be undercut. Printers—in stark

[96] H. Seebohm Rowntree's remarks, quoted in Chapter 1, are found in *Land and Labour: Lessons from Belgium* (London, 1911). See also *Exposition universelle . . . 1910*, pp. x, 1 and 120.

[97] De Winne, A., *Door arm Vlaanderen*, met een brief van Ed. Anseele en een aanhangsel van K. Beerblock (Rotterdam, 1904), 33, 97, 248, 251. Many of these same trades prevailed in rural Wallonia, a place just as foreign to urban Walloons as the Flanders countryside to the inhabitants of Brussels. See Van Hoeyland, C., 'L'Industrie de la tannerie à Tamise', *Avenir Social* (1902), pp. 257–8. In the years around the turn of the century, both hand and machine basket-making increased in Verviers and Liège, attracting hundreds of lace-makers to the trade.

contrast to their fellows in other European countries—similarly showed no particular hostility to women typesetters.[98]

Lastly, this overview of the many and varied work-roles of Belgium's lower-class women in the *fin de siècle* must not overlook agriculture, where women provided a significant percentage of the waged labour-force, useful for harvesting and planting, as well as for the more constant work of tending fields and dairying. The Belgian countryside, one of the most agriculturally successful regions of Europe, was worked in our period by thousands of notoriously hard-working men and women, whose skill drew abundant food from very reluctant soil.[99] Taken for granted during the height of Belgium's industrial miracle, they began to receive more attention in the years around the turn of the century. And here again investigators were startled to discover significant numbers of women: in 1882 44.2 per cent of agricultural labourers were women.[100] Here, too, despite their crucial contribution to the success of the nation's farms, women earned much lower wages than men, and enjoyed none of the job security offered to male agricultural labourers who were contracted to work for several years at a time.

CONCLUSION

This 'women's army', so essential to Belgium's industrial revolution, had spread everywhere in Belgium by the close of our period. But despite the growth in the number of recruits, their living and working conditions continued to reflect both the severe class division of Belgian society and the extent of the bourgeois ruling class's indifference to those masses in the lower stratum. Given this situation, workers' resistance was surely overdetermined. And resist they did. Beginning in the years of the First International, women and men in Belgium's factories, mines, and workshops organized and began to formulate a strategy of resistance—grounded, unusually, in both gender and class. That movement of workers is the subject of the third part of this study.

[98] A *margeuse* worked justifying margins. The words are quoted in *Enquête de la femme*, 136. There were Belgian printers who were hostile to women's entry into typesetting rooms, of course, but they were nowhere near as hostile as French printers, as evidenced by the infamous Couriau affair in 1913. See my discussion of this crisis in 'Women and the Labour Movement in France, 1869–1914', *Historical Journal* (autumn, 1986), 809–32.

[99] See the admiring retelling of this story by the British Fabian socialist H. Seebohm Rowntree, in *Land and Labour*.

[100] *Enquête de la femme*, 129.

PART III

Women and Politics

We must not wait for men to give us freedom. . . . Our emancipation must be our own work!

Nellie Van Kol
De Vrouw, 15 August 1893

7

Working Women in the Period of the First International, 1860–80

INTRODUCTION: WORKING WOMEN AND POLITICS

> A cette époque [the late nineteenth century] en Belgique comme ailleurs, le féminisme ne concernait qu'une petite minorité de femmes. On rencontrait exclusivement des féministes dans un group sélect des femmes issues de la bourgeoisie intellectuelle, pour qui la conquête de l'integralité des droits civils et du droit au travail était une manière— importante—d'échapper à l'ennui du foyer et de mariages souvent forcé.
>
> Els Witte[1]

In the case of nineteenth-century Belgium, two historiographical myths have developed, both of which have helped ensure the disappearance from the historical record of the women workers who were the pioneers of proletarian women's rights. The first concerns the internal history of the Belgian left. Although there are competing versions, most historians have agreed that before the arrival of Marxian socialism (and to some degree even after), the workers' movement was predominantly 'Proudhonist', especially in Wallonia. Because one salient feature of Proudhonism was its founder's active contempt for women—a sentiment encapsulated in Proudhon's famous phrase, 'courtesane ou ménagère'—it was generally assumed that working women were either overtly or covertly excluded from Proudhonist workers' movements, particularly those organized under the aegis of the First International.

The origins of the second myth are more straightforward, and concern not only the hegemony of bourgeois versions of history, but also more genuine problems of historical research in Belgium. As Els Witte suggests,

[1] Witte, E., Craeybeckx, J., and Meynen, A., *La Belgique politique de 1830 à nos jours*, trans. Gouaert, S., (Brussels, 1990), 120.

most historians have agreed that 'feminism', such as it was in Belgium, was entirely the affair of women of the upper classes. And indeed, such women had a striking history: beginning with Théroigne de Méricourt, and including intellectuals such as Zoë Gatti de Gamond, these women played important roles in left-wing politics of all kinds.[2] However, their class origins generally restricted their claims for rights to property and political rights. None carried any message of revolt for their lower-class sisters. Some, in fact, accepted Proudhon's restrictive view of proletarian women, though, as we have seen, they were often reluctant to abolish those women's trades that served their own interests, including both domestic service and the making of luxury goods.

A bourgeois women's movement is also more readily documented than a struggle undertaken by women of the lower classes. First, its proponents belonged to the literate classes, who recorded their lives in books, brochures, essays, and letters. They also belonged to Belgium's ruling élite, which documented its governance and the attitudes which justified its continued rule. Thus, although Belgium's bourgeois proponents of women's rights have often been 'hidden from history' simply because of their sex, the retrieval of their collective past is much less complicated than that involving those whose history—as women and as workers—has been neglected twice over.

Documentary evidence from which to recreate the history of politics amongst *ouvrières* and *werksters* is rare and scattered. Unless researchers begin with an interest in women's activities, they will almost invariably overlook the very fragmentary archival information—including, for example, a woman's name in a police report of a workers' meeting, a remark about the prevalence of 'women and children' in a political demonstration, and so on. Tiny notices of women's meetings, hidden on the back pages of workers' newspapers, are similarly obscure, as are brief references to *Amazones* or *Pétroleuses*. And of course most historians have been interested in the dominant culture (and its description of itself) and thus have rarely read the hundreds of short-lived newspapers produced by Belgium's working class.[3] These difficulties have only exacerbated the well-known reluctance

[2] Such women are described in various sources, including De Weerdt, D., *En de Vrouwen? vrouw, vrouwenbeweging en feminisme en Belgie, 1830–1960* (Ghent, 1980); Landes, J. B., 'Representing the Body politic: The Paradox of Gender in the Graphic Politics of the French Revolution', in Melzer, S. E. and Rabine, L. W., *Rebel Daughters: Women and the French Revolution* (Oxford, 1992), 20–1, and Polasky, J., 'Utopia and Domesticity: Zoë Gatti de Gamond', *Proceedings of the Western Society for French History* (Lawrence, Kan., 1984), 273–81.

[3] It must be said, too, that access to such papers is very limited. Although the government

of most historians to concern themselves with the history of working women.

And yet, working women's political history—particularly as it unfolded in Belgium in the course of the second half of the nineteenth century—is 'a terrible thing to lose'.[4] This section of the book takes up the task of rediscovery, focusing on two periods: that of the First International, 1865–1880, and that of the Second Socialist International, in the years from 1880 to the outbreak of war in 1914. In both periods, textile-workers played a central role: the working women of Verviers and of Ghent were consistently amongst the most militant in Belgium's working-class movement for women's rights. Furthermore, the First Internationalist women's movement of Verviers, the subject of Chapter 7, developed a women's rights ideology that was directly contradicted by that which emerged in Ghent during the Second International (the focus of Chapter 8). Because both theoretical structures were created by women with similar work and life experiences, they suggest that little about women's politics was pre-determined by the kinds of sociological or economic factors often adduced to explain such theoretical choices. In other words, the sexual division of labour, or the extent of participation in factory work, or even the relation of married to single women in the workforce, were evidently relatively unimportant factors in determining the goals and strategies of textile-workers' struggle for women's rights.

Of course the historical fact that Belgium's working-class women played an essential and continuous role in industrial labour was an important element in the development of women's politics amongst the nation's proletarian women. These Belgians were not Eric Hobsbawm's nineteenth-century women, who 'belonged to the proletariat not as workers, but as wives and mothers of workers'. Neither they nor anyone else expected that they would experience class only by virtue of their relationships with

has begun to microfilm those papers collected in national archives, most remain in a perilous condition: pages are torn or missing, or illegible because of fire or water damage. Moreover, few of those held in the Bibliothèque Royale are complete. It is possible to read straight runs of most papers only by travelling from archive to archive, seeking missing issues. Historians who have failed to undertake such arduous work, whose interests did not directly concern working women, cannot be faulted.

[4] This is a paraphrase of former vice-president of the USA Dan Quayle's most famous malapropism which resulted from his attempt to quote the slogan of the National Negro College Fund: 'A mind is a terrible thing to waste'. What Quayle said instead was, 'What a waste it is to lose one's mind, or not to have a mind is being very wasteful. How true that is'. Quoted in *Mother Jones* (July/August 1992), 15.

proletarian males.[5] Thus—as we have seen—few demanded that women cease waged labour after marriage or motherhood. There was no indigenous demand that wives be supported by a 'family wage', such as dominated working-class politics in Britain in these years. Instead, Belgium's working women demanded the right to continue the wage-earning that ensured their independence, though, as we shall see, the women of Verviers chose very different, and often internally contradictory, means of attaining their goals.

This chapter concerns only the first half of the story: that of the women who organized an early women's movement within the structures of the First International, with its headquarters in Verviers. The women of Verviers were not the only organized advocates of women's rights or the only First Internationalists in Belgium in these years. Others existed, and Chapter 7 closes with a brief look at the sparse evidence of women's sections, and women members of mixed-sex groups, in Liège and Charleroi. But the central concern here is the relatively well-documented women's movement of Verviers, which was—for all its 'anarchist' principles—the most coherent and the most visible in Belgium.

VERVIERS

As I gazed from my window ... I could not avoid feeling pity for the beings whom I knew to be shut up in the innumerable mills filling the valley. I commiserated with the workers—men, women, children—whose silhouettes I could discern behind dusty workroom windows. I watched them passing to and fro amongst the machines—indefatigable, though shaken with the wild rocking and dizzying revolutions [of the machines] and despite the wet atmosphere. They laboured on, impregnated with wool grease and oil, in the deafening uproar, through the long days, through the long nights, through the long week.[6]

The memory of such scenes eventually drove Laurent Dechesne into the sparse ranks of Belgium's reformers at the end of the century.[7] But although his reactions were commendably sympathetic—particularly strik-

[5] See Hobsbawm, E., 'Male and Female in Socialist Iconography', *History Workshop Journal* 6 (1978), 131–40.

[6] Dechesne, L., *L'Avènement du régime syndicale à Verviers* (Paris, 1908), 5.

[7] Lines dividing classes were very clearly drawn in Belgium. Those in the upper ranks were sparse: one 1865 estimate put 100,000 families into the 'rich or comfortable' category; 420,000 families into a 'middling' group (many, this study noted, on the brink of collapse); and 480,000 families into the working class. See Jean Neuville, J., *La Condition ouvrière au XIXe siècle, i. L'Ouvrier objet* (Brussels, 1976), 156.

ing against the backdrop of bourgeois indifference to the nation's working class—they were described entirely in the images of his class, those who lived beyond the factory's dust-encrusted windows. From his childhood home, high in the hills overlooking Verviers, Dechesne objectified those 'dusty silhouettes' into the brave, 'indefatigable' victims of reformers' imagination.

Ironically, however, those same distant figures in reality had little in common with the pitiful factory slaves of Dechesne's memory. On the contrary, Verviers' wool-workers were amongst the most militant workers in Belgium in the 1860s and 1870s. And they did not limit their militance to informal struggle; they also organized. By the end of the 1860s, under the umbrella of the Association Internationale des Travailleurs, they had created the most cohesive workers' movement in Belgium.

What is still more striking is the fact that their movement began by supporting women's equality. Leaders, moreover, encouraged women to join. Soon, Verviers's AIT housed an active, vocal women's organization, which articulated a complicated form of 'proto-feminism', grounded in maternity and domesticity, but at the same time demanding the most complete social and political equality between the sexes.

The background out of which the Verviers workers' movement developed included two essential features. First, the workers' predilection for broad, anti-authoritarian ideologies of every kind ensured that they were from the first a 'broad church'.[8] It was the anarchists—rather than the more

[8] To reiterate what was noted in Ch. 3, it was the case that Verviers's people hated authority. Most historians offer three explanations: first, there were no guilds in the Liège region, and so artisans worked independently. Second, the Liège Bishopric had been independent until the French annexed it following the French Revolution, and even late in the 19th century, inhabitants described themselves not as Belgians but rather as Verviétois, Liègeois, and so on. Third, Verviers was basically a small town of people who worked in wool—as their parents, grandparents, and great-grandparents had done before them. Factory work did not destroy solidarity; if anything, it strengthened it, as the Frenchman Léon de Seilhac remarked in 1911: see *Le Lock-out de Verviers* (Paris, 1911). It should be noted here that in Verviers, the term 'anarchism' was used to indicate those often-contradictory aspects of a 'movement' that by its nature was difficult to define coherently. James Joll's definition generally suits the First International activists of Verviers. He describes 19th-century anarchists as at the same time anti-authoritarian, anti-centralized, and utopian. Like Joll's subjects, these Verviétois were 'heirs of all utopian, millenarian religious movements which have . . . confidently expected that "the trumpet shall sound and we shall be changed . . . in the twinkling of an eye". On the other hand, they are also the children of the Age of Reason . . . They are the people who carry their belief in reason and progress and peaceful persuasion through to its logical limits.' See Joll, J., *The Anarchists* (New York, 1964), 13. Temma Kaplan has discussed women's preference for anarchism (loosely defined) in Spain, in 'Woman and Spanish Anarchism', in Koonz, C., and Bridenthal, R., *Becoming Visible: Women in European History* (Boston, Mass.: 1977), 400–21.

doctrinally prescriptive collectivists—in the First International who at-
tracted the working people of Belgium's wool capital. Secondly, the
diversity of the local movement encouraged the city's highly independent
textile *ouvrières* to create their own space inside the movement where they
articulated their women's programme. Moreover, in the Verviers section of
the AIT women found a significant number of male militants and leaders
who supported their efforts.

This chapter concerns this First International women's movement in the
period from the first years of organization, in 1868 and 1869, to the death
of the last local AIT section in 1880.[9] It has two primary goals: to rectify
the historical error that excludes working women from 'feminist' efforts in
these years; and to suggest that assumptions about the goals of working-
class proponents of women's rights in the nineteenth century have been
too narrow.[10]

The Workforce

First, a thumb-nail sketch of the city's textile workforce in the period
from the late 1860s to 1880 recalls the background against which our
story unfolds. In this heart of Belgian wool production, the red-brick
mills of our earlier period had been joined by many more. Inside the
city limits new factories continued to appear along the banks of the
Vesdre River. But the industry had grown: dozens of wool-mills dotted
the landscape around Verviers, and many villages were drawn into the
city's economic sphere. By the late 1860s, a total of 560 mills employed
nearly 8,000 women and girls. The proportion of female to male in the
wool factories remains unclear: one source counted 40 adult men, 20
adult women, and 40 children of both sexes in every 100 textile-workers.
Another source from the same year claimed that women and girls out-
numbered male wool-workers. However, as we have seen in Chapter 3,
female workers of all ages remained essential to wool production. In or

[9] The AIT itself was long since moribund if not defunct, dealt a mortal blow by the failure
of the Paris Commune. But Verviers's movement survived through the 1870s, and some would
argue that Verviers's workers' reluctant participation in the Second International showed their
continued loyalty to the ideas and practices of the AIT.

[10] 'Feminism' is anachronistic: it was not used to describe advocates of women's rights
until later—and then primarily in France. So I have generally avoided this convenience, using
other terms except when the usage is clear. As for definitions of what was or was not
'feminist', I have suggested my own in *Working Women and Socialist Politics in France: 1880–
1914* (Oxford, 1986). During the writing of that book, I would have considered the goals of
the Verviers women to have been discouragingly reactionary. I am obliged to Dr Polly
O'Hanlon for her suggestion as to how to think differently about such women's goals.

out of the mills, they worked in virtually every stage of the production process.[11]

One certainty was that a high proportion of textile-mill workers were married women. The giant Simonis factory in Verviers, for example, reported that one-third of its workforce were married women. Many, moreover, were the sole supporters of their families.[12] For them, life was particularly difficult, since they consistently earned lower wages than men: in wool-combing and machine-spinning, for example, women averaged between one-half and two-thirds of men's wages.[13]

Ouvrières, then, had every economic motive to join or to organize a movement for change, and from the first, Verviers's workers' movement included active women members. It was a movement grounded in a policy of 'non-exclusivity', so that all working people were welcomed and all ideas accepted. The founding charter of the city's first 'proto-union', founded in 1856, defined a prospective member as 'any worker, without regard to occupation, sex, or status'.[14] Such a non-restrictive policy quickly attracted women.

The Beginnings

Little is known about the first 'proto-union' beyond the fact of its unusual inclusionary policy, nor is information available for its first decade of existence. But when the first Verviers group to join the Association Internationale des Travailleurs was founded in 1867, it certainly did not emerge from a vacuum. Its proximate stimulus was a manifesto, written by a weaver from nearby Dison, Frédéric-Joseph Thiry. Thiry's widely circulated brochure, *L'Avenir des Travailleurs*, was soon followed by the founding of the Francs-Ouvriers in Verviers. This group immediately started a

[11] These, and other figures, are found in *Enquête—1886*, 14, 52, 53, 54. See also Vercruysse, F., *Le Lock-out général de l'industrie textile à Verviers (sept.–nov. 1906): Extrait de la Revue du Travail du 31 janvier 1907* (Brussels, 1907), unpaginated. The latter includes a study of ancient traditions in the local industry which is illustrated. The text divided the work by gender: men were 'washers', 'weavers', 'pressers', and 'fullers', and women were 'warpers' and 'shearers'. Men and women worked together in beating, spinning, and carding.

[12] It should be noted that 'families' in Verviers—and elsewhere in 19th-century Belgium— meant both young children supported by wage-earning parents and old parents supported by wage-earning children. Many of the single women described as 'the sole support of their families' were daughters caring for elderly parents.

[13] *Enquête de la femme*, 55.

[14] Messiaen, J.-J. and Musick, A., *Verviers: Mémoire ouvrière, xi, Histoire des fédérations* (Brussels, 1985), 9. This volume, like all the others in the series, fails to investigate the consequences of such a non-exclusionary policy, and women's role in these early years remains unexamined.

newspaper, *Mirabeau*, that quickly became the official paper of the AIT in Belgium after the Francs-Ouvriers joined the AIT in 1868.

From the outset, the issue of women's equality shaped the local movement's practices as well as its debates. One local leader decried the divisiveness of this issue, which complicated organizational efforts amongst the contentious working people of Verviers:

> They love dispute and hate conformity [and] that isn't all! The ingenious and analytical mind of the Verviétois has ascertained that there are two sexes amongst the workers, and thus it is possible to subdivide, to cut up the already minuscule bodies even more.[15]

And split they did: by the opening months of the 1870s, the AIT's 6,000–7,000 local members (estimates vary) were divided into hundreds of groups. (These were mixed-sex groups, with identical requirements for men and women members.) Through the months before the first all-women AIT group was organized in Verviers in 1871, the debate over women's equality raged, both in meetings and in the pages of the widely read *Mirabeau*. (In the summer of 1868, the paper already had a print-run of 4,000 per issue.)[16]

It was a complicated, heated argument, replete with stereotypes on every side. At the same time, it included some of the most original ideas heard anywhere in Europe in these years—many of which were only rediscovered in the more recent feminist movement of the 1970s. Its persistently contradictory positions make it difficult to analyse. Nevertheless, it was within this vexed debate that Verviers's women's movement developed its central demands. Thus a narrative of the public discussion, however unavoidably complex, is essential for understanding the slightly more coherent developments of later years.

The Debate: 1869–71

In the early years, the movement was dominated by men: men directed sections and men edited *Mirabeau*. Thus it was they who first began to

[15] Varlez, L., *Quelques pages d'histoire syndicale belge: Mémoires et documents* (Paris, 1902), 135.

[16] See discussions in no. 28, 'E. Hins à "X", Bruxelles, 2 juillet 1868' in Devreese, D. E. (ed.), *Documents rélatifs aux militants belges de l'AIT: correspondance, 1865–1872* (Leuven/Brussels, 1986), 61. See also Messiaen and Musick, *Verviers: mémoire ouvrière*, xi, 9, and no. 340, 'De Bevelhebber van de rijkswacht van Verviers aan de procureur-generaal te Luik, 3 mei 1869' in Wouters, H., *Documenten betreffende geschiedenis der arbeidersbeweging ten tijde van de 1ᵉ Internationale (1866–1880)*, i (Leuven, 1970), 308.

theorize about women's rights. At first, their opinions fell into relatively clear 'pro' and 'anti' positions, as proponents of women's equality faced off against fairly clearly identified opponents. Nevertheless, as will shortly become clear, both sides borrowed ideas and prejudices claimed by the other to support their purportedly antithetical positions. Thus the potential leaders of the women's movement of 1871 heard a very complicated message from both sides. As they began to work out their own positions on issues, the women did so against a background of contradiction.

The 'antis' tended to ground their opposition to women's participation in public life in a stereotype common all over Catholic Europe: that women bore an innate predilection for spiritual matters, for religious belief; thus they were particularly vulnerable to manipulation by priests. Writing in *Mirabeau* in April 1868, a local AIT member explained: 'Catholic priests have understood very well that they can pick out and manage the moral influence of woman, and today it is upon her that their execrable domination rests'.[17] In a world in which radical progress was measured by the degree of rejection of the church, this belief assured for women the suspicion of many male militants.

This writer's views were representative: men (and some women) repeatedly voiced the opinion that women should be excluded from political rights because they (or, in this rhetoric, 'she') were the passive victims of priests.[18] Amongst the more moderate of these opponents were those who promised a happier future, after a proper (i.e. secular) education had rescued 'woman' from clerical blandishments. But a few die-hards insisted that female religiosity was pre-determined by nature: only the strictest control—by men—could prevent its pernicious influence from slowing, or even blocking, revolutionary change.

One corollary of this view was that woman's proper place was inside a household where she was both controlled and protected by the male family head. Ironically, the secular Proudhonists who propounded this view spoke in terms identical with those of the most reactionary Catholics. In words that might have gladdened the Pope's heart, for example, one Proudhonist wrote, 'Amongst your duties . . . mothers, the most urgent is to resume your place in your *foyer*, near your children, where you are irreplaceable'.[19]

Other opponents of women's participation in the political world (presag-

[17] See *Mirabeau*, Apr. 1868.
[18] See e.g. 'La Cooperation', *Mirabeau*, 5 Apr., 2 Aug., 1 Nov. 1869.
[19] Maiet, H., 'L'Union fait force', *Mirabeau*, 1 Jan. 1868.

ing Antonio Gramsci's analysis of power and working-class sexuality[20])
predicted that women's factory work meant a loss of male control over
women's sexuality. 'Profit-takers seduce *your* wives, *your* daughters' warned
one writer (emphasis added). Women did not resist easily: 'Grandeur of
soul' and 'great strength of heart' were all that protected a young *ouvrière*
'if she wants to become a woman, an honest wife, a respectable mother'.
Woman's propriety, he implied, was male property, almost as readily
alienated by capitalists as labour.[21]

These opponents of women's rights faced opposition from key AIT
leaders, and soon after from leaders of a new women's movement as well.
Amongst the supporters of women's equality, however, there was serious
disagreement. Some did not reject the idea of women's innate 'difference',
but instead they turned this concept on its head, claiming that it was
precisely woman's biologically determined difference, and the social role it
prescribed, that gave her grounds for having rights. Those holding this
view agreed that 'woman's place was in the home', but they did not paint a
portrait of an economically dependent, male-owned 'wife', rather, their
model woman earned her independence by working at home in the
domestic out-putting system (which had a long history, after all, in the
region) and exercised her natural talents as educator of her children. With
equality of rights—alongside difference of roles—woman had a place in
the class struggle. 'Women's exclusion from the mills', wrote one male
proponent of these views, 'does not exclude them from the struggle. All
women should be organized'.[22]

On the other hand, many male and female AIT members soon began to
articulate a very different view of women's rights—that already widespread
within the International itself.[23] Although, curiously perhaps, this view was

[20] See Gramsci, A., *Selections from the Prison Notebooks*, ed. Hoare, Q. and Nowell Smith, G.
(New York, 1971), 296–7: 'It is worth drawing attention to the way in which industrialists . . .
have been concerned with the sexual affairs of their employees and with their family
arrangements in general. One should not be misled . . . by the "puritanical" appearance
assumed by this concern. The truth is that the new type of man demanded by the
rationalization of production and work cannot be developed until the sexual instinct has been
suitably regulated and until it, too, has been rationalized'.
[21] Un Francs-ouvrier, 'De l'Émancipation des travailleurs', and anon., 'À Propos du travail
des femmes et des enfants dans les mines', *Mirabeau*, 3 May 1868 and 4 Feb. 1869. See also
an untitled piece in *Mirabeau*, 7 May 1869. These were, of course, the years when hysteria
about women coal-miners' sexuality reached its height; see Ch. 5.
[22] Fédération des cercles d'instruction mutuelle', *Mirabeau*, 20 Feb. 1870.
[23] See Lehning, A., *From Buonarroti to Bakunin: Studies in International Socialism* (Leiden,
1970), 193. See also Moses, C., *French Feminism in the 19th Century* (Albany, NY, 1984), which
describes the history of Jeanne Déroin, who spoke at the International's congress in favour of
women's rights. See also the history of the first women's group to join the AIT, told by

most often expressed by male AIT leaders in Verviers, even after the founding of the women's section, it was held by some rank-and-file *ouvrières*, as we shall see. This side of the debate denied outright all essentialist claims predicated on male and female differences, arguing that it was the very fact of being human that ensured rights for every individual, regardless of sex. Women, excluded from equality in the public world of politics and work and also in the private domestic sphere, had an obligation to struggle for their rights on both fronts, and on their own behalf. It was an *ouvrière* who explained, in a letter to *Mirabeau* in January 1870, that she joined the AIT 'to gain our social rights, especially women's rights, which are more unknown and misunderstood than those of men'. She apologized for her exclusivity: 'I am a woman, and therefore it is my duty to consecrate my efforts to my own sex'. She had a right to join the struggle, she added, because she worked long hours, 'from 5 a.m. to 10 p.m.'. She demanded two immediate reforms: a *caisse de résistance* (strike fund), and an AIT women's section. In such a woman-only group, she wrote, 'we shall abandon all of that timidity in which our weakness has plunged us, and, following the example of the Geneva women, we shall join the Association Internationale des Travailleurs'. Shortly thereafter, a woman from Hodimont wrote that she, too, had joined the AIT, and based her right to membership on the fact that she 'earned the bread of her two children'.[24] (These women, and the others who joined the AIT in these months, did not shun wives. Instead, additional letters from *ouvrières* called upon 'sister workers and proletarians' wives', or, simply, *'ouvrières et femmes'*.[25]

By the early spring of 1870, women were active everywhere in the local AIT—pressing for equal rights, forming women's propaganda committees within their sections, and so on.[26] The issue of women's role in the movement, as well as in the industrial world, continued to engage theorists. In April *Mirabeau* launched the first of a series of essays addressed to the woman question, the first an anonymous two-part piece titled 'The Emancipation of Wom*en*'.[27] In keeping with Verviers's working people's traditional willingness to balance many points of view at once, this piece juggled

Auzias, C. and Houet, A., in La Grève des ovalistes, Lyon, *juin–juillet 1869* (Paris, 1982), and Maritch, S., *Histoire du mouvement social sous le Second Empire à Lyon* (Paris, 1930).

[24] 'Correspondance', *Mirabeau*, 2 Jan. 1870, and ibid., 20 Feb. 1870. Invitations to women to join groups are in this issue and in 6 Feb. 1870.

[25] Ibid. 6, 13, 30 Mar. 1870.

[26] Noted ibid. 13, 30 Mar. 1870.

[27] Ibid. 3 Apr. 1870. Note the use of the plural: 'antis' almost always referred only to 'woman'—and usually as objects in sentences written in the passive voice. Linguistic agency tended to belong to plural subjects.

several arguments. Nevertheless, many of the author's central ideas were strikingly original. He (or, much less likely, she) began by outlining *ouvrières'* 'bleak lives'—constricted by work and by 'domestic slavery'. Two parties bore responsibility for women's conditions: men and women. But asking men to change things was useless, since they derived too many benefits from the *status quo*. 'The emancipation of women', he argued, paraphrasing the slogan of the International, 'must be the work of women themselves'.[28] More surprising was his strategy: women's first step towards liberation was to refuse their slavery, even if that slavery 'profited' them. By allowing their oppression to continue—and especially by accepting its benefits—women were 'forging their own chains'. And worse, by living their economic and domestic slavery, they were teaching their daughters a pernicious lesson. 'Women must instead break their chains and create their own freedom', the author concluded.[29]

The second half of the essay, which appeared two weeks later, held more surprises. As a first step towards winning their own emancipation, women should organize groups where they could describe their oppression and, from such detailed evidence, develop an analysis of their special conditions. This analysis would then form the basis for a political strategy aimed at bringing women into 'public life'.[30] This was consciousness-raising *avant la lettre*; like the author's other concepts, it prefigured a women's movement born in Western Europe and the United States a century later.

However radical on some issues, this writer did not take the next logical step into an analysis of women's domestic oppression, which linked her biological role with all unwaged household work. Instead, he argued that such domestic labour was 'essentially the special work of wom*an*' (his lapse into the singular form was not accidental), who could 'never desert the *foyer*'. The liberation of this 'woman'—so that she could become 'man's true companion'—depended upon her retreat from the factories. 'Woman', he concluded, 'must cease working all day at one job and all night at the other'.[31] It was not clear, here, whether a domesticated *ouvrière* would continue her wage-earning at home, a principle insisted upon by even the most essentialist women leaders. It may have been that this author—for all his other progressive ideas—shared many men's preference for a wife 'kept' by male wages.

[28] Fédération des cercles d'instruction mutuelle', *Mirabeau*, 3 Apr. 1870. The AIT slogan went, 'Workers' emancipation must be the work of the workers themselves'.

[29] Ibid.; this author was adding yet another highly original idea to the debate—that the only way to live under oppression was to live in resistance or 'as if' one were free.

[30] *Mirabeau*, 17 Apr. 1870.

[31] Ibid.

Published in the next issue of *Mirabeau*, another anonymous writer offered the views of an unequivocal opponent of women's emancipation. In 'To What is Women's Role Reduced in Present Society', a writer condemned all working women. Using the singular throughout, he argued, 'Woman is merely an instrument of production, competing with men and with other women'. She lives 'a life of hunger and fear, driven by the foremen's brutality ... An *ouvrière*', he declared, 'is not a woman'. But a simple move home offered no relief: women working for wages in the domestic out-putting system, he insisted, 'fail in their maternal duties'.[32] The message was clear: only economic dependence ensured the genuine female article.

The paper's editors were not happy with such thoroughly Proudhonist views. Alongside the article, they reiterated *Mirabeau*'s non-exclusionary policy, which guaranteed space to any views without censorship 'if the writer is a worker'.[33] In addition to this mild disclaimer, the editors chose to serialize a work they titled 'L'Homme Perfide', by the realist writer and painter Émile Leclerq, which was an unambiguous argument in favour of women's full emancipation.[34] Leclerq opened the tale with an outline of man's treatment of womankind: 'Man uses every means to paralyse, humiliate, and conquer her', he wrote. 'He is a beast ... at the peak of civilization, in Paris, he makes her a courtesan; in the intermediary stages, she is only a housewife, Proudhon's idea'. He criticized the widely-quoted French romantic historian, Jules Michelet: 'He makes her a doll, with a body so ethereal that she cannot work, cannot walk, cannot carry a child. ... She can only smile: *courtesane ou comédienne*'.[35] In real life, Leclerq remarked, 'woman is neither a goddess nor a courtesan; she is by nature our companion and our equal. Respect her, she will be worthy, love her, she will be sweet, educate her, she will be strong'. He concluded: 'Woman is in no way man's inferior ... she must be granted justice'.[36]

In the next *Mirabeau*, Leclerq took up the question of women's work, defending her right to equality on the grounds of her contribution to industry. 'In our factories, in our coal mines, in our fields a woman [is] equal to man in strength and courage'. Only a 'despot' would argue otherwise, but 'he is unlikely to relinquish his prejudices: as he lies about

[32] Ibid. 24 Apr. 1870.
[33] Ibid.
[34] It was an unusual choice, though amongst widely serialized works, read (and read aloud) by Belgian workers after 1876, was another concerned with women's rights, Nicolai Chernychevsky's *Que Faire?*, first published in Russian in 1869, and in French in 1876.
[35] Leclerq's work was called 'Infer des Femmes'. It began in *Mirabeau* on 24 Apr. 1870.
[36] Ibid.

"the people", so he lies about women'.[37] Only work ensured women's equality,[38] and hence the bourgeois ideal, the non-working woman, could never attain rights. Leclerq argued that 'her muscles atrophy, and they become fat. White, pink, delicate, these true dolls are a true horror'. His ideal, on the other hand, were the women of Belgium's *pays noir*. In the coal-fields, 'woman is nearly unrecognizable: her contours have become angular and she has acquired a physical strength equal to man's; her physiognomy has been transformed; she has become hard and masculine. She proves that she can work hard, from sunrise to sunset . . . conclusive proof of her equality'.[39]

In place of Proudhon's 'courtesane ou ménagère', Leclerq offered a new dichotomy: at one extreme, a 'disinherited', without education, working in 'deforming and brutalizing jobs'; at the other, a 'privileged hothouse plant or luxury article'. Neither was desirable, and instead, the writer argued for androgyny: 'It is by a fusion of the forces of man and woman that one will be able to compose the most perfect synthesis of humanity'.[40]

Surprisingly, no immediate reactions to Leclerq's ideas appeared in *Mirabeau*, though in the closing months of 1870 the paper published a handful of attacks on women. The most strident suggested that local support for women's rights was far from unanimous. Signed by 'Miron', the article claimed that women were hopeless 'religious fanatics'; men, who were 'naturally sceptical' inevitably quarrelled with their 'organically religious wives', who were 'less intelligent, unable to reason'. A wife 'loves mysticism and requires domination', Miron cried. 'She is man's appendage'. To demonstrate the validity of this claim, this non-religious writer pointed to Biblical evidence: Adam's rib.[41]

[37] Ibid. 8 May 1870.

[38] Tying women's emancipation in a capitalist society to direct participation in production relations was discussed many years later by James, C. L. R., in *Modern Politics* (Detroit, 1973), 117ff. See also Amartya Sen's research which shows that women who earn their own existence in waged work stand a far better chance of living a 'normal' life-span. His research is summarized in 'More than One Million Women are Missing', *New York Review of Books* (20 Dec. 1990), 21–39.

[39] The similarities between Leclerq's positions and those held by several participants in the debate over women miners emphasizes the narrowness of Belgium's intellectual community. There were so few of them that they tended to read and echo each other's work. Several people condemned 'idle' middle-class women, and many located them in the United States.

[40] *Mirabeau*, 8 May 1870. His ideas, of course, had their roots in Fourier.

[41] 'Les Femmes et le Catholicisme', ibid. 21 Aug., and 4 Sept. 1870.

Mina Pucinelli: 1871

By the middle of 1871, then, women members of Verviers's AIT sections (whose total number is, unfortunately, unknown)[42] encountered both support and hostility, both approval and disapproval, and all couched in a variety of arguments. Every message, moreover, was full of contradictions. Leclerq demanded work and physical strength as prerequisites for emancipation, but addressed his message to the males who would 'give women justice'. Others proposed wage-earning within the domestic sphere as a grounds for women's equality. Still others implied that motherhood, not wages, earned women rights.

Despite such confusion women continued to join the variety of mixed-sex groups and activities which flourished in Verviers and most of its surrounding towns and villages. No consideration was given to founding a women's section until Mina Pucinelli arrived on the scene. Although a causal relationship cannot be clearly established, the visit of the charismatic ex-Communarde to Verviers and Liège was probably the stimulus for the first women's sections in the area. (They were not the first in Belgium: a women's section in the mining town of Montigny-sur-Sambre had sent delegates to the national AIT congress in 1870.)[43]

Like other ex-Communardes (Louise Michel and Paule Minck, for example), Pucinelli was a striking personality. She stirred every audience with her revolutionary rhetoric—and terrified officials.[44] From the moment she set foot on Belgian soil, her movements were tracked by the police. Her first stop was Brussels, where police agents described her as 'a journalist and author, an ex-member of Garibaldi's army'. Police in the capital sent warnings of her revolutionary purpose all over the country, and when she arrived in Verviers in October of 1871, local authorities immediately began their surveillance. One police agent described 'the ex-*capitaine* of the "Avengers of Death" under Garibaldi'. 'Her army', he reported, 'included 500 Spaniards whom she recruited and paid to follow her to Italy'. From

[42] Sources disagree about membership figures, and none counts women separately. The highest figure comes from Degée, J.-L., *Le Mouvement d'éducation ouvrière: Évolution de l'action éducative et culturelle du mouvement ouvrier socialiste en Belgique (dès origines à 1940)* (Brussels, 1986), 23, who claims 7,000 members; a lower figure is in Messiaen and Musick, Verviers: *Mémoire ouvrière*, xi, 10, which cites 6,000.

[43] See 'AIT. 5me congrès belge', *Mirabeau*, 19 June 1870.

[44] It is interesting to note that the national police archives contain no record of her; nor could I discover any more information about her in French sources or in works on the Commune.

Italy, she had journeyed to Paris to join the Commune. In exile, following its collapse, Pucinelli found her way to Verviers.

Invited to speak by Verviers's Francs-Ouvriers, Pucinelli was introduced by a local militant as 'one of those called *pétroleuses*, a *communeuse* ... courageous, always leading troops, carrying a red flag'. It was an old stereotype of Marianne, of course, made famous by Délacroix decades before. But Pucinelli embraced this flattery: 'I am proud to be the first woman who has had the honour and the courage to carry the red flag', she declared modestly.[45]

There is no record of the audience's response to her first speech. But one police spy was impressed: 'That woman is dangerous', he declared. 'I am inclined to believe that if she were to hold a few meetings, she would attract and bring along with her all the *ouvrières* of our little city because she speaks with enough eloquence to soften those unfortunates' hearts'.[46] He was soon proved right: throughout October Mina Pucinelli's meetings drew crowds of women, and men. Police officials continued to report their fear: 'It is my opinion that this woman has the disposition of a *pétroleuse* of the first water', wrote a police commissioner. His counterpart in Liège added, 'she appears to be an "exaltée", escaped from the workshops of the Paris Commune. ... She spoke as adventurers of that kind always speak, and promised her co-operation to workers affiliated to the International'.[47] The presence of so many women at her meetings aroused particular concern from the guardians of public order. The Verviers police commissioner warned, 'The widow of Leonard Pucinelli (*sic*) ... Mina Muller ... gave a Sunday talk ... Many women came to that meeting ... her sojourn here could become dangerous'.[48]

Pucinelli soon began to focus her attention on women in her audiences. At one Dison meeting, when she encountered a male heckler, Pucinelli shifted from her subject to the subject of women's participation in the movement, telling them that they 'must marry socialist ideas' (rather than men?) 'because on you alone depends the triumph of those ideas'.[49] Back in

[45] See Messiaen and Musick, *Verviers: Mémoire ouvrière*, xi, 9, and no. 533, 'Uittreksel uit een particulier verslag, 25 Sept. 1871, Cureghem', in Wouters, *Documenten ... van de 1e Internationale*, i, 421. Delacroix's painting is discussed by Marina Warner, in *Monuments and Maidens; the allegory of the female form* (London, 1985), 271ff.

[46] No. 541, 'Een politiesagent aan de commissaris te Verviers, 27 okt. 1871', in Wouters, *Documenten ... van de 1e Internationale*, i, 427.

[47] No. 542, 'De Politie commissaris van Verviers aan de administrateur van openbare veiligheid, 27 okt. 1871', ibid. 428, 429.

[48] Ibid., no. 545. See also nos. 546, 548, 549, 550, and 551, pp. 429–35, which report these meetings.

[49] Ibid., no. 550.

Verviers, a few days later, she addressed another audience, in 'an immense hall, overflowing with people, including many women'. There, Pucinelli announced that a women's meeting would be held in Verviers the following day. It, too, 'attracted great numbers of women', to whom she 'preached devotion to the International'.[50] Through November, the ex-Communarde continued speaking, and the police continued watching. Although not all her speeches concerned women or revolution, most, according to one official, concluded 'with a peroration to women to join the workers' movement', because 'without them, the goal was not possible'. Usually, he added, 'she was warmly applauded'.[51]

Pucinelli's visit produced two immediate results. On the one hand, local groups with no women members undertook to recruit them. The organized *ourdisseurs* (warpers), for example, invited *ourdisseuses* to join their section, in brochures distributed in their workrooms. They also held a series of organizational meetings for potential women members. Other previously male groups began similar efforts. The second result was the founding of Verviers's first women-only AIT section.[52]

THE WOMEN'S SECTION IN VERVIERS

At their first meeting—chaired by Marie-Barbe Heuchenne—the women's group established the principles that would continue to shape their efforts until the death of the local AIT in 1880. These convictions flew directly in the face of those previously established by the AIT itself. In place of demanding women's economic independence from men (as well as equal access to work and equal pay) the Verviers women's group claimed an equality grounded in women's biological difference. Motherhood, they agreed, provided the basis for women's claims to equal political rights. These rights included the right to attend meetings of the International which would require husbands to take over 'household tasks'.[53]

[50] Ibid.
[51] Ibid.
[52] See Oukhow, C., *Documents rélatifs à l'histoire de la Première Internationale en Wallonie* (Leuven, 1967), 138. It should be noted that Oukhow is one of the few Belgian historians to argue that the AIT in Belgium was not dominated by the ideas of Proudhon but rather by those of Bakunin. My research suggests that she is correct. See also 'Annonces', *Mirabeau*, 24 Dec. 1871, 7 Jan. 1872, in the latter both the 'ourdisseurs-ourdisseuses' and the 'caisse de résistance des ouvriers et ouvrières des filatures disonaise' report meetings. These issues of the paper also contain reports of mixed-sex strikes.
[53] In *Mirabeau*, 11 Feb. 1872. Another meeting to discuss 'women's emancipation' was announced on 18 Feb. From then on, such notices appeared regularly. There had been many

Because these Verviers women were proposing a political line that contradicted that of the organized women's sections in the International, it is important to describe the arguments shared by those sections—and by the International itself. Led by the Swiss Section des Travailleuses (the use of 'worker' was significant), women in the International (together with their male supporters) had long rejected Proudhon's 'women to the *foyer*' prescription. But they had gone further, articulating a position of their own. This position was summarized in one Swiss militant's impassioned speech to the International, reported in *Mirabeau* in March, 1872.[54] 'The demand to end women's work is madness', she declared. 'In the first place, women are essential to industry'—the economic system favoured by Internationalists. But more importantly, 'women share with men the primary right to work, the first duty of every human being'. 'Work gives independence', she added, 'and safeguards dignity'. 'Yes,' she continued, 'women are vulnerable to exploitation, to long hours and low wages which undercut male workers' interests'. But the solution was not more exploitation. Rather, women must organize and demand equality. 'The women workers of Geneva are the first to understand this truth; they have founded the first section of workers in the AIT', and demanded 'equal pay' for equal—and equivalent—work. 'Alone', she concluded, 'we can do nothing. Together we can create whatever we will'.[55]

Doubtless there were those in Verviers—male and female alike—who agreed with this view. Although there are no records to document the private beliefs of the women members of the Verviers AIT who did not join the women's section (and there were hundreds who did not) it was clear from their enthusiastic participation in the various mixed-sex activities of the organization that local women held a variety of opinions not articulated in the women's groups. Within mixed-sex unions, for example, as well as in myriad other groups—evening classes, propaganda and study groups, free thinkers' groups, and dozens of social clubs—women were free to participate in AIT politics without joining a single-sex organization.

One documented public statement of local individuals' commitment to the International in these years was the choice to be buried with a non-religious, AIT-led service. Here, many women demonstrated a loyalty to the movement as a whole, not only to the women's movement within it. A

founded, in *Mirabeau*, 30 July 1871. But there is no evidence linking it to the 1872 women's section (which was, of course, not organized around a particular occupation).

[54] *Mirabeau*, 17 Mar. 1872.

[55] Ibid.

review of civil burials reported in *Mirabeau* from 1872 to 1880 showed that roughly as many females as males made this choice, and reports of their funerals show that only some of the women were described as members of a women's section.[56]

There was one other symbol of the inclusiveness of the AIT. Centres which housed the movement's various activities were known as 'Maisons du Peuple'—in contrast to the exclusively masculine names given to similar institutions in France ('Cercles des Travailleurs') or Britain ('Working Men's Clubs'). All Belgian AIT headquarters (and later socialist party centres) included all the people in their name, not just the patriarchs.

Given the informality of membership qualifications, it seems likely that dozens of working women joined both mixed-sex groups and one of the many local women's sections which soon followed the Verviers pioneers into existence. The Vesdre Valley Federation was a very broad umbrella, and members were free to belong to the AIT in many capacities. Given the rapid proliferation of women's sections in the region, however, it is clear that they filled a need not met elsewhere.

At the same time, the rapid 'cloning' of the Verviers's women's section was also due to the commitment and tirelessness of two women: Hubertine Ruwette and Marie Mineur. Both were textile-workers, and both held firm essentialist convictions, but there the similarities ended. Mineur was single and lived alone with her mother, whom she supported; Ruwette was married to a local male leader and had children.[57] Documents indicate that the two worked together in the early days of the women's section. In April 1873 they travelled together to the national AIT congress, as delegates from the Verviers's women's section. Soon after that congress, however, Ruwette disappeared from the historical record.[58]

Marie Mineur, on the other hand, continued to play a key role in both local and national working-class politics for several years. One of the first descriptions of her, written by a Liège militant 'Epille Pillius' just after the founding of the women's section, asserted that 'She has the stuff of a

[56] See *Mirabeau*, Mar.–Oct. 1873. Burials were detailed in a regular feature called 'Nécrologie'. Of course the pages of *Mirabeau* are hardly a good source for an accurate count or detailed reports of such events. Nevertheless, given the constant claim that women were religious fanatics, the number of women's secular funerals is striking. On the other hand, there were several reports of local women's vicious attacks on 'free-thinking' mourners which suggested that women could be as violently 'counter-revolutionary' as they were radical.

[57] See *Mirabeau*, 17 Mar. 1872. Many AIT meetings in that year were held 'Chez Ruwette'.

[58] See ibid., 23 Mar., 24 Aug., 7 and 21 Sept., and 19 Oct. 1873.

femme-pétroleuse.[59] Mineur's reputation as a fire-brand soon spread, as she travelled through the region organizing dozens of women's sections. The content of Mineur's many public speeches in Maisons du Peuple all over the Verviers *arrondissement* can be summarized in a single phrase: 'L'homme à l'atelier, la femme au ménage'.[60] It was a deeply-held conviction: from the moment of the founding of the first women's section in 1871 to the demise of the local women's movement in 1880, Mineur continued to defend this position.

Moreover, she found willing recruits to her campaign to return women home from the mills. Throughout 1872 and into the next year, numbers of local women's sections grew—in Ensival, in Dison, in Huy, and in nearby Liège. As far as can be ascertained—evidence is extremely sparse and impressionistic—it seems clear that the Verviers section's political line was shared in these other women's groups. For a significant number of working women, then, a future workers' paradise included women working at home rather than in wool factories.

Nevertheless, as a deep industrial depression struck the textile industry in 1873, the women's dream retreated into a very hazy distance. Soon, all discussions of workers' utopias fell silent in the face of the much more serious struggle to survive. Unemployment and declining wages struck every household. And then, although AIT leaders counselled against it, the textile-workers went on strike. For a few weeks that autumn, strikers and their families were protected by the strike funds collected over the years by AIT members. But with no alternative sources of income (Verviers and its environs were dominated by the production of woollens), the end of the funds meant the end of the strike. After a few months, the strike collapsed in ignominy.[61]

Local AIT leaders were horrified. They denounced the strike, and all

[59] *Mirabeau*, 24 Mar. 1872. At women's burials, militants from women's sections from outlying towns and villages as well as from Verviers spoke. These reports comprise some of the most detailed evidence of women's participation in local movements. A research assistant, Enrique Garcia, who toiled through two workers' newspapers, found himself constantly frustrated by the difficulty of finding any information about women. He annotated his research notes with the following: 'THEY ONLY NOTICE THEM WHEN THEY'RE DEAD!!!' (*sic*). It might be remarked in this context that the only Belgian woman included in James Guillaume's exhaustive, 2-vol. *L'Internationale: documents et souvenirs, 1872–78* (Paris, 1985), is Jeanne Brismée, whose claim to notice was her premature death, which occurred during the imprisonment of her AIT militant husband, Desiré Brismée, who was not allowed to leave prison for her funeral. Reports of her death and the Belgian government's heartlessness filled the pages of the worker press.

[60] Stated repeatedly in the meetings reported in *Mirabeau* 23 Mar. and through both August and September of 1873.

[61] In Messiaen and Musick, *Verviers: Mémoire ouvrière*, ix, 11.

strikes as a means of struggle. They offered instead a new programme promising what one historian has called 'the total, radical emancipation of the workers'.[62] What did this mean? As one local weavers' group put it, 'the destruction of society'.[63] The Vesdre Valley AIT got a boost when the national AIT council decided in December of 1873 to move its headquarters from Brussels, where the movement was languishing, to a much more active Verviers. *Mirabeau* immediately became the official organ of Belgium's International, and the paper quickly lost its highly localized character.

This new role as movement headquarters did not signal any loss of local commitment to women's emancipation, however. Instead, local militants pointed with pride to women's significant role in the strike and in the meetings, marches, and demonstrations which had greeted the economic crisis earlier in the year. Many male leaders, in fact, began to describe women as the key in determining the success or failure of revolutionary struggle. One writer argued that the women of Ensival were 'the famous weight in the scale of revolution'. Shortly thereafter, a local woman echoed this phrase in a speech to a crowd of textile-workers: 'Woman', she told them, 'counts for everything in the revolutionary scales'.[64]

As the economic situation improved in 1874, the AIT resumed its efforts to recruit new members, to organize new groups, and, indeed, to sub-divide old ones. In the process, many more women's groups appeared and joined the federation. The substantial presence of women in the local movement soon provoked a backlash. For the first time, direct attacks on women—especially wage-earning women—began to appear in *Mirabeau*. Alfred Duffon, for example, proclaimed that women who took part in politics first 'scorned men', then 'abandoned cradles', and lastly 'competed for men's jobs'. This trajectory had only two terminal points: prostitution or the Church (presumably, Duffon thought them equally bad.) The only chance to halt this journey was for a woman 'to return to her correct place'.[65] Another writer also linked women's religiosity with independence from men. 'Totally different from men', women tended towards a 'religious fanaticism', which drove them 'to read books'. These, in turn, did not render them 'tender and caressing', but rather 'atrophied their brains', thus 'driving men from their homes'.[66]

[62] Ibid. See also De Weerdt, D., *De Belgische socialistische arbeidersbeweging op zoek naar een eigen vorm. 1872–1880* (Antwerp, 1972), 54–5.
[63] Quoted in Thibaut, W., *Les Républicains belges, 1787–1914* (Brussels, 1961), 87.
[64] See 'Mouvement ouvrier', in *Mirabeau*, 7 Dec. 1873, and 15 Feb. 1874.
[65] 'Aux femmes', ibid. 3 May 1874.
[66] 'L'Instruction et l'émancipation de la femme', ibid. 28 June 1874.

In reaction to such attacks, local women deployed their own version of the 'difference' argument. Marie Mineur, for example, published two long attacks on *crèches* for working women's children on the grounds that they were little more than a bourgeois plot to force working women to abandon their children! 'Not content with exploiting us', she wrote, 'our masters now insult us. To this I say: "You are a hundred times cowards! . . . Take care! Your turn will come; one day, believe it, vengeance will appear in person, and like you, the revolution will be without pity; you will see the woman of the people, the worker's wife, brandishing the avenging axe and punishing the outrage done her honour".[67]

It was certainly an unusual reversal of the more common women's demand for more child-care centres! But at the same time, it was in no way an acceptance of Proudhonist arguments about women's inferiority. Instead, Marie Mineur proposed a revolutionary rejection both of bourgeois efforts to continue exploiting working-class women's labour and of its implied corollary: that *bourgeoises* were different from their proletarian sisters. They were mothers and wives; *ouvrières* were factory labour. And in the context of Verviers, claiming equal status to Verviers's bourgeois *ménagères* was, in fact, tantamount to proposing revolution. In a city where all proletarian women worked for wages, and all the women of the industrial and govenmental élite enjoyed lives exemplary of the bourgeois domestic idyll, class divisions amongst women were even more clearly marked than they were amongst Verviers's men—virtually all of whom earned money in the capitalist world of production, though some, of course, received it as salaries and others as wages.

In November of 1874 the paper published a lengthy example of contemporary male 'feminism'. The essay is interesting for several reasons. First, in this era when Belgian progressives were attempting to describe and to site elements of a national identity, the anonymous author called for Belgians to imitate the New World, rather than cling to the old—represented first by France, and then by the rest of Europe—which stuck fast to antiquated concepts. Second, he linked racist arguments justifying European imperialism with sexist arguments supporting patriarchy. Third, he attacked—again—stereotypes of women's religiosity.

Prejudice against women flourished amongst the French, who, he wrote, 'treat women badly', and then 'claim scientific legitimacy' for their actions on the 'positivist grounds'—that women's brains are smaller than men's, and thus inferior. These arguments 'are just like Europeans' arguments

[67] 'Correspondance. Les Crèches—émancipation de la femme', *L'Ami du Peuple*, 9 Feb., 22 Mar. 1874.

about Negroes', grounded not in science, but rather in bigotry. French misogynists even included some 'self-proclaimed socialists', who based their hostility to women on observations of animals. 'In every species', they claimed, "femmes" are inferior to "mâles" '. Such observations, they claimed, followed the positivist precepts that supposedly underlay the thinking of Belgian internationalists.

But *Mirabeau*'s writer was scornful. He—and others in the Verviers AIT—willingly accepted 'Auguste Comte's ideas about experimental evidence'. But they would not accept 'Michelet or Proudhon'. The former's ideas were 'élucubrations malsaines', while the latter's were 'the crudest inanities'. A real 'positivist' believed that experiment was necessary before any judgements about male and female character could be reached. This writer proposed that ten boys should be 'raised to be charming dolls', whilst ten girls were taught to be 'good tomboys' (*bonnes luronnes*), 'strong of body and mind'. Then socialists could judge. Those who continued to believe Proudhon's unsubstantiated views were merely those who, like Proudhon himself, 'long to enjoy authority over everything'.

But even if women were inferior to men, they still had 'a right to equality and justice', just as 'inferior men' had rights. The author abjured readers to remember that all these kinds of arguments had long been used by the bourgeoisie to deny workers their rights. The article continued, in ringing tones: 'Abandon old European prejudices, look to the New World, where women are educated, independent, invincibly on the road to Liberty'.[68] Lastly, this writer concluded, women were not 'naturally' religious, but only chose the church when they were rejected by AIT men. 'Men must emancipate women in order to emancipate themselves: every human being has a right to justice'.[69]

Clearly, *Mirabeau*'s journalists counted themselves amongst the minority in the national debate unfolding over women coal-miners in these same years.[70] And they may well have constituted a minority voice in the Belgian International as a whole. But their vociferous condemnation of both Michelet and Proudhon showed that, at least in Verviers, neither popular bourgeois intellectual misogyny nor working-class Proudhonism held sway. Until 1876, as we have seen, the movement's loose structure and theoretical flexibility encouraged various contradictory and opposing views to flourish. But this state of affairs did not last. As local leaders increasingly sought a national presence—indeed, as some even began to

[68] 'L'Avenir de la femme', ibid. 25 Oct., 1 Nov. 1874.
[69] Ibid., and 13 June 1875.
[70] More articles in the debate are found in this paper starting on 30 May 1875.

aspire to anti-anarchistic political power—and as the International itself grew weaker, the old tolerance vanished.

Leaders' shifting ambitions, as well as competition from a developing socialist movement, soon led to a split in the AIT between socialists and anarchists. In anti-authoritarian Verviers,s these 1876 divisions led to local efforts to strengthen, and indeed even to articulate what might be seen as more politically pure anarchist commitments. Some local leaders, in fact, proposed that Verviers's movement should imitate the Russian anarchists by becoming both more extreme and more violent. This group's impassioned and aggressive rhetoric frightened the national leadership—who quickly moved their headquarters to Antwerp. Locally, when the extremists failed to convince most of their colleagues to join their move to the left, they formed a new group, Étincelle (Spark). All of the editors of *Mirabeau*—the fiery Gérard Gérombou plus Pierre Bastin and Émile Piette—joined the new organization.

But one issue soon fractured Étincelle's precarious unity: women's role in the movement. For Gérombou, leader of Étincelle (which became, under his leadership what Denise De Weerdt has called 'the brains trust of the Vesdre Valley Federation') woman's place was at home. In a speech to the Verviers women's section (of which his wife, ironically, had become a leader) this radical declared his preference for the Proudhonist line promulgated by the national AIT leader, César De Paepe. 'Woman's real place' was in the home, not outside, 'competing with her husband for *his* wages' (emphasis added).[71]

He pretended that he supported women's equal rights, but suggested that they be postponed due to the 'domination of the Church'. At the same time, he decried men's abandonment of the home: 'Mothers have the worst time; children come to them first to complain of hunger because the father has disappeared to the café-bar'. But, Gérombou insisted, such unjust maternal burdens were not his idea; rather Nature had dictated women's role. Still, 'she is not worth less because of this. The man is mentally and physically superior; [but] she is graceful and affective. Her greatest and best destiny is to make a man'.

Paraphrasing De Paepe, Gérombou concluded, 'male revolutionaries must take woman out of industry and make her a wife and mother.' They must also 'drag her from her ignorance and superstition to make her a

[71] See De Weerdt, *Belgische socialistische arbeidersbeweging*, 54–5, and 'Meeting de la Section des Femmes de Verviers', *Mirabeau*, 9, 16 Apr. 1876. See a discussion of De Paepe's ideas in De Weerdt, *Belgische socialistische arberdersbeweging*, and Abs, R., *Histoire du Parti Socialiste Belge, 1885–1960: Synthèse historique* (Brussels, 1974), 3.

teacher of her children'. At the same time, he added, every woman must join the movement, 'to help her husband, her brothers, her sons'. He ended his speech by tossing a crumb to his female audience: 'Man usually tells woman she must stay at home; instead, from time to time he must send her to a meeting—whilst he cares for the children'.[72]

Happily for the women of Verviers, Gérombou's disdain was not widely shared by Étincelle's militants. In June and July of 1876, Émile Piette, this time choosing the pseudonym 'Prol Ether', published a series of articles in *Mirabeau* supporting women's equality. 'Prol Ether' began by dismissing all the 'authorities' whose ideas were traditionally deployed to deny women's equality, including 'Aristotle, Lafontaine, Montesquieu, Rousseau', and the worst of the lot, Proudhon. The latter's only goal, Prol Ether insisted, 'was to put women into seclusion'.[73]

Why did some men so passionately 'desire to contain and restrict women?' he asked. After all, 'women were not those who had destroyed societies, chosen despots'. Rather, 'mothers of families' had played an important role in the Commune and other revolutionary activities. 'Flora Tristan, Mme Homiot, Pauline Roland, Mme Dora D'Istria' were all women. Moreover, Verviers itself had a women's section 'entirely composed of *ouvrières*'. None of these women, whether 'famous' or 'merely simple workers' could be labelled 'coward', the writer concluded.[74]

This slightly eccentric defence of women suggested the nature of the rift between Étincelle's leaders. And at the same time, the paper began to serialize the 'socialist catechism' written by the French leader Jules Guesde. This *Essai de catéchisme socialiste* detailed Guesde's enthusiastic support for women's emancipation and its publication similarly hinted at the differences of opinion, since it implied that socialism—at least Guesde's version of socialism—had local support despite its direct opposition to anarchist principles. The catechism was, moreover, solidly 'feminist'. Guesde described women's lot:

On entering a family, does not a woman lose her name? Does she not become purchased property? ... She is subordinate, without legal will, without liberty in

[72] *Mirabeau*, 9, 16 Apr. 1876.
[73] *Ibid.*, 4, 11, 18 June, 2, 9, 16 July 1876 for articles by Prol Ether. Guesde's *Catéchisme* began on 30 July 1876. See also my 'Re-writing the History of Socialism: Working Women and the Parti Ouvrier Français' in *European History Quarterly*, 17 (1987) 285–306 for a discussion of Guesde's attitudes toward women. Denise De Weerdt characterizes all Étincelle's members as 'hard-necked anarchists' without distinguishing their different attitudes towards women's liberation. See *Belgische socialistische arbeidersbeweging*, 106.
[74] *Mirabeau*, 16 July 1876. The use of 'mères de famille' was a play on the common Belgian category, 'pères de famille', which denoted a patriarch.

her person or her possessions, indebted for everything—dignity or dishonour, well-being or misery—to her seigneur or master.

Socialists' duty, Guesde believed, was to transform this sorry destiny and to free women.[75]

A few months later *Mirabeau* bolstered the case for a socialist—rather than anarchist—version of women's liberation, publishing Benoit Malon's 'Between Socialists'. In this imaginary dialogue between a Proudhonist and an advocate of women's rights, the French leftist criticized both Proudhon himself and his adherents, arguing instead for 'women's freedom from domination by the family', within 'a just social organization that would ensure that all adults were truly independent, able to live from the fruits of their own work'.

To Proudhonists who claimed 'woman should live off the work of her husband or father because her place is in the home', Malon replied:

Woman is a human being with the same rights to independence, to dignity, to as complete a development as man, and if she wants to live from her work, . . . no one has a right to say, 'no, we want you to serve man, as Manou, Moses, St-Paul, Mahomet, and others have preached'. All women form a kind of proletariat, and should act in solidarity with all workers.

Malon wanted to guarantee women's independence by convincing everyone to live 'in free unions', supported 'by communal kitchens, dining rooms, and so on, such as rich Americans enjoy'. 'Families', he proclaimed, 'are for love, care, study, and art'.[76] This Frenchman's interest in American women was widely-shared by Belgian progressives of the time, as we have seen.[77] In the spring of 1877, M. Molinari voiced a similar opinion in a series of lectures in *Maisons du Peuple* in Verviers and its environs. Describing his recent trip to the United States, Molinari told his audiences that he had discovered that 'women are equal to men; and are working everywhere'.[78]

Not all travellers to Verviers looked to North America for arguments in

[75] Ibid. 30 July 1876. Many of Guesde's ideas were borrowed from his friends Paule Minck (whom he met during their mutual exile after the Commune) and Hubertine Auclert.

[76] Ibid. 13, 20 Aug. 24 Sept., 1 Oct. 1876. Here again the USA is depicted as a women's utopia. Malon's argument that women and the proletariat had their exploitation in common continued to be made throughout the period of the Second International. The Belgian movement was also committed to the arts—both as education and as enjoyment. The best discussion of the socialist party's efforts to draw workers into art is Paul Aron's stimulating *Les Écrivains belges et le socialisme (1880–1913)* (Brussels, 1985).

[77] Many of these ideas about the American women's utopia must surely have come from Alexis de Tocqueville's *Democracy in America*, which circulated widely.

[78] 'Un Aperçu de la conférence de M. Molinari', *Mirabeau*, 18 Feb., 2, 19 Apr. 1877.

the debate over women. Soon after Molinari's visit, a French refugee living in Verviers published a lengthy attack on supporters of women's independence which compared Belgium's working women with Africans. 'Résille"'s series of essays in *Mirabeau* criticized Belgium's willingness to allow 'women and children'—'Belgium's Africans'—to work in the nation's many industries. 'Everyone weeping over the Africans', he noted, 'should observe our own Africans . . . women and children in the mines, and mills . . . Our little Negroes'.[79] Like other opponents of women's independence, Résille addressed his remarks to a male audience, those who 'possessed' the 'little Negroes'. This rhetorical choice was typical of those whom Benoit Malon characterized as 'men who fear equal women'.[80]

The most extreme version of this fear appeared in *Mirabeau* in 1877 in an anonymous article in which the author employed the familiar language of property to decry women's mental and sexual state. 'Woman belongs to the priests', he began. Her sole hope was 'a husband who would wrap her in jealous and exclusive protection', a man who 'wants her whole body and mind'. If this paragon was able to 'prevent any sharing of her, she is saved . . . She becomes a true wife, a true mother'. Alas, however, few women enjoyed this idyll: 'Most women remain poor souls, fearful and superstitious'.[81] Another *Mirabeau* writer was even more hostile. Woman were 'cholera', 'witches', and—worst of all— 'spinsters'. These latter were 'more dangerous than vipers', presumably because of their independence from men.[82] Given Verviers's considerable 'spinster' population, such vitriol could not have aided efforts to recruit women into the local AIT, even as 'wives'! And indeed, the publication of such extreme views signalled the beginning of the end for Verviers's women's rights movement.

In the course of the following year, 1878, the Vesdre Valley Federation declined, riddled with dispute. Gérombou and his followers in Étincelle drove both Émile Piette and Pierre Bastin from the group and from *Mirabeau*. By the early months of 1879, the once-flourishing paper was printing only 2,500 copies, and only 1,500 paying subscribers remained. This collapse was an internal affair. Antwerp's paper *De Werker*, now the official AIT organ, was thriving. Police reported that it sold all its 6,000

[79] 'Résille' was a French professor called Sellier, exiled in Belgium, who wrote several Proudhonist pieces for *Mirabeau*. This one is from 7 Jan. 1877.

[80] 'L'Éducation des femmes', *Mirabeau*, Apr. 1877; Malon's words ibid., 13 Aug. 1876.

[81] 'Éducation', ibid.

[82] Ibid., 29 Apr. 1877.

copies, and even made a profit![83] And like the early *Mirabeau*, *De Werker* was a consistent supporter of women's rights.

During these months of decline, local women's groups vanished, one by one. By the summer of 1877 all the women's sections in neighbouring towns—in Ensival, in Dison, in Hodimont, and Bésonrieux—were gone. Only the Verviers group remained. But it, too, was clearly in its death throes. Notices of meetings pleaded for attendance—which was down sharply. Recruitment propaganda increased, but its tone grew more and more strident as it failed to attract new members. Moreover, the group's leaders decided to throw in their lot with Gérombou's *tendance*. The result was that every women's meeting in Verviers from the end of 1877 onward featured speakers arguing against women's liberation. To cite only one of many examples, one speaker told her Verviers audience, 'Woman's duty is to render her interior agreeable to her husband, to raise her children with good values, to assume the care of men'. According to reports, these words were 'warmly applauded'.[84]

Mirabeau, now without the collaboration of any supporters of women's liberation, increased its attacks on women. The nadir was reached in an article by P. Bragnard, who criticized women's waged work, particularly mining. He described the shock of one Frenchman, J. Reynaud, who claimed to have visited a Belgian mine. Descending into the pit, Reynaud had encountered 'an offensive odour':

It wasn't the emanation of man which spread over such great distance, or that of a horse or mephitic gas or powder; it was something of an odious sickliness, insupportable, heart-turning. Our guide divined our thoughts and indicated a low, inclined gallery. 'It comes', he told us, 'from there, where the women are'.

Reynaud was traumatized: 'I can still see them', he wrote, 'hair disordered and flying around, naked breasts and shoulders, the fetid smell . . . It was a scene from Dante, which will forever haunt me'. From that point, he insisted, he was 'eternally committed to women's return to the home'.[85]

At the end of 1878 *Mirabeau* survived a change. Led by Gérombou, the radicals of Étincelle left the paper and started their own, the short-lived *Cri du Peuple*. A new editor, Théodore Brandenberg, came to *Mirabeau*. Under his leadership the paper continued its discussion of the woman question; in

[83] *Royaume de Belgique*, Archiefs van Buitenlandse, 186.I.1877.D. No one has yet published research on the women's movement in Antwerp and its environs in this period, but a cursory reading of *De Werker* suggests that there was such a movement. A Ghent-style socialist-feminist movement developed there later, and included many of the women mentioned in *De Werker* in the earlier period.

[84] Reported in *Mirabeau*, 18 Nov. 1877.

[85] Ibid. 23 Dec. 1877.

general, its articles were positive. Versions of women's emancipation now included both those of local socialists and of some vocal bourgeois feminists of the time. One contributor who was both a socialist and a feminist was the French woman, Eugénie Potonié (who later married another bourgeois radical, and became Eugénie Potonié-Pierre). True to her class origins, but curiously out of place in Verviers, Potonié's primary concern was for women's equal access to the professions – particularly to that bastion of male supremacy (in France as in Belgium), the medical profession. She also published reports of many bourgeois women's conferences, including one held in Paris in the autumn of 1878, where the primarily bourgeois delegates resolved in favour of women's 'absolute right' to work at any job, to earn equal pay, and to form their own women's trade unions.[86]

Meanwhile, Étincelle's *Cri du Peuple* used much of its brief existence to promote the anti-women views of Gérard Gérombou. From the first, working wives were the target. One writer described the situation of 'a typical *ouvrier*':

He lives behind alleys and obscure stairways, in attics that he inhabits with his numerous family ... The wife is there, ragged, crouched in a corner, feverishly occupied with some sewing. This woman is still young, but for lack of care, she retains nothing of the natural attractions that had initially given her such 'empire' over her husband.[87]

(No one noted that this was the domestic setting to which Gérombou and his friends wanted to confine women.)

Cri du Peuple's pages were not entirely empty of support for women's rights. One piece called for 'a new system of education', that would 'free women of the need to care for children' so that they would 'no longer exist as men's subordinates'. By lodging workers' children in communal schools, women could 'earn their living ... completely independent with respect to men'. Given Gérombou's views, this was a startling piece. Nevertheless, the children would learn the proper lessons in the schools, which would be run entirely by women. Girls would 'learn good housewifery', whilst boys learned 'artisanal trades'. The girls' training would render them 'capable of earning their living', in order to be 'independent from men', but they would not take men's work. Instead, careers suitable to their schooling included those of '*ménagères*, school-teachers, dressmakers'. Boys, on the other hand, could become 'artisans, engineers, architects'.[88]

[86] Ibid. 19 Jan. 1879.
[87] 'La Vie (domestique) de l'ouvrier', *Cri du Peuple*, 18 Aug. 1878.
[88] 'L'Instruction', ibid., 22 Dec. 1878.

There was no reaction; soon thereafter, in June 1879, *Cri du Peuple*'s editors published their swan-song: 'Our resources are exhausted—the workers, our brothers (*sic*) are completely indifferent to all the work of emancipation, and their inertia paralyses our efforts. We must await more propitious times'.[89]

The failure by the paper's editors even to mention 'sisters' in their farewell underscored the weakness of the local women's movement in that year. Despite the claims of local police officials that the Verviers women's section continued to flourish (police counted 'at least 200 members of the women's group plus numbers more in [other] local socialist-internationalist groups')[90] the Verviers women's section soon disappeared from view. Marie Mineur wrote a last letter to *Mirabeau*, pleading that the paper pay more attention to women readers, but it came to naught. Soon the paper, too, died.[91] A few months later, in the summer of 1880, the Vesdre Valley Federation disbanded.

VERVIERS, AFTER 1880

At the same time, however, an unorganized workers' movement continued to grow in the region. Public officials recorded, fearfully, 'revolutionary socialist activities' throughout the textile region in all the years from 1880 to 1885. In 1885 a local section of the newly organized socialist *Parti Ouvrier Belge* (POB) appeared. But the local women's movement, as such, was gone. Those women who began to play key roles in the Verviers socialist party after 1885 were all new. Some, indeed, evidently came into the city from outside—including, for example, two socialist women who arrived one day 'by train from Brussels', according to police spies. There was also one 'anarchist outsider' who attracted police attention in the second half of the 1880s, though little is known of her except that she employed aliases, including 'Marie Antoine Cyvoet', and 'Louise Henriette Favet'.[92]

Despite the existence of a socialist party, Verviers remained true to its heritage and frustrated most attempts to impose party discipline. Despite local workers' keen enthusiasm for politics of all kinds, they showed little

[89] Ibid. 21 June 1878. The editor at this point was Toussaint Malempré. Émile Piette ('Prol Ether') was listed as 'distributor'. The ideas presented here had much in common with those of Chernychevsky, and suggest their author had read *Que Faire?*

[90] *AEL*, Sûreté Publique, X.V. 1–25, no.17, 15 Nov. 1879.

[91] 'Correspondance', signed 'M.M.', ibid., 1 Jun. 1879. This is the last archival appearance of Marie Mineur, assuming, of course, it was she.

[92] *Royaume de Belgique*, Archiefs van Buitenlandse, 186.II.18/8, 'Note confidentielle, Verviers, 1884'.

desire to submit to the dictates of a centralized party—particularly one led from Brussels by bourgeois intellectuals, as the POB soon was. After many years of struggling with his comrades one discouraged Verviers socialist described his home as 'that city of anarchistic and individualistic socialists, capable of energetic efforts, but incapable of submitting to a continuous discipline'.[93]

Those words, spoken in 1902, sum up the history of the First International in Verviers, including that of the city's women's movement. So long as the movement was just that—a broad wave of workers, each with different, contradictory views, each free to express them and to quarrel over them—the Verviers International prospered. But once a struggle for 'correctness' and for discipline emerged amongst militants and leaders, the International died.

In the broad history of European—or indeed even Belgian—worker politics, the story of Verviers's First International is little more than a minor episode. Nevertheless, in the more particular history of Europe's working women, it has several claims for attention. First, the extent of Verviers's working women's active participation blunts stereotypes of women's political passivity which are still widespread in much of the historiography both of working women and of left-wing politics in general. Whatever the claims of some historians to the contrary, Verviers's *ouvrières* proved that working women possessed no proclivity for an apolitical life.

Secondly, the story of Verviers suggests that anarchism, very loosely defined in this context as a commitment to incoherence, to contradiction, to anti-authoritarian behaviour, attracted women and their supporters, who found in the movement's flexibility a space in which to create their own politics. That they did not succeed in propounding any single, coherent theory of women's emancipation was not a negative result of their efforts. Instead, their loose organization, bolstered by a variety of contradictory principles, encouraged working women to join, whatever their feelings about their roles as workers, as mothers, or as wives. In Verviers and in the villages and towns in the surrounding countryside, women claimed equal rights on various grounds, drawn from their productive or reproductive lives, or a combination of both.

Thirdly, the significance of *Mirabeau* in the collective life of Verviers's workers underscores the importance of literacy in efforts to organize the working class in these years. And for women, the abilities to read and write meant that they were also able to mark the historical record in ways

[93] Varlez, *Quelques pages*, 114–15. This remark underscores the extent to which 'anarchism', at least in Verviers, was something of a muddle of all anti-authoritarian ideas which supported workers' rights.

unknown to women elsewhere, where such documents as women's letters to the worker press were extremely rare.

Lastly, the extent of local women's participation here underscores an argument I have made before. In those industrial contexts where work included every member of a given community—from childhood to death—women were much more likely to find a welcome within an emergent working-class movement, even in one where Proudhon's hostility shaped many local attitudes. Working together, living together, socializing together, the men and women of Verviers's textile-mills quite naturally practised politics together. Male chauvinism existed, as we have seen, but even when it was at its most extreme, in the pronouncements of Gérard Gérombou, for example, it did not call for women's total exclusion from public political life.

BEYOND VERVIERS

One question remains in this examination of the First International in Verviers. To what extent were Verviers's women typical of Belgian working women as a whole? We cannot answer this question fully, since most sources from which one might construct a detailed history of Belgian working women's politics in the years between 1865 and 1880 are missing. Verviers—not least because a complete run of *Mirabeau* exists—offers one of the few relatively well-documented workers' cities in this period. However, it is clear that Verviers was unusual in many ways. First, workers were literate. Second, they tended to work in the same industry: male or female, Verviers's workers produced wool. Moreover, women inhabited a social and economic world that was little different from men's. In this, they were also different from most other Belgian workers. Nevertheless, some evidence exists to support the argument that working women elsewhere were politically active in the First International—and in considerable numbers. A thoroughgoing exploration of this evidence lies beyond the boundaries of this study. But a brief sketch of AIT activities in two other locales—Liège and Charleroi—suggests that the case of Verviers's *ouvrière*'s enthusiasm for politics was less than unique.

Liège

The Liège workers' movement was never clearly distinct from that in nearby Verviers. Communication between the two cities was both easy and constant, as papers and speakers travelled back and forth. Liège also shared Verviers's centuries-old tradition of 'anarchist' leanings, which valued

individualism and independence above all. On the other hand, the industrial workforce of Liège was much more fragmented, with dozens of industries and hundreds of artisanal trades supporting Liège's working class. Not surprisingly, then, the workers' movement in Liège had a considerably more varied and complicated history.

Furthermore, Liège's working class included a significant number of illiterates: in 1866, the entire province of Liège—including literate Verviers—had an illiteracy rate of nearly 50 per cent. (This was not the highest rate in Belgium, by any means. Years of educational neglect had produced extremely high rates: in the Hainaut, including Charleroi and the Borinage, 57 per cent of inhabitants were illiterate; in East Flanders, including Ghent, the rate was a staggering 60 per cent.) In the 1890s observers estimated that of the inhabitants of the Liège *arrondissement*, about 33 per cent were illiterate.[94]

Both the low rate of literacy and the variety of work experience exacerbated existing tendencies towards anarchistic heterogeneity. Politics in Liège, then, unfolded within dozens of tiny groups, including food cooperatives, workers' restaurants, savings societies, and groups for study, for social activities, and for politics. In January of 1869 there were enough such groups to support a local police official's judgement that Liège was 'the heart of the first International'.[95] In that month, the Liège AIT listed 700 members living within the city limits, plus a further 500 in nearby Lize-Seraing.[96]

Such success prompted both fear and overreaction from local officials. During the massive strikes of 1869, which broke out in steel-works and textile factories in the area, authorities quickly called on armed troops to control the crowds. In one confrontation in Seraing, armed soldiers killed and wounded many of the 5,000 to 6,000 men, women, and children who had gathered in the streets.[97] The AIT leadership quickly announced from

[94] Estimates from Jean-Luc Degée, *Le Mouvement d'éducation ouvrière: Évolution de l'action éducative et culturelle du mouvement ouvrier socialiste en Belgique (des origines à 1940)* (Brussels, 1986), 14, and Bonda, J., *Histoire anécdotique du mouvement ouvrier au pays de Liège* (Liège, 1949), 144.

[95] Quoted in Flagothier-Musin, L., *Liège: Mémoire ouvrière*. VI (Brussels, 1985), 6.

[96] Ibid. 6–7.

[97] Bourgeois fears recorded in *AEL*, Sûreté Publique, V.VI - 3, VI.A. 1–115. These document the spread of the AIT in Liège, and virtually every piece notes the presence of women, or 'women-and-children'. See also documents quoted in Léon Linotte, *Les Manifestations et les grèves dans la province de Liège de 1831 à 1914: Inventaire sommaire des archives de la sûrété publique de la province de Liège* (Leuven, 1964) esp. carton V, 1868, doss. A&B, and carton VI, 1869, doss. A&B. Linotte discovered that the AIT records after 1873 have vanished. Given the fact that these are the very years when Verviers's women's movement reached its peak, the lost archives may have documented a similar movement in Liège.

Brussels that 'the most complete terrorism reigns in Liège', where 'the minister intervenes in person with owners, encouraging them to fire any employees or workers who join the International'.[98] A local official warned, 'The movement has again brought to light the false ideas widespread in the working class . . . Those promulgating such ideas are *esprits malades et mécontents*, who are abusing the freedoms we enjoy in order to create a deplorable antagonism between workers and owners'.[99]

As a result of the strike, dozens of AIT members were blacklisted in Liège. Not surprisingly, this drove the movement underground, and local sections began to meet in secret—hiding, as much as possible, the identities of both members and militants. Of course this tactic was prudent, but unfortunately it not only protected Internationalists from the prying eyes of the *patronat*, it also hid them from the historical record. And with the loss of local members' identities came the loss of their gender as well: even police spies were unable to identify individuals, reporting only 'meetings'.[100]

There are sufficient references from outside to show that Liège's women did participate in International activities, but existing information suggests that the attitude of the Liège leaders towards working women was much less flexible than that promulgated in Verviers. In 1869 the Liège AIT section declared unequivocally that their goal was 'to remove women and children from the factories and return them to school and to home', thereby 'strengthening and respecting the family'.[101] Indeed, families were the heart of the Liège movement, as is shown by one contemporary description of life in the Liège International in these years:

Each Sunday, the husband, the wife, and the children went to the Maison du Peuple to laugh, to play, to recreate . . . and little by little to join in some drama groups, choral circles, fanfares, harmonies, trumpet societies, accordian players' groups, and so on.

For children, the AIT offered games, singing, and excursions. According to

[98] No. 28, 'E. Hins à Bruxelles, 2 juillet 1868' in Devreese, *Documents . . . militants belges*.

[99] M. Liebman's *Les Socialistes belges, 1885–1914: La Révolte et l'organisation* (Brussels, 1979), is a refreshingly impassioned and partisan work; these words are on p. 17. The author underlined 'esprits malades et mécontents', adding, engagingly, 'Liaison idéologiques digne d'être soulignée. Je souligne, donc'.

[100] See *AEL*, Sûrété Publique, VI. A-44, Jan.–Feb. 1869; VI.A. 45–66. Some reports exaggerated wildly. One claimed that 'all the miners of Liège, Charleroi, and the Borinage' belonged to the AIT in April, 1869. The same report counted 300,000 AIT members in Belgium as a whole. See no. 282, 'Process tegen de Internationale als vereniging van misdadigers wegens hun oproep van 13 april 1869', in Wouters, *Documenten . . . van de 1e Internationale*, i, 197–9.

[101] PG, 218.A, 125, 'brochure, Liège, 1869'.

one woman militant, all these activities ran all through the day every Sunday, in order to 'prevent church influence'.[102]

Given the heavy emphasis on the family, it was not surprising that the rituals surrounding the burials of women members celebrated their maternal and wifely qualities rather than their politics or work. A typical speech at the burial of 'Femme Laurier' in June 1873 described her as 'a model mother and model wife'. Such language was common—except in reports of police spies, which preferred to characterize female dead as 'mistresses' or 'concubines'.[103]

In the 1870s the Liège movement grew, and the first women's meetings were organized, although these failed to stimulate any Verviers-style women's sections. Not even regular visits by Marie Mineur, who delivered countless speeches in Liège, bore fruit. At one meeting in November 1873, called to recruit women members, Marie Mineur remarked the complete absence of women in the audience—'as there would have been at Verviers'.[104] Liège's *ouvrières* evidently did not choose to create their own separate movement. But this did not mean that male leaders did not try to lead them in that direction. Shortly after Mineur's complaint, the Liège AIT paper, *Ami du Peuple*, declared on the front page: 'Alongside the AIT, the Women's International is being added. . . . It is the story of a constant progress of renovatory ideas. Woman has the right, together with man, to emancipate herself morally and materially'. The editors explained the benefits awaiting women members, 'In emancipating herself intellectually, woman makes the task of male workers much lighter. Until now, she has been impregnated (*sic*) with religious prejudices and has supported Catholicism in great measure'. The solution? The editors adopted familiar language, in which men carried the responsibility:

Man must turn his eyes towards her and help her to arrive at her emancipation . . . The male workers of Verviers have achieved this goal. There exists today in that city a women's propaganda section, with a considerable number of members . . . The effort must aim at the destruction of Catholicism which is woman's enemy.[105]

In this initial statement, as well as in subsequent statements on women's 'emancipation', the Liège leaders echoed many of the contradictions familiar

[102] The first remark was that of Victor Serwy, the second, of an anonymous woman; both quoted in Jean-Luc Degée, *Le Mouvement d'éducation ouvrier*, 28, 29 resp.

[103] No. 686, 'Nota in inkt (14 juni 1843)', in Wouters, *Documenten . . . van de 1e Internationale*, i, 537.

[104] *L'Ami du Peuple*, 13 July 1873, reports one Mineur speech. Her remark was reported on 16 Nov. 1873.

[105] Ibid., 21 Sept. 1873.

in Verviers. But there were some fresh ideas. One writer in *Ami du Peuple* in December 1873 tried to dilute the effects of Proudhonism by deploying the Liègeois's traditional love of complete individual freedom: 'No one should try to fix a single identity, a single role' on women. 'Woman might be a housewife or a courtesan', he noted, 'but she should do either by her own free will ... All ways open to human activity should be as open to her as to the man; this is not only just', he concluded, 'it is also necessary. Men who have ruled the world alone until now have achieved no results sufficient for them to be able to conclude logically that they must preserve their supremacy indefinitely.'[106]

On the other hand, the paper's editors were not reluctant to restrict women's choice of work: dressmaking headed their list of 'appropriate women's occupations', while coal-mining—not surprisingly—brought up the rear. Still, there was some support for the *hiercheuses* in the Liège AIT. One militant defended their work on the grounds that any effort to exclude women from the pits would provoke 'anathemas' from *hiercheuses*. Their anger, in turn, would shake the working-class household, and 'Disorder would ensue'. 'Please do not destroy one evil simply to create another', pleaded this writer.[107]

No amount of propaganda stimulated a women's section, despite *Liègeoises'* collective enthusiasm for mixed-sex activities in the AIT. Some women, indeed, even became movement militants. Although records are sparse, Lucie Dejardin recalled several women leaders in the AIT movement of her youth, and despite the widespread illiteracy of *ouvrières*, *Ami du Peuple* included some letters from women members, especially from *couturières*. But beyond this brief and scattered information, nothing more is known. Not until organized socialism came to Liège in the mid-1880s do archival documents begin to allow a more thoroughgoing history of the local workers' movement.

Charleroi

This coal city's manufacturing infrastructure was much less heterogeneous than that of Liège. Two industries dominated Charleroi's labour-market in the late nineteenth century: coal and glass. The city—of more recent origins than either Verviers or Liège—lacked a history of political attitudes such as those that shaped the workers' struggle in the other cities.

[106] 'La Propriété individuelle', ibid. 7 Dec. 1873.
[107] 'Du Travail des enfants et des femmes dans les manufactures, mines, etc.', ibid. 14 June 1874. See also 'La Révolution', and 'Appels', both in 28 Dec. 1873.

Moreover, proletarian politics in Charleroi were slow to develop, and grew not out of social groups, food co-operatives, or study circles, but rather out of the plethora of small, evanescent strikes that shook the region in the 1860s and early 1870s.

This high level of industrial unrest—coupled with the fear engendered by miners in most bourgeois hearts—made local industrialists far more wary of their workers than were owners in Liège or Verviers, despite the much more organized, and potentially more subversive, workers' movement in both cities. These patronal fears ensured that class confrontations in Charleroi were much more violent. Officials in the area, in fact, proved consistently willing to deploy the most lethal force against every strike or mass demonstration. In the approving words of a local newspaper, Charleroi's officials engaged enthusiastically in the 'energetic combat' required by a 'virile state'.[108]

As we have seen, repression did not prevent Charleroi's workers from striking. Gradually, however, they began to learn to control strikes by forming permanent groups or proto-unions. Many of these eventually joined the AIT, including the first miners' union, founded in Montigny-sur-Sambre (just east of Charleroi, along the river).[109] Once the miners brought the AIT to Charleroi, towards the end of 1867, sections proliferated. Marcel Liebman has counted some 42 sections in the city in 1868. One local official complained to the Minister of Justice in April of that year that the *'fiches'* of the International were 'everywhere'. Moreover, worried authorities noted 'constant' International meetings—attended, in one agent's words, by 'great crowds of women and men'. According to one visiting national AIT militant, Internationalist ideas were heard everywhere, 'in cabarets, in homes, in the coal-pits . . . the women joining in'.[110]

But then came the dark events of 1868, the 'Massacre of Montigny-sur-Sambre', as they quickly came to be known: 10 died and 45 lay wounded after armed and mounted troops attacked a group of striking miners. As with all such occasions, details varied from observer to observer, but most sources agreed that it began when a vast crowd of miners and glass-workers, with their families, gathered in a courtyard outside the Épine mine. Unable to find a speaker, the crowd 'amused themselves'—in one onlooker's words—by breaking mine office windows. Most agreed that

[108] Quoted in Liebman, *Socialistes belges*, 14.

[109] De Weerdt, *Belgische socialistische arbeidersbeweging*, 19. According to De Weerdt, this union was the only such group outside Flanders.

[110] Liebman, *Socialistes belges*, 35; no.77, 'De Bavay aan de minister van justitie, 10 april 1868', and no.180, 'Uittreksel uit een brief van Tonbeau aan De Paepe, oktober 1868' in Wouters, *Documenten . . . van de 1e Internationale*, i, 50, 128, resp.

the crowd did not 'build barricades' (an act still redolent of revolution), as bourgeois newspapers claimed later. But one small *gamine* did erect what one AIT official remembered as 'a small screen'. Whatever the proximate cause, terrified mine-owners summoned help, and mounted troops arrived quickly. The soldiers charged the stone-throwing crowd, shooting and stabbing with bayonets. Amongst those killed was one woman who was apparently only 'seeking her husband'. Some of the 45 wounded suffered serious revolver wounds, which socialists later claimed was evidence that officers (the only troops allowed to carry this weapon) had joined the attack.[111]

The killings did not halt the strike. Over several months, into 1869, it spread, ultimately to the mining communes of the nearby Borinage. Because of their sympathy over the violence and death, the national AIT leaders, as well as members in Verviers, Ghent, Antwerp, and Liège, sent 'solidarity' funds. Charleroi's striking workers reacted with warmth. Dozens of new Internationalist groups appeared in the area, and amongst these was the first women's section, founded in Montigny-sur-Sambre. This group made its first national appearance at the 1869 congress of the AIT, where it was introduced as 'an example which we hope will be imitated'.[112]

This Montigny women's section took a position similar to that articulated later by Marie Mineur. For these women, work outside the home was not suitable, and in this mining town, their concern focused on the region's thousands of *hiercheuses*. In a speech at the 1870 national congress, the group's delegate roundly condemned women's work below ground. More 'seemly work', she insisted, included tasks customarily assigned to women: sewing, laundry, and so on. The official *compte-rendu* of the meeting described 'repeated applause' for the speaker, 'the first woman to speak in a Belgian congress'. The note-taker added, patronizingly, 'We hope that at the next congress there will be more than one'.[113] (It was two years before more women attended: as noted above, Marie Mineur and Hubertine Ruwette went to the 1873 congress as delegates from Verviers.) As this speech suggested, nothing emerged from the Montigny women's section that threatened a very conventional role for women: in its working-class version, this meant waged work inside the domestic sphere. No word of

[111] No. 28, 'Eugène Hins à "X", Bruxelles, 2 juillet 1868', in Devreese, *Documents . . . militants belges*, 57. See also *Royaume de Belgique*, Archiefs van Buitenlandse, 186. I. 'Socialisme, anarchisme, grèves, mouvement sociale', 'Massacres à Montigny', which listed 20 wounded, including 'wives and mothers'. This archive also includes a drawing showing one woman and several men being killed; women were arrested, as well. See PG, 218, 'Charleroi. Mai 1868'.

[112] Hins's letter is cited in fn. 16, above.

[113] Quoted in De Weerdt, *Belgische socialistische arbeidersbeweging*, 24.

praise for Charleroi's women coal-miners ever slipped from the lips of a woman member of the local AIT.

Despite the local movement's evident opposition to women's work underground, many women miners joined the organization in the 1870s, though their numbers remained relatively small. Evidence is sparse, but there seems no reason to doubt that women who did join the AIT were active members. In June 1874, for example, a mixed-sex AIT group in Mariemount organized a 'women only' meeting aimed at recruiting more women members. 'With the help of two *citoyennes* from Verviers', and 'in spite of the tropical heat, many women came', wrote a local journalist. At the evening's end, the speakers had managed to recruit 54 new women members for the AIT.[114] Women also joined several other local Internationalist groups, including a mixed-sex Free Thinkers society in Charleroi which called itself 'The Rights of Man and Woman'.[115] Furthermore, as Charleroi's workers began to organize more recognizable unions, many women miners (and glass-workers) lined up and paid their dues, as we shall see in Chapter 8.

Given the apparent similarity of views between women leaders in Verviers, where women's groups enjoyed significant success, and those in the Charleroi area, where only a handful of women joined single-sex organizations, it is interesting to speculate about the reasons for the difference. Perhaps, as many contemporaries noted, women's traditional work in the Charleroi area—in mining and glass-making—was sufficiently satisfying to turn them against women who wanted to 'return' them to the home, and thus to lower pay and status. Or perhaps most of these women, who worked so closely with men doing 'male' work, simply saw no reason for separate women's sections? Perhaps both were true. But here, as elsewhere in the history of working women's political choices, the absence of any records of individual women's thoughts on these, and other, matters, means that any explanation, however plausible, remains in the realm of almost pure speculation.

CONCLUSION

By the end of the First International, it was clear that Belgium's working women would play a key role in whatever movement eventually succeeded

[114] 'Correspondance-Hainaut', *Ami du Peuple*, 14 Sept. 1873.
[115] Ibid. 19 Dec. 1875, and 'Mouvement ouvrier', 21 June 1874. The paper announced one further meeting of this group on 19 July 1874.

in organizing the nation's proletariat. At the same time, the often vexed relations between men and women in the movement, demonstrated by the persistence of disconcertingly contradictory attitudes in the various attempts to articulate a theory of women's emancipation, would clearly continue to shape both behaviour and ideas in the political future of Belgium's working class.

To summarize, Belgium's working women in these years encountered two kinds of message—both aimed at attracting them to the First International. One claimed their 'equal rights' to political, social, and economic independence. In this country where male workers also lacked voting rights, the focus of this equality was primarily economic; the right to work for equal and equivalent wages was a primary issue. No one disagreed with the view that all working-class women must work for wages (indeed a few, as we have seen, thought Belgium's *bourgeoises* would benefit by relinquishing their 'idleness' for productive work). At the same time, however, only a few far-sighted male leaders (e.g. Émile Piette in Verviers) recognized that women's full liberation meant a revolutionary change in men's private lives. Most did not challenge the view that women's primary duty—and indeed fulfilment—was found in her reproductive experience. Given this, women's domestic labour was but a 'natural' outcome of a biological role.

The leaders of the Verviers women's section recognized the problem inherent in this position. Women who earned their wages outside the home faced a kind of 'double slavery': 12 or 13 hours in the mills, followed by many hours of work at home. At the same time, children's care during working hours was relinquished to neighbours, relatives, or even nuns, in those rare cases where places were found in a *crèche*. As they sought to deal with this problem, they began increasingly to describe a solution that would include women's removal from the mills and mines, and their 'return' to their proper place in their homes. There, what made women distinct from men—their maternity—would be 'liberated' from bourgeois society's constraints. Women could act as mothers and wives, experiences which formed the basis for their claim to participate equally and fully in politics, at the same time as they earned their wages, but not in 'men's work': rather, women's living should come from women's traditional skills: sewing, knitting, embroidering, straw-plaiting, and so on.

This language of separateness—without a prescription for women's economic dependence, such as bourgeois reformers favoured—clearly attracted many hundreds of textile *ouvrières* in the Verviers region, together with some women in Liège, and a few in Charleroi. Whatever the

unconsidered implications of this argument grounded in difference—read, sometimes, as superiority—it allowed women adherents to describe and claim a distinct identity. In a world entirely run by men, such 'essentialism' offered the possibility of a parallel women's world.

These ideas of 'difference' revealed the hypocrisy of those proletarian men—as well as those in the ruling élites—who insisted that motherhood was a key social, as well as personal, function. If motherhood was, as so many men claimed, the most important role any human being could play, then working women should be able to play it, in a manner that demonstrated its importance. Mothers, in other words, should not be forced to accept unequal rights if their maternity was of such primary social value.

At the same time, as we have seen, no one in these years managed to articulate a coherent theory of women's emancipation—through difference, or despite biology. Nor did anyone invent a practical programme which would conceivably have reached the goal. Instead, most discussions of women's rights ended in a muddle. This was not a particularly vexing problem for the International so long as it remained a highly localized, tolerant, anarchistic movement, but as Belgium's workers gradually turned away from such loose practices, in favour of well-organized trade unions and—for many—socialist ideas and practices, the flexibility that allowed all sorts of confusion within the movement disappeared. With it, much of the grass-roots character of the First International gave way to hierarchy, centralization, and ideological conformity, and in such a relatively highly structured movement, women, with their 'double work', were unable to move up the party ladder. Instead, they remained on low rungs, far from the centres of power. How working women confronted this problem as it developed in the Parti Ouvrier Belge in the years after 1885 is the subject of the next chapter.

8

Working Women and Politics:
the Second International

In his *Mémoires*, Émile Vandervelde recounted what the Belgian socialist leaders described as his conversion to feminism. It occurred at the 1891 congress of the Second International, where he gave a speech about women's role in the movement. 'Like most Belgian socialists', he recalled, 'I shared Proudhon's view'; women belonged inside the home, their 'natural sphere'. He was convinced, he added, that women 'lacked an aptitude for politics'. At the end of his speech, he sat down, expecting applause. Instead, the leader of the powerful German socialist party, Karl Liebknecht, rose to his feet, visibly angry. 'Fort bien!' he cried sarcastically. 'Courtesan or domestic slave: here is how a *socialist* understands women's role?' 'Alors', Vandervelde remembered, 'it was a *coup de foudre*. On the question of socialist feminism, I had encountered my road to Damascus'.[1]

Alas, however, it proved a very short-lived conversion. Although the Belgian socialist party promulgated a progressive position on women's rights (adding various provisions to the party platform adopted at Quaregnon in 1894, and appointing the socialist-feminist Émilie Claeys to the national council, for example) it was quick to betray women's cause at the first notes of the electoral siren-song after the turn of the century.

A detailed history (in so far as sources would allow) of the relationship between Belgium's working women and the movement purporting to represent their class in the years from 1885 to 1914 lies beyond the scope of this study. However, given the near total absence of information about working women's participation in the development of class organizations after the collapse of the First International, this chapter undertakes to sketch an outline of key events in this history as it developed between Belgium's *ouvrières* and *werksters* and the Parti Ouvrier Belge. For the joint purposes of organization and brevity, the chapter is arranged in the following manner. It begins with an introductory overview of the party's

[1] Vandervelde, É., *Souvenirs d'un militant socialiste: Première partie: Mes débuts dans la vie socialiste, 1881–1914* (Paris, 1939), 142–3.

activities with regard to working women in its ranks, including the difficulties they—and potential women members—faced. Secondly, it includes a brief survey of working women's political activities in two cities treated in the concluding section of Chapter 7, Liège and Charleroi. Although this section is necessarily abbreviated, it offers a glimpse of 'phase two' of working women's political activities in those two areas, and, certainly, points the way for future research.

The heart of the chapter, however, lies in Ghent. There a genuinely grass-roots socialist-feminist movement emerged—a phenomenon rare in nineteenth-century Europe. Led by the ex-textile-worker Émilie Claeys, the women of Ghent managed not only to create their own movement within the local party, but also to shape the broader politics of the Ghent movement as a whole. From the early 1880s, both male and female militants in that city articulated a radical, transformative theory of women's emancipation; and, in contrast to members of virtually every other European socialist party of the time, they worked to put their ideas into daily practice.

Although such strong, radical roots were not easily destroyed, they were irrevocably weakened when the national, Brussels-based party leadership betrayed the women's cause in the winter of 1901–2, choosing electoral expediency over principle. From that point, Ghent's unique socialist feminism began to change. Although a few male militants continued to work towards the earlier goals, the women leaders vanished. Gradually, within the heart of the national party, a comfortable, unthreatening women's auxiliary group was created. It sited itself at the margins of the Parti Ouvrier Belge/Belgische Werklieden Partij (POB/BWP), and undertook the 'embourgeoisification' of Belgium's socialist women's movement. Led by bourgeois ladies, the self-styled 'Socialist Women's Group' distanced themselves from the earlier radicalism and feminism of Ghent's working women.

These events did not abolish women's radicalism from the larger Ghent movement. Particularly in the final years of our period, a few women and men began to resurrect the ideas and tactics of Émilie Claeys and her comrades. Ghent's socialist union movement also continued its practice of including women at all levels of activity throughout our period, but the national party's actions prevented Ghent's women's revolution from spreading through party ranks. Moreover, just as the socialists were in the process of marginalizing women workers from the party, the Catholics began to discover them. The church's successes and failures in their attempts to organize these women are recounted, briefly, in the conclusion of this chapter.

BELGIAN SOCIALISM IN THE BELLE ÉPOQUE

> Whatever their theory, virtually all who have had anything to do
> with modern labour and socialist movements (except the anarchists)
> have hitherto taken it for granted that the way to the future,
> whatever it might be, led through organization: through associations,
> leagues, unions, and parties, the more comprehensive, the better.
>
> Eric Hobsbawm[2]
>
> Chacun doit pouvoir se trouver à l'aise dans la grande maison.
>
> Madeleine Rebérioux[3]

The words of both Eric Hobsbawm and Madeleine Rebérioux perfectly
capture the character of Belgian socialism in the period of the Second
International. On the one hand, no socialist—or indeed, anarchist, at least
in Verviers—ever considered that there was any alternative to organizing
workers into an army that might successfully confront their heavily
fortified (and armed) opposition. At the same time, Belgians always
displayed an overriding commitment to creating a 'grande maison', from
which no worker was excluded. Even women, however little their interests
were served by the party after 1902, were always quite pointedly included
in grass-roots socialist activities of all kinds. Part of the explanation lay in
the fact that the Belgian party, unlike others in the Second International,
practised a highly flexible form of socialism. As I have noted before, the
fact that they named all their headquarters 'People's Houses', rather than
'Workingmen's Clubs' or *Cercles des Travailleurs* (or, indeed, the Belgian
Catholic's choice, '*Maisons des ouvriers*') was emblematic of the absence of
desire for ideological or practical conformity.

That the movement was so embracing has not, of course, kept historians
from engaging in tendentious arguments about the precise nature of
Belgian socialism in this era. Of particular concern has been the extent of
the Belgian movement's adherence to—or rejection of—marxism. But this
is not our concern here. Instead, writing the history of working women,
hitherto neglected by most historians, demands much more specificity.
What follows, therefore, is an abbreviated chronology, together with an
outline of several key factors within Belgian socialism that shaped the
vexed relations between the party and its female constituents.

In the 1870s two socialist political parties, albeit very small ones, were

[2] Hobsbawm, E., 'Should the Poor Organise?', *New York Review of Books*, 23 Mar. 1988, 44.
[3] Rebérioux, M., 'Le Socialisme belge de 1875 à 1914', in Droz, J. (ed.), *Histoire générale du socialisme, ii, de 1875 à 1918* (Paris, 1974), 324.

founded in Belgium: the Vlaamse Socialistische Partij, headquartered in an already activist Ghent, and the Parti Socialiste Brabançonne, centred in Brussels. In 1879 the two merged, becoming the Parti Socialiste Belge Partij Socialistische Belgie. The main goal of this united group was universal male suffrage, though leaders continued to support various more localized campaigns.

Meanwhile, every industrial corner of the country saw the emergence and spread of socialist groups. In 1885 all these diverse groups came together, forming the POB/BWP.[4] From the outset, the primary issue was the vote, sometimes including women's vote, sometimes not. The resulting 'single issue' politics meant, of course, that from the first the Belgians aimed their sights willy-nilly on electoral success rather than 'revolution'. Indeed, the rhetoric of party leaders—especially by comparison with that of leaders of the nearby French Guesdists—was strikingly free of revolutionary demands. As many historians have noted, 'reformism' rather than 'revolution' always dominated organized Belgian socialism.

From 1885 to 1900 the POB/BWP supported a series of mass general strikes in pursuit of male suffrage (partial male suffrage was won in 1893). It also elected a number of socialist representatives to the Chambre, and managed, especially in the 1890s, to take control of many communal councils all over industrial Belgium.[5] Throughout the period, membership was never restricted to political parties alone. The POB/BWP needed all kinds of grass-roots support in order to sustain strikes and demonstrations. Thus young socialist groups, 'Rationalist' and 'Free Thinkers' clubs, dozens of study circles of all kinds, as well as trade unions, mutual aid societies, and co-operatives all joined in a very loose confederation under the party umbrella. Of course the party did have a structure: a national council was supported by provincial and local councils. But virtually all were welcome—including those stubbornly unwilling to agree to any programme, such as the still anarchistic workers of Verviers, and those who adhered to an 'independent', or 'apolitical' movement, such as the Chevaliers du Travail of Charleroi.

Although the party grew steadily, vote-conscious leaders rapidly became impatient. By the century's end, many had begun to consider an alliance with the out-of-office liberals. (Leaders such as Louis Bertrand had long

[4] The decision to eliminate the word 'socialist' from the party name was deliberate. The party hoped that independents might be attracted.

[5] The story is outlined in, *inter alia*, Aron, P., *Les Écrivains belges et le socialisme (1880–1913)* (Brussels, 1985), 21. Aron dates these early years as those when workers, rather than bourgeois, were still dominant in the party, as I am arguing with regard to women as well.

favoured such co-operation—aimed, of course, at electoral success which the socialists, limited by the partial voting rights of male workers, could not achieve alone.) It was not until a weakly-supported general strike in 1902 once again failed to bring universal male suffrage (i.e. unqualified by property ownership) that those favouring such an alliance got their way. The two groups joined forces from that year until the war. But at what expense? The main compromise devastated feminist party members: the liberals refused to countenance even a discussion of women's suffrage.[6]

Whatever the ethics of the POB/BWP's choice to jettison women's rights to placate their new allies, they did gain their immediate ends: electoral success followed, and the left—now including liberals—increased their numbers in the Chambre. In 1908 78 alliance members, including 43 liberals and 35 socialists, sat in parliament. They were still outnumbered by the 88 Catholics, and destined to remain so, but at least the balance had begun to shift, even without the necessary electoral reforms.

This pursuit of votes blinded the party leadership to all but the most pragmatic considerations. Many within the movement—particularly younger members—became increasingly distressed with the theory-free (and therefore non-Marxist) position of the leadership. Influenced by radicals within the Second International (headquartered in Brussels after 1900) such youthful leaders as Camille Huysmans, Louis De Brouckère, and a young Henri De Man proclaimed themselves 'true Marxists', and founded a new *tendance*, called Lutte des Classes, which had its headquarters in a more radical Liège. These younger socialists heaped scorn on the compromising pragmatism of older party leaders. In De Man's words: 'La théorie de revisionnisme belge n'est rien d'autre que la négation de la théorie'.[7] This young militant tendancy had no more than a gadfly role in the party until after the war (when the birth of the Third International provided them with legitimacy). But that is another story.

The Belgian party's disconnection of theory from practice, however

[6] The liberals said they feared women's 'conservatism'. They were probably right to assume that their own female relatives, educated by the church, were likely to vote for the Catholics. On the other hand, their collective hostility to women's rights surely discouraged most women from joining their cause.

[7] Quoted in Sztijnberg, M., 'L'Interprétation belge des décisions de l'Internationale sur le ministérielisme (1909–1911)', *International Review of Social History*, 10 (1965), 248, which is a particularly useful article. Other interpretations of socialist party history are cited below. See also Vandervelde, *Souvenirs*. It might be noted here that Belgium's closest economic rival through the 19th century, Britain, also harboured a Second International party that was intensely reformist. See Janet Polasky's forthcoming study of Émile Vandervelde, which details Vandervelde's reformism and his rise to control of the party.

frustrating to young radicals, did not explain their ultimate rejection of the
issue of women's emancipation. Indeed, many women were attracted to the
POB/BWP specifically because of the absence of dogma, just as their elders
had joined the equally ideologically 'messy' First International in Verviers.
In the end, however, working women members became the victims both of
electoral pragmatism and of the powerful bourgeois ideology of women's
proper sphere. The latter was particularly strong amongst the chief propa-
gandists of the post-1902 socialist women's group. These women, virtually
all *bourgeoises*, articulated a domestic role for women that would have
pleased the most rabid conservative. For them, all women belonged in the
margins of political life, rearing young male socialists, supporting socialist
husbands, but leaving political activity to the men.

Why did these socialist women choose this policy of subordination? The
explanation lay partly in the class origins of the new women leaders, many
of whom were at the same time members of the bourgeois feminist
movement, which aimed its efforts not at drawing working women into
the struggle for political and economic equality, but rather at various
reforms of concern to women of the middle classes. (They were particularly
anxious over the right to own and control property.) Moreover, the wider
Belgian feminist movement included not only *bourgeoises*, but also socialists
who claimed a working-class constituency, and Catholic feminists. Ironi-
cally, both groups identified working women's primary role as domestic,
within the sphere of the family.

Male socialists, in general, perceived all kinds of feminism as a threat. In
the case of socialist women, some men leaders feared that they would put
more effort into the struggle for women's rights than they gave to class
politics. The latter effort, socialists always insisted, should take precedence,
since the socialist utopia would automatically erase inequalities based on
sex.[8] And as for Catholic feminists, they were feared twice over. Not only
did they lure women into the struggle for women's rights, but they also
threatened to stimulate women's purported 'natural' religiosity, rendering
them susceptible to control by the church. Worse, because these same male
leaders believed in women's powerful manipulative influence within the
family, Catholic successes amongst working women would translate into
lost male votes for the socialists.

The threat of various kinds of feminism drove the socialist party to test
a variety of strategies. First, they denied the usefulness of a women's
vote—bourgeois feminists' central demand. In socialist families, men voters

[8] This idea enjoyed a long life. See the essays collected in Sargent, L. (ed.), *The Unhappy
Marriage of Marxism and Feminism* (Boston, Mass., 1981).

would represent everyone's view.[9] Others insisted that women would surely vote for the Catholics, at least until their 'correct' education could be completed. Lastly, some argued that the struggle for a women's vote was 'bourgeois', and not truly 'proletarian', an argument simultaneously under-cut, of course, by the leadership's persistent struggle for male suffrage.[10]

In constructing a policy on women's issues after 1902—once the voices of most socialist feminists had been silenced—the party depended upon choosing positions contrary to those adopted by the bourgeois feminists. Thus when the latter group announced its opposition to protective labour legislation (which would make women unequal competitors in the labour-market), the socialists did an about-face, and announced their support for such legislation, on the grounds that laws limiting women's hours and excluding them from some key occupations would have the desired effect of 'returning' women to their 'primary' work as mothers and wives! The domestic idyll, dear to bourgeois hearts, thus began to spread through the socialist ranks.

In this, as in other such policy decisions, party leaders revealed their keen desire to join mainstream society, which, in Belgium, was bourgeois society. It was clear by the early twentieth century that socialists had begun to see themselves not as a subversive force struggling against the oppression of the working class, but rather as one of three 'pillars' supporting the Belgian status quo (the other two being liberals and Catholics). In pursuit of this end, they remade working women into angels of the proletarian hearth.

These anti-feminist socialists were only part of the picture. There were some male leaders who favoured women's equality within the movement. But even amongst this group, attitudes conflicted. Some— usually Flemish—leaders wanted women to enjoy complete equality, with equal work, equal pay, equal economic independence, equal political rights. Others argued a 'separate but equal' line. This was not a thinly disguised socialist misogyny, such as that promulgated in these years by the French leader Paul Lafargue.[11] Rather, it was a belief similar to that held by women within the Verviers First International: working-class families ought to include a mother free to live and work at home, where she could be at once worker and mother. Proponents of this view were not privileging

[9] It was John Locke's opinion that in a family, a wife was represented by the husband.

[10] Of course Verviers's anarchists regularly announced their opposition to a single-minded pursuit of the vote.

[11] See my discussion in *Working Women and Socialist Politics in France, 1880–1914: A Regional Study* (Oxford, 1986), 192–4, 196–8, 206–7.

women's weakness; rather, they argued that women's differences showed their particular strengths, which made it imperative that they play a political role. They supported women's vote on the grounds that it would bring different—and often better—values to Belgian political life. To a large extent their views constituted a Margaret Thatcherism *avant la lettre*: housewives knew how to run a household budget, to keep life clean and orderly, to work hard. These skills, they argued, were needed in public life, as well as inside private households.[12]

All these various attitudes played themselves out against a backdrop of changing political fortunes in the years from 1890 to the war. The narrative of those changes, focusing particularly on their effects on our subjects, forms the rest of this chapter.

THE CONTEXT

Whatever socialists' positions or practices, of course, working women faced many real barriers to their political participation. They worked, usually at least 12 hours a day, from Monday through Saturday every week. Moreover, they demanded of themselves a very high standard of housewifery, famous in Flanders, but equally widespread in Wallonia: they washed, cooked, cleaned, mended, and swept far more than most women of the industrial slums of other countries, if outsiders were to be believed.[13] And, despite the very high rate of infant death, most working women had many children to look after. Although many eye-witness accounts of workers' meetings and demonstrations (as well as visual representations of strikes, such as Eugène Laermann's famous painting 'La Grève')[14] counted hundreds of women carrying children as they joined the milling crowds, the presence of such children always inhibited women's activities. In most pictures of strikes and marches from these years, women were depicted burdened like saplings after an ice storm, weighed down by children—one in their arms, three or four clinging to their skirts, a few more dragging along behind. At the very least, the presence of young children was a serious distraction.

[12] This 'domestic feminism' was widespread in the United States. See e.g. Kish Sklar, K., *Catherine Beecher: A Study in American Domesticity* (New Haven, Conn., 1973), and the writings of Jane Addams. It is ironic that many women who promulgate these ideas are themselves public figures, who do not practice what they preach.

[13] Their French Flemish neighbours were the same: see my *Working Women*. And it remains the case, as any visit to slums in e.g. Ghent and England's industrial north will show.

[14] Laermann's painting is in the Fine Arts Museum, Brussels.

There was another, more serious, problem. Movements require leaders, and in Belgium in these years, the working-class women's movement had few. There were several reasons. First, those charismatic women who led working women's movements elsewhere—Clara Zetkin in Germany, Paule Minck in France—had managed to overcome class barriers in order to appeal to those who did not share their bourgeois origins. In Belgium, however, class divisions proved much more permanent, not least because many influential *bourgeoises*—including those in the socialist milieu—were educated not in secular schools, but rather by the highly élitist Belgian church. Except for Nellie Van Kol, who worked in the Ghent movement, there were no women of the middle classes who were able to reach across the class divide to inhabit the working world. This meant that leaders would have had to have emerged from the working class itself. And here lay another problem: household work, plus motherhood, prevented most women's development into political leaders. Moreover, those who were single—and there were many, as we have seen—could not risk losing their jobs, a common penalty imposed by blacklisting employers in Belgium. (This problem was commonly solved by the party in the case of male militants, who became party officials or paid organizers.) If these problems were not sufficient to discourage any would-be leaders, Belgium's working women also suffered a short life expectancy: most textile-workers, for example, probably died before 40. Since militants were not created overnight, those women wanting to become leaders had but few years in which to do it.[15] Worse, few Belgian working women (excepting those in Verviers) had much education: illiteracy remained high, and higher amongst women than men. This did not in itself preclude women's participation in socialist activities, most of which did not require the ability to read, but it certainly limited an individual's ability to work as a militant or leader.

Overcoming these problems was possible, although it would have required a commitment on the part of male leaders that most women never enjoyed. The party never formally·undertook to train and cultivate women cadres, and thus it was not surprising that even when women leaders did emerge on the political scene, they soon vanished from the records. In fact, names of women speakers or demonstration leaders appeared and disappeared with striking rapidity as young enthusiasm met organizational indifference and neglect. (The situation was quite different for those the leadership identified as future male militants, who were carefully nurtured and trained, as extant autobiographies testify.)

[15] See Fauviau, H., *Le Borinage: Monographie politique, économique, sociale* (Frameries, 1929), 45–6, and my *Working Women*, 33–4.

Despite these daunting obstacles, however, Belgian working women, like their sisters all over industrial Europe, did manage to find a space for politics in their daily lives, particularly at the local level. All over the towns and cities of Wallonia and Flanders, working women joined the *fin-de-siècle* socialist movement. Characteristically, each local organization assumed its own personality, and thus women's roles within them differed—sometimes markedly—from place to place.

Liège

Here, a detailed story begins not with working women's initial efforts at politics (described briefly in Chapter 7), but rather with the first extant records of those activities. Until the 1880s, much of the usual evidence for such a history is missing, as we have seen. The record only becomes clear from the latter months of 1886, following the mass strikes in the spring of that year. No doubt prompted by those strikes, the police became extremely assiduous in their reports of potentially dangerous activities amongst local workers. And virtually every police spy reported the presence of women: in August at a socialist meeting about women's work in the coal mines; in September and October at gatherings called to discuss universal suffrage. Not only did police spies record numbers of women in every audience, they also discovered women on the speakers' platforms.

The first female speaker noted in police reports was 'Citoyenne Bemelmans', who spoke on various issues of local concern at a meeting in December, 1886. In the following months she was often featured at socialist events, discussing the restriction of women and children from underground coal-mining, the abolition of religion from everyday life, and universal suffrage. Soon after Bemelmans's appearance in police records, she was joined by a second woman, 'Citoyenne Thomas' from Verviers, whose ideas were apparently similar.

There were others, as well, but their names went unremarked. Reports noted only their presence, and made occasional vague references to their subjects, including, *inter alia*, women's emancipation and 'the social situation'. Police reporters, sadly for our purposes, continued the tradition of ignoring the content of women's lectures. Thus where men's words were painstakingly recorded, only the merest hints of women's ideas remain. A typical report dismissed a woman's speech at a Liège socialist meeting as 'the girls' usual little speech'![16]

[16] Reports in Linotte, L., *Les Manifestations et les grèves dans la province de Liège de 1831 à 1914: Inventaire sommaire des archives de la sûreté publique de la province de Liège* (Leuven, 1964),

Through 1887 women continued to draw large crowds. Thomas addressed '600 miners and their families' at Beyne-Heusay (near Liège) on the subject of 'women's emancipation' and 'women's rights', which, she argued, 'must be equal to those of men', according to one unusually verbose police spy. Citoyenne Bemelmans also continued her lectures in various workers' *quartiers* throughout the Liège area, although her police observer remained uniformly indifferent to her words, which he usually dismissed as 'a recitation learnt by heart'.[17]

The local POB leadership did not interest themselves in the specific recruitment of women until May 1887, after 700 boiler-makers—including 'beaucoup de femmes'—walked off their jobs at Cockerill in Seraing. Women's active role in that strike encouraged the local party to try to organize more of them. For a few months the Liège leadership printed recruitment brochures and published newspaper articles, all promising local women that socialism would 'end their employment' so that they could be supported by men! At the same time, they were guaranteed a place at the forefront of the class struggle, leading marches and demonstrations. But this was no special honour; instead, party officials admitted, women were less likely to be attacked by armed and mounted troops.[18]

Unfortunately, there is no record of women's reaction to the promise of unemployment and physical sacrifice. Liège's women speakers, on the other hand, took a slightly different, and probably more promising, tack when they joined the recruitment effort. Citoyenne Bemelmans, for example, echoing the Verviers women of earlier years, argued that women's difference suited them to the class struggle. 'You feel the social question in your hearts and in your dignity', she told a female audience. 'Enough resignation!' she concluded: 'join together and put a stop to these things ... Make your husbands and brothers join the workers' movement ... When the army, the magistrates, and the priests form a trinity to exterminate the people, it is time to unite to demand our rights'.[19]

In the following year, 1888, women speakers continued to appear at socialist events, and continued to elicit enthusiasm. '*Salut* to the *plébienne* who comes to speak, *salut* to sunlight and liberty', cried one man at the

carton XLIII, 1886, doss. A. nos. 441–506, and 522–31. Fuller reports are found in *AEL*, Sûrété Publique, XLIII, A. 521, 'Liège, 4 déc. 1886', XIV, A. 1–291, '1886', nos. 167, 229, 257, 268, 275, 285, 287.

[17] Ibid. XV, A. 1–81, '1887', nos. 4, 23, 26.

[18] Ibid. B. 1–143, '1887', nos. 107, 129.

[19] *Archives, Ville de Liège*, XLIV, 1887. A. 15. 15 fév. 1887, XLI, A. 14, 8 mars 1887, and XLI, A. 17, 17 mars 1887.

appearance in Seraing of 'Citoyenne Gonda'.[20] These many meetings ultimately found success: at the end of 1888, Liège's first women's POB section was organized, and a similar section in Verviers soon followed.

Details of this movement's history are lost; it seems likely that the women's main goal was that promulgated in Verviers in the First International: working women should abandon industry for work and motherhood at home. Leaders certainly included Mme Monseur and Citoyenne Maréchal of Verviers, and Marianne Wasson of Liège.[21] Many of the earliest reports suggested that they were heavily involved in supporting women's strikes. At one strike meeting in Liège, Mme Monseur told her audience that she had 'abandoned her home and family to come and exhort Liège *ouvrières* not to give up the struggle'. She promised that their sisters in Verviers's women's section would send immediate help. (The police spy was unable to comprehend the audience's reaction. He made a special note of the noise that continued through the speeches, and added that 'much gaiety' filled the room. 'The little *ouvrières* appeared much amused', he added, dismissively.)[22]

Male workers turned to Mme Monseur when they wanted to reach their female co-workers. On one occasion, when Liège mechanics were threatened by dismissal because de-skilling had encouraged employers to hire women in their jobs, they invited Mme Monseur to a union meeting. After hearing their complaints, Monseur explained that dividing the working class by gender was a mistake. Only 'solidarity' and a 'demand that women be paid equal wages' would deny employers their victory. She also told her audience that she spoke to them as a woman with 'two roles': that of worker, and that of mother. The combination, she claimed, had given her '*mâle* and energetic accents'. (Who knows what she meant? Perhaps her work was 'male', whilst her motherhood was 'energetic'?)[23]

The Liège workers' movement was much better documented in the next decade of the 1890s, not least because it was then that a young Lucie Dejardin first became aware of class politics. During adolescence, she discovered Marianne Wasson, a local militant who helped found women's

[20] Ibid., XLI, A. 14.

[21] The latter is best known because of her friendship with the young Lucie Dejardin, who recounted her relationship with the Ensival woman in later years in Chalmers, E. B., *Lucie Dejardin: Hiercheuse et député socialiste* (Huy, 1952).

[22] See *AEL*, Sûreté Publique, XVI, A. 1–84, no. 42, 26 Nov. 1888, no. 78, 22 Dec. 1888, and XVII, B. 1–140: 1889, no. 93, 29 Nov. 1889.

[23] Reported in 'Association des mécaniciens, Liège', *L'Avenir*, 14 Apr. 1889. Monseur, now frequently joined by Citoyenne Maréchal, continued to speak to women strikers in Liège and its environs. See e.g. 'Grève-La linière St. Léonard, Liège', in *Avenir*, 1 and 22 Dec. 1889.

party sections all over the region. As a result of Wasson's efforts (as well
as those of other local women) such groups spread. One typical women's
section, in the mining commune of Beyne-Heusay, called themselves 'La
Plébienne'; they marched in parades carrying their own banner, 'all dressed
in red'. The goals of the women's sections, according to Dejardin, were
'the same as those of their brothers'. They joined the national socialist
party *en masse* when the Quaregnon programme of 1894 added the
demand for women's full emancipation, including suffrage.[24]

Throughout the decade of the 1890s, women's groups met and new
ones were formed. Women's issues, and women themselves, were also
included in virtually every socialist or syndicalist activity. Ancillary groups,
such as the 'Young Rationalists', also welcomed women members, and
placed the issue of women's liberation amongst their primary goals.
Moreover, crowds of local women continued their active public role. In
every strike, every demonstration, every *fête*, they marched beneath red
flags, garbed in red and sporting phrygian bonnets.[25]

In the same decade names of women militants continued to appear and
disappear in police records. At one women-only meeting, called by socialists
in October 1894, 300 women heard the well-known Marianne Wasson,
who was joined on the platform by two unknowns, Citoyenne Bury, from
Verviers, and Citoyenne Moineau. (The latter may well have been Monseur;
police spies were notoriously inaccurate, especially about women's names.)
Unfortunately, the police report of the meeting was unusually laconic. This
time, however, the explanation did not lie in misogyny: the police had
been caught off guard, since no female agents were at hand when the
meeting's leaders excluded all men from the room![26]

In 1895 Brussels's bourgeois feminists' newspaper printed a story about
the Liège socialist women's groups, 'Meetings de femmes à Liège'. *La
Ligue*'s reporter described the popularity of the women's meetings, organ-

[24] See Chalmers, *Lucie Dejardin*, 42.
[25] See *AEL*, Sûrété Publique, XVIII, A. 1–222, 1890, and B. 1–111, 1890; XIX, A. 1–99,
1891; XLIX, a. 1892, nos. 59, 219, 231. In July 1893, the national congress of Libre-Penseurs
et Penseuses at Liège resolved in favour of women's 'complete economic, civil, and political
equality'. Reported in *La Ligue*, July 1893. Reports of other such meetings are in *AEL* Sûrété
Publique, XLVIII, A. nos. 25, 50, 101, 1891, and XX, A. 1–226, 1892.
[26] Ibid., LI, A. no 169, 18 Oct. 1894. It is surprising to discover Joseph Bonda's claim that
there were no women in socialist organizations except for a few school-teachers who had a
mixed-sex union in Liège. See *Histoire anécdotique de mouvement ouvrier au pays de Liège* (Liège,
n.d.), 329–30. The official socialist party history mentions women—and indeed, even the
Ghent women's group—but with little detail and with no recognition of the importance of
the issue of women inside the party before 1914. See Pétry I. and Farge, R., 'Présence des
femmes au coeur de l'action socialiste', in *Les Fastes du Parti, 1885–1960* (Brussels, n.d.), 313–
24.

ized by the Parti Ouvrier Liègeois. Two gatherings, held in two different workers' *quartiers*, attracted 1,200 women. Speakers were Citoyennes Maréchal and Wasson; their subjects included 'women's legal situation and the Code Napoléon', and 'women's status in society'. The journalist noted that the meetings were 'orderly', and the audiences 'attentive'; both speakers were 'warmly welcomed'.[27] In the following year, Namur's socialist newspaper, *La Bataille*, wrote that because of Liège's women's sections, 'we can count on a new strength'. According to the paper, the primary goal of the women's groups was 'to create and run *patronages* for the education and protection of socialist workers' children'.[28]

Many Catholics noticed the activities of these socialist women. The leader of social Catholicism, Father G.-C. Rutten, argued that these *Liègeoises* had become crucial to the success of strikes, because they prevented their weaker-willed husbands from giving in. One wife, he wrote, was so frustrated by her inability to keep her striking miner husband from returning to work during a strike that she followed him through the streets, ringing a bell![29]

Although it was clear that women were very active in local socialist politics by the end of the nineteenth century, it was also clear that they were not always supported by their male comrades. In Liège, as elsewhere, women were still expected to fulfil their traditional dual roles. 'It was the universal law for the majority of women that they must work two jobs', Lucie Dejardin complained bitterly. In spite of the fact that 'women had already worked all day by their sides', men remained 'scarcely impressed'. They still expected to enjoy leisurely evenings, when they were free to go out to union or party meetings, or to sit reading party papers whilst their wives toiled at the myriad domestic tasks that burdened working-class mothers of families. Moreover, this rule held for proletarian males of all ages. The small girls of the miners' *quartiers* of her childhood worked as 'little mothers', doing housework and looking after children whilst their brothers played or joined men at café-bars or meetings. No wonder, as Dejardin's biographer noted, 'Lucie began to revolt against masculine egotism'.[30]

From quite early in her life, in fact, Lucie Dejardin recognized that Liège socialists' commitment to women's emancipation was limited by traditional gender expectations. These latter produced an odd duality in women's

[27] *La Ligue*, Jan. 1895.
[28] Extract, 'Chronique Liègeoise', in *La Bataille*, 10 Apr. 1896, in Fonds Chambon.
[29] See Le Père G.-C. Rutten, *Nos Grèves houillères et l'action socialiste* (Brussels, 1910), 263.
[30] Quoted in Chalmers, *Lucie Dejardin*, 49–50.

political participation that became increasingly apparent after the turn of the century. As local socialists began to create their own rituals and customs, females began to play two roles: in reality, working in the mines and mills, striking, marching, organizing, meeting, speaking; and in socialist imagery, representing abstract socialist goals, such as 'justice', 'peace', and so on. Women were expected to assume these ritual roles willingly: in one mass march for women's suffrage in Liège, an announcement called on all participants to appear as 'Mariannes, coiffées du bonnet phrygien'.[31]

After the socialist party turned its collective back on women in 1902, women's groups in Liège began to lose members. For several years after 1902, women's support for socialism wavered, while leaders of the women's movement struggled to understand the betrayal. Finally, Lucie Dejardin and her friend Marianne Wasson decided to act: in 1910 they re-created a women's POB section in Liège. This group, significantly, avoided any suggestion of militance, calling itself the 'Ligue des femmes socialistes'. (Interestingly, it was in that same year that French socialist women abandoned their earlier feminist name and re-formed under the anodyne, 'Groupe des femmes socialistes'.)[32] Even within this Liège group, however, women continued to struggle to find their place in the broader socialist movement. As Dejardin remembered, no consensus was ever reached, even on the simple issue of whether women's groups should remain separate from the mainstream party, or should integrate fully into the party structure (which, it will be recalled, allowed such groups to join).[33] It may be that the presence in Liège of the young militant tendancy—of De Brouckère, De Man, Huysmans, and others—helped divide the women's movement. Those young men, all from the nation's educated ruling class, were never active supporters of women's rights, as we shall see with De Man, later.

The confusion in Liège was mirrored in Brussels, as national party leaders formulated no coherent post-1902 policy defining women's place in the movement. It was not until 1912, in fact, that the national party decided to invite the many local and regional women's groups to send delegates to national congresses. With this gesture, they awarded women's groups a legitimacy previously withheld, but it came too late, and little changed in the time remaining before the German invasion in 1914.

[31] *Archives de la Ville de Liège*, LLVIII, doss. A. 1901.

[32] See Sowerwine, C., *Sisters or Citizens? Women and Socialism in France since 1876* (Cambridge, 1982).

[33] One of the most interesting investigations of this issue of separatism vs. inclusion in mixed-sex groups is that by Clare Collins: see 'Women and the British Labour Movement', PhD thesis (London School of Economics, 1991).

Of course socialist party politics were not the whole story of Liège's workers' movement. Women and men workers, whatever their politics, continued to organize and join unions, and here again women were active.[34] The miners' union of Liège province, which directed its efforts at 'the *ouvriers, ouvrières,* and machinists of all categories, underground and at the surface of coal mines in the province', found a unique means of encouraging women's membership. They acknowledged women's lower wages, and created two categories of members: 'A' workers, including all women and all children under 18, and 'B' workers, all adult men. The first category paid lower dues—and most received lower benefits. All those in group A who were 'heads of families', however, whatever their age or sex, received the higher benefits of group B.[35] This recognition of women's special difficulties highlighted the extent to which Liège's union officials and leaders accepted women. And this acceptance was not restricted to the miners: even a group notorious elsewhere for its unwavering misogyny, the printers, welcomed women into their union. In 1914, in fact, there was even a separate *Syndicat des ouvrières du livre* in Liège, with 49 members.[36]

In addition to the story of Liège women's socialist and syndicalist activities in the period from 1886 to 1914, there was another tale, an extension of the female role in emergent ritual life. It was a story told visually by dozens of artists, who chose Liège's *ouvrières* as subjects for paintings, sculptures, and photographs. A hint of their approach appeared in the party's call for 'Mariannes' in phrygian bonnets and red dresses. But there was more to come, as socialists imitated other Belgians and began employing images of female workers, especially miners, to represent ideas and special events, as will be outlined briefly in Chapter 9.

Charleroi

In this period, relations between Charleroi's workers and the socialist movement were fraught with confusion. Unlike the multi-industry city of Liège, Charleroi housed only two primary industries: coal and glass. They were not, to employ vulgar Marxist terms, analogous. Glass production—

[34] It bears repeating that historians of these unions usually neglect to include women. See e.g. Dechesne, L., *L'Avènement du régime syndical à Vervier* (Paris, 1908), 52.

[35] See Déthier, N., *Centrale syndicale des travailleurs des mines de Belgique: 60 années d'action, 1890–1950,* (n.p., n.d.), 51, 56. This union leader notes that the idea of a 'family wage', paid to men, did not appear in the miners' movement until after the war, see p. 160.

[36] See Bonda, *Histoire anécdotique,* 344. The printers' efforts to recruit women to their union are documented in *Revue du Travail* from the mid-1890s until the war. These efforts centred in Brussels, however, and thus lie beyond the focus of this work.

whether of humble industrial bottles or of fine crystal—demanded highly skilled workers: blowers, cutters, engravers, designers, and so on. Coal, on the other hand, required brute strength, courage, and a willingness to work past exhaustion. Many contemporaries believed that these differences meant that no single workers' movement could represent both. Glass workers, most thought, who were paid far more than even the most skilled coal-miner, would cling to their status as labour aristocrats, disdaining their humbler brothers and sisters. But those who made this claim overlooked an important fact. Glass-workers, like local miners, identified themselves first as Carolingians. This regional identity proved far more important in the history of Charleroi's workers' struggles—and women's place in them— than any consideration of the hierarchy of labour.

What did it mean to be 'Carolingian'? For our purposes here, the most important aspect in the *fin de siècle* was the traditionally mixed-sex workforce. This did not mean that men and women customarily shared jobs, as they were likely to do in the textile cities, for example. Here, men and women tended to occupy clearly gendered jobs. Sometimes, age also dictated specific work. In the coal mines, as we have seen, women worked as *hiercheuses* until their mid- to late twenties. In glass, too, it was primarily young women who occupied the most sought-after job, that of 'porteuse de canons'. In both these cases, the pay was better than that earned in most other 'women's jobs' in Charleroi. (In these years, it should be recalled, they included the various sweated trades, as well as employment in scattered textile mills and potteries.) In both cases, too, the work carried with it considerable pride. *Hiercheuses* boasted physical strength, high wages, and a treasured *insouciance* in the face of danger. Similarly, the *porteuses* valued their strength and special agility. Carrying heavy cylinders of newly-blown glass demanded both these qualities. Like the *hiercheuses*, they wore uniforms easily identified by passers-by. Their youth attracted similar reactions from their co-workers, as well. As older miners recalled the jolly, constantly singing *hiercheuses* of their youth, so elderly glass-blowers remembered playful, pretty, and equally gay *porteuses*.

For older women, age brought important changes, in both work and status. In coal, those who moved to work at the surface relinquished the positive images that were the purview of all those who laboured under- ground. Coming up from the earth's 'entrails' signalled a significant loss of status. In glass, however, age did not necessarily diminish women workers' importance. Most who remained in the industry became skilled cutters and polishers, exchanging their short skirts and white blouses for long, aproned dresses and headscarves. No loss of status accompanied this change, not least because new, and much more 'feminine', skills took the place of the

old. Thus where older women coal-miners rarely figured in popular workers' songs, older women glass-workers sometimes did.

This is not to suggest, of course, that the young women of each industry were celebrated in the same way or to the same extent. The *hiercheuses* (here, as in Liège and the Borinage) enjoyed a reputation for 'tomboyishness', symbolized by their 'men's clothing'. Women glass-workers, by contrast, were frequently identified with the characteristics of their product: an exaggerated femininity, delicacy, fragility. When these women workers sang at work, their songs were described as 'little ariettes' by male comrades. Others remembered women's hair in similarly diminutive terms, as 'little ringlets'. Indeed, everything associated with female glass-workers underwent shrinkage in the language of those writing or singing about them—a transformation quite inappropriate to the rougher world of the coal-mine.[37] One typical song described the *coupeuses* as 'enchanting' and 'magical', adjectives which surely would have rung false if applied in song to the more androgynous *hiercheuses*.[38]

Folkloric definitions of labour in Charleroi usually included female and male workers together. One popular song reminded Belgians to think about the workers who made their drinking glasses. The lyricist added a list of those workers. In it, women were lined up within the working group, differentiated only by the gender of their work titles and by 'feminine' adjectives'.[39] There were other songs, some written for men to sing to the women, others for women to sing alone. One man's song described the glass-work's mascot, a kitten kept by *porteuses*.

There was one song that sang only of a female worker. A very rare example of a working woman's voice, 'L' Petite Verrière' was written, in Wallon, by Félixa Wart-Blondieu at the turn of the nineteenth century. Its lyrics were an interesting combination of 'feminine' diminutives and 'masculine' qualities, such as occupational pride, fortitude, 'roguishness'. The following extract gives the flavour

> I am the little glass-maker
> Who goes off every morning.
> I am truly proud
> When I leave with my *quertin*.
> I go bouncing off in my *sabots*

[37] See 'Nos Verriers', a song found in 'Folklore', Fonds Chambon. These lines come from stanza 6. Constantin Meunier sketched several pictures of these women at work, and the results are very different from his pictures of tomboyish *hiercheuses*.

[38] 'Avez-vous déjà bien pensé', is in 'Folklore', ibid. Both songs were in Wallon.

[39] Ibid.

> Like a real little rogue
> In my pretty short skırt
> And my little satin scarf . . .
> I don't envy any girl
> I never stop
> I am always happy.
> I go straight along like a crossbow
> Never applying a brake . . .
> I don't miss a day
> Except for Monday *ducasses* . . .
> I am in my place on time
> Sitting at my cutter's table.
> When I am working,
> I never stop singing . . .'[40]

That such occupational pride developed amongst Charleroi's working women was explained, at least in part, by the absence of the kind of male hostility directed by male workers at their female colleagues in neighbouring countries, such as Britain, for example. The strength of men's solidarity with women in Charleroi was demonstrated as well in the language of the local socialist party, which took pains to avoid limiting its rhetoric to masculine forms. A typical appeal to local workers to join Mayday celebrations planned for 1890, for example, called for 'miners, metalworkers, glass-workers, pottery-workers: *ouvriers* and *ouvrières* of all categories'.[41]

Given this inclusiveness, it was ironic that the group that ultimately dominated Charleroi's workers' movement was an imitation of that supremely masculine example of American workers' groups, the Knights of Labour. Charleroi's Chevaliers du Travail employed what were thought to be highly gendered rituals and rites, imitative of the more bourgeois Freemasons. According to one historian, the Chevaliers' main appeal lay in their exclusivity, their 'jacobinism'.[42] And yet from their first years in the 1880s—their growth impelled by the arrest and imprisonment of two young union leaders after the Badoux incident of 1886—the union's maleness had certain important limits. Although they did hold secret

[40] Ibid. and Tipoli, P., 'Kiki', also in 'Folklore'. Henri Lefebvre sent the glass-worker's song to Chambon in 1962 for his collection of documents from Belgium's glass industry. Lefebvre dated the song 1912.

[41] PG, no. 227, extract from *La Bataille*. Mayday events in that year drew 16,000 workers in Charleroi, and 5,000 in Mons, according to officials.

[42] This is detailed in Abs, R., *Histoire du Parti Socialiste Belge, 1885–1960: Synthèse historique* (Brussels, 1974).

meetings, women were allowed to attend, though they were asked to leave for rites or discussions of ritual secrets.[43] Equally secret 'forest rites' (reminiscent of those described by Zola in *Germinal*), always included women, however—although whether as equals, or in ancillary roles, is not known.

Local membership growth in both the Chevaliers and various socialist groups slowed in 1887 when local socialists and unionists together left the national party over the issue of the general strike. Charleroi's beloved leader, the lawyer Alfred Defuisseaux, had long supported using the strike as an effective weapon in the class war. But after the violence of 1886, party leaders in both Brussels and Ghent decided to oppose any further use of the general strike for political ends. Defuisseaux was expelled from the party, and for the next two years, at least, Charleroi's socialists turned their backs on the national scene.[44] Although they eventually re-joined the POB/BWP in 1889, and played an active part in the long campaign for complete male suffrage, they never overcame a lingering suspicion of the national leadership. While other local movements gradually became more attached to a centralized, national party structure, Charleroi's groups remained at a distance.[45]

Charleroi's organized workers, perhaps more than any other Belgian labourers, revelled in the defiance of authority (and relief from monotony) found in the mass action of the strike. Any workers' meeting, even those with a specifically political intent, was likely to end in a work stoppage. The most extreme example occurred in the spring of 1895, when a series of meetings featuring Juliette Saussez, speaking about women and socialism, culminated in a massive glass strike: between 6,000 and 9,000 men and women walked off their jobs.[46]

Women's notorious militance was so essential to maintaining such strikes that the glass-workers' newspaper, *Revanche de Verriers*, pleaded constantly for women to join in union activities. Most appeals to Charleroi's *porteuses de canons*, and *tireuses de grilles* were aimed at women's hearts. *Ouvrières'* particular hardships, went the argument, combined with their

[43] The French feminist theorist, Hélène Cixous, would certainly argue that women were excluded because men thought they would laugh. See 'Castration or Decapitation?', trans. Kuhn, A., *Signs* (autumn, 1981), 41–55. The source for the information is Delattre, A., *Histoire de nos coronas* (Verviers, 1953), 54–6.

[44] See Michel, J., 'La Chevalerie du travail: Force ou faiblesse du mouvement ouvrier belge?', *BTNG/RBHC*, 9 (1978) 134.

[45] See ibid. 141. See also Poty, F., Delaet, J.-L., *Charleroi: Mémoire ouvrière*, iii (Brussels, 1985).

[46] PG, 232, Corps de Gendarmerie; and 'Aux Femmes', *Revanche de Verriers*, 15 Apr. 1895. There is no further information about Juliette Saussez in my sources.

'natural' sympathies, lent them a 'special awareness of working-class miser-
ies', in one writer's words.[47]

By the end of the 1890s, working women's prominence in Charleroi's
working class brought the first socialist-sponsored feminist congress to
that city. Reports of the meetings were sparse, but one official notice
stated that the meeting was led by both women and men militants,
including two local leaders, 'Pirson-Lothier and his wife'. (The latter was
described as a Charleroi 'feminist leader'.) The meetings concluded by
resolving several key feminist demands, including representation on all
workers' bodies (including the important Conseils des Prud'hommes, work
inspection teams, and so on), equal pay for equal work, and an 8-hour day
for all workers, regardless of sex or age.[48]

Charleroi's working women were clearly deeply embedded in union and
political life. But they did not entirely escape the misogyny directed at
working women elsewhere. After the turn of the century, one particularly
vocal opponent of women's rights emerged from amongst local miners.
Alfred Lombard was convinced that women were the source of all male
unionists' failures. At one point he declared women 'the most terrible
enemy of *syndicats*'. 'That woman *ouvrière*, little educated, bewildered both
by the capitalists and the clericalists' legends, is a constant problem', he
complained. Because of her, 'money paid to the union is money lost'.
Tellingly, he usually referred to the objects of his contempt as 'filles'.[49] At
the same time, Lombard tried to defuse likely local opposition to such
views by posing as a supporter of women's recruitment to the union. But
his reasons exposed his prejudice: 'Women hold the power in the household
and thus it will be the woman, by her little *causettes* at home and
amongst her women friends who will make recruits for the union'.[50]

Happily, Lombard represented a minority not only locally, but also in
the national miners' movement. Throughout the years after the turn of the
century, the male-led miners' union, for example, directed recruitment
efforts and various campaigns at women. One surprising example was the
position taken by the union paper, *L'Ouvrier Mineur* on women's pensions.

[47] See *Revanche*, 15 Apr. 1895 and 'Aux Femmes', 10 Feb. 1896, as well as an untitled call
to women on 10 Jan. 1902. 'Tireuses' were those who stoked the furnaces and re-heated the
glass during the blowing process.

[48] PG, 244 A, Congrès Féministe ouvrière, 16 July 1899. See also, 'Le féminisme avant la
lettre', *Journal de Charleroi*, 25 June 1899. This was a story published in preparation for the
congress. It told of Agnodice, an Athenian woman who had fought for the right to study medi-
cine.

[49] Lombard, A., 'La Puissante organisation des mineurs anglais', *Ouvrier Mineur*, Feb. 1903,
and report of a speech by Lombard ibid., June 1906.

[50] Lombard, A., 'L'Organisation syndicale', *Ouvrier Mineur*, Sept–Oct. 1901.

There were two kinds of pensions paid to women: those paid to widows of miners, and those paid to female miners who had become disabled through work-related illness or accident. Ordinarily, both kinds of payments ceased if a woman married, whether or not she had been a widow. At the point of her marriage, each received a single payment (a 'dowry') equivalent to two years' pension. The union argued that whilst this was a just settlement for widows, it was completely unfair to women receiving their *own* pensions, earned by their own work in the mines. A disabling work accident, the union argued, diminished a woman worker's value just as much as it did a man's. The sum paid in this kind of pension was meant to compensate a worker for his or her lost monetary value, and should not be taken from a woman simply because she married. By contrast, a widow's value was not similarly compromised by her huband's death. Therefore, the union concluded, the two groups—of widows and women workers—ought not to be grouped together simply on the basis of gender.[51]

Such an analysis of the connections between gender, work, and marriage was remarkable, particularly since it came from within the national miners' union. Any comparison with the miners' union papers of other countries— Britain, France, Austria, or, the most misogynistic of all, Germany—would quickly highlight the uniqueness of gender attitudes within Belgium's mining community. Even when the Germans repeatedly attacked Belgian miners for 'allowing' women to work in the coal industry—attacks heard at every 'international' miners' meeting from 1900 to 1914—the Belgians remained unmoved. Although they voted in favour of resolutions calling for restrictive labour legislation for women, they did so with little enthusiasm and no misogyny. On the whole, Belgian men steadily refused to close their ranks to the working women of their tight-knit world. (And here again, the case of Belgium flies in the face of historiographical stereotypes about gender relations in the industrial working class in our period.)

These very brief outlines of women's part in the Second International era workers' movements of two distinct industrial regions offer little more than broad hints of the more detailed story. But their basic premiss, that working women played a part in the Belgian workers' movement that was distinctly different from that described by historians of other parts of Europe in this period, finds further support in evidence from other industrial centres. Indeed, the essential elements of the stories of both Liège and Charleroi were replicated—albeit with numerous local variations—through-

[51] 'À Propos de la caisse de prévoyance des mineurs', ibid., May 1902.

out Belgium's working world. And thus 'little by little, women came to swell the socialist ranks, wanting to act', recalled one contemporary.[52] New women members came from all over—not only from their traditional occupations, in mining, textiles, and glass, but also from steel and iron (both, like mining, usually considered bastions of proletarian masculinity). In 1893, for example, police in Tubise reported a parade of 650 metal-workers, led by 140 women.[53] In 1898 the Fédération Métallurgique Belge confessed that it had—'unforgiveably'—neglected the 4,000 to 5,000 women working in their industry. Only in 1897 had union leaders seen the light and begun to organize women, and from then on many thousands of women joined the movement.[54] Moreover, these metal-workers were not the only male unionists who suddenly 'discovered' women. The marble-workers—cutters, engravers, and polishers—also showed sudden concern about their female co-workers in the final years of the nineteenth century. (Women in marble works were usually employed as 'dailies', doing all the various odd jobs found in quarries or stone masons' yards.)[55]

Industrial Wallonia was not the only venue for such efforts. In fact, one key centre of socialist agitation both about and by women was the Flemish university city of Leuven. Police and other state officials kept a very close eye on the small city throughout the years from 1899 to 1914, and their reports documented widespread socialist and feminist activities. The local Flemish-language socialist press was also replete with stories of working women's militance, not only in Leuven, but also in nearby Antwerp.[56]

Even women in rural Belgium felt the brush of socialist women's politics during the *belle époque*. At the POB/BWP's agricultural congress in 1900, a representative from the Flemish town of Ath told the meetings that his 'mutuality' had floundered until the men had had 'the fortunate idea of admitting women'. 'In fact,' he noted, 'this was an excellent tactic; women

[52] Delhaye, J.-P. et al., *Hainaut occidental: Mémoire ouvrière*, iv (Brussels, 1985), 46–7.

[53] PG, 233, Tubise, gendarmerie.

[54] 'Les Fédérations nationales de métier en Belgique—Fédération métallurgique', in *Avenir Social* (1897), 259–61. Peter Scholliers's study of this group makes no mention of women: see *De Gentse metaalbewerkers in de 19e eeuw: de enquête van L. Varlez* (Brussels, 1985). Given the stereotypes, it might be interesting to note that the union listed the following trades open to women as well as men: mechanics, casket-makers, locksmiths, blacksmiths, wrought-iron workers, iron casters and moulders, sheet-metal workers, iron turners, planers, bronzers, engravers, limestone-cutters, and rollers.

[55] See 'Les Fédérations nationales de métier en Belgique', *Avenir Social* (1898), 332.

[56] PG, 242, Agitation, 1899, 1903, 1904. Both these cities deserve close study by historians interested in rediscovering women lost from Belgian history.

often prevent their husbands from joining organizations, but here, these women have become the most ardent defenders!'[57]

How successful overall were these efforts to recruit women of the people to socialism? Although unreliable, one government report estimated that 9.2 per cent of male workers and 1.76 per cent of female workers belonged to socialist unions in 1900.[58] The report did not note which categories of workers were counted, or whether or not 'socialist' included the many fellow-travelling 'independent' unions, such as those that dominated Verviers. But assuming that the category 'worker' included only those working outside agriculture, this percentage of women added up to a significant union membership of 565,474.

These two short outlines of women's activities in the working-class struggles in Liège and Charleroi, together with the brief facts linking them with other regions, provide only a suggestion of the extent of working women's much more varied political and union participation in these years in Belgium. Although sources treating other centres are even sparser and more contradictory than those for our geographical foci here, one hopes that further local research—perhaps with newly discovered archival sources—will prompt a much more detailed narrative of women's workers' roles in the class struggle all over Belgium's working world.

Ghent

The history of Ghent's women's movement falls into two periods: from 1885 to 1902, when it flowered into the most theoretically sophisticated women's movement anywhere in the Second International; and from 1902 to 1914, when it declined sufficiently to leave the field open to the Brussels-based, mainly bourgeois, and almost entirely francophone socialist women.

By any standard, Ghent was the birthplace of Belgian socialism. From the earliest days of Vooruit, the solidarity of Ghent's working class grew steadily. At the beginning of 1885, the food co-operative alone had 2,342 member families.[59] Of the conditions for membership, the first, that all applicants be workers, was possibly the most important. Ghent's socialist movement (like the earlier workers' movement in Verviers) was from the first a genuinely grass-roots effort, the precise opposite of that in the rival

[57] Loupoigne, 'Enquête agricole', *Avenir Social* (1900), 101.
[58] *Revue du Travail* (1901), 58.
[59] Van Den Heuvel, J., *Une Citadelle socialiste: Le Vooruit de Gand* (Paris, 1897), 7, 19.

centre of socialist politics, Brussels, where the party was always dominated by bourgeois intellectuals.

By the mid-1880s, Vooruit had grown into far more than a modest food co-operative, as we have seen. For their 25-centime initiation fee, members enjoyed a wide variety of benefits, including not only the customary range of insurance funds, but also every imaginable kind of social activity. Indeed, Vooruit had become, as contemporaries remarked, a 'citadel of socialism', a genuinely parallel society within bourgeois Belgium. Vooruit's solidarity was such that one observer claimed that it stifled dissent. In the words of Jules Van den Heuvel,

This phenomenon of complete docility, absolute on the part of the very considerable worker masses, and in a milieu as irreverent as the Ghent population, will surprise some . . . But it is in every fibre of the heart that the worker is held to the party. He (*sic*) is tied by interests: to mothers, the co-operative furnishes the household's bread, groceries, shoes, clothes, coal, and all at a better price than elsewhere; to the father, a union and better wages.[60]

Of course not only fathers belonged to the union—or mothers to the co-operative. Instead, Vooruit's politics breathed life into every working family. Each *coron*, each tiny workers' street, had a political committee which identified and trained prospective militants from an early age. Here, too, in thousands of small meetings, usually in *estaminets*, workers joined the movement and quickly found their way to the *Werkershuis* near the city centre, more popularly known simply as 'Vooruit'.

Party leaders were alert to the importance of this highly localized political life. In 1886 they objected strenuously to the proposed destruction of the crowded, unhealthy workers' quarters of the city. Moving workers to suburbs, far from their traditional neighbourhoods in the heart of Ghent, was 'a social danger', according to Vooruit's leader, Édouard Anseele. The danger, as he saw it, lay in the physical separation of classes; of course a parallel danger was that socialism might not have flourished once the city's highly politicized working-class communities were disbanded. Moreover, much socialist enthusiasm depended upon workers' daily experience of the stark contrast between the opulence in which the local industrialists lived and their own grim poverty.[61]

A second characteristic of the Ghent movement was its attachment to the socialists of French Flanders. Lille and Roubaix were the headquarters of Marxism in France in these years. Both party leaders, Jules Guesde and

[60] Ibid. 23.
[61] *Enquête—1886*, ii, 16.

Paul Lafargue, eventually represented these cities in the French legislature. Both repeatedly visited Ghent in the 1880s, as did the socialist feminist Paule Minck and the ex-Communarde Louise Michel. Guesde and Minck, and to a lesser extent Michel, were enthusiastic speakers in the feminist cause, and their public meetings in Ghent enjoyed considerable success amongst the city's women workers.

German socialists also played a local role. Karl Liebknecht, amongst others, regularly visited the city. As Vandervelde was to discover in 1891, Liebknecht—together with many other German leaders, not least August Bebel—carried his convictions about women's equality wherever he travelled in the socialist world.[62] Both the French and the Germans helped shape Ghent's socialist politics. Most importantly for our purposes, the promulgation of a theory of women's liberation within both France and Germany helped encourage the birth in Ghent of a socialist feminist movement.

This effort began in July 1886, when a Socialist Women's Propaganda Club was founded.[63] (It was quickly imitated: in Antwerp in 1887, in Leuven in 1889, in Brussels in 1890). From that date, every political gesture by Ghent's socialists—every meeting, march, strike, demonstration, or *fête*—was marked by feminism. In Ghent the POB/BWP's primary goal, the vote, was never ambiguous about gender. Suffrage, for Ghent's socialists, meant suffrage for both women and men.[64]

The Socialist Women's Club spread its message all over the city, publishing many brochures and books articulating their demands. In 1889 two titles appeared: *De Vrouw in de Maatschappij* by 'Sylvia' and *Het Vrouwenstemrecht* by Émilie Claeys ('Women in Society' and 'Women's Suffrage'). 2,250 copies were printed of the first, and an impressive 12,000 of the second; both joined the more than 5,000 books already available to members in Vooruit's lending library.[65]

From the outset, the unquestioned leader of the women's club was

[62] See 'Socialistes Gantoises', in *Voix de l'Ouvrier*, 21 Dec. 1884.

[63] Reported in *Reglements van den socialistische propagandaclub voor vrouwen ingericht den 25 juli 1886* (Ghent, 1886); Vanweehaeghe, S., *De Socialistische vrouwen, de socialistische Vooruitziende vrouwen en 'Stem der Vrouw'; sachets van het ontstaken en de evolutie van de socialistische vrouwenbeweging en haar orgaan* (Ghent, 1983), i and ii; De Weerdt, D., Galla, G., Van der Wildt, F., *100 Jaar socialistische vrouwenbeweging* (Brussels, 1985).

[64] See Keymolen, D., 'Vrouwen emancipatie, 1844–1914', in Van Houtte, J. A., Niermeijer, J. F., Presser, J., Romein, J., and Van Werveke, H., *Algemene geschiedenis der Nederlander*, xiii (n.p., 1978), 67. See also Avanti, *Een Terugblik. 2de herziene en aangevulde uitgave, met bij voeging van der toestanden tot 1931* (Ghent 1939), 97.

[65] Avanti, *Terugblik*, 123, and *Enquête—1886*, ii, 10. See also Liebman, M., *Les Socialistes belges, 1885–1914: La révolte et l'organisation* (Brussels, 1979), 192–3.

Émilie Claeys.[66] Local Catholics accused this textile-worker of 'founding in our city that horrible thing: a club of women socialists and Free Thinkers'.[67] And she certainly was a free thinker. In *Vrouwenstemrecht* Claeys outlined the premisses of a theory of women's emancipation entirely new to Belgium: in a capitalist society, women's equality demanded a direct relationship to production. This was a necessary basis for the requisite economic independence from men, as well as the sole means of preventing women's lives from being 'warped' by the subjugation experienced by economically dependent wives.

In 1889 such ideas were startingly new. Moreover, the women's group added one demand that was equally ahead of its time: equality, they believed, must characterize every aspect of life, both personal and economic. Only the equal treatment of men and women workers would result in what they described as 'women's revolution'. To this primary goal, they linked several issues long of concern to Belgium's working women: equal pay, equal legal and civil rights, and most importantly, the vote.[68]

Because of the women's insistence on equality, Ghent's socialist party never supported inequalities in reform legislation. In the 1886 enquiry, for example, Vooruit's witnesses argued in favour of shorter hours for everyone, without regard to sex or age. They reasoned that this reform would provide more employment for everyone. Wages, housing conditions, health and safety standards were also claimed for all of Belgium's workers.[69]

Ghent's socialist successes soon prompted opposition. At the end of 1887 the anti-socialist Volksbelong was founded. By 1889 this mixed-sex group claimed 8,500 members, whose membership included membership in a consumer co-operative modelled on Vooruit. Shortly thereafter, in 1891, the Catholics joined the race for workers' hearts and minds, founding a group called the Ligue ouvrier anti-socialiste. As the use of French indicated, this was a mixed-class group. The only requirement was that potential members be Catholics.[70] By 1892 the Catholics had grown sufficiently concerned about the spread of socialist feminism to found a

[66] No full-length biography of this remarkable woman exists. Philip van Praag has written a study of her life: 'Emilie Claeys, 1855–1943', in *Tijdschrift voor sociale geschiedenis*, 11 (June 1978), 177–96.
[67] Quoted by van Praag, ibid. 178.
[68] Emilie Claeys, *Het Vrouwenstemrecht* (Ghent, 1892).
[69] *Enquête—1886*, ii, 16.
[70] Van den Heuvel, *Citadelle socialiste*, 25 ff.

women's auxiliary, designed to counter socialist influence on Ghent's *werksters*. It, too, was open to all classes.[71]

Not to be outdone, Vooruit reacted by opening a Sunday school for girls, run by militants in the women's club. Its stated purposes included opposing both the church and 'liberalism'. (This should be remembered: it became important a few years later when Brussels leaders proposed an alliance with the liberal party.) The Sunday school met from 4:30 to 8:00 p.m. and cost each student 5 centimes.[72]

To the numerous meetings held to recruit new women members, Vooruit added dozens of newspaper stories aimed specifically at *werksters*. The party paper, also called *Vooruit*, featured announcements of new women members—many couched in quasi-religious language. A woman from Diest, for example, described her 'call' to socialism. Others told of being 'awakened' to the news.[73] Further, *Vooruit* regularly dramatized women's achievements all over the world. In January of 1889, for instance, editors congratulated two American women who had qualified as ship's captains. 'Bravo!' cried the paper.[74]

In the 1890s, the women's group got its own newspaper, *De Vrouw*, edited by Émilie Claeys and a newcomer to Ghent, Nellie Van Kol. The latter, although married to a Dutch socialist, Hubert Van Kol, was actually a *Liègeoise*, Jacqueline Porrey. According to Belgian police spies, she was 'a fervent adept of socialist theories that she defends under her pen name, "Nellie"'.[75] Her husband also wrote under a pseudonym, 'Rienzi'; his work, always concerned with women's history and/or women's rights, appeared regularly in the socialist and feminist press.

Underscoring the extent to which Ghent's women's movement was the work of both men and women was an abundance of male interventions in the pages of *De Vrouw*. One of the most interesting of these was a long poem, written by Peer Corstiaan and published in August 1893. It recounted the story of a father, who had 'inherited a sense of justice from my much-loved mother'. A longing for justice had, in turn, driven him into the socialist struggle—on behalf of his three daughters, to whom he hoped to pass on his legacy.[76] This poem's message was a familiar one in Ghent:

[71] Keymolen, 'Vrouwen emancipatie', 67.

[72] 'De Socialistische zondag school', *Vooruit*, 4 Jan. 1889.

[73] Ibid.

[74] 'Amerika', ibid. Jan. 1889.

[75] *Royaume de Belgique*, Archiefs van Buitenlandse, 186.II. In 1880 the pair were in Switzerland. Later, they returned to his native Netherlands, where Nellie Van Kol helped create a Dutch women's movement linked to that in Ghent.

[76] In *De Vrouw*, 15 Aug. 1893.

men and women occupied the class struggle together, and on each other's behalf.

The women's collective position was set out in Émilie Claeys's book, *Vrouwenstemrecht*, which was a ringing manifesto calling for women's suffrage. For those familiar with such manifestos, it took a familiar form: beginning with those historical figures whose lives demonstrated the justice of the author's claims, the manifesto went on to argue the case. Claeys's heroes here included Condorcet, Olympe de Gouges, and Mme Roland from the French Revolution (but not, interestingly, the Belgian, Théroigne de Méricourt), Louise Lacombe and Julie Daubié from France's 1840s feminist movement, and John Stuart Mill from the more recent past.[77] Claeys also cited the successful feminists of Wyoming and Kansas: the former, she noted, had won the vote, while the female inhabitants of Edgerton, Kansas, had obtained a limited local suffrage.

Given these victories elsewhere, why were Belgian women so far behind? Claeys's manifesto outlined the barriers preventing Belgium's women from obtaining their rights. Most important was a deeply felt hostility to women, based—in her view—entirely on stereotypes (many of which, she added, were also used to prevent male workers' enfranchisement). These included a purported political 'immaturity', a lack of sufficient education, and 'natural tendencies', either for reaction (if opponents were liberals) or for revolution (if they were conservatives). Claeys argued that both male and female workers should be granted the suffrage, and that both had earned it in precisely the same way: by labouring with identical strength in Belgium's industries. 'No one', she added, 'could claim that the work of women carders and spinners, of weavers and finishers, is not just as profitable as that of male spinners, weavers, finishers, and other factory slaves'. Moreover, the work of 'flower-makers, seamstresses, laundresses, and dressmakers' was as useful as that of 'suit- and shoemakers, printers, carpenters, and so on'. Indeed, given the fact that social usefulness was the ground for claiming rights, women possessed a double claim. 'We women, who are doubly oppressed have thus even more need of rights', she added. 'This system alone is just, and in the name of justice we demand that it be put into practice'. Objecting to the humiliating provisions of Belgium's legal code she cried, 'We shall no longer be kept in the same category with lunatics and idiots!'

Claeys concluded her call to arms by attacking the widely held belief that if women voted, their 'natural' religiosity would drive them straight into the arms of the church. This was an ancient canard, Claeys wrote, as

[77] For information about these women see Moses, C., *French Feminism in the 19th century* (Albany, NY, 1984).

old as Condorcet's criticism of it, a century earlier. Women in fact possessed no particular religious tendency; rather they simply had less education than men. And whose fault was that? 'The more ignorant the woman, the guiltier the men', she argued. 'It is men who have seen to it that women's knowledge is limited to household skills, to keeping children, cooking the soup, cleaning the house'. Whenever women tried to discuss politics, 'Men say: "Foei! that is men's business, not women's" '.[78]

Like Lucie Dejardin, Claeys was infuriated by such 'male egotism'. Unlike Dejardin, however, Claeys inhabited a milieu that welcomed women's efforts to overcome patriarchy. Ghent's socialists were, in fact, so notoriously sympathetic to women's struggles for rights that they drew the approbation of Brussels-based bourgeois feminists. That group's newspaper, *La Ligue*, published several articles in 1893 praising Ghent's women's movement, including an adulatory report of the socialist congress held in Ghent in that year in which women played an active role.[79]

Émilie Claeys was especially vocal during the meetings. In a long speech, she outlined several women's demands, including the right to vote in all 'industrial and labour councils'. Moreover, she argued that the party should spend much more time engaged in the women's struggle—more time on women's education, more time recruiting women to trade unions that called themselves 'socialist'. Furthermore, 'fathers of families' should not enjoy a 'plural vote': 'Men must not vote in women's name', she said firmly. To ensure that the party met women's demands, Claeys proposed the following resolution:

The congress, in keeping with the programme of the POB/BWP, as well as with the resolutions of the International, declares that the POB/BWP will pursue by every means in its power the suppression of every law which consecrates the civil, political, and economic inferiority of women; that it claims the right to vote for women, as well as men.

Further, she added,

The congress demands that women be eligible to stand and to vote for all economic and political councils, communal councils, those of industry and labour, *bureaux de bienfaisance*, and so on. It suppports women in all these demands and will claim their immediate realization'.[80]

[78] Claeys, *Vrouwenstemrecht*.
[79] 'Les Femmes au congrès socialiste de Gand (2–3 avril 1893)', *La Ligue*, July 1893. Official party reports were bland: see *Parti ouvrier: Compte-rendu du congrès extraordinaire tenu à Bruxelles, 25, 26, déc. 1893* (Brussels, 1893), 15.
[80] Ibid.

Delegates at this 1893 congress did not let her down. Not only did they vote this very strongly worded resolution, but they also elected its proposer to the party's central committee. Their choice was remarkable: other European socialist parties were busily adding their 'token' woman to governing councils, but the Belgians were amongst the few to choose an articulate, genuinely revolutionary feminist for the position. (Lily Braun, chosen by the Germans, was wholly bourgeois in her ideas and outlook; Aline Valette, the French choice, was hardly a feminist at all; only the Austrians, whose woman council-member was another ex-worker, Adelheid Popp, followed the Belgian example.)[81]

Neither the success of the resolution nor Claeys's appointment lured Ghent's feminists into a false optimism. Instead, the women's group increased their pressure for change. From the pen of Nellie Van Kol came another salvo—an angry charge directed at the party. 'For years and years', Van Kol began in a deceptively mild tone, 'there has been beautiful theorizing about women's equality in socialist party programmes'. 'But', she continued, 'all that time, in practice, women have been shoved into the background'. This was no longer acceptable: 'Every socialist administrative body, every congress, must be half women', she announced. Many men, she went on, said they favoured women's equality, but then added 'women are not ripe for equality'. 'We must wait until we have reached the necessary degree of development', they tell us, 'But I object to this!' Van Kol exclaimed. 'First our backwardness is said to be our own fault, then we are told that we must wait for men to declare us ready for complete equality . . . We see no end either to our minority or our inequality'.

This Ghent feminist was aware that there might not be enough female militants to make up half of all administrative bodies. Even those willing to undertake the work were burdened with heavy domestic responsibilities that would necessarily interfere. 'But if this is the case', Van Kol argued, 'let us put women into one-third of all positions'. Only this will ensure that men will cease deploying 'beautiful theories with no action'. In conclusion, Nellie Van Kol restated the basic feminist principle articulated in the First International, that women's emancipation must be the work of women themselves. 'We must not wait for men to give us freedom. Why should we? Why should we get it only from our husbands and masters? No, no, we shall not! We shall struggle with men, under one flag, we shall struggle

[81] Meyer, A., *The Feminism and Socialism of Lily Braun* (Bloomington, Ind., 1985). For Valette, see my *Working Women*, 197–9. See also Popp's autobiography, *La Jeunesse d'une ouvrière*, trans. Valette, M. (Paris, 1979).

with and for our husbands and brothers, but our emancipation is our own work!'[82]

This *Liègeoise* was clearly a worthy heir of Théroigne de Méricourt, and together with Émilie Claeys, Van Kol continued to lead Ghent's women's movement into the forefront of the nation's socialist struggle. Soon, the movement attracted an international spotlight: at the Zurich workers' congress of the Second International in 1893, both Van Kol and Claeys carried the Ghent position in favour of absolute equality for men and women in the labour-market into the debate about protective labour legislation, which was then favoured by every member party except their own. Following an argument in favour of such legislation offered by the German *bourgeoise* Louise Kautsky, Claeys explained the Belgians' reasoning. She was vehement in her insistence that the two sexes must be treated with absolute equality, in hours of work and in wages, but the congress was not swayed; only the Scottish women added a voice to hers, and in the end their party decided to abstain from voting. Everyone else voted in favour of a resolution supporting special protective legislation for women workers.[83]

But Ghent's women were undeterred. In the autumn, they took on both the bourgeois feminists of *La Ligue*, and those socialists who had begun to try to weaken their movement by accusing all feminists of being 'bourgeois'. To the organized *bourgeoises* they said, 'Abandon your aristocratic reserve, hold out your hand to women who are struggling for the conquest of their rights'; to 'women workers', they added, 'suppress all dissent in the party, and offer a hand to all women who struggle for their rights. Peace amongst women of good will'.[84]

Tirelessly, they travelled the country, giving speeches, attending meetings, recruiting and encouraging women, and applauding men who supported their cause. Amongst the most important group of such male supporters were members of Free Thinkers groups, who were committed to 'absolute equality between the sexes', in the approving words of Émilie Claeys. In a speech before their national congress Claeys said that 'women struggle constantly against the image of mother and angel of the home', but the Free Thinkers 'recognize that women should not only have all equal rights, but also that there should be unity between men and women in every respect. It is better not to create winged

[82] 'Een Woord...', *De Vrouw*, 15 Aug. 1893.
[83] *Congrès international ouvrier socialiste tenu à Zurich, 6 au 12 août 1893*, iv, no. 9 (Geneva, 1977), 583–4.
[84] 'La Féminisme socialiste', *La Ligue*, Oct. 1893.

angels', she concluded, 'Solidarity would be much more complete if women were equal'.

The Free Thinkers agreed. Their congress, which included a considerable number of women delegates, passed a resolution that supported women's emancipation, and demanded that education be integrated. After the congress, Van Kol and Claeys suggested adding to the Free Thinkers' commitment to reject both male slavery and women's 'double slavery', a women's motto: 'We have ourselves to free and must join in to fight together'.[85]

Like the Free Thinkers, Van Kol and Claeys identified the roots of inequality in the early years of life. Both reiterated the absolute necessity of treating boys and girls on the basis of the most painstaking equality. Otherwise, socialist children would simply assume the gender identities assigned by Belgian society. No task, no gesture, they believed, should carry gender: boys should learn all domestic work, while girls learnt that there were 'other opportunities beyond washing, cooking, and sewing'.[86]

It was a difficult programme, even in what was arguably the most progressive city in Belgium at the turn of the century. But the two leaders found many adherents, not least because Émilie Claeys possessed, according to her contemporaries, what the twentieth century would label 'charisma'. Claeys's biographer, Philip van Praag, noted that she was 'a wonderful public speaker'. Her qualities did not always win approbation; many in the party 'found her difficult', a reaction not unfamiliar to 'exceptional women'.[87] Both she and her friend Nellie Van Kol were uncompromising and, no doubt, unforgiving. Like most passionately determined radicals, they were an awkward reminder to would-be hypocrites amongst their colleagues.

In Ghent, at least, their faith in their male comrades was rewarded. In all local socialist activities, working women were drawn in, not only as members, but also as members of directing committees. The United Men and Women Flax-workers' Union, for example, showed a remarkably steady enthusiasm both for increasing its female membership and for attracting women into the union's directing council. Of course the fact that women were a majority in the linen industry's workforce helped explain the union's commitment. But a comparison between the practices of a similar, local, socialist textile union in the French city of Roubaix (likewise

[85] 'De Recht der Vrouw. verdigd. op het congres der vrijdenkers te Herstal', *De Vrouw*, 15 July 1893.
[86] Ibid.
[87] van Praag, 'Emilie Claeys', 183, 111.

a socialist stronghold) and those of Ghent's flax-workers demonstrates the uniqueness of the Flemish union's attitudes. Where French women textile-workers—all over France, not just in Roubaix—met hostility, misunderstanding, and, worst of all perhaps, indifference, their sisters in Ghent found a warm welcome.[88]

By 1896 the flax-workers had sufficient members to attract the notice of the national Conseil supérieur du travail, when it launched a campaign for shorter hours in the mills (Ghent's linen-mills required shifts of between 12 and 13 hours). The Conseil undertook another *enquête*, aimed at ascertaining the facts of the city's linen-workers' daily experiences. They encountered a stubborn rejection from Ghent's mill-owners. Although workers willingly testified at local hearings (complaining particularly about the impossibility of doing both their jobs, in the mills and at home) not a single owner appeared. Ultimately the Conseil lost patience, and decided that if the hill would not come to Mahomet, Mahomet would have to go to the hill. They planned several visits to local mills, and informed owners of their intentions, but on 21 December 1897, the owners together refused permission to enter any linen factory. The reason they gave was that such visits might encourage workers to demonstrate for their demands! And anyway, they added, no owner would consider shortening the working day, so why discuss it?[89]

The event exemplified the obduracy of Ghent's wealthy *patronat*. Even with the intervention of a government body such as the Conseil, union demands stood little chance of success. Ghent's employers simply would not move.

From 1896 the Flax-workers Union became even more vigilant in defence of women's interests. In the union's new newspaper, *Het Vlasbe-werker*, a narrative of consistent, unambigous support for women's efforts was written. From the first issue, which featured an article by Émilie Claeys detailing linen-workers' special health problems, the paper repeatedly highlighted women. A series of profiles of local union leaders, for example, included many prominent local women, including Coralie Van Beveren. Van Beveren had, the paper noted, played a key role in party and union politics for several years, both as a militant and as a featured speaker at socialist meetings. In 1896 she was 29, the mother of five children, only one of whom remained alive. She had started work in a flax mill at the age

[88] I have detailed the textile union's misogyny in 'Women and the Labour movement in France, 1869–1914', *Historical Journal* (autumn, 1986), 809–32.
[89] AGR, *Conseil Supérieur du Travail*, no. 33, Ghent, 26 Dec. 1896; no. 34, 16 Dec. 1897.

of 7, and later, typically, married a man working in the same mill.[90] Her story was similar to that of many other young women militants of her era. Most entered the mills when very young; most suffered the deaths of many children; and most married within the textile community. The fact that Van Beveren had also inherited her occupation (her parents were flax-workers before her) was also typical in Ghent.

In addition to featuring stories about local women, *Vlasbewerker* employed inclusive language, shunning the masculine exclusivity usually practised. This was often very awkward in Flemish constructions: 'Vlasbe-werkers en bewerksters', for example, or 'vlasbewerkerskiezers en vlasbe-werksters niet kiezers', in two typical examples. But the editors clearly considered the occasional inelegances a small price to pay for an accuracy that was at the same time politically consistent.[91]

Other aspects of the paper measured women's role in the union. In 1897 *Vlasbewerker* began to follow the common practice in working-class newspapers of illustrating Mayday issues with large, full-page pictures. In a largely illiterate society, these pictures were an essential means of propaganda. And from the first, the paper's artists acknowledged women's central presence in the class struggle. Unusually in socialist iconography of the time, women workers appeared as themselves as well as in the guise of the more usual allegorical figures (such as the female carrying the 'torch of socialism'). The picture drawn for Mayday 1897 was typical: it showed several women workers—in their uniform dresses, shawls, and wooden clogs, holding lunch bottles and buckets in their laps—seated on a bench, gazing at passers-by. Strolling past were two bourgeois, a man and a woman, both attired in the clothing that marked their class, and staring suspiciously at the workers. Juxtaposed against one *werkster*'s clumsy lunch bucket was an item unknown to most workers (except for those who made them), a parasol, held carelessly across a lace-covered shoulder by the *bour-geoise*.[92]

When *Vlasbewerker* used females to illustrate abstractions, their iconography was typical of the times. In January 1898, for example, the paper ran a large illustration showing a female figure called 'The Triumph of Socialism'. She was an unusually well-fed Triumph: compared to French Mariannes of the era the figure was quite large. But in keeping with the usual practice, the figure wore classical drapes—slit nearly to the top of one exposed

[90] *Vlasbewerker*, 1896. Many dates are obscured in the early issues of this paper.

[91] 'Men and women flaxworkers', and 'Men flaxworker voters and non-voting women flax-workers'.

[92] *Vlasbewerker*, May 1897.

thigh, but covering both breasts. In one hand, she carried a flag, in the other, an unsheathed sword. The caption admonished: 'Workers, be zealots for the 8-hour day!'[93]

There were many other such drawings during the *belle époque*. Although space limitations prevent undertaking such a project here, the iconography of Belgian socialist trade unionism would reward further study, particularly from the point of view of gender relations within the proletariat. In these visual works, Belgians once again flew in the face of what have become historiographical stereotypes: here, most famously, Eric Hobsbawm's argument that women in socialist pictures appeared only in allegorical form (whilst men represented 'real workers'), a fact he attributes to their absence from the socialist movement.[94]

Ghent's women workers acknowledged the paper's efforts to include them amongst the readership, as well as in the union. In March 1898 a group of women working in *La Lys* flax-mill wrote to Vlasbewerker, thanking the editors for the space given to women workers' concerns. They signed their letter 'In solidarity, your working women party comrades'.[95] Their letter started a trend: dozens of working women—alone and in groups—wrote to the paper, detailing their working conditions and offering opinions on various political issues. Their increased participation in the union newspaper reflected a similar growth in their union membership. Although a precise count of each union's membership is unavailable, one figure shows that by the end of the 1890s, more than 1,300 working women in Ghent belonged to socialist unions.[96] Given both the prevalence of women in the flax industry, and the concerted attempts by the flax union to recruit them, it is likely that the bulk of these women belonged to that trade union.

In June 1898 the paper again turned gender stereotypes upside-down, explaining an election loss in a traditionally Catholic commune by the absence of women's vote. The paper argued that if women had voted, the socialist vote of 4,229 would have doubled, thus defeating their opponents' 5,083 votes.[97]

[93] Portraits of women workers appeared only rarely as symbols of the workers' struggle in the French press. Others typical of Ghent were found in *Vlasbewerker*, Jan. 1898 and Feb. 1898.

[94] See Hobsbawm, E., 'Man and Woman in Socialist Iconography', *History Workshop Journal* 6 (autumn, 1978), 131–40.

[95] 'Briefwisseling: aan de redactie van het vakblad *De Vlasbewerker*', in *Vlasbewerker*, Mar. 1898.

[96] Numbers from *Revue du Travail* (1898), 709.

[97] 'Maatschappij. De Vlasbewerkers en bewerksters, aan de werklieden de fabrieken', *Vlasbewerker*, 8 June 1898. It was in this year that the French Guesdists began to turn their backs on socialist working women as they pursued male votes.

The union, and local women's groups (*De Vrouw* had 1,800 paid subscribers in the mid-1890s) soon attracted national attention. The party journal, *L'Avenir*, began to publish stories by and about Ghent's feminists. 'Rienzi' called them 'The Prophetesses of revolution'.[98] Others detailed textile-workers' horrific conditions, both in the mills and in private life. Many articles lamented the nearly inevitable outcome of flax-workers' pregnancy in the city which was devastated by infant deaths. One doctor reported the harrowing fact that although flax-workers (like other working women) gave birth an average of six to eight times, over half of their babies died. Childbirth took a terrible toll on mothers' health as well: another doctor described the deleterious health effects of constant pregnancy amongst textile-workers in one Ghent workers' quarter—a neighbourhood where many women had given birth 15 or 17 times![99]

Even those babies who survived infancy enjoyed only very precarious health throughout their short childhoods before they entered the mills. Most suffered a variety of bone problems, including rickets, cranial deformations, and constant difficulties with their teeth. Unspecified 'digestive difficulties' were also common: diarrhoea killed children in Ghent's working class as readily as it kills the children of the developing world today. One Ghent physician estimated that at least 96 per cent of workers' children in the city endured one or more of these serious health problems. And, he added with unusual sympathy, chronically sick children tended to cry through the nights, further taxing the equally fragile health of their exhausted parents. 'Motherhood', he remarked, so idealized in bourgeois society, did not constitute 'a happiness for working-class women'. Instead, 'C'est un chagrin de tous les instants, je dirais même une chose redoutée'. Because of the 'anguish of seeing so much death', mothers 'are forced to harden their hearts'. Worse, they knew neither the reasons for all the deaths nor any remedies. This 'is the private misery of every working-class mother', he concluded.[100]

Despite, or perhaps because of, such miseries, Ghent's working women continued to organize and agitate. In 1900 Émilie Claeys and Nellie Van Kol started a new women's paper, this one aimed specifically at suffrage, called *Stem der Vrouw*, or 'Women's Vote'. The decision was motivated, in part, by the birth in that year of a Brussels-based women's group, the Ligue des femmes socialistes. Amongst the leaders of this organization was Lalla Vandervelde, the British-born wife of the POB's leader, Émile Vander-

[98] *Avenir Social* (1898), 174–9, 204–12.
[99] Dr Ad. Miele, 'La Lutte contre la mortalité des enfants', ibid. 271–7.
[100] Ibid., and AGR, *Conseil Supérieur du Travail*, 38, séance, 9 Feb. 1898.

velde. This group, dominated by socialist *bourgeoises*, included many women who were also members of the bourgeois feminist movement of Brussels, a group equally committed to women's suffrage. Isabelle Gatti de Gamond, for example, with a foot in each camp, published a manifesto which declared the intentions of all three groups: 'The right to vote: one conscience, one voice'.[101]

Ghent's suffragettes, however, had opposition, had they but known it, and it was opposition from within their own movement. A warning about the socialists' less than enthusiastic support for women's suffrage was sounded by Émile Vandervelde himself, who introduced a suffrage bill in the Chambre in November 1900. Rather than extending equal voting rights to men and women, Vandervelde proposed only a limited suffrage for women in provincial and municipal elections.

This half-hearted gesture would soon prove to have been the last move in the direction of women's rights made by the Brussels party leadership in the years before the war. But even the fact that Claeys had been excluded from the party's governing council (in 1896) for fear her single-motherhood would offend potential voters amongst Catholics did not lead Ghent's women leaders to doubt the party's good intentions. Instead, they reacted with joy to the news of Vandervelde's bill.[102]

From 1900 to the outbreak of war, Ghent's women's movement—particularly under the union umbrella—continued to grow and develop. Numbers of women members in both unions and party organizations grew, and key male militants joined the feminist cause. Of these, Karel Beerblock (editor of *Vlasbewerker* after 1900) was the most committed. He, and others, enthusiastically adopted the unequivocal 'absolute equality' line of Émilie Claeys and Nellie Van Kol. By the middle of 1900, so many Ghent men were demanding to join the women's group that the women decided to admit them. As a precaution, however, the group added a rule prohibiting any man from speaking first at a meeting![103]

Interestingly, Ghent's men began to join just as the women's feminism grew even more militant, more opposed to the 'bourgeois idyll' supported elsewhere by recalcitrant male Proudhonists. In the words of one *Stem der Vrouw* writer, 'Eulalie', this ideal family life meant that 'men go off to do something—banking, factory-owning, politics'—whilst women remain at

[101] See Keymolen, D., Castermans, G., and Smet, M., *De Geschiedenis geweld aangedaan. de strijd voor het vrouwenstemrecht, 1886–1948* (Antwerp, 1981), Isabelle was the daughter of Zoë Gatti de Gamond.
[102] 'Vrouwenbeweging', *Vlasbewerker*, Mar. 1900.
[103] *Stem der Vrouw*, July 1900.

home, 'waiting for them to come home so that they can serve them'. 'What a meaningless life!' the writer exclaimed.[104] Such attitudes kept some local women wary of men's real intentions in joining their movement. One woman published a long piece in the flax-workers' paper questioning men's sincerity, and demanding that socialist men begin practising what they preached, not just by offering women a token partial vote, but by demanding full suffrage, adding women to the national party council, and choosing female party leaders. 'Women must work and slave bearing the household burdens', she wrote angrily, 'but law-making, the power to make the rules that could change workers' slavery . . . that might diminish our cares and so forth, these are not for them!'[105]

In the ranks of the flax-workers' union, women also began to stir. At the end of 1900, they counted the number of women members in the union and noted that there were only 2 women for every 10 men. Even in the cotton-workers' union, they pointed out, there was a higher proportion of women members—and cotton employed a majority of males! Moreover, the cotton union included women on its governing committee. 'Women want real equality', one member insisted, 'they want to take their places as people, as leaders of society'.[106]

Subsequent issues of *Vlasbewerker* featured more attacks on male unionists. In one, an anonymous female reader joined several other women correspondents in denouncing male unionists who—to use a modern colloquiallism—'talked the talk but refused to walk the walk'. 'This is a painful truth', she asserted.[107]

Such cries soon struck a nerve: the union leadership announced it had decided to pay a wage to its administrators, 'hoping to be able to get a certain number of women to consent to serve on the directing committee'. They confessed publicly, 'The union has 75% women members, and the administration is nearly all men'.[108] (It is not clear why this count so completely contradicts the earlier figures which showed so many more men members than women. On the other hand, such contradictions were entirely characteristic of Belgian data for the period.)

This year, 1900, was the apex of socialist feminist achievement in

[104] This point of view was extremely rare amongst *fin-de-siècle* working women. Perhaps only the organized silk-workers of the Isère, Rhône, and Cévennes, together with some organized Swiss working women, shared the Ghent group's convictions.

[105] 'Stemrecht voor de vrouw', *Vlasbewerker*, Sept. 1900.

[106] 'T Gent bij de vlasbewerkers en bewerksters', *Stem der Vrouw*, Sept.–Oct. 1900, and 'Ester', 'Klacht', in the same issue.

[107] 'Bemme lijkheden der vrouwen', and 'Zeer waar', ibid.

[108] *Revue du Travail* (1900), 417.

Belgium, however. A shift of party policy—whispered in Vandervelde's partial suffrage bill—was in the air; inside secret meetings, the party leadership had already begun its abandonment of the women's cause.

The first sign of this change was detected by *Stem der Vrouw*'s editors at a women's congress held in Ghent. Despite the venue, the meeting was run almost entirely by Brussels party leaders and militants. Significantly, the event was not even announced beforehand in the Ghent women's paper. But actions at the meeting prompted quick response: the paper ran a series defending women from the charges levelled by socialist delegates. In the first article, 'N', who must have been Van Kol, answered the rhetorical question, 'Does the women's struggle lead to man-hating?' Needless to say, she replied in the negative, adding that the single goal of the Ghent women's movement was to stop the gendering of every aspect of life, especially work. 'We no longer want the work that is usually done by women to be met with contempt when done by women, or by peals of laughter if done by men'. No one 'should be forced into categories by gender'.[109] Another article attacked the opinion now often voiced by male party leaders that working women did not want the vote. The anonymous author pointed out that *bourgeoises* might disdain the vote, but working women, who, after all, needed it the most, were demanding it. Women's suffrage was a proletarian issue, and a working-class goal.[110]

The defensiveness of these articles highlighted the changes taking place within the POB/BWP leadership. On the one hand, many men (and some women from outside Ghent) were trying to diminish the feminist movement, and avoid guilt by labelling it 'men hating'. On the other hand, certain key socialists (no one knows who they were, but developments would suggest that they included the party leadership), had decided that women's suffrage was not an important goal; thus, they readily named it 'bourgeois' in an attempt to marginalize it from the 'real, proletarian' struggle. Both claims privileged class over gender, and although this tactic was increasingly common all over the parties of the Second International, it proved most devastatingly effective in the Belgian party, where the French-speaking leadership had begun to push the more revolutionary, working men and women of Ghent to one side.

There were two proximate explanations for the leadership's perfidious behaviour. The Catholics, alert to every possibility of blocking socialist growth, came out in favour of women's suffrage in 1901. Of course most

[109] *Stem der Vrouw*, Jan. 1901.
[110] 'Onze algemeene vergadering', *Vlasbewerker*, Feb. 1901.

saw this gesture only as an attempt to discourage women from joining the socialists. The Catholics also realized that their gesture would stimulate all those latent prejudices about women's religiosity and subjugation to the church which still lurked within the male socialist movement. But anti-women's suffrage socialists fell upon the Catholics' move with glee, claiming that even the Catholics recognized that women would vote the way the church instructed.[111] Some Ghent feminists tried to counter such claims, pointing out that only the continued exclusion of women from full party participation would drive women into the Catholics' arms, but their words fell on deaf ears. The second explanation lay, as we have seen, in the liberals' refusal to entertain so much as a discussion of women's suffrage. When the socialists decided to pursue electoral success in an alliance with that party, women's rights paid the price.

The controversy found supporters on both sides in Ghent. In the middle of October 1901, the local party leadership—perhaps already cognizant of the national council's still covert decision to jettison women's suffrage—held a public meeting to 'discuss' the issue. *Stem der Vrouw* reported that the meeting was carefully packed with men who came 'just to laugh at the idea', although the 'old, trusted supporters of women's rights', including Karel Beerblock and Édouard Anseele, were also in the hall. At the close of the meeting, the mostly male audience voted through a resolution calling on the party to drop its support of women's suffrage. It was a striking victory for the Brussels leaders.[112] Emilie Claeys and Nellie Van Kol were furious. They quickly protested to Ghent's party committee: 'We're supposed to spend all our time now struggling for *men's* rights?' they asked sarcastically. 'We have already fought for men's rights, in 1893, and we are not ready to do it again'. The party, they concluded, 'has betrayed 6,872 women party members'.[113]

Ghent being Ghent—the headquarters of a proletarian women's rights movement—there were a few, bleating attempts by male militants to 'explain themselves' to the outraged women. Many letters arrived at *Stem der Vrouw*'s offices, most of which tried to convince women that their writers were not against women's voting rights as such, but that they feared that the issue was 'getting confused with the separate issue of a full male suffrage'! Of course such explanations did little to pacify Ghent's

[111] 'Vrouwenstemrecht', *Stem der Vrouw*, July 1900.

[112] Ibid. Nov. 1901.

[113] Published ibid. See also the narration of these events in Keymolen, 'Vrouwen emancipatie'.

feminists. And however much they might have wished otherwise, most recognized that their party, the feminist party, was over.[114]

WORKING WOMEN AND THE UNIONS

The end of feminist politics did not signal an end to women's participation in Ghent's union movement, however. In fact, quite the contrary; women's membership continued to grow unabated. The continuing story of women's part in the union movement merits a brief description before we turn back to the political events of the winter of 1901–2, which saw Belgian socialists drive the working women's movement from their ranks.

Throughout 1901 the flax-workers' directing committee continued both to report successes in bringing more women into the union and to search for still more efficacious methods of further recruitment. On Mayday *Vlasbewerker* published a striking visual representation of their campaign: the front page featured a fully clothed Marianne, wearing a phrygian bonnet and carrying a banner reading 'United Men and Women Flax-Workers'. In her other hand, the figure reached down to pull a second female from the ground; she, too, was fully clothed, though without Marianne's symbolic trappings. Behind them, the requisite 'socialist sun' rose above a horizon marked by a row of smoking chimneys and factory buildings. The caption read 'Work, Rights, Reason, Prosperity'.[115] This union banner—featuring females as both symbol and reality—was particularly striking in the context of union banners of the era from other European nations, including those of textile unions, which almost never depicted working women.[116]

More than symbolic representations, Ghent's union leaders—male and female—offered prospective women members several benefits of particular concern to them. For example, Ghent's oldest mutual aid society, the Bond Moyson, hired a woman doctor, explaining that women had a right to be examined by women physicians when claiming their benefits. Furthermore, they hoped this move would attract more women to their organization.[117]

The year culminated in a great union festival, celebrating Vooruit's

[114] See subsequent issues of *Stem der Vrouw*.

[115] *Vlasbewerker*, May 1901.

[116] In the UK Hobsbawm's argument is supported, as any review of British trade union banners will show.

[117] Peelman, N. 'Aan de vlasbewerksters', in *Vlasbewerker*, Sept. 1901. This was also reported in *Revue du Travail* (1901), 1035.

move into their vast new headquarters, a four-storey art nouveau building set on a canal in the city's centre. Officially called 'Ons Huis' (Our House), the structure was always known popularly as 'Vooruit'. This name, in fact, was soon painted in enormous letters along the roof line, visible in much of the city. It was the workers' own 'mansion', one which rivalled even the grandest houses of Ghent's wealthy bourgeoisie. Ghent's socialists had much to celebrate: when Vooruit opened, membership in one or more socialist activity—co-operatives, social clubs, mutual aid and insurance groups—as well as in the party and party-linked trade unions flourished. Unions, for example, had many thousands of members: one source showed that a full 50 per cent of all the city's workers were organized, and of those in socialist (as opposed to liberal or Catholic groups) the majority was female.[118]

This local socialist union movement tried to spread its feminist message beyond the city's walls, despite the increasingly hostile climate. Karel Beerblock, for example, still an official of the flax-workers' union, ventured into the Brussels 'lion's den', agreeing to speak at one of a series of 'feminist banquets' held during 1902. The fact that these supposedly socialist feminist meetings were elaborate banquets exposed their entirely bourgeois character, which Beerblock quickly condemned. He told his luxuriously dressed audience that they must do more than listen to 'nice speeches' in favour of 'little reforms'. They must learn first of all to hurdle the barriers of class their lives exemplified in order to welcome working women into their midst. 'Each time they are placed in relation to women of the leisured class', he warned, 'they are diminished and humiliated. Our duty', he concluded hopefully, 'is not merely to note injustice, it is to struggle actively against it'.[119]

Perhaps he realized that his words were wasted. He had only to note the nature of his audience, after all. Further, he might have seen the stark contrast between union life in Brussels and union life in Ghent, symbolized by the leadership of his own union and that of the national textile federation. In Ghent, his own union's directing committee included three women: Coralie Van Beveren, Marie Van de Sompel, and Pauline Bracke. The committee of the national textile federation, based in Brussels, was exclusively male. And the differences increased once the socialist party as a

[118] See Jules Destrée, *Le Socialisme et les femmes* (Brussels, 1897), 6, 17–18, and Varlez, L., *Quelques pages d'histoire syndicale belge*, Musée sociale (Paris, 1902), 131–3. It might be noted here that men formed the majority in both liberal and Catholic unions.

[119] 'Les Dîners féministes', *La Ligue*, 1902. Beerblock's views were also detailed in 'Verslag over de vrouwenbeweging in Vlaanderen: voorgedragen door Charles Beerblock', also in this issue. He dated Ghent's first working women's group from 1878.

whole dropped women's suffrage from the party programme: Ghent's flax-workers' union programme continued to demand 'women's right to vote, pure and simple'.[120]

Despite their commitments, however, the flax-workers' union, along with every other socialist-supported enterprise in Ghent, soon felt the ire of women betrayed by the party. In the spring of 1903, local women launched an attack on the hypocrisy of Ghent's socialists, who, they pointed out, had managed to prevent the presence of a significant number of women representatives on directing committees of most groups. Even the flax-workers' union was guilty. The now all-male leaders defended themselves, claiming that the union never counted women and men separately, and thus did not 'number' men and women on directing bodies![121]

Stem der Vrouw's editors were not satisfied. They continued to attack, ultimately drawing a lengthy, highly defensive reponse from the union paper. In it, the writer insisted that the union had always fully supported women's complete equality. Beerblock, for example, was a 'pioneer of the struggle', who had always supported the women's movement 'with life and zeal'. The paper added more examples demonstrating the flax-workers' collective devotion to the women's cause, concluding, 'At the close of the day, we shall be seen to have been our socialist women friends' best friends'. The paper appended a list of the union's full membership by occupation. In so far as gender can be accurately identified in the names of these members, the list showed at least 775 females, working in 59 different categories of work. Females in the list outnumbered males by a considerable margin.[122]

Of course it was true that in the ideal feminist world envisaged by Claeys and Van Kol, women and men's equality would render counting by gender irrelevant. No one would need to worry about numbers of women on directing councils and so on. But in claiming that they always treated women as men's equals, the flax-workers' leaders were being more than slightly disingenuous. In fact, it was in 1903 that the union's commitment to women's struggle began to weaken significantly.

The change was marked by a new editor for *Vlasbewerker*, Karl Hannick. His first hostile signal to Ghent's unionized feminists was his refusal to use inclusive language. Instead, he addressed his columns solely to male readers. Then in November 1903 he celebrated the visit to Ghent of one

[120] *Vlasbewerker*, Mar. 1903.
[121] Ibid. May 1903.
[122] Ibid. June 1903.

Elisa Van Langendonck, the wife of a Leuven socialist deputy. Van Langendonck, invited to the city by a long-time flax-workers' union militant Jan Samijn, was a long-standing foe of women's liberation. In Hannick's enthusiastic report of her speech at Vooruit his agreement was evident. Van Langendonck, he reported approvingly, condemned women's factory work. According to this speaker, waged work outside the home 'flies in the face of nature's dictates for woman' (*sic*). Nature meant for woman to remain in the domestic world, where she belonged.[123]

Whether or not Claeys or Van Kol heard this speech is unknown. But those of their supporters who heard it must have been horrified, particularly those amongst them who belonged to the previously feminist flax-workers' union. By the end of 1903 the union paper was no longer publishing defences of women's equality.[124]

Nevertheless, some of the union's leaders—in contrast to its paper's editor—continued to include women and men sympathetic to the women's cause. But many found themselves, disconcertingly, relegated to the union's history. Like 1960s student radicals, the early leaders of Ghent's socialist union movement were transformed into heroic, though antiquated, 'pioneers'. Sophie Lippens, for example, who had been a writer for the union paper for many years, was featured as an heroic 'forebear', one who had 'faced prison' in 1893 in the struggle for the (male) vote.[125] Even Beerblock, whose work for the union, and especially for women's rights in the movement continued unabated, found himself historicized. But Beerblock had a means to prevent his complete marginalization: he used his new position as movement 'grandfather' to publish advice in a regular column in *Vlasbewerker*, beginning at the end of 1904. He called his column, 'Letter to my young women work companions', addressing them as 'Beste Vriendinnen', and signing each effort 'Uwe Vriend'. Every letter explained the 'material and intellectual' benefits of the workers' struggle, and repeated his uncompromising support for women's emancipation. He repeatedly cited his long friendship with those two other 'elders', Émilie Claeys and Nellie Van Kol.[126] Alas, however, their appearance in Beerblock's column was the only evidence of their continued presence in the city in 1904. Both had, in fact, disappeared completely from local radical politics, as a result of events outside Ghent's movement, to which we now turn.

[123] Hannick, K., 'Het Textielcongres', ibid. Dec. and Nov. 1903.
[124] Ibid. Dec. 1903.
[125] Ibid. Mar. 1904, Nov. 1904.
[126] The first 'letter' in Oct. 1904.

SOCIALISM REJECTS PROLETARIAN FEMINISM, 1901–14

In 1901 the Belgian socialist party chose expediency over principle, agreeing to a demand that they drop their commitment to women's suffrage in exchange for an alliance with the liberals. The decision was taken at a secret meeting of the party's national council, on 10 October: 34 members voted in favour, 1 against, and 3 members abstained. In the words of Marcel Liebman, 'C'est une violation pure et simple d'un des points importants du programme socialiste'. But this was not all. In Liebman's impassioned language, 'That is not the only surprise that the Parti Ouvrier had reserved for its members. There was a second: it went so far as to indulge itself in the claim that the decision was taken at the behest of the socialist women themselves'. How did they accomplish this? They easily found a willing traitor to the women's cause in Lalla Vandervelde, wife of the party leader. At the first congress after the council vote, during a 'discussion' of the 'proposed' policy change, she obliged her husband and his colleagues by offering the following resolution *in the name of the Socialist Women's Federation*! (emphasis added)

Considering that the political equality of the sexes constitutes one of the essential principles of socialism, the POB demands women's right to vote at every level . . . But, considering that the immediate demand of this right to vote for the legislature threatens to compromise the unity of action of the partisans of universal male suffrage, the Fédérations des femmes socialistes, inspired by the superior interest of the Parti Ouvrier, proposes that the delegates and voters suspend the movement for universal female suffrage until the victory of universal suffrage for men.[127]

There were protests. Vincent Volkaert and Jules Destrée argued against the proposition, and one woman, Paule Gil, herself a member of the Women's Federation, reacted 'furiously', according to the party's reporter. Lalla Vandervelde's intervention in the name of the women's group had, in fact, taken Gil utterly by surprise, and it soon became clear that the whole group shared Gil's astonishment, as member after member expressed their disagreement with Vandervelde's gesture. But the resolution passed over their protests, as the party leadership had intended.

At a subsequent congress of the Women's Federation, Lalla Vandervelde

[127] See Liebman, M., *Socialistes belges*, 227, 229. Émile Vandervelde's hypocrisy ran deep. In July 1901 he replied to an attack by a Catholic leader with a strong defence of his 'absolute' commitment to women's suffrage. The party paper, in the same month, ran another such defence. Materials in PG, 'Agitation', 240. Keymolen also narrates this 'spectacular' about-face in Keymolen, *et al.*, *Geschiedenis geweld aangedaan*, 28. See also *Stem der Vrouw*, Nov. 1901.

was roundly condemned; women socialists demanded that the party reconsider its decision, but they soon discovered that their views meant nothing. The party continued to insist blandly that the socialist women themselves had 'generously' stepped forward to sacrifice themselves for the greater good of the class struggle. Paule Gil summed up the women's bitterness: 'Tous les congrès socialistes proclament l'égalité de sexes, mais on se dérobe quand il s'agit de réaliser les principes'.[128]

Perhaps, as Liebman argues, the ugliest element in this sudden change of the Belgian socialist heart was the leaders' cynical effort to make it all appear women's own idea. They were fortunate that there were other socialist women who willingly joined Lalla Vandervelde's original lie, and they quickly made use of them. At the annual party congress that year, several 'socialist women' spoke against women's suffrage—including an elderly Isabelle Gatti de Gamond and a group of male militants' wives. Each imitated Mme Vandervelde's strategy, insisting that although they possessed a full personal commitment to women's equality, they were willing to put the party's interests first.

Still, many women in the audience remained so enraged that the leadership tried another ploy to divert their anger. They proposed to establish a permanent 'women's seat' on the national council. Lest anyone suggest a potentially troublesome woman for the role, they nominated Gatti de Gamond. One male delegate almost 'gave away the game', however. He rose to oppose the idea of such a position on the grounds that such work was 'unsuitable' for 'woman'. Émile Vandervelde was quick to respond. Oozing self-righteousness, the party leader rose in pretend horror: 'It is a question of individual principles whether or not each of us considers our wives, our sisters, as equals, including with regard to responsibilities. It is, moreover, up to the congress to decide if it wants or does not want the equality of the sexes; but I am demanding of you simply that you honour one woman, an altogether superior comrade'.[129]

Liebman notes that this speech was greeted 'warmly'. An approving army quickly rose to salute Vandervelde. Elise Van Langendonck 'congratulated the congress on its decision to nominate Gatti de Gamond'. Uriah

[128] Quoted in Liebman, *Socialistes belges*, 227. Bourgeois feminists reported these reactions in several issues of *La Ligue* in 1902. They documented the fury of Lalla Vandervelde's socialist women comrades. Vandervelde herself, in her autobiography (not insignificantly titled *Monarchs and millionaires*) explained that she never 'fitted in' in Belgium. And later, she insisted, she 'grasped the unwelcome truth that the Belgian socialists not only disliked, but were actually hostile to women taking part in any form of public life . . .' (London, n.d.), 36. I am grateful to Janet Polasky for this quote.

[129] Liebman, *Socialistes belges*, 229.

Heepishly, Van Langendonck told her listeners, 'Merci d'avoir confiance en nous'.[130] It was a dark day in the history of Belgian socialist feminism. From then on, relations between feminists and anti-feminists in the party grew steadily worse. Even in Ghent, with its proud heritage of radical women, the movement, as such, began to die. It did not go gently. But as Denise Keymolen has noted, by the end of 1901 even *Stem der Vrouw* appeared to be suffering a terminal malaise.[131] Two pieces, published by the once-radical paper, signalled the transformation to come.

The first, published in November, expressed a misogyny so extreme as to recall the antediluvian attitudes of Hyack Kuborn's clique in the Royal Academy of Medicine. It was written, however, not by a bourgeois physician, but rather by an official of Ghent's socialist municipality, Pierre De Bruyne. In 'Recht op Antwoord' (Right of Reply), De Bruyne argued that voting was not a 'natural right'. If it were, anyone would be entitled to vote. 'Would *you* [presumably women] want *us* to give the vote to a child? To the wild Indians [sic] of the Congo?' he asked, exposing the full range of his prejudice. Women's suffrage, he insisted, was 'splitting the party. This will only give our opponents power'. He instructed his female readers: 'Selfish women must cease demanding the right to vote'.[132] In the following issue, an *arbeidster* agreed: party solidarity before women's suffrage. This woman 'feared' that local women militants, and those who supported their demands for the vote, had 'become too bourgeois', and 'forgotten the lives of ordinary people'.[133]

These two articles, and others like them, marked the entry of Ghent's party into the maelstrom of theoretical and practical changes in which Belgium's entire socialist movement was caught. According to Paul Aron, everything, including 'the motivations and social origins of party leaders', as well as the whole 'aesthetic and political culture' of the movement was transformed in the course of only a few short months.[134] Caught up in the process, *Stem der Vrouw* underwent a startling apostasy: once the revolutionary vanguard of Belgium's socialist feminist movement, the paper's editorial committee now spoke the language of happy slaves. Where once appeared stirring calls for autonomy and independence, the paper now featured treacly portraits of perfect mothers and lessons in husband-pleasing

[130] Ibid.
[131] Keymolen *et al., Geschiedenis geweld aangedaan,* 28.
[132] *Stem der Vrouw,* Nov. 1901.
[133] 'Een ernotig gesprek—Eene arbeidster', ibid., Dec. 1901.
[134] Aron, *Écrivains belges,* 22.

cookery. Women's place was no longer on the political platform; Ghent's socialist women had returned home.

It is unnecessary to add, perhaps, that Nellie Van Kol disappeared from the scene—returning with her husband to the Netherlands. Émilie Claeys chose 'internal exile', becoming an activist in a local Dutch Reformed Church, whose *predikant* was the nephew of the Dutch socialist leader Domela Nieuwenhuis. From the day she chose religion, according to her biographer, Claeys ceased living as a socialist.[135] The disappearance of these once-fiery feminist leaders from the struggle was a vote with their feet against those who had betrayed them. They were soon replaced, by those whose opinions directly contradicted their dearest principles, including Élise Van Langendonck, and wives of other party leaders. Under the new leadership the Ghent socialist women's groups moved quickly into a marginal role, a supporting part written for them by the national party leadership.

A few survivors continued to labour on in Ghent. Karel Beerblock, for example, continued to write and to speak, not only in his native city, but also amongst the *bourgeoises* who dominated socialist women's groups in the capital. He never ceased recounting the sufferings of working women to their leisured sisters, hoping that tales of small girls 'robbed of their childhoods by domestic toil' might move the hearts of Brussels' socialist ladies. 'Still very young', he told one audience of *bourgeoises*, 'they are already little women, caring for and guarding their brothers and sisters, cleaning the house, preparing the meals while mother works. . . . For the women of the people, there is never any hope of a sweeter life, for a time of peace and rest. From the tenderest age to the edge of the tomb, they know only work and care'.[136] His words fell on deaf ears. So, too, did those of one woman worker who travelled from Ghent to Brussels to participate in a debate over women's suffrage. Two *bourgeoises* spoke first, arguing the official socialist line, that women were not yet 'ready' to vote. The spinning-mill worker disagreed, angrily defending women's right to vote. If women were not sufficiently 'developed', she told the assembled ladies, it was because from girlhood they did nothing but work. Boys went to school; young men to political meetings. Girls, on the other hand, went into the mills and factories, and later added housework to their daily burdens. 'After having treated women as inferior beings for centuries, who dares now reproach them for lacking culture?' she exclaimed. And whether they lacked culture or not, women still played 'the most important role in

[135] From van Praag, 'Emilie Claeys'.
[136] 'Les Dîners féministes', *La Ligue*, Jan. 1902.

industry, in the household, in teaching . . . Despite all that has been used against them to maintain their abasement, she concluded, 'this demonstrates clearly their aptitudes and their genuine superiority'.[137]

A handful of Brussels *bourgeoises* agreed. Paule Gil, indefatigable despite her dismay in 1902, addressed a similar socialist women's meeting. She told the audience that Ghent, where women remained active in socialist trade unions, still allowed women to hope for emancipation. She cited figures: in the flax-workers' union, 1,200 of the 2,000 members were women; in the weavers' union, 700 of 1,500 members were women. Furthermore, all over Flanders there were women-only unions, especially in Alost and Gramont. Even in recalcitrant Brussels there were a few women-only unions—amongst hat-makers, shoe-makers, and printers.[138]

But however active women remained in their unions, they were increasingly marginalized from party politics. Even police officials finally noticed the change after 1902; many reports began to observe—doubtless with pleasure—a steep decline in support for women's suffrage.[139] In Ghent it was a young socialist militant, Paul De Witte, who sounded the death knell. This man, who had been reared in Vooruit's ranks, declared, 'The triumph of women's universal suffrage would be a disaster for our ideal, for worker reforms, even for the women's cause, because they have gained nothing from a quarter of a century of clericalization and reaction'.[140]

In 1903, the national party felt safe enough from feminist opposition to start a women's paper in which to publish the party's new 'essentialist' line. This paper, run by the now completely auxiliary socialist women's federation, was *La Femme Socialiste*. It was printed in Brussels, in French. From the outset, the paper addressed itself exclusively to mothers and wives of socialists, rather than to working women. Although the paper dutifully printed notices of workers' activities, and occasional stories of women's union struggles, its emphasis was on the creation of a domestic idyll within the proletarian family as imagined by the bourgeoisie. As for *ouvrières*, they were merely what one of the paper's writers called 'that ignorant class of women'.[141]

[137] Reported ibid., Mar. 1902.

[138] 'Mme Paule Gille' (*sic*) ibid. Gil's speeches were also reported to officials. See PG, 240. Here she is called, variously, 'Paule Gyl', and Dame Paul-Gil' (*sic!*). The other Flemish language socialist paper, *De Volkswil*, published a ringing call for women's complete equality, including their right to vote, on 8 Mar. 1902.

[139] PG, 240, 'Agitations, 1900–1902'. The dossier is titled 'Corps de la gendarmerie. Compte-rendu d'un événement extraordinaire . . . 21 Feb. 1902'.

[140] De Witte, P., *De Geschiedenis van 'Vooruit' en de Gentsche socialistische werkersbeweging sedert 1870* (Ghent, 1898), 228.

[141] *La Femme Socialiste*, 12 Apr. 1903, and subsequent issues.

The message of this paper even spread into Ghent, via a transformed *Stem der Vrouw*, which borrowed features and stories in a useless effort to halt the steady decline in readership. The stories from the Brussels' women's group were highly traditional, and detailed the ways in which working women could create domestic havens that would 'keep their men at home'. There were little household hints about tasteful decorations, as though Ghent's slums could be 'gentrified' with women's hard work and (bourgeois) good taste.[142]

As 1903 wore on, the socialist party increased its efforts to convince women that the class struggle should always take precedence over their equality. Only 'women of the bourgeoisie', they were told, favoured 'women's rights'. In Ghent Elisa (as the Flemings spelt it) Van Langendonck dutifully carried the party line: addressing what remained of the Ghent socialist women's group in November 1903, she instructed them that their 'primary duty' was to the class struggle. Working women's lives, she said, 'are a struggle *for* life, not *against* men' (her emphasis).[143]

In January 1904, the city's socialist women sent a delegation to a conference on protective labour legislation held in the Netherlands. There, delegates from all over Europe voted a resolution opposing any restrictions on women's work—particularly if such laws were passed without consulting women workers themselves. But these women from Ghent, whose forebears had once stood alone amongst European socialists to oppose any limits on women's equality in the labour-market, now voted in favour of such legislative constraints. They argued that those who opposed narrowing women's access to waged work did not understand 'the special role reserved for woman (*sic*) as educatrice of children'.[144] It was a stunning volte-face by Ghent's women's movement.

A few radical voices were still heard in Vooruit's corridors. Throughout 1904, in fact, a quarrel over women's roles in the party continued to rage amongst local male leaders. Beerblock, as usual, remained a firm supporter of women's equality. Indeed, in that year he published a remarkable piece of didactic fiction, *Idalia*, which recounted the transformation of an oppressed young working women into a militant socialist and feminist.

[142] Ibid. 10 May, 12 July 1903. One *ouvrière* was sufficiently troubled to complain about the exclusive focus on mothers and wives. 'Speak to us sometimes about the high cost of meat, of women workers' demands, and of those political questions concerning the party', she wrote. The editors replied: 'Motherhood and families are important concerns of the socialist party'. This exchange was in July 1903.

[143] 'Propagande', *Femme Socialiste*, 15 Nov. 1903.

[144] 'Nouvelles de l'étranger', ibid. 17 Jan. 1904.

(Oddly, given the paper's editorial stance, the novel was serialized in *Stem der Vrouw* starting in April).[145]

To an extent, at least, the Ghent split over women's rights was part of the growing gap between militant Flemings and the French-speaking leaders in Brussels. (In that year, in fact, one militant observed that the party was divided into three distinct and competing sections: Brussels, Wallonia, and Flanders.)[146] The views of those locked in the bourgeois milieu of the Brussels party differed markedly from those of their colleagues in Ghent. When Auguste De Winne visited Vooruit after several years spent working in Brussels, he was astonished to discover that his view of women's place in the movement were not shared by his host Édouard Anseele. 'Is it not the case', he asked Anseele,

'that socialist women must content themselves for the moment with helping us in our struggle, so that our movement will not become still more complicated by special and maybe improper demands? Would their emancipation not necessarily result from socialism, as a natural and inevitable consequence? The mountain that we must move is already so huge!'[147]

To De Winne's surprise, Anseele disagreed vehemently. Women must have their place in the movement, he said, 'they have even more reason to fight than men'. The more demands they made of the movement, the better. 'This is not Paris', Anseele told his young visitor. 'The movement here has no *bourgeoises* . . .' Furthermore, he criticized those in the socialist party who 'humiliated and insulted' working women. It reminded him of the insults suffered by Ghent's weavers when they first launched Vooruit decades earlier: 'But the Ghent women are brave'.[148]

As the two men argued, in a hallway in Vooruit, De Winne caught sight of a group of women at work in a nearby room wrapping stacks of *Stem der Vrouw*, to sell on the city's streets. 'I looked at them', he wrote later, 'they were bareheaded; shawls covered their thin shoulders. One, and then another, stood up and left the room, a bundle of newspapers under her arm, to begin the difficult apostleship. And I said to myself: "My wishes go with you"'. This was De Winne's 'road to Damascus'. Unlike Vander-velde's, however, his conversion was long-lived. For him, the sight of

[145] See *Stem der Vrouw*, and Avanti, *Een Terugblik*, 360.

[146] De Winne, A., *Door arm Vlaanderen met een brief van Ed. Anseele en een aantrangsel van K. Beerblock* (Rotterdam, 1904). The author described Flanders as 'men, women, and children slaving day and night for poverty wages'. Wallonia, by comparison, was 'free and socialist' (pp. 256–9).

[147] Ibid. 254.

[148] Ibid.

those politically determined women, preparing to encounter taunts and jibes in Ghent's streets, strengthened his own socialist convictions. On the train back to Brussels he remembered thinking: 'Ghent is a real spa for sick socialists!'[149]

In May 1904 a few Ghent socialist women attacked the Brussels women's group's rejection of women's suffrage. While the leaders of the Femmes Socialistes defended themselves by arguing that socialist women had never 'really' wanted the vote (on the grounds that it would, in Élise Van Langendonck's phrase, 'masculinize mothers') the Flemish women announced their 'continuing support for women's suffrage'. In their public statement, moreover, they reiterated some earlier demands: equal representation in every socialist body, including leadership councils; and the undertaking, by any group calling itself socialist, of an active struggle for women's rights.[150] Their efforts achieved grudging acknowledgement from their Brussels rivals. When Lady Aberdeen visited the Brussels women's group early in 1905, she enquired if there were any working women involved 'in their own emancipation'. Not in Brussels, she was told, 'But there are Flemish working women's groups, especially in Ghent, with male supporters, [including] the valiant Flemish feminist, Karel Beerblock'.[151]

Later that same year Gertrude De Brouckère recorded her admiration for Ghent's women socialists in an article published in the Paris journal *Le Mouvement Socialiste*. She described Ghent's success in organizing working women as 'unique in the Belgian movement'. Indeed, she acknowledged the gap between the demands of Ghent's women and those of her own Brussels group, explaining that Ghent's women worked outside their homes for wages whilst those in the nation's capital did not work at all. Thus the Brussels group 'aimed propaganda at wives and mothers'.[152] (Evidently, the working women of industrial Brussels were beyond her experience!)

This division between bourgeois Brussels and proletarian Ghent grew wider as the months passed. In the autumn of 1905 one event underscored the differences in the two parties. Ghent's female cotton-workers went on strike, and after a long and hard struggle, the women and men of the city's cotton-mills won, having been supported throughout by the resources of the mighty Vooruit. It was the largest successful strike in the history of Ghent's massive cotton industry. Karel Beerblock reported the strike for

[149] Ibid. 254–5.
[150] Reported in *Femme Socialiste*, 22 May 1904. Van Langendonck's words were printed on 20 Mar. 1904.
[151] *La Ligue*, 1905.
[152] 'Les Femmes socialistes en Belgique', in *Mouvement Socialiste* (1905), 311ff.

Femme Socialiste, in words heavily critical of ideas about women's place circulating within the Brussels party:

The woman who, according to current opinion, is created by nature for *la vie intérieure*, who has as her exclusive mission making her surroundings agreeable and raising children; the woman, who must invariably move only within this narrow circle, never knowing a broader horizon, to whom it is forbidden to mix in economic and political struggles, has acquired all at once a great importance in this the longest, most difficult strike that we have ever known.

Women had led the strike throughout, holding meetings, speaking, encouraging their work-mates, serving as strike committees, talking to the *patronat*: they had spoken to communal authorities and to government ministers; they had raised money, And strike leaders earned the loyalty of the majority of the city's cotton-workers. 'Hundreds of women attended every meeting—mothers, wives, daughters, all demanding more rights . . . for themselves, for their families, for their class', Beerblock said. 'What a gross error it would be to believe that woman is inferior in courage, in intelligence; that her social education is narrower than man's!'[153]

The strike was equally exemplary of solidarity between male and female workers in Ghent. After 14 weeks the owners tried the time-honoured technique of dividing the strikers by gender—offering shorter hours with the same wages. For workers paid by the day, who were virtually all men, this meant a significant victory, but for those paid by the piece—most women—it meant either a work speed-up, or a loss in pay. The owners hoped that some 2,000 men workers would grab the advantage and return to the mills, stranding their 2,500 striking female colleagues. But the tactic failed, and a majority of the strikers voted against the offer, and resolved to continue the strike until victory was won by all. This show of solidarity, Beerblock noted, carried a lesson to all socialists. 'Social democracy should now see that it must support women's rights more actively and give them a real role in running all party administration, all party organizations'.[154]

Alas, Beerblock's hopes were dashed—again. Indeed, not only was the Brussels party increasingly hostile to including women within the movement, it also grew further from its own male proletarian constituency. As Paul Aron has noted, it was in 1906 that the Belgian socialist party began in earnest to transform itself into a respectable bourgeois political party. From that moment its social attitudes, its activities, and its morals all began to mirror the dominant values of bourgeois society. One example of the

[153] Beerblock, 'Femmes victorieuses', *Femmes Socialistes*, 29 Oct. 1905.
[154] Ibid.

party's new quest for propriety appeared in a condemnation of Léopold II's scandalous sex life. Combining the traditional socialist opposition to the monarchy (and to capitalists) with a curious prudery, one writer noted:

Up until these last years, Léopold seemed to be a monstrous business tycoon who relaxed from the cares of his fabulous enterprises in the arms of any passing houri who took his changing fancy, in the manner of our middle-class merchants and speculators: actresses and good time girls provided him with a harem. . . . Today, the situation has changed: the King no longer stoops to prostitution like his associates, in wild outbursts of sensuality and lasciviousness: now, prostitution climbs to meet the King . . .[155]

(Leopold's gesture, it seemed, was to take up residence with his 'concubine', a woman who had once worked as a dancer.)

Moral criticism in this vein began to flow from the pages of *Le Peuple*, the official party newspaper. All sorts of street theatricals—popular with workers everywhere—came under attack. The paper's editors even criticized the street theatre of Carnival: these 'pleasures of the street are gross and unhealthy', Jules Destrée complained, 'the café-concert is as debilitating as the exhibitions of the music halls'.[156]

How much closer to his fellow workers was the writer of *Idalia*! Republished along with his other short fiction in 1906, Beerblock's short novel celebrated a young woman's 'conversion' to socialism and to feminism during a Vooruit-sponsored strike in her mill. From her first speech, to an audience full of mothers carrying squalling infants, 'Ida' argued that 'women are not weaker than men. They have demonstrated this in the mills. Women must rise up, and demand their rights'. As she struggled to build a women's movement, Ida discovered opposition: 'I cannot understand how some men can say they are socialists but not support women's rights', she mused. Soon, however, Ida met her romantic hero—a local mill-worker who supported women's efforts. When mill-owners blacklisted her, he backed her efforts to find other work—which she did in the previously all-male occupation of gardening. In an end worthy of the most loved penny dreadfuls, Ghent's first woman gardener married her socialist beau. Unlike most romantic heroines, however, she lived the socialist domestic idyll, sharing all work, including child-care, equally with her husband.[157]

[155] Aron, *Écrivains belges*, 59, and quoted in Ascherson, N., *The King, Incorporated: Léopold II in the Age of Trusts* (London, 1963), 292. Léopold was then in his 80s; he died in 1909. See also Polasky, J., *Between Reform and Revolution: The Democratic Socialism of Émile Vandervelde*, forthcoming, esp. ch. 3.
[156] Quoted in Aron, *Écrivains belges*.
[157] Beerblock, K., *Onbegrepen: Propagandaschrift ter ontwikkeling der vrouwen* (Ghent, 1906), 10 and 215–16.

Although not surprising in the context of progressive Ghent, Beerblock's ideas were highly original in the context of both the national party and of the Second International as a whole. In these years, socialists all over Europe increasingly promulgated an ideology of women's place that echoed bourgeois prescriptions restricting women to their separate—and very unequal—sphere. The scenario offered in *Idalia*—as well as in Beerblock's other propaganda tales—where one working woman's struggle for political, economic, and personal autonomy ended in victory, underscored the unique quality of socialist life in Ghent (and probably elsewhere in Flanders) in these years.

The central party's gradual marginalization of women from the movement enjoyed diminishing returns. Working women did not join the *Ligue des femmes socialistes*; nor did they read its newspaper or attend its meetings. Soon, the Belgian party's failures to attract women members became apparent even in the Second International itself. At the Second Congress of Socialist Women, held in conjunction with the congress of the Second International in Stuttgart in 1907, the Belgian women admitted their inability to match the successes of the Germans or Austrians in recruiting working women to their group. They claimed that although socialist trade unions had about 4,000 women members (a grave underestimate), socialist women's groups included only about 600 women all over Belgium. (By contrast, the Austrian party claimed 32,000 working women amongst its membership.) Some delegates from other countries readily identified the *Ligue's* weakness, telling the Belgian women that although it was good to fight for men's rights, they must take care to spend equal time and energy in the battle for women's emancipation. But the Belgian women's movement was far too compromised to reform. Already moribund when the congress opened, *La Femme Socialiste* soon ceased publication.[158]

Had the Brussels women undertaken any serious self-examination after the Stuttgart meetings, they might have discovered that the women of Ghent were in the process of regeneration in these years. Indeed, the whole Ghent movement found a new lease of life; Vooruit itself began again to expand, as Denise Keymolen has noted. Its growth in turn stimulated the creation of new socialist 'Vooruits' all over Flanders.[159] *Stem der Vrouw* soon discovered new readers, and by 1910 the once-dying paper had 1,600 subscribers, with a further 1,400 copies sold on the streets, by women like those observed by De Winne a few years earlier. In another

[158] Reported in *Femme Socialiste*, Nov. 1907.
[159] Keymolen, *et al., Geschiedenis geweld aangedaan,* 42.

year the successes of these Flemish women all over Flanders led to the
founding of an umbrella organization of their own: the *Vlaamse Federatie
van Socialistische Vrouwen*, which included 23 member groups, with 1,050
active members. In stark contrast to the slow death in progress amongst
the Brussels women's 'federation', this Flemish movement continued to
grow: by 1914 it had 1,800 members. In addition to these who paid dues
to this political organization, Flanders also included thousands of women
who joined and supported socialist or 'neutral' trade unions.[160] Despite its
successes, however, the Flemish women's movement moved no closer to
Brussels: instead, it grew and flourished in splended isolation from French-
speaking Belgium, whose socialist leaders remained oblivious of the causes
of their failure to attract working women to the party.

Even when the erstwhile Brussels militant Maria Tillmans, once editor of
the defunct *Femme Socialiste*, decried the party's failures with working
women at the 1910 party congress, no one listened. Her complaints
constituted a serious indictment of the party leaders. She tried to warn that
the Catholics would quickly fill the void the leaders had created by their
neglect of working women (and in fact the Catholics' campaign was
already well under way by 1910). But not only were her criticisms ignored,
she herself was rejected: nominated to fill Gatti de Gamond's seat on the
party council, she was not elected.[161]

More widespread was the amnesia demonstrated by Lalla Vandervelde
in her 1910 survey of protective labour legislation. In her book, Mme
Vandervelde limited her discussion to 'workingmen's associations', as
though there were no associations of working women. More surprisingly,
she wrote: 'Women, unfortunately, have remained in the background [of
the union movement]'. She explained: 'More exploited even than the men,
terrorized and made into fanatics by the priests, they have scarcely
combined for the defence of their interests'.[162] And this was the woman
promoted as a women's leader by the POB! No wonder Brussels *ouvrières*
stayed away from that city's art nouveau Maison du Peuple in droves. No

[160] Ibid. 42–3. Antwerp's women's movement continued: see Léon de Seilhac, *Le Lock-out
d'Anvers* (Paris, 1908), 75.
[161] *POB. compte-rendu du 25e congrès annuel tenu à la 'Maison du Peuple' de Bruxelles, 6–7 fév.
1910* (Gand, 1910). Camille Huysmans warned that 'women's unions are not seriously
organized and there are only a few "living" Flemish associations. The work is therefore im-
mense.'
[162] The language and attitudes were similar to those prevalent in the labour movement of
her native country. See Vandervelde, L. and Jacobs, M. F., *Labour Laws for Women and
Children in Belgium*, trans. Harvey, E. C. (London, 1910).

wonder, too, that male leaders so easily absolved themselves of any responsibility toward Belgium's working women.

It should be remembered, of course, that some French-speaking Belgian women outside Brussels were less oblivious. In Liège Lucie Dejardin and several of her friends founded a socialist women's league in 1910. In the few years before the war, this group struggled to organize a 'second wave' of socialist feminism in Wallonia,[163] but they enjoyed only limited success until after the war. The sole result of their efforts was the brief re-emergence of the issue of women's suffrage on the agendas of socialist meetings after 1912, just after men won full voting rights.[164]

There may have been other such gestures in French-speaking Belgium. At least one French visitor remarked on Belgian socialists' visible commitment to women's rights. In his words, 'Like the socialists of every country, the Belgians are partisans of women's suffrage. The equality of the sexes and of rights is a fundamental credo inscribed at the top of their political demands'. And indeed, as far as words went, the party had begun, once again, to privilege women's rights in its printed materials. On the eve of the war, the party's *Vade Mecum* declared that 'Socialism will emancipate woman (*sic*) economically, and will establish—by itself—the complete equality of the two sexes'.[165] Of course careful readers (or experienced cynics) should have noted the ambiguity: if socialism would 'automatically' bring about women's equality, there was no need to organize feminism within the movement. But bourgeois feminists were hopeful: 'At the next congress the party will be particularly occupied with spreading propaganda amongst women, whom the socialists recognize they have neglected until now'.[166]

Needless to say, any socialist admission that they had 'neglected' women was disingenuous. The Brussels party leaders had not 'neglected' women; they had deliberately marginalized them in their opportunistic rush for success at the polling booths and for bourgeois respectability. Alas, however, this exculpatory line soon created an enduring myth, told as fact by party historians. Before the War, most have argued, working women were absent from the socialist labour movement. The tireless women of Verviers in the First International, of Liège and Ghent in the Second, 'disappeared' from the official story of the socialist party's past.

[163] See Keymolen *et al.*, *Geschiedenis geweld aangedaan*, 42, and 'Vrouwen emancipatie', 72.

[164] See Wellens, H., 'Vrouwenbeweging en vrijzinnigheid in Belgie rond de eeuw wisseling (1892–1914)', Rijksuniversiteit Gent, licentiatt in de moraal wetenschap, 1982–3.

[165] Charriaut, H., *La Belgique moderne: Terre d'expériences* (Paris, 1910), 251, and Conseil Général du Parti Ouvrier, *Vade mecum du propagande socialiste* (Brussels, 1914), 53.

[166] 'Les Femmes ouvrières', *La Ligue*, 1914.

To complete this sorry tale, it should be noted that even after the War, the socialist party once again broke its word to women supporters, voting to oppose women's suffrage—this time on the grounds that it was supported by the right. Only in 1925 did the party decide—with some reluctance—to support a limited women's suffrage. In the debate over this decision, it was Émile Vandervelde himself who declared 'women in their great majority do not care about the right to vote. Their political education has not yet been done'.[167] But despite such equivocation, and in spite of the hostility of many male socialist leaders, women were granted local and provincial voting rights. (They did not, however, win full suffrage until after the Second World War.)

AN ALTERNATIVE: THE CATHOLICS

The absence of women from histories of socialism has left the field open to those who would perpetuate the stereotype of women's 'natural' religiosity—a tendency that would, if true, have made them particularly vulnerable to church-led efforts to organize women's unions. Catholics did try to organize men and women workers in our period. Did they enjoy any striking successes amongst Belgium's *ouvrières* and *werksters*? One historian, Carl Strikwerda, has argued recently that working women did choose Catholic unions over alternatives. Although he does not argue that women outnumbered men in the Catholic workers' movement (which they did not), he does claim that at least as many working women belonged to Catholic unions as joined socialist ones. His peak date for such membership is 1910. His argument, moreover, is supported by a second historian of the women's Catholic trade-union movement in Belgium, Evelyn Thayer Eaton.[168]

Before disputing these contentions, and the evidence upon which they rest, I would present two caveats. First, I agree with Professor Strikwerda's caution against the common practice of assuming that only socialist organizations were 'authentically working class'. Only the most vulgar Marxists

[167] See Vandervelde, É. and Fester R., *Le Suffrage des femmes: Maintenant ou plus tard?* (Brussels, 1923), 3. Vandervelde, it should be noted, was arguing for women's suffrage, while Fester, from Charleroi, was against.

[168] Strikwerda, C., 'The Divided Class: Catholics vs Socialists in Belgium, 1880–1914', in *Comparative Studies in Society and History*, 30.2 (April 1988), 353, and Thayer Eaton, E., *The Belgian Leagues of Christian Working Class Women* (Washington, DC, 1954). A study of the various forms of Catholic efforts amongst workers is Gérin, P., 'Aspects éducatifs de l'action de sociétés ouvrières catholiques avant 1914', *BTNG/RBHC* 10 (1979), 189–215.

could indulge in such wishful thinking. Secondly, it was the case, as Strikwerda argues, that in the final years before the War, the Catholics began to enjoy some significant successes amongst Belgium's workers. By 1914, in fact, Catholic trade unions provided a serious rival to those of Belgium's two other 'pillars', socialists and liberals. And after the War, Catholic trade unions achieved dominance—a position they continue to hold today.[169]

These things said, however, the issue of the relations between working women and Catholic unions raises two key questions. To what extent did women workers join such unions? And were women more attracted to religious politics and unions than their male counterparts, as the stereotype claims? Neither the archives nor other documentary sources available for the years from 1880 until the War offer any evidence that would support a positive answer to the second question. Indeed, the contrary appears to have been the case: male workers were much more attracted to Catholic unions than their female counterparts. On the other hand, in the latter years of our period, women workers, along with men, did begin to respond to Catholic recruitment efforts, and this fact requires explanation. Ideologically speaking, the Catholics were always quite clear about women's proper place in society. Women's primary and defining role was that of mother; her ideal sphere was inside the family. However, although many Catholics supported various nineteenth-century efforts to restrict women's waged work to their homes, a few key leaders accepted the reality of Belgium's industrial economy: no sweating system could ever provide sufficient waged work for the country's millions of proletarian women. Some leaders also saw the challenge posed by socialist and a-political union successes; to counter these threats, a Catholic effort became necessary.

Amongst the first Catholic leaders to speak out about working women were two feminists, Louise Van den Plas and Victoire Cappe. The first started work just after the turn of the century, basing her efforts on a demand for equal pay for women as her primary platform. Victoire Cappe similarly rejected earlier Catholic-led efforts to force working women out of the workplace into domesticity. She, too, called for Catholics to support efforts to organize Belgium's female workforce into unions.[170]

[169] See Confédération des syndicats chrétiens, *Cent ans de syndicalisme chrétien, 1886–1986*, (Bruxelles, n.d.).

[170] Van den Plas, *Pourquoi les chrétiens doivent être féministes* (Brussels, 1902). She is also cited in *De Christene vrouw*, extract no. 19, 43–4, in Keymolen, 'Vrouwen emancipatie'. For Victoire Cappe, see extract no. 20, p. 44. See also Gérin, P., 'Louise Van den Plas et les débuts du "féminisme chrétien de Belgique"' in *BTNG/RBHC* 1/2 (1969), 254–75. Of course the Pope did not agree: see Léo XIII, *Rerum Novarum: On the Condition of Labor* (New York, 1939), 9, 10, 28.

However sincere, both faced difficulties. Like most industrial workers of the era, Belgium's *ouvrières* and *werksters* were alienated from a church which had so long allied itself with the very people who so cruelly exploited them. Indeed, so widespread was this proletarian anti-clericalism that even witnesses from traditionally Catholic Flanders, testifying before the 1886 commission, argued that local working people had 'lost' their religion. One man from Goselies insisted that 'religious feeling has diminished over the past 25 years, especially amongst the women, who appear to want to emancipate themselves from the duty imposed by the church'.[171]

The first Catholic efforts tried to halt this decline in Flanders—especially in Ghent. In the 1890s, local Catholics helped to found a rival to Vooruit, 'Het Volk', a co-operative that included not only working people, but also members of the local bourgeoisie. The motto of this group was 'Country, Family, Work'. When Het Volk proved less than wildly successful, leaders changed the motto, hoping to appeal directly to growing Flemish nationalism: in the new motto, 'Religion' replaced 'Country'.[172] A few years later, in 1893, a Catholic women's group appeared in Ghent, led by a woman worker, Virginie Broeckaert-Marant. They had a newspaper, *De Christine Vrouw*, which continued to appear from 1893 until the War. But despite strong support from the local church, this organization never enjoyed much success amongst Ghent's working women, as Denise Keymolen has demonstrated. The longevity of the paper depended more on the church's willingness to finance it than on member subscriptions.[173]

In 1896 a government report noted the existence of a Ghent *Ligue des femmes anti-socialistes*, which included one *couturières'* union. In that same year, according to officials, the city's anti-socialists also supported 'eight or nine male workers' unions'. And a few years later, the Catholics added an 'anti-socialist textile workers' union', the primary goal of which was 'to remove women from the factory workforce'.[174] Before 1900 none of these groups attracted more than a handful of members.

In that year, however, local Catholics threw themselves into the effort to organize Ghent's workers. They managed a few successes amongst women: the Christian Textile Workers Union's women's section (the

[171] *Enquête—1886*, i, 1016, and Neuville, J., *L'Évolution des relations industrielles en Belgique: L'avènement du système des 'relations collectives'*, i (Brussels, 1976), 294ff., and 'Il y a cent ans naissait le syndicat des Broederlijke Wevers', *Étude Sociale*, ix. *La Pensée Catholique* (Brussels, 1957), which argues that the original weavers' group was deeply religious.

[172] Confédération, *Cent ans*, 35.

[173] Keymolen, *et al.*, *Geschiedenis geweld aangedaan*, 24.

[174] *Revue du Travail* (1896), 245, and (1898), 986.

Catholics almost always preferred to keep women separate from the mainstream male group) counted 100 members by 1906. By 1909 there were 'a few' women dressmakers and seamstresses in Catholic unions and by 1912 local Catholics felt sufficiently confident to create a Secrétariat des Syndicats Féminins. (Its French title was significant: it belonged to the French-speaking bourgeoisie, not to Flemish-speaking workers.) This group claimed several unions of 'housewives and women farmers'.[175]

Ultimately, the Catholics created an umbrella federation for their various local textile unions, including dressmakers, and other non-factory workers. Its membership soon spread beyond the confines of Ghent, into the other textile-producing cities of Flanders. In 1913 the government counted the federation's membership: they found 8,367 male members and 3,164 female members, distributed amongst 73 unions.[176] One union, the Vrije Katoenbewerkersbond (the Free (Male) Cottonworkers' League) of Ghent, designed a banner that symbolized its underlying convictions. It featured a single worker, a woman, seated at a spinning wheel, against the background of the Ghent skyline. One of the spinster's hands rested on a shield which read 'Right and Duty'. In the lower right-hand corner stood a Lion of Flanders, upright on a pedestal, while the upper left corner was decorated with a Jerusalem cross. The banner was sewn with heavy black outlines, suggestive of medieval stained glass.[177] Thus did the Free Cotton Workers combine women's waged work with the prescribed domestic idyll, figured in quasi-religious imagery.

The available statistics demonstrate that the Catholics never achieved much success in the Ghent milieu, or in Flanders as a whole, and the failure was duplicated elsewhere. According to Denise Keymolen, even on the eve of the War, after years of intense organizing, the Catholics had managed to attract only 13,000 to 14,000 women members, including a significant number from the *petite bourgeoisie*. There were a further 15,000 women in the Boerinnenbond (the Farmers' Association's female auxiliary), as well as 17,000 women members active in various non-union farmers' groups. These numbers were considerable, of course, and after the War they would grow much greater. But in a world peopled by millions of women

[175] See ibid. (1906), 1109, (1909), 516, (1912), 1341–3. See also *La Ligue*, 1912.

[176] *Revue du Travail* (1913), 370.

[177] The banner is found in Confédération, *Cent ans*. This group probably sponsored the stained-glass window depicting textile-workers in the Cathedral of St Bavo in Ghent. It shows four work scenes: two with male workers, two with female workers. Despite this illustration of the Catholic preference for the separation of the sexes, such separation almost never occurred in the mill workrooms depicted.

industrial workers, they did not represent any significant working-class challenge to the socialists.[178]

The Catholics' relative lack of success in organizing working women cannot be attributed solely to the church's insistence on a domestic ideology that excluded women from the workplace. The privileging of motherhood over waged work, as we have seen, had proved highly successful in Verviers's working class in earlier years. A more likely explanation of the Catholics' general failure was the church's association with Belgium's ruling class. This association was continued within the unions: most were directed not by working women themselves, but rather by Catholic *bourgeoises*. Their distance from working women's daily lives was, needless to say, considerable.

Evelyn Thayer Eaton, in her highly sympathetic study of Catholic trade unionism amongst Belgium's working women, cited one lecture exemplary of this class divide. Given by Victoire Cappe in Brussels it was attended 'by all classes', but the seating arrangements revealed the implicit hierarchy: the ladies, in plumed and elegant hats, sat in the front rows; behind them sat several rows of less elaborately hatted *bourgeoises* and *petites bourgeoises*. And lining the back rows, in their distinctive small hats and rough clothing, sat, in Eaton's words, 'the working girls'.[179] As was usually the case amongst socialist women, this class bias was quite unconscious; it was grounded not in hostility but simply in blank incomprehension. In one speech in 1909, for example, Louise Van den Plas explained to a national Catholic congress that 'working women only work until marriage. Before that, they live with their parents, so they don't mind their smaller wage'.[180]

Key male Catholics were even worse, often combining both class and gender prejudices in their views of working women. Father Rutten, the social Catholic leader, told his fellow Catholics that working women were responsible for most of the restiveness in Belgium's working class: 'Daughters of miners go as servants, where they are mute but rebellious witnesses of the frivolous, useless life of their masters ... They then return, marry, and stir up hatred in their husbands' hearts for a society which reserves uninterrupted work for some, and the leisures of the *salons* for others'.[181]

Perhaps the most telling example of organized Catholics' inability to

[178] Keymolen, 'Vrouwen emancipatie', 73–5. She argues, correctly in my view, that Catholics enjoyed some success because they addressed themselves to working people's daily needs whilst the socialists, in many areas, were immersed in theoretical and political quarrels.

[179] Eaton, *Catholic Leagues*, 61.

[180] Quoted in Mission, A., *Le Mouvement syndical: Son histoire en Belgique de 1800 à 1914* (Namur, 1921), 293–4.

[181] Rutten, *Nos Grèves houillères*, 328.

shake off their prejudices was the position taken by Louise Van den Plas on suffrage. She supported women's vote, but only if the property conditions that restricted men's voting rights were applied as well to women. But in addition to votes given according to husbands' real property, she insisted on counting children and husbands as grounds for women's votes. Thus married women would have more votes than single women, and mothers would receive as many more votes as they had children. 'Only mothers and wives will defend the faith', she argued. Although she often said that women were 'naturally' more religious than men, she clearly had some doubts about single women.[182]

There were, then, several barriers between Belgium's Catholics and its working women (and men) that helped explain the weakness of their efforts at organization in our period. Moreover, these obstacles were greater against working women, a fact which may help explain why Catholic unions found more success amongst Belgium's men workers. (The fact that Catholics named their workers' headquarters 'Maisons des Ouvriers' was just as suggestive of their politics as the socialists' name for theirs.)[183] From the best evidence available, there were 107,000 more dues-paying male members in Catholic trade unions in 1914 than women members (in 1914 there were about 16,000 women Catholic union members).[184]

Of course the rate of unionization of Belgium's workers was very low whatever the sponsoring organization. (One figure, quoted above, estimated that only about 7 per cent of all Belgium's workers were unionized in 1910.) Thus attention to comparative figures may well be much less important than the evidence of other measures of working people's attitudes. Moreover, it is important to remember that neither union membership nor church attendance necessarily signalled belief or lack of it. Despite lamentations about workers' alienation from the organized church, almost everyone agreed that the majority of Belgium's workers were 'religious'—a fact evidenced in the many 'Saints Days' celebrated for patron saints of various occupations. In other words, Belgians driven from the church by the class preferences of the clergy did not necessarily

[182] Reported in *Stem der Vrouw*, Dec. 1904.

[183] See Charriaut, *Belgique moderne*, 195.

[184] Figures from Keymolen, 'Vrouwen emancipatie', 173–5, and Van Kerkhoven, J. (ed.), 'Le Mouvement ouvrier chrétien, vu de Flandre', *Contradictions* (autumn, 1986), 12.

relinquish their religious faith. Indeed, Auguste De Winne judged that in Flanders, 'everyone, male, female, dog, or cat, is Catholic'.[185]

Given this religiosity amongst both males and females, together with the socialists' rejection, the Catholics clearly missed their opportunity to organize Belgium's working women in these years. And ironically, they missed it for many of the same reasons that the socialists failed: class bias, together with tenacious stereotypes about women. Thus the Catholic story was similar to the socialist one. Excoriated or patronized by the bourgeoisie, exploited by industrialists, neglected by the state, and ignored by key socialist leaders, Belgium's working women found themselves without a safe organizational haven throughout the years before 1914.

[185] De Winne, *Door Arm Vlaanderen*, epigraph.

PART IV

Conclusion

'Cette "vulgarité" de sentiments dont Paul Lechat dénonce la triomphe dans la bourgeoisie européenne du XIX siècle, la Belgique, née si essentiellement bourgeoise, et, dès 1830, si penétré d'esprit bourgeois, ne pouvait y échapper que par miracle. Le miracle n'est pas produit'.

Thérèse Henrot
Belgique (Paris, 1958), 133.

9

Belgium in the *Belle Époque*

Toute la Belgique n'est qu'une grande bourgeoisie[1]

Thérèse Henrot

Marche de ton pas énergique
Marche de progrès en progrès
Dieu, qui protège la Belgique
Sourit à tes mâles succès
Travaillons! notre labeur donne
Et nos champs la fecondité . . .

Chant National de 1860, Charles Rogier

The attempt by some Belgian working women to create a political space in which to express their desires for transformed gender and class relations came to little. Unlike the Verviers *ouvrières* of the First International, however, these later women did not see their movement collapse as a result of the more general collapse of the wider movement. Rather, the POB/BWP successfully re-created itself into a French-speaking, centralized party, run by 'respectable' bourgeois men. The party grew steadily in the years before the First World War, playing a central role within the Second International and at the same time increasingly identifying itself with the Belgian nation.

When war broke out in 1914, Émile Vandervelde was appointed Minister of State, crowning his—and the party's—ascent to respectability. Lalla Vandervelde recalled, 'all those who had hated us before showed a sudden desire to become our closest friends'.[2] One mark of socialist absorption into the bourgeoisie was the extent to which they joined with other political tendencies in the search for national identity, a quest that expanded as Belgians encountered the problems of empire just as they discovered

[1] Henrot, T., *Belgique* (Paris, 1958), 102.
[2] Vandervelde, L. *Monarchs and Millionaires* (London, n.d.), 36.

their place at the crossroads of a Europe which was increasingly economically intertwined if overtly stridently competitive.

Belgian nationalism—to the audible frustration of their ambitious king, Léopold II—never reached the emotional frenzy seen elsewhere in Europe. Part of the inability to express an unfettered nationalism stemmed from most Belgians' uncertainty about the nature of their collective identity. Not only was Belgium a relatively young country, but a serious cultural division—between the Flemish-speaking north and the French-speaking south—inhibited a straightforward rush into national egotism. The traditional localism of Belgians further fractured the *pays civil*, and militated against the emergence of a simple notion of 'Belgianness'. Lastly, the self-conscious and overweening nationalism of Belgium's neighbours ran counter to something in the Belgian temperament. As one Belgian has remarked, most of the nation's inhabitants, whether Fleming or Walloon, lack 'a grand international vision of themselves'.[3] On the whole, most were content to remain mentally, as well as physically, at home, awash in a familiar bourgeois self-satisfaction.

Nevertheless, these relatively self-effacing Belgians were not entirely immune to nationalist fever. As we have seen, they continued to celebrate themselves in great public parties to which they proudly invited Europe. In these *fin-de-siècle* exhibitions, monumental sculpture and architecture exemplified Léopold II's grandiose visions. (The huge and unappealing arch and museums of the Parc Cinquantenaire were Léopold's, as was the extremely ugly and disproportionately large Palais de Justice.) These structures, their styles lifted whole from other cultures, loomed over Brussels' *belle époque*, dwarfing more modest buildings, especially those designed with the delicate lines of Belgium's art nouveau (preferred, as we have seen in Ghent's Vooruit and Brussels' Maison du Peuple, by aesthetically inclined socialists).

In Belgium, as elsewhere, one striking element in this turn-of-the-century nationalism was the emergence of symbolic self-representation: female figures increasingly embodied aspects of national identity. In France, Marianne assumed a bourgeois personality, reflecting the comfortable domesticity of the early Third Republic. A French sculptor exported this bourgeois Marianne to the United States, where 'Miss Liberty' soon became the primary symbol of that nation. Germans built threateningly colossal 'Germanias'—curiously ambiguous symbols of this 'Fatherland', while Britain had its Britannia, modelled on its 'real' national symbol. In

[3] Jacquemyns, G., *Histoire de la crise économique des Flandres (1845–1850)* (Brussels, 1929), 14.

this era, Britannia assumed a Kiplingesque smugness, a decidedly Victorian, over-fed air. Soon even in insecure Belgium, a figure began to emerge from the plethora of cultural possibilities.[4]

The story of the emergence of Belgium's 'Marianne', who though identified primarily with a progressive national self-image was not the exclusive representative of the left, takes up the various issues that have shaped this text: women's relation to work and to bourgeois ideology, working women's role within the organized movements of their class, and lastly the myriad ways in which class and gender intersected throughout the decades from Independence to the War. Furthermore, it suggests new paths of research, which will, one hopes, lead to a broader history of Belgium at the same time as rescue still more of the nation's forgotten women.

BELGIUM'S MARIANNE

The appearance of this national symbol was aided by two factors. First, the Belgian socialists had long articulated a socialist aesthetic; many of the movement's members and sympathizers inhabited the lively Belgian avant-garde of the period, which was stimulated by this 'paradise of bourgeois capitalists' to heights of anti-hegemonic satire. Secondly, Belgium's disappearing *hiercheuses* provided socialist artists with a natural subject, and one whose appeal was no longer compromised by a vexed reality, thanks to reform legislation. (Those most pitied by all *fin-de-siècle* reformers were, as we have seen, the linen-mill workers of Flanders, who never served as artistic alternatives to the *hiercheuses*.)[5]

It would not be accurate to argue that the *hiercheuses* emerged as Belgium's sole national icon: in 1914 the country still lacked a single image readily identified with the nation. But it was certainly true that images of Belgium's female coal-miners wandered through the public imagination— shifting and changing, now representing this abstraction, now that. It is a

[4] See Agulhon, M. and Warner, M., *Marianne into battle*, and *Monuments and Maidens*, resp. See also the dust-jacket illustration for James, H., *A German Identity, 1770–1990* (New York, 1989), which shows 'Germania', in medieval garb, greeting 'Italia', in classical clothing. In this period Britain's warrior queen, Boadicea, yielded her place in the public imagination to a more domesticated monarch, Victoria, Tennyson's 'Mother, wife, and queen'.

[5] There were representations of visibly suffering 'women of the people', but no Belgian artist portrayed any other female industrial workers as heroines of labour. A few artisans including *boteresses* drew such attentions, and a handful of other industrial workers—glass-workers, for example—were drawn by artists, but amongst females only *hiercheuses* achieved heroic status.

complicated story, demanding a separate study,[6] but its outlines encapsulate some concluding thoughts in this history of Belgium's working women.

From very early on, Belgian socialism was linked to ideas about a new art—the art of the people, or about the people. The socialist aesthetic credo came from Lamennais, who, writing in 1840, proposed that 'Artists must descend into the entrails of society, gathering themselves the life which beats there'.[7]

And of course Belgium's 'entrails' were the mines. We have seen in Chapter 5 the attractions of life underground as it was imagined in the middle years of the century. Chapter 6 examined, briefly, the emergence of *hiercheuses*' portraits in the final decades of the century, but by the *fin-de-siècle*, what had been but a trickle of drawings soon became a flood.

It was Vincent Van Gogh who launched the *hiercheuses* into artistic history, drawing women coal-miners during his sojourn as a missionary in the Borinage in the late 1870s. A few years later, a second artist visited Belgium's *pays noir*. From that moment in the early 1880s to his death in 1904, Constantin Meunier painted, drew, and sculpted dozens of *hiercheuses*.[8] In virtually every depiction, these females represented Meunier's idea of a national icon. Like the Hollands Maid of tradition, most of Meunier's *hiercheuses* carried the tool of their trade. Where the Dutch figure had carried a pike, however, Belgium's new working 'Marianne' carried her coal-shovel.[9] Again, like female allegorical heroines everywhere, the *hiercheuses* wore head-coverings: for the phrygian cap of Marianne, Belgium's *hiercheuses* substituted a distinctive dark head-scarf.

A 'Marianne of the proletariat' was not a new idea at the end of the nineteenth century. In Catholic Belgium, as Henri De Man noted later, any central allegory was bound to be represented by a female. De Man recalled, 'in my Flemish homeland . . . from the time of my youth the most popular socialist song was a "Song of Marianne", beginning "I am Marianne

[6] See my 'The Rhetoric and Iconography of Reform: Women Coal Miners in Belgium, 1840–1914', *Historical Journal* (spring, 1991), 411–36.

[7] Félicité Robert de Lamennais is quoted in *Art et société en Belgique, 1848–1914*, catalogue from an exposition. Palais des Beaux-arts de Charleroi, 11 Oct.–23 Nov. 1980, 59. See also Clark, T. J., *The Painting of Modern Life: Paris in the Art of Manet and his Followers* (New York, 1985). Clark argues that French artists used 'marginals' to represent modernity. This does not entirely fit the Belgian case, where the social definition of 'marginals' was much broader, and where the avant-garde was always associated with the socialist political project. See Maus, O., *Trente années de lutte pour l'art: Les XX, La Libre Esthétique, 1884–1914* (Brussels, 1980), and Aron, P., *Les Écrivains belges et le socialisme (1880–1913)*, (Brussels, 1985).

[8] The dates of Meunier's showing of his *hiercheuses* are found in André Fontaine, *Constantin Meunier* (Paris, 1923).

[9] A description of the Hollands Maid is in Schama, S., *Embarrassment of Riches: An Interpretation of Dutch Culture in the Golden Age* (New York, 1987), 380.

Prolétaire!", and ending "one day when the hour of vengeance sounds, I shall take as spouse those who march the most bravely by my side!"' According to De Man, this social heroine was at once spiritual and erotic.[10]

The *hiercheuses* began, increasingly, to play this role in artistic life. Theirs was a complex message, of course: unlike the dockers and steel-workers celebrated in Meunier's worker-hero pantheon ('equals of the ancient gods', in Jules Destrée's admiring phrase)[11] these *hiercheuses* were both goddess and revolutionary whore. In trousers and scarves, wielding black coal-shovels, these figures were at once politically subversive and sexually challenging. Their loose trousers and bare feet, moreover, hinted at androgyny. Their physical freedom in a world where *bourgeoises* were tightly controlled by fashions which demanded the most complete constriction of the female body represented a profound attack on bourgeois sexual respectability.[12] One of Meunier's contemporaries was quite clear about the sexual allure of the sculptor's bronzes. Victor Rousseau recalled that one of Meunier's bronze *hiercheuses* 'loomed in my mind ... an adorable silhouette, slim and nearly voluptuous'. Her slenderness, he added, 'de-hanchée aux formes que l'on devine désirables'.[13]

Meunier was not the only artist intrigued by *hiercheuses*. Cécile Douard, a Frenchwoman working in Mons in those years, produced a series of drawings that illustrated the report of the ladies' committee for the Chicago World's Fair in the 1890s. Subsequently, mining women became the focus of nearly all Douard's work. Her pictures included both young females and very old, very ragged, female 'witches', stooped over clawing at the slag-heaps or hunched beneath the weight of great sacks full of gleaned coal.[14] Douard's figures differed from Meunier's by showing the reality—of youth and of old age in the mines. Where Meunier's mine scenes tended to feature static figures—sometimes chatting or flirting, but rarely working—Douard's figures featured both movement and dirt. To

[10] De Man, *Au Délà du marxisme* (Paris, 1929), 111.

[11] Quoted in Émile Cammaerts, *The Treasure House of Belgium: Her Land and People, her Art and Literature* (London, 1924), 118. Destrée was describing Meunier's many male figures.

[12] Artists were aware of the possibilities contained in workers' clothing, and many began to collect key items of such clothing for use in their work. The restrictive clothing of *bourgeoises* is described in Smolar-Meynart, A. (ed.), *La Femme et l'égalité, 1789–1889: De la dentellière à l'avocate*, catalogue from an exhibition. Musée de la costume et de la dentelle de la ville de Bruxelles, 24 Mar.–24 Sept. 1989 (Brussels, 1989).

[13] Quoted in Fontaine, *Meunier*, 100, and in Verhaeren, E., *Pages Belges* (Paris, 1926), resp.

[14] Douard's pictures are found in *Enquête de la femme*. Several paintings are owned by museums in Liège and Charleroi. Although Douard wrote two autobiographical works, neither mentions her work amongst the *hiercheuses*.

Meunier's exclusive concentration on youthful, pretty females, Douard added a visible compassion for the old, exhausted women of the mines. In fact Douard's *glaneuses de charbon* were harsh social allegories. Her gleaning women evoked one overriding emotion: horror. There was nothing sexual about these figures, and nothing at all of heroism. Instead, Douard chose a very dark palette with which to convey the reality of these women's lives. Their bodies were bent, their hands claw-like, their feet clad in torn rags: immiseration was given form.

Meunier and Douard were soon joined by many others—François Maréchal, Armand Rassenfosse, Xavier Melléry, and Pierre Paulus, amongst them—who chose *hiercheuses* as subjects. Images of Belgium's woman miner spread everywhere; by the end of the century, she had become the prototypical heroine of labour. The socialist press noticed the possibilities inherent in such icons: after 1900 propaganda glorifying Belgium's women workers flowed from socialist presses—and in fact increased following the party's rejection of women's political participation in 1902![15]

Socialism and avant-garde art movements overlapped, as I have said. Thus it was not surprising that certain avant-garde groups chose this labour heroine to symbolize their movement. In 1905, when young Walloon artists and intellectuals founded a new journal, *La Jeune Wallonie*, which proclaimed its purpose 'Pour l'art et la terre wallonne', they chose to represent Young Wallonia with a highly idealized *hiercheuse*. The illustrator (Pierre Paulus) followed the conventions of the genre: both hands on hips, she stands in her wooden clogs amidst a slag-heap. Her figure is framed by the smoke rising from mine chimneys looming behind. Here, however, there was nothing of the 'coquette': she is young and friendly, but in no sense erotic. At the same time there is nothing of Douard's realism; instead, she is highly folkloric—detached entirely from the reality of economic life.[16] (Incidentally, this figure was produced in the same year that the organizers of the Liège exposition commissioned still another portrait of a *hiercheuse*, to symbolize the city in exposition publicity.)[17] On the other hand, in the work of at least two contemporaries, women miners represented working women's sexuality. Both Armand Rassenfosse (a student of Félicien Rops) and François Maréchal painted *hiercheuses* as trollops, their clothing either missing (Rassenfosse was particularly fond of

[15] See PG, Cours d'Appel, Brussels, 'Agitations politique et sociale, congrès, troubles, grèves élections, attentats à la dynamite, no. 242. See also *Le Peuple*, 1900 and esp. 1902 ff.

[16] Copies of the journal are found in the Musée de la vie wallonne, Liège.

[17] The torn poster (its upper right-hand corner is missing) is in Antwerp's Vleeshuis Museum.

bare-breasted figures) or ripped and tumbling provocatively from bare shoulders, sometimes exposing one breast.[18]

These risquée *hiercheuses*, overtly rather than covertly erotic, were extensions of the already widely voiced view that work in coal somehow rendered females more sexual. But there was another element—present in the unglamourous *glaneuses* of Douard—that came increasingly to shape public representations of female coal-miners: sentiment. Perhaps nowhere were Belgium's female mine-workers more clearly intended to invoke the lacrimose emotions prescribed by the late Victorian bourgeois world than in the work by Gustave Marissiaux exhibited in Liège in 1905. In this remarkable show, as we have seen, hundreds of Marissiaux's photographs of coal-workers focused on females. The photographer posed his subjects with care, highlighting the contrast between prevalent bourgeois ideas of femininity and the black, hard world of the mines. Beautiful young women and girls, in pristine clothing, pushed heavy waggons and shovelled coal against the looming, ominous black background of the coal mine. A typical photograph—now a picture postcard available for sale in the gift shop of the Musée de la vie wallonne in Liège—showed a small girl, in distinctive headscarf and clogs, seated at the top of a vast black mountain of slag. She gazes wistfully over broad fields spread below her; and in the distance, a church tower marks the presence of a village. Her youth, her beauty, her longing undoubtedly tugged—as intended—at viewers' hearts.[19]

These photographs were, and remain, highly popular. For socialists they represented Belgium's grittiest realism; for others they evoked both national-ist pride (that women had once done such work and that they were now legally prevented from going down the mines), and nostalgia for a 'disappearing' industrial world. For the women of the mines symbolized a vanished era—the blackest years of an industrial revolution declared at an end by the century's end. Such feelings determined Charleroi's choice of another *hiercheuse*'s portrait to represent that city at its international exposition, in 1909 (Pierre Paulus was once more the artist).

The romantic, nostalgic re-creation of the women who had once worked underground in Belgium's black country intensified with time. At the 1909 Charleroi exhibition, for example, *hiercheuses* appeared not only on publicity

[18] See Decroes, C. and Clercz-Léonard-Étienne, F., *François Maréchal*, catalogue from an exhibition: Stadtischen Kupferstich-kabinetts Luttich (n.p., n.d.), no.53, 'La Hiercheuse', 1915. This figure resembles an 'after the fall' version of the figure on the Liège poster of 1905. Rassenfosse's work is in public museums all over Belgium.

[19] These photographs are in the Musée de la vie wallonne; Mme Nadine Dubois kindly made them available to me. Several are reproduced as picture postcards—continuing the tradition of earlier years!

posters and brochures, but also in the fair's catalogue (painted this time by François Maréchal), on medals, and even on tickets. On the latter they shared space with Belgium's other most heroic industrial images, (male) steel-workers, miners, and so on.[20]

It was not until after the war, however, that the Belgian *hiercheuse* reached her aesthetic apotheosis as a pure embodiment of national nostalgia. And although this story lies beyond our period, it provides some explanation for the subsequent disappearance of these *hiercheuses* from the written record. In the inter-war years, portraits from the turn of the century were transformed into high art by the connoisseurs of Belgium's cultural élite. At the Royal Art Society's first exposition in the 1920s (held under royal patronage) six of Meunier's previously unexhibited *hiercheuses* were hung amongst 'Belgian Masterpieces, 1830–1914'.[21]

Belgium's icons of female labour were so popular that they spread abroad. In 1923 the British Independent Labour Party illustrated its newspaper with one of Meunier's bronzes labelled, 'A Belgian Pit Girl'. In May of the following year, they chose one of Cécile Douard's portraits for their Mayday issue: 'Pit Girls Ready To Go Down the Mine', and in September they again used a Douard picture, this one entitled 'Pit Girl Pushing a Truck'.[22]

In the 1930s the socialist city of Liège decided to honour local labour. First, they commissioned 'Fontaine de la Tradition' for a city square. This monument featured one panel showing the *hiercheuses'* local forebears, the *boteresses* (together with one 'cotiresse', or street merchant). A few years later they commissioned another monument, which was designed by Joseph Zomers, and dedicated to the local folk hero, the marionette 'Tchantches'. But despite its ostensible purpose, to celebrate the city's puppet mascot, the monument was actually a tribute to the *hiercheuse* who is the puppet-mistress. Holding the puppet aloft, this *hiercheuse* stands with

[20] I found the main exhibition poster for sale in a Brussels arcade and photographed it. Other objects from the exhibition are found in Gustave Drèze (ed.), *Le Livre d'or de l'Exposition de Charleroi en 1911*, i, ii (Charleroi, 1911). See also L. Cloquet's description of the event in *Les Artistes wallons* (Bruxelles/Paris, 1913), 100, 101. Fonds Chambon, no. Q4c includes postcards for sale at the exposition showing very respectable women glass-workers at work.

[21] See Société Royale d'Encouragement des Beaux-Arts et 'L'Art Contemporain', *Œuvres Choisis de Maîtres Belges, 1830–1914*, catalogue from an exposition: Musée Royal des Beaux-arts d'Anvers, 12 Jun.–30 Oct. 1920 (Antwerp, 1921). In these years the socialist commune of Couillet commissioned a painting for its city hall from Alex-Louis Martin. It was called 'Triptich de la Mine' and featured a central panel showing a *hiercheuse*. See Champagne, P., *Le Peintre Alex-Louis Martin et l'art moderne* (Mons, 1929), 27.

[22] I am grateful to Clare Collins for these references.

a hand perched on one provocatively extended hip. The puppet's waist is level with the top of her head scarf, and Tchantches's *sabots* cling to one of the female figure's clearly defined breasts. The pose is highly erotic, as this *Liègeoise* flaunts the tiny male figure. In this representation, the masculine folk identity of Liège is utterly dominated by its female industrial labour.

Elsewhere, *hiercheuses* continued to attract artistic attention. In Charleroi, the photographer Émile Chavepeyer proved an apt heir to Marissiaux, producing dozens of striking—and equally romanticized—studies of women coal-workers. He, too, used the femaleness of his subjects to highlight the 'masculinity' of the industrial world.[23] And it was in that city, too, that the *hiercheuse* achieved her iconic peak—or nadir, depending on taste. In the middle of the 1930s Charleroi commissioned its own 'monument': a vast, wall-sized canvas by Edmond Dumont called 'Fleur Du Terril' (Flower of the Slag-Heap), which hangs today in the city's Fine Arts Museum, the centrepiece of a room devoted to industrial scenes. Without the caption, however, viewers would be hard-pressed to explain its presence amidst paintings of factories and mines. What it shows is not the coal-covered, smoke-framed figure familiar to viewers of other portraits of Belgium's women coal-miners. Rather, it features what looks like a shepherdess. Dumont's palette was almost entirely pastels: the background sky, far from billowing with the customary black clouds, glows in gentle pinks and soft blues more appropriate to a summer evening in the Ardennes than to Charleroi. The rosy-cheeked female figure, clothed in a milk-maid's costume, stands gazing happily over the bucolic landscape below her. Flowers and grasses, rippling softly in a breeze, grow on the once-feared slag-heap beneath her feet. Her coal bucket, innocent of any sign of coal, suggests nothing more than a milk pail, waiting to be filled. Not a single element in this curious painting evokes the *hiercheuse*'s harsh past. Once sexually threatening, strong, subversive, proud, the *hiercheuse* is tamed.[24]

Thus was the *hiercheuse* caused to disappear from an elaborate visual

[23] His work is found in the Musée de la Photographie in Marchienne-au-Pont, outside Charleroi. See also Mayeur, *et al.*, *Émile Chavepeyer* (Fleuru, 1989). Mme Véronique Vercheval at the museum first showed me these pictures and I am grateful.
[24] I am not the only viewer struck by this painting; the German historian Hans Seeling was similarly baffled. See his *Les Wallons pionniers de l'industrie allemande*, trans. Pauquet-Dorr, J. (Liège, 1983), 161–2. There were other examples of the taming of Belgium's working women. See e.g. a 1975 postage stamp series, 'Thema Belga', which shows *boteresses*, amongst others. Another 1971 stamp showed a lace-maker, but the *hiercheuses* have never found their way on to a Belgian stamp, which perhaps indicates how forgotten they are. The country's obsolescent 50 centime piece features Meunier's bust of a male miner.

history. Soon, she was exiled even from the written past: in a recently published, prize-winning study of Belgian coal-mining, *Les Gueules noires* by Michel Delwiche and Francis Groff,[25] no mention of women mars the entirely masculine text. Indeed, the only hint that women ever worked in coal is a single photograph of some French women coal-miners, taken to document women's 'temporary' war work.

This narrative of the iconic role of Belgium's women workers has been exceedingly brief, though I hope suggestive. However, this visual evidence supports my argument that Belgium's working women played a distinct role in that country's economic and social life in our period. Unlike France's Marianne, whose femaleness, according to Maurice Agulhon, demonstrated the weakness of the Republic, the popularity of Belgium's icons underscored Belgium's unshakeable pride in its turn-of-the-century identity as the industrial capital of Europe.[26]

THE OTHER 'OTHER'

Hiercheuses, or women workers in general, were not the only subjects available in the Belgian search for national identity. In the final decades of the nineteenth century, a second 'other' emerged to signify national superiority. This measuring image was not found underground in the 'entrails' of the earth, but rather 'below' Europe, in the geographically designated 'nether world' of Africa.

Although Belgians were considerably less enthusiastic about setting their national identity against a colonial background than were most other Europeans, they did participate in the creation of an empire. The conquest of the Congo was almost entirely the work of the king, who recognized in it both the possibility of making massive profits and of directing attention away from the political and social problems that plagued Belgium. As early as 1864 Léopold had suggested empire as a way to settle the most vexed problem of those years, constant quarrels between liberals and Catholics. He wrote 'only on the day when we possess an overseas policy will we be able to cauterize the appalling cancer of liberal–clerical conflict which is

[25] Delwiche, M. and Groff, F., *Les Gueules noires* (Brussels, 1985).

[26] Agulhon, M., *Marianne into Battle: Republican Imagery and Symbolism in France, 1789–1880*, trans. Lloyd, J. (Cambridge, 1981), 185. Agulhon's wise caution bears repeating here: 'The sex of a Nation! One can imagine how far up the garden path of socio-psychoanalytical meditation one could be led if one pursued that track. We must admit that we would put no great faith in such a venture, believing that to apply categories of individual psychology to collective concepts could lead one to make the mistake of taking metaphors for realities'.

eating us away and wastefully diverting both our energy and the living strengths of the nation'.[27]

Once the work of 'diversion' was under way, in the 1880s, 'the natives' very quickly attracted the kind of public attention once focused only on working women. In 1889, during the 'anti-slavery conference' in Brussels (the disingenuous means by which Léopold fooled the world into believing in his altruistic intentions in Africa), one historian noted that 'vain arguments from certain quarters suggested that "trade spirit" was actually good for the health of the African body'.[28]

Some bourgeois feminists used conditions in Africa to support women's rights in Belgium. In 1893 *La Ligue* claimed that 'the equality of the sexes is absolute in Kondeh, or if there is inequality it is in favour of the women'. On the other hand, the male feminist leader Louis Frank insisted that only those parts of the world inhabited by Anglo-Saxons—i.e. New Zealand, Canada, and so on—provided equal rights.[29] As was the case earlier with women workers, the people of the Congo were available to support any point of view.

Even the socialists got into the act, again some using the 'other' positively, some negatively. Many warned against an African empire on the grounds that reform sentiments would go abroad, stranding Belgium's workers. Proponents of this view drew analogies between colonized people and proletarians. In 1889, for example, *Vooruit* published a comparison between the dispossessed 'natives' of Africa and Belgium's internal dispossessed. Without higher wages and better conditions, the paper opined, 'onze kinderen alleen slacht-offers worden des bloetwet dan is dit alles daaraan te wijten, dat wij geene kiezers zijn en hier in ons land behandeld workden gelijk Congolanders'.[30]

In 1902 Liège's *Le Travail* joined the chorus of bourgeois nationalism, printing, approvingly, 'The Congo Hymn', given to the Congo Free State by its owner, the Belgian king. One stanza went:

> After centuries of slavery
> The good 'negr' is now well content
> Almost entirely free of cannabalism.
> And he is able to learn Flemish . . .

[27] Quoted in Ascherson, N., *The King, Incorporated: Léopold II in the Age of Trusts* (London, 1963), 51, 57.

[28] Ibid. 115.

[29] 'En Afrique centrale', *La Ligue*, Oct. 1893; and Frank, L., *Les Salaires de la famille ouvrière* (Brussels, 1896), 60.

[30] 'Wat willen socialisten?' *Vooruit*, 5 Jan. 1889.

The song continued in this vein, describing how the poor natives, who had once survived on a diet of bananas, now ate ham, thanks to the Belgians![31] Vandervelde himself believed in the primitive nature of the African 'others'. When the Chambre debated whether or not to assume ownership of the Congo, Vandervelde argued that it was their duty—as civilizers. According to Madeleine Rebérioux, he was convinced that 'colonization is necessary to the progress of Blacks', and thus, 'he refused to oppose the buying back of the Congo'.[32]

However, that there was even hesitation about assuming state control of Léopold's empire demonstrates my point here. In Belgium, considerably less pro-colonialist sentiment than that prevalent elsewhere coloured the public debate. Indeed, for the most part the Belgians stayed on the fringes of what one writer has described as the 'hurricane of nationalism' that swept the continent. So reticent were they, that the king was heard to cry in frustration: 'In regard to the national sense, the Belgian is backward!'[33]

THE SOCIAL CARBUNCLE

Though Léopold II did not remark it, 'the Belgian' was similarly backward in the more important arena of social life. In these years Belgians' collective immobility meant that the vast, festering sore constituted by the nation's working class continued to trouble the body politic. One Belgian historian has summarized the entire period from 1830 to 1914 as follows: 'Belgium knew an extraordinarily rapid development from the economic point of view, but appeared to remain as one of the most retrograde nations from the social point of view'.[34]

Ironically, nationalist competition provided abundant documentation for Belgium's position on the lowest rung on the ladder of social reform, and workers fell upon such information with glee. In 1905 an international

[31] *Le Travail*, 2 Feb. 1905. The following issue of the paper condemned the racism prevalent in the United States, demonstrating how readily one perceives the mote in another's eye: see 4 Mar. 1905.

[32] Rebérioux, 'Le Socialisme belge de 1875 à 1918 (Paris, 1982), 329. See also Polasky, J., *Between Reform and Resolution: The Democratic Socialism of Émile Vandervelde*, forthcoming, esp. ch. 3.

[33] Quoted in Huizinga, J. H., *Mr. Europe: A Political Biography of Paul Henri Spaak* (New York, 1961), 41.

[34] Le Brun, P. Bruwier, M., Dhondt, J., Hansotte, G., *Essai sur la révolution industrielle en Belgique* (Brussels, 1981), 708.

survey of literacy amongst military conscripts showed Belgium near the bottom. (Germany's literacy was highest: only 7 out of 10,000 recruits were unable to read; for England and France the figures were far higher: 380/10,000 and 460/10,000, respectively.) In Belgium 1,010 of every 10,000 young men called for military service could not read! Only Italy had worse figures—about 3 times those of Belgium. (The Belgian paper that reported this bleak news added, sarcastically, 'Quant aux Belges, donneront-ils au monde ce spectacle original de réaliser l'instruction obligatoire au Congo?).'[35]

In 1906 the miners' newspaper revealed the degree of Belgian exploitation of its working class, publishing a comparative survey of working hours and wages:[36]

Hours per Week

Country	Hours
United States	49
England	51
Germany	55
France	58.5
Belgium	65

Hourly Rates
Belgian Francs

United States	1.87
England	0.87
France	0.66
Germany	0.60
Belgium	0.37

Belgium also trailed, as we have seen, in control of labour practices: except for the minimal laws affecting women's and children's mining, passed at the end of the 1880s, Belgium had no legislation. Britain, Germany, and France, by comparison, had laws concerning maximum hours, health and safety standards, and child labour by the early years of this century. Even the under-industrialized Netherlands had strict restrictions on children's and women's work and hours. But Belgium remained

[35] 'Les Illettrés', *Le Travail*, 25 Nov. 1905.
[36] 'Pour la réduction des heures du travail—la manifestation de Bruxelles', *Ouvrier Mineur*, 1906.

committed to using state action only to ensure the steady flow of francs into bourgeois bank accounts.[37]

After the death of Léopold II in 1909, the situation might have changed had the new king, Albert, concerned himself with the plight of millions of his subjects. At first, he appeared to have a social conscience. In 1910 he publicly approved the end to the system of military conscription that had allowed the rich to buy substitutes from amongst the country's poor: 'All classes of society are now engaged equally in the performance of the same sacred duty,' he announced, 'the defence of our native land'. But his motives were mixed: 'For the future, a really national army, both solid and numerous, will form for poor and rich alike a healthy school of patriotism'.[38] And that patriotism, he soon showed, remained grounded in the contented self-satisfaction characteristic of bourgeois Belgium throughout our period. In a speech opening the 1910 international exposition, he crowed, 'This Exhibition ... proves to the eyes of the world the immense progress realized during three-quarters of a century by Belgium. We see a home of labour, where the co-operation of genius—daring in its creations—and intelligent industry have produced marvels in all fields of human activity'.[39] It was indeed true that industrial marvels and vast prosperity were the hallmarks of Belgium's *belle époque*, but so were misery and stifling poverty, tucked away out of bourgeois sight in every corner of the country, kept in their place by repeated military intervention throughout the period.

CONCLUSION

In these years just before the War, Belgium remained a society riddled with contradiction and inequality. Henri de Man recalled the country of his youth as 'the Belgian enigma':

a country very advanced from the economic point of view; the most industrialized country in the world; a country where class antagonisms are pushed to the extreme, but where politics are dominated by struggles between clericals and anti-clericals; a working class which contains to the highest degree the conditions required for the formation of class consciousness, but barely beginning to organize

[37] See the chart prepared by Keymolen, D., *Vrouwenarbeid in Belgie van ca. 1860 tot 1914* (Leuven, 1977), doc. 2, pp. 29–31.

[38] Quoted in Graham, E., *Albert, King of the Belgians* (New York, 1929), 35. Obligatory primary education finally came to Belgium in 1910.

[39] Quoted ibid. 132.

itself on the syndical terrain; a Parti Ouvrier composed nearly exclusively of proletarians but dominated by a petit-bourgeois mind.[40]

The social history of Belgium, then, particularly when seen from the point of view of those at the bottom of the social hierarchy, the women workers of Belgium's mills, mines, and workshops, provides a corrective to any sanguine version of the inherent benevolence of unfettered capitalism. Left unchecked to exploit and drain a miserable, suffering workforce, industrial capitalism does not produce any sort of utopia. Moreover, although it has been fashionable of late to declare in favour of some imaginary 'invisible hand of the market', on the grounds that at least it has not proved itself as incompetent and restrictive as an overly heavy 'visible hand of the state'[41] the Belgian case demonstrates that even in that paradise of capitalists, there never was a 'free' hand. It was never a question of whether the state would intervene or not, only on which side of the class divide. In Belgium, the choice was clear. But Belgian workers did not live long enough, or sufficiently free of hunger, disease, and ignorance even to become aware of any state role in their, or anyone else's, lives. Belgium's workers, in fact, enjoyed the most complete freedom from state interference. They could work, virtually from the cradle to the grave, seeing the state only in the form of strike-breaking, armed troops, and police (or military officers who relieved young male workers of their waged toil for the brief period of their conscription). Worse still, perhaps, their efforts to organize met failure—in the case of the First International—or disillusionment, when the Second International's party threw off its proletarian fetters to join what was by then a perfectly hegemonic bourgeois society. In the historical teleologies of both movements, women workers lost their chance to capitalize on their occupational status within the working world to transform gender relations, or, along with their male comrades, Belgian society.

In conclusion, it is necessary only to re-state briefly what has been the underlying argument of this book: that is, that waged women played an essential role in every aspect of Belgium's social history in the period from Independence to 1914. This has, nevertheless, been a limited examination of this history centred on five industrial regions, and much more study remains to be undertaken to complete the picture. Of course as the text makes clear, the task of historians concerned with that country's working women is no easier than that facing historians of hitherto invisible women

[40] De Man, H., *Cavalier seul* (Geneva, 1948), 78. The bitter tone can be attributed to De Man's wartime disgrace and exile.
[41] This formulation comes from Cornuelle, R., 'New Work for Invisible Hands', *Times Literary Supplement*, 5 Apr. 1991, 5.

elsewhere. And in Belgium, the problems are complicated by the evident loss of vast quantitites of documentary materials. Many of those reports that remain extant, of course, occlude women's participation, so that working women's activities are marginalized or minimized until their collective history remains just slightly beyond the normal reach of labour historians.

Nevertheless, sufficient materials remain to support a wider picture of Belgium's unique working women. Their equal exploitation—unaltered by custom or by legislation throughout our period—lent them a conviction of their right to equal treatment within the labour movement, a conviction more widely shared in the Belgian workers' movements of the second half of the century than in such efforts in most other countries. Although their political ambitions were stifled when Belgian socialism transformed itself into social respectability, Belgium's working women's movement flourished as nowhere else. Moreover, that this history was, until now, mostly lost only argues for the extent to which total bourgeois hegemony has been achieved since the First World War. From what might be characterized as the 'tribalism' of nineteenth-century working communities, in which gender roles were far more equal, Belgium's proletariat followed its political leaders into the individualistic, competitive, and—most importantly—patriarchal world of industrial capitalism.[42]

[42] The notion that working-class solidarity was a result of a social structure closely resembling what anthropologists know as 'tribalism' occurred to me as I was reading Annette B. Weiner's highly stimulating new study, *Inalienable Possessions: The Paradox of Keeping while Giving* (Berkeley, Calif., 1992). It would help explain both the solidarity of Belgium's working-class communities and the relative absence in them of gender hostility.

Select Bibliography

PRIMARY SOURCES

Archives

I. Archives Générales du Royaume, Brussels
Administration des Mines:

850	1898
851	1903–6
866	1856–8, 1868, 1884
867.1	1868–70
867.2	1858–60
867.3/4	1840s
867.5	1860s
868	1850–80
869.1	1899
869.2	1897
896	1838–40, 1852, 1858, 1860–3
915	1863–7
921–3	no titles
984	1891–4
985–7	no titles
1016	1832–44, 1892
1017	1844: 'coalitions'
1018	1887–90: 'grèves'
1018.2	1872–6: 'généralités concernant les grèves' 1862–9, 1871–2, 1877–9, 1884
1044–6	no titles

Inspection des Mines: 623
Ministère de l'Emploi et du Travail: Conseil Supérieur du Travail

17–20	'travail des femmes, des adolescents, et des enfants dans les établissements industriels, 1889–95'
21–4	'durée du travail, 1897–1904'
25–6	'salaire minime'
32–46	'commission de l'industrie linière, 1897–98'
47	'1904'
53	'commission de l'industrie du bois, 1903'

54 'commission de sécurité ct salubrité, 1899–1903'
Ministère de l'Intérieur: 110
Ministère de la Justice
Administration de bienfaisance et de prisons, nos. 48–50, 67–8, 625
Administration de la sûreté publique:

33	Police des Étrangères—dossiers généraux
115–21	no title
122	'clubs, meetings, 1839–40'
123–4	no title
125	'troubles dans la province de Brabant, 1848–49'
126–30	no title
131	'tentatives de troubles dans la Flandre Orientale, 1848–9'
132	'tentatives de troubles dans la province de Liège, 1848'
133–43	no title
150–2	no title
1016–18	no title
1018^2	'généralités concernant les grèves, 1872–76'

Printed brochures:
Édouard Ducpétiaux, 'Les Institutions de bienfaisance en Belgique', in M. P. Lentz (ed.), 'Statistiques des aliénés en Belgique' (Leuven, 1863)
II. Archiefs van Buitenlandse, Brussels
186.I 'socialisme, anarchisme, grèves, mouvement sociale'

12	'dynamite. matière explosives (*sic*), socialisme'
1853	'commencement des troubles à Liège'
1857	'Tournai, désordres'
1868	'commencement des troubles à Tournay'
1868–71	'AIT'
1872	'Ligue Internationale de la Paix'—'AIT'
1876	no title

186.II
1. 'La Statistique des ouvriers industriels sans travail en Belgique', M. E. Waxweiler, conférence internationale de chômage à Paris, 18–21 Sept. 1910.
2. 18/8: 'Note confidentielle—vente et colportage des journaux socialistes à Verviers, 1884'
3. 23 Mar. 1886: 'M. le Ministre des Affaires Étrangères à M. Delfosse'
4. note: Henri-Hubert Van Kol
5. 'propagande socialiste, 1886–87'
6. 18 Jan. 1887: 'Le gouvernement Belge et le socialisme'
7. 'les grèves en Belgique'
8. 'troubles en Belgique', Berlin, 1887
9. 'Ministre de l'Intérieur à M. le Gov. de la Flandre Occident, 18 avril 1889'
10. 1891
186.III: '1894–1910'

III. Archives, Ministère des Affaires Étrangères, Brussels
 C.2298 'industrie cotonnière, 1832–39'
 C.2298 'industrie cotonnière, 1840–59'
 D.2311–I 'questions sociales et ouvrières (1830–50)'
 D.2311–II 'questions sociales et ouvrières (1842–49, livrets')
 D.2311–II² 'questions sociales et ouvrières (1851–70)'
IV. Parquet Général, Cours d'Appel, Brussels; 'Agitations politique et sociale'
 217 'socialistes', 1848, 1849, 1852, 1854–9
 218A 'affaires politiques: questions ouvrières', 1862–9
 218B no title
 219 1873
 221 1884
 222 1884–5
 223 1885
V. Archives de l'État, Liège
 Sûreté Publique
 I.A.1–3
 II.A.1–11; B.1–13
 III.A.1–9; 12, 19, 24, 30, 31; B.1–19
 IV.A.1–109; B.1–19
 V.A.1–3
 VI.A.1–115
 VII.C.1–99; U.1–41
 IX.V.1–181
 X.V.1–25
 XI.A.1–11; B.1–20; C.1–12
 XII.A.1; B.1–58; C.1–9
 XIII.V.1
 XIV.A.1–291; C.1–314
 XV.A.1–81; B.1–143; C.1–3
 XVI.B.1–37
 XVII.A.1–114; B.1–140
 XVIII.A.1–222; B.1–85
 XIX.A.1–99; B.1–19
 XX.A.1–226; B.1–85
 XXI.B.1–350 (1895)
 XXII.A.1–36; B.1–99
 XXIII.A.1–52; C.1–148 (1895)
 XXIV.A.1–89; B.1–11
 XXV.V.1–15
 Others
 1ʳᵉ Partie:
 Carton XLIII.A—1886
 2ᵐᵉ Partie: 'Manifestations, meetings, grèves'

Carton I: 1899
 „ II–III: 1900–01
 „ IV–VI: 1903
 „ VII: 1905
 „ VIII: 1906
 „ IX: 1907
 „ X–XI: 1908–09
 „ XII–XIII: 1910–11
 „ XIV–XVI: 1912–13
4^{me} Partie: 'Registres indicateurs'
Carton LVIII: B–'Grèves, avril, mai 1899'

VI. Archives de la ville de Liège
 LVI 1899: Dossier A, 'manifestations'
 LVIII 1901: Dossier A, 'manifestations'
 XLIV 1887: Dossier A, 'manifestations', 1–43

VII. Archives de l'État, Mons
 F. Administration des mines: 121, 124^1, 124^2, 127^1, 127^2
 Archives communales, Jemappes
 II 633: 'Hornu. 20–21 Oct. 1830' (2 docs.)
 II 636, 639, 640
 Archives communales: Wasmes
 522 'grèves': 1869, 1872, 1877, 1879, 1885, 1886, 1887, 1888, 1893, 1897, 1902, 1912
 661 'catastrophe de la boule, 4 mars 1887, correspondance divers'
 663 'écoles d'adultes: correspondances et déliberations'
 665 'cercles des réunions populaires—bibliothèque'

Published Primary Documents

Bayer-Lothe, J., *Documents relatifs au mouvement ouvrier dans la province de Namur au XIXe siècle: IIme partie, 1849–1886* (Leuven, 1969).

Devreese, D. E. (ed.), *Documents relatifs aux militants belges de l'A.I.T., correspondance 1865–1872* (Leuven/Brussels, 1986).

Freymond, J. et al., (ed.), *La Première Internationale*, ii (Geneva, 1962).

Guillaume, J., *L'Internationale: Documents et souvenirs*, i, ii (Paris, 1985).

Linotte, L., *Les Manifestations et les grèves dans la province de Liège de 1831 à 1914: Inventaire sommaire des archives de la sûreté publique de la province de Liège* (Leuven, 1964).

Oukhow, C., *Documents relatifs à l'histoire de la Première Internationale en Wallonie* (Leuven, 1967).

Wouters, H., *Documenten betreffende de geschiedenis der arbeidersbeweging (1831–53).* vols. i–iii (Leuven, 1963).

——*Documenten betreffende de geschiedenis der arbeidersbeweging ten tijde van de 1e (1866–80)*, i (Leuven, 1970).

Institutes, Libraries, Museums

Corning Glass Museum, Corning, New York
 Fonds Chambon
 I: 1*a*, 3*a–c*, 4*b,c*
 Q: 4*c*
 S: 3*b*
 T: 5*c*
 Charleroi – Wallonie – Belgique – Pennsylvania – USA, pamphlet (Charleroi, 1990).
Institut Royal du Patrimoine Artistique, Brussels
 Collections:
 Cécile Douard
 François Maréchal
 Xavier Melléry
 Constantin Meunier
 Armand Rassenfosse
 Félicien Rops
Musée de la Photographie, Mont-sur-Marchienne (Charleroi): Mayeur, C. (ed.), *Émile Chavepeyer, 1893–1959* (Brabançon, 1987).
Musée de la Vie Wallonne, Liège: Collection: Gustave Marissiaux
Wren Library, Trinity College, Cambridge: A. J. Munby Collection
 Diaries: 33, 36
 Notebooks: 4, 66
 Album: 6

Printed Sources

Congresses, Political Party Publications
Congrès International Ouvrier Socialiste tenu à Zurich du 6 au 12 août 1893, no. IV, vol. 9 (Geneva, 1977).
Conseil Général du Parti Ouvrier, *Vade-Mecum du Propagande Socialiste* (Bruxelles, 1914).
Parti Ouvrier Belge, *Compte-rendu, VIIe congrès annuel, Verviers, 28–29 juin 1891* (Brussels, 1891).
——*Compte-rendu, Xe congrès annuel tenu à Quaregnon, 25 et 26 mars 1894* (Brussels, 1894).
——*Compte-rendu du congrès extraordinaire tenu à Bruxelles, 25, 26 déc. 1893* (Brussels, 1894).
——*Compte-rendu du 25me congrès annuel tenu à la 'Maison du Peuple' de Bruxelles 6–7 fév. 1910* (Gand, 1910).

Official documents and publications. Royaume de Belgique

Commission (sic). *Enquête sur l'industrie linière en 1840: Rapport*, i, ii (Brussels, 1841).

Commission du travail, *Réponses au questionnaire concernant le travail industriel*, i, (Brussels, 1887).

——*Procès-verbaux des séances d'enquête concernant le travail industriel*, ii (Brussels, 1887).

——Instituée par arrêté royal du 15 avril 1886, *Questionnaire relatif au travail industriel* 4 vols. (Brussels, 1887–8).

Commission instituée par arrêté royal du 7 sept. 1843, *Enquête sur la condition des classes ouvrières et sur le travail des enfants: Lois, arrêtés, règlements et législation étrangère concernant les classes ouvrières* (Bruxelles, 1846, 1848).

Comité central du travail industriel, *Bulletin*, août 1895. Ministère de l'Industrie et du travail, *Rapports annuels de l'inspection du travail 1907* (Brussels, 1908).

——Office du Travail, *Recensement général des industries et des métiers, 31 oct. 1896* (Brussels, 1901).

——Office du Travail, *Salaires des ouvriers dans les mines de houille* (Brussels, 1901).

——Office du Travail, *Revue du Travail, 1896–1914* (Brussels; published annually).

——Office du Travail, *Statistique des grèves en Belgique* (Bruxelles, 1896–1900, 1901–5, 1906–10).

Ministère de l'Intérieur, *Enquête sur la condition des classes ouvriers et sur le travail des enfants*, 3 vols. (Brussels, 1846).

Rossel, E. (ed.), *Belgium, its Institutions, Industries, and Commerce*, catalogue from the Louisiana Purchase Exposition, Saint-Louis, 1904 (Brussels, 1904).

Other Official publications

Bastin, N., Delaet, J.-L., Gosselin, F., Leboutte, R., Massart, D., Thiry, M., Toussaint, J. (eds.) *L'Art verrier en wallonie de 1802 à nos jours: Exposition organisée par les villes de Charleroi, Liège, Mons et Namur* (Charleroi, 1985).

Bibliothèque Royale de Belgique, *Exposition de gravures et dessins d'Armand Rassenfosse, 18 juillet–31 août 1936* (Brussels, 1936).

Chambre de commerce de Liège, *Rapport sur les travaux de la chambre de commerce pendant l'année 1901* (Liège, 1902).

Drèze, G. (ed.), *Le Livre d'or de l'Exposition de Charleroi en 1911* (Charleroi, 1911).

Gore, J. 'The Nations of Antwerp', in Wright, C. D. and Weaver, O. W. (eds.), *Bulletin of the US Department of Labor*, no. 17 (July 1898), 597–612.

Greer-Saussez, M. (ed.), *Le Borinage au temps de Vincent Van Gogh: Exposition*, Office du tourisme de la ville de Mons (Mons, n.d.).

Liège Exposition Internationale: Catalogue général officiel, 2me partie, sections étrangères (Liège, 1930).

Province de Liège, *L'Organisation judicieuse des loisirs nouveaux de la classe ouvrière* (Liège, 1920).

Reglement van den Socialistische Propagande-club voor Vrouwen ingericht den 25 juli 1886 (Ghent, 1886).

Société royale d'encouragement des beaux-arts et 'l'art contemporain', *Œuvres choisies de maîtres belges, 1830–1914*, Musée Royale des Beaux Arts d'Anvers, 12 juin–30 oct. 1920 (Antwerp, 1921).

Unofficial publications

DUCPÉTIAUX, É., *Budgets économiques des classes ouvrières en Belgique*, 2 vols. (Brussels, 1855).
——*Mémoire sur le paupérisme dans les Flandres* (Brussels, 1850).
Éléments d'enquête sur le rôle de la femme dans l'industrie, les œuvres, les arts, et les sciences en Belgique (Brussels, 1897).
FOSSION, N., *Réponse au rapport de M. Kuborn sur le travail des femmes dans les mines* (Brussels, 1869).
KUBORN, H., with Devaux, A., Dupont, E., Laho. U., Vandevelde, G., *Aperçu historique sur l'hygiène publique en Belgique depuis 1830* (Brussels, 1897).
——*Rapport sur l'enquête faite au nom de l'académie royale de médecine de Belgique par la commission chargée d'étudier la question de l'emploi des femmes dans les travaux souterrains des mines* (Brussels, 1868).
LEKEU, J., *Enquête ouvrière et industriel: À travers le centre, croquis et moeurs* (Brussels, 1907).
MARESKA, J. and Heyman, J., *Enquête sur le travail et la condition physique et morale des ouvriers employés dans les manufactures de coton, à Gand* (Gand, 1845).
SCHOENFELD, M., *Nouvelles recherches sur l'état sanitaire, moral et social des houilleurs pendant la periode actuelle de salubrité des mines en Belgique. Discours et études sur le travail des filles dans les charbonnages* (Charleroi, 1870).
L'Union des charbonnages, mines et usines métallurgiques de la province de Liège, *Du Travail des femmes dans les mines: rapport presenté par une commission spéciale et approuvé par le comité permanent de l'Union des charbonnages . . . de la province de Liège dans sa séance du 10 mars 1869* (Liège, 1869).
VAN BASTELAER, D.-A., *La Question du travail des femmes et des enfants dans les houillères en présence de la statistique officielle: Discours prononcé dans la séance du 6 nov. 1869 de l'Académie royale de médecine de Belgique pendant la discussion du rapport de M. Kuborn* (Brusells, 1869).
VLEMINCKX, J. F., *Lettre à l'Académie royale de médecine à l'occasion de la publication de l'enquête ordonnée par M. Le Ministre des travaux publics sur la situation des ouvriers dans les mines et les usines metallurgiques de la Belgique, 26 mars 1870* (Brussels, 1870).

Newspapers and journals

L'Ami du Peuple, Liège, 1873–5.
L'Avenir, Liège, Verviers, Huy, La Hestre, 1889.
L'Avenir Social, revue du POB, 1896–1902.
La Belgique Artistique et Littéraire; Brussels, 1909, 1911–14.
Le Cri du Peuple, Verviers, 1878–9.

L'Exploitée, Geneva, 1907–8
La Femme Socialiste, Brussels, 1903–8.
Le Gantier/De Handschoenmaker, Brussels, 1895.
Germinal, Brussels, 1907–8.
L'International, Verviers, 1869–72.
La Jeune Wallonie, Liège, 1909.
La Ligue, Brussels, 1893–1914.
Le Mirabeau, Verviers, 1868–80.
The Nation, New York, 1880–1914.
The New Leader, London, 1923, 1924.
L'Ouvrier Mineur, 1901–11.
Le Peuple, 1900–14.
La Question Sociale, Brussels, 1890, 1894.
La Revanche des Verriers, Lodelinsart, 1895–1911.
La Revue Socialiste, Paris, 1885–1914.
De Stem der Vrouw, Ghent, 1900–4.
De Textielbewerker, Ghent, 1900–4.
Le Travail, Vallée de la Vesdre, 1901–5.
Union des Femmes Wallonne, Liège, 1913–14.
De Vlasbewerker, Ghent, 1889–1904.
La Voix de l'Ouvrier, Brussels, 1884–5.
Vooruit, Ghent, 1889–1902.
De Vrouw, Ghent, 1893–1902.
De Werker, Antwerp, 1875.

Catalogues from Unofficial Expositions

De Arbeid in de kunst van Meunier tot Permeke, Antwerp, 26 Apr.–10 June 1952 (Antwerp, 1952).
Art et société en Belgique, 1848–1914, Charleroi, 11 Oct.–23 Nov. 1980.
Association belge de photographie, *IVe Salon International: Cercle artistique et littéraire*, 4–10 Oct. 1902.
De Weerdt, D., 'Zoë, Isabelle, Louise et les autres . . .', *Vie des femmes, 1830–1980*, Banque Bruxelles Lambert, 16 Oct.–30 Nov. 1980, 15–58.
'Documents et rapports', Exposition universelle de Londres en 1862 (Brussels, 1863).
Dumont, G.-H. and Walgrave, J., 'La Femme belge et le travail', *Vie des femmes*, Banque Bruxelles Lambert, 16 Oct.–30 Nov. 1980, 59–71.
European and American Art Committee, *Exhibition of Contemporary Belgian Painting: Graphic Art—and Sculpture* (New York, 1929).
'Exposition Constantin Meunier', catalogue Galerie Georges Giroux, 11 May–18 June 1928.
'L'Exposition collective des charbonnages de Belgique', Exposition universelle et internationale de Bruxelles (Brussels, 1910).

Exposition—Gand: Un siècle d'histoire sociale, Gand, 18 Feb.–19 Mar. 1931 (Brussels, 1939).

'L'Exposition du travail à domicile—documents, monographies, statistiques', Exposition internationale et universelle de Bruxelles, 1910 (Brussels, 1911).

L'Industrie en Belgique: Deux siècles d'évolution, 1780–1980 (Brussels, 1981).

Liège: Photographes de J. Cayet, J. De Coninck, Ch. Dessert et archives centrales iconographiques d'art national, intro. by Carlo Bronne (Brussels, 1949).

Musée de la vie wallonne, Liège, *La Photographie en wallonie des origines à 1940*, Liège, 19 Oct. 1979–27 Apr. 1980.

Pinon, R., and Dubois-Maquet, N., *Parures et métiers de la femme au XIXe siècle*, Liège, 26 May–30 Oct. 1977.

Pirard, J., 'L'État et l'industrie, 1848–1913', in *Industrie en Belgique: Deux siècles d'évolution 1780–1980* (Brussels, 1981), 105–12.

Rapports du jury et documents de l'exposition de l'industrie belge en 1847 (Bruxelles, 1848).

Smolar-Meynart, A., *La Femme et l'égalité, 1789–1989: De la dentellière à l'avocate*, Musée du costume et de la dentelle de la ville de Bruxelles, 24 Mar.–24 Sept. 1989 (Brussells, 1989).

Vanschoenbeek, G., 'De la Passivité au mouvement sociale', *L'Industrie en Belgique: Deux siècles d'évolution, 1780–1980*, (Brussels, 1981), 127–42.

van Uitert, E. (ed.), *Van Gogh in Brabant*, Noordbrabants museum, 's Hertogenbosch (Swolle, 1987).

Contemporary Books and Pamphlets

Ansiaux, M., *Heures de travail et salaires* (Larcier, 1896).

'Avanti' (Oscar Roelandt), *Een Terugblik: 2de herziene en aangevulde uitgave met bij voeging van de toestanden tot 1931* (Ghent, 1939).

Becour, L., *Le Travail des femmes et la composition d'imprimerie* (Lille, 1894).

Beerblock, K., *Onbegrepen: Propagandaschrift ter ontwikkeling der vrouwen* (Ghent. 1906).

Bertrand, L., *La Limitation de la durée du travail* (Gand, 1906).

Bois-du-Luc, 1865–1985, pamphlet (n.p., n.d.).

Boulger, D. C., *Belgian Life in Town and Country* (New York, 1904).

Briavoine, N., *De l'Industrie en Belgique: Causes de décadence et de prosperité, sa situation actuelle*, 2 vols. (Brussels, 1839).

de Brouckère, C., *Principes généraux d'économie politique* (Brussels, 1851).

de Brouckère, G., 'Les Partis socialistes: Belgique, l'organisation des femmes socialistes', *Le Mouvement Socialiste*, ii (Jan.–Apr. 1905), 311–14.

de Brouckère, L., 'Le Lock-out de Verviers', *L'Avenir Social* (1906).

——'La Misère intellectuelle en Belgique de 1830–1895', *Conseil général du POB*, Brussels, 119–56.

Cabanis, P. J. G., *Rapports du physique et du moral de l'homme* (Paris, 1802).

Cardijn, l'Abbé J., *L'Ouvrière isolée, février 1913* (Leuven, 1913).

CARTE, R., *Les Mineurs: Une journée au domaine de la houille* (Brussels, n.d.).

CHALMERS, E. B., *Lucie Dejardin: Hiercheuse et deputé socialiste* (Huy, 1952).

CHARRIAUT, H., *La Belgique moderne: Terre d'expériences* (Paris, 1910).

CLAEYS, E., *Het Vrouwenstemrecht* (Ghent, 1892).

CLOQUET, L., *Les Artistes Wallons* (Brussels/Paris, 1913).

COLENBRANDER, H. T., *De Belgische omwenteling* ('S-Gravenhage, 1905).

Conseil général du POB (ed.), *75 Années de domination bourgeoise, 1830–1905: Essais de Camille Huysmans, Louis de Brouckère, et Louis Bertrand* (Gand, 1905).

DE COSTER, C., *The Legend of the glorious adventures of Tyl Ulenspiegel in the land of Flanders and elsewhere*, trans. by Whitworth, G., (London, 1918).

CRUTZEN, J., *De L'Évolution des idées dans la bourgeoisie et dans la classe ouvrière à Verviers deupis cinquante ans* (Brussels, 3 Jan. 1914).

DAUBY, J., *De l'Amélioration de la condition des classes laborieuses et des classes pauvres en Belgique au point de vue moral, intellectuel et physique* (Brussels, 1885).

——*Des Grèves ouvrières: Aperçu sur l'état économique et social actuel des classes ouvrières en Belgique; causes et caractère des grèves; moyens de les diminuer ou de les supprimer; conditions d'application et d'exécution* (Brussels, 1879).

——*De la Réglementation du travail des femmes . . . dans l'industrie en Belgique: Moyen de solution pratique de la question* (Brussels, 1863).

DECHESNE, L., *L'Avènement du régime syndical à Verviers* (Paris, 1908).

——*Conception du droit et les idées nouvelles* (Paris, 1902).

——*Syndicats ouvriers belges* (Paris, 1906).

DELATTRE, A., *Le Chant de la mine* (Liège, n.d.).

——*Combat* (Brussels, 1949).

——*Dans la Bourrasque* (Brussels, 1946).

——*Floria* (Brussels, n.d.).

——*Une Grande bataille sociale: La grève des mineurs du Borinage (août–oct. 1924)* (Brussels, 1925).

——*Histoires de nos corons* (Verviers, 1953).

——*Reflexions sur le syndicalisme* (Brussels, 1926).

DE MAN, H., *Au Delà du marxisme* (Paris, 1929).

——*Cavalier seul* (Geneva, 1948).

DENIS, H., *La Dépression économique et sociale et l'histoire des prix* (Brussels, 1895).

DE PAEPE, C., *De la Propriété collective*, intro. by Benoît Malon (Paris, 1891).

DE SMET, E., *L'Évolution du mouvement syndical ouvrier en Belgique: discours prononcé à la séance solennelle de rentrée de la conférence du jeune Barreau de Gand, 24 nov. 1894* (Gand, 1894).

DESTRÉE, J., 'L'Art, la littérature', *Le Mouvement Socialiste*, 1. (Jan–Apr. 1903), 88–96.

——*Mons et les montois* (Brussels, 1933).

——*Le Socialisme et les femmes* (Brussels, 1897).

DÉTHIER, N., *Centrale syndicale des travailleurs des mines de Belgique: 60 années d'action, 1890–1950*, (n.p., n.d.).

DE WINNE, A., *Door Arm Vlaanderen, met een brief van Ed. Anseele en een aanhangsel van K. Beerblock* (Rotterdam, 1904).

De Witte, P., *De Geschiedenis van Vooruit en de Gentsche socialistische werkersbeweging sedert 1870* (Ghent, 1898).

Doff, N., *Jours de famine et de détresse* (Paris, 1927; orig. 1911).

Dognée, E. M. O. and Dognée-Devillers, J. N., *Liège: histoire—arts—lettres—sciences—industries—travaux publics* (Liège, 1881).

Douard, C., *Paysages indistincts* (Liège, 1929).

Dumas, A., fils, *L'Homme-femme* (Paris, 1872).

Dumortier, H., *De la Situation financière et économique des communes rurales de la Flandre Occidentale* (Bruges, 1854).

Fesler, R. and Bottriaux, J., *Pays de Charleroi.*, préface de J. Destrée (n.p., n.d.).

Fierens-Gevaert. 'Les Villes de Belgique', *The Times: Numéro spécial consacré à la Belgique* (Brussels, 1920), 144–5.

Frank L., *Essai sur la condition politique de la femme* (Brussels, 1892).

——*Les Salaires de la famille ouvrière* (Brussels, 1896).

Gatti de Gamond, I., *Éducation-féminisme: Question sociale, morale et philosophique*, 2 vols. (Paris, 1907).

Gatti de Gamond, Z., *De la Condition sociale des femmes au XIXe siècle, de leur éducation publique et privée* (Brussels, 1833).

Gauchez, M., 'La Poésie féminine', *La Belgique Artistique*, 26 (Jan.–Feb.–Mar. 1912), 274–82.

——'Les Vivants et les morts: Jenny l'ouvrière', *La Belgique Artistique*, 30 (Jan–Mar. 1913), 352–60.

Gheude, C., *La Chanson populaire belge* (Brussels, 1907).

Guicciardini, L., *Description de tous les Pays-Bas*, trans. de Belleforest, F. (Amsterdam, 1609; 1st Italian edn. 1582).

Hamp, P., *Le Lin* (Paris, 1924).

Haust, J., *La Houillère liègoise* (Liège, 1925).

Houdez, G., *Les Troubles de Charleroi, mars 1886: Vingt-cinq ans après* (Frameries, 1911).

Hubermont, P., *Les Cordonniers* (Brussels, n.d.).

Hugo, V., Dumas, A., *Guide du touriste en Belgique* (Brussels, 1845).

Huysmans, J. K., *Marthe: The story of a woman*, trans. Putnam, S. (orig. 1876; repr. Bern, 1992).

Hymans, H., *Belgische kunst des 19e Jahr-hunderts* (Leipzig, 1906).

James, H., Jr. *Transatlantic Sketches* (Boston, Mass., 1875).

Lemonnier, C., *La Belgique* (Paris, 1888).

——*Paysages de Belgique: Choix de pages* (Brussels, n.d.).

——*Les Peintres de la vie* (Paris, 1888).

Léo XIII, Pope, *Rerum Novarum: 'On the Condition of Labor'* (New York, 1939).

Lewinski, J., *L'Évolution industrielle de la Belgique* (Brussels, 1911).

Limbourg, P., *Âmes Wallonnes: Esquisses et silhouettes* (Verviers, 1910).

Malva, C., *Un Mineur vous parle* (Lausanne, n.d.).

Marichal, H., *L'Ouvrier mineur en Belgique: Ce qui'il est, ce qu'il doit être* (Paris, 1869).

Marx, K. and Engels, F., *La Belgique des insurrections* (Paris, n.d.).

MISSION, A., *Le Mouvement syndical: Son histoire en Belgique de 1800 à 1914* (Namur, 1921).

MOREL, E., *Les Gueules noires* (Paris, 1907).

OLIVIER, R. P., *L'Ouvrière belge: Catéchisme sociale* (Brussels, 1919).

DES OMBIAUX, M., *Essai sur l'art Wallon ou Gallo-belge* (Brussels, 1912).

De Ongezondheid van het werk in de vlasspinnerijen. Ekende vakvereeniging de vlasbewerkers en bewerksters (Ghent, 1903).

L'Organisation judicieuse des loisirs nouveaux de la classe ouvrière (Liège, 1920).

PIERARD, L., *Belgian problems since the war* (New Haven, Conn., 1924).

——Pierson, M. A., *Belgique, terre d'exil* (Paris/Brussels, n.d.).

——*Constantin Meunier* (Brussels, 1937).

——*En Wallonie* (Brussels, 1911).

——*Pierre Paulus* (Antwerp, 1948).

——*De Flammes et de fumées* (Brussels, 1934).

——*Visage de la Wallonie* (Brussels, n.d.).

PIRMEZ, E., *La Crise: Examen de la situation économique de la Belgique* (Charleroi, 1884).

QUÉTELET, A., *A Treatise on Man and the Development of his Faculties*, trans. Knox, R. and Simbert, T. (Edinburgh, 1842; orig. 1835, Paris; 1836, Brussels).

RENARD, M., *Le Borinage* (Saint-Ghislain, n.d.).

ROWNTREE, H. S., *Land and Labour: Lessons from Belgium* (London, 1911).

RUTTEN, Père G.-C., *Nos Grèves houillères et l'action socialiste* (Brussels, 1910).

DE SEILHAC, L., *Le Lock-out d'Anvers* (Paris, 1908).

——*Le Lock-out de Verviers* (Paris, 1907).

SIMON, J., *L'Ouvrière* (Paris, 1861).

SIMONIN, L., *Underground Life or Mines and Miners*, trans. and adapted to the present state of British mining and ed. Bristow, H. W. (New York, 1869).

STRACKE, D. A., *Arm Vlaanderen* (Ghent, 1913).

TENNENT, J. E., *Notes d'un voyageur anglais sur la Belgique: Industrie, commerce, culture, arts, état moral*, trans. Justin, P.-M., 2 vols. (Brussels, 1841).

TRATSAERT, J. (ed.), *National Proverbs: Belgium* (London, 1915).

TWAIN, M. (Samuel Clemens), *King Leopold's Soliloquy* (orig. 1905; repr. New York, 1961).

VAN DEN HEUVEL, J., *Une Citadelle socialiste: Le Vooruit de Gand* (Paris, 1897).

VAN DEN PLAS, L., *Pourquoi les chrétiens doivent être féministes* (Brussels, 1902).

VANDERVELDE, É., *Les Dix dernières années du regne de Léopold II, 1900–1910).

——'Flamands et Wallons socialistes', *La Revue Socialiste*, 45 (1907), 11–28.

——'Le Parti Ouvrier Belge et l'église catholique', *Le Mouvement Socialiste*, 1 (Jan–Apr. 1903), 193–202.

——*Souvenirs d'un militant socialiste: Première partie. Mes débuts dans la vie socialiste, 1881–1914* (Paris, 1939).

——and Fesler, R., *Le Suffrage des femmes: Maintenant ou plus tard?* (Brussels, 1923).

VANDERVELDE, L. *Monarchs and Millionaires* (London, n.d.).

——and Jacobs, M. F., *Labour Laws for Women and Children in Belgium*, trans. Harvey, E. C. (London, 1910).

VAN RAEBROECKX, A., *Studiekringen voor christene werklieden: Handleiding* (Ghent, 1910).

VARLEZ. L., 'Quelques pages d'histoire syndicale belge', Musée Social, *Mémoires et documents* (Paris, 1902), 6–200.

VERCRUYSSE, F., *Le Lock-out général de l'industrie textile à Verviers (sept.–nov., 1906): Extrait de la Revue du Travail du 31 jan. 1907* (Brussels, 1907).

WAXWEILER, E., 'La Révolution industrielle en Belgique', *La Nation Belge, 1830–1905* (Liège, 1905), 97–113.

WOUTERS, C. and Deneubourg, P., *Réflexions sur le travail des femmes dans les mines* (Mons, 1870).

SECONDARY SOURCES

Books

ABS, R., *Histoire du Parti Socialiste Belge, 1885–1900: Synthèse historique* (Brussels, 1974).

ACKERMAN, E. B., *Health Care in the Parisian Countryside, 1800–1914* (New Brunswick, NJ, 1990).

AGULHON, M., *Marianne into Battle: Republican Imagery and Symbolism in France, 1789–1880*, trans. Lloyd, J. (Cambridge, 1981).

——*La République au village: Les populations du Var de la Révolution à la Seconde République* (Paris, 1970).

ARON, P., *Les Écrivains belges et le socialisme (1880–1913)* (Brussels, 1985).

ASCHERSON, N., *The King, Incorporated: Léopold the Second in the Age of Trusts* (London, 1983).

BARTHES, R., *Système de la mode* (Paris, 1967).

BARTIER, J., *Naissance du socialisme en Belgique: Les Saint-Simoniens* (Brussels, n.d.).

BAZALGETTE, L., (ed.), *Constantin Meunier et son œuvre* (Paris, 1953).

BEHETS, A., *Constantin Meunier: L'homme, l'artiste, et l'œuvre* (Brussels, 1942).

BIDELMAN, P., *Pariahs Stand up! The Founding of the Liberal Feminist Movement in France, 1858–1889* (Westport, Conn., 1982).

BOLOGNE, M., *L'Insurrection prolétarienne de 1830 en Belgique* (Brussels, 1929); Flemish version: *De Proletarische opstand van 1830 in Belgie* (Leuven, 1979).

——*Notre passé Wallon* (n.p., 1973).

BONDA, J., *Histoire anécdotique du mouvement ouvrier au pays de Liège* (Liège, n.d.).

BOWLBY, R., *Just Looking: Consumer Culture in Dreiser, Gissing, and Zola* (New York, 1985).

BRIGOTTE, M., *Histoire industrielle de Charleroi* (Mons, 1987).

BRONNE, C., (ed.), *Lettres de Léopold I: Premier roi des belges* (Brussels, 1943).

BRUWIER, M., Busieau, M., and Dorsimont, D., *Mons-Borinage: Mémoire ouvrière*, viii (Brussels, 1985).

CAMMAERTS, É., *The Keystone of Europe: History of the Belgian dynasty, 1830–1939* (London, 1939).

——*The Treasure House of Belgium: Her Land and People, her Art and Literature* (London, 1924).

CAULIER-MATHY, N., *La Modernisation des charbonnages liègeois pendant la première moitié du XIX^e siècle: Techniques d'éxploitation* (Liège, 1971).

CHADWICK, W., *Women, Art and Society* (London, 1990).

CHAMPAGNE, P., *Le Peintre Alex-Louis Martin et l'art moderne*, préface de Jules Destrée (Mons, 1929).

CHLEPNER, B.-S., *Cent ans d'histoire sociale en Belgique* (Brussels, 1979).

——*Le Banque en Belgique. Étude historique et économique*, i. *Le Marché financier avant 1850* (Brussels, 1926).

CHRISTOPHE, L., *Constantin Meunier* (Antwerp, 1947).

CHURCH, C., *Europe in 1830* (London, 1983).

CLARK, T. J., *The Painting of Modern Life: Paris in the Art of Manet and his Followers* (New York, 1985).

CLAUS, H., *The Sorrow of Belgium*, trans. Pomerans, A. J. (New York, 1990).

COLLARD, L. *et al.*, *Les Fastes du Parti, 1885–1960* (Brussels, 1965).

Confédérations des syndicats chrétiens, cent ans de syndicalisme chrétien, 1886–1986 (Brussels, n.d.).

COWIE, D., *Belgium: The Land and the People* (London, 1977).

DARRAS, J. and Snowman, D., *Beyond the Tunnel of History*, a revised and expanded version of the 1989 BBC Reith Lectures (London, 1990).

DE BRABANDER, G. L., *Regional Specialization, Employment and Economic Growth in Belgium between 1846 and 1970* (New York, 1981).

DE BRUYN, A., *Anciennes houillères de la région Liégeoise* (Liège, 1988).

DECROYÈRE, V., *Croquis et sihouettes de mon pays* (La Louvière, 1927).

DEGÉE, J.-L., *Le Mouvement d'éducation ouvrière: Évolution de l'action éducative et culturelle du mouvement ouvrier socialiste en Belgique (des origines à 1940)* (Brussels, 1986).

DEHOUSSE, F., Pacco, M., and Pauchen, M., *Léonard Defrance: L'œuvre peint* (Liège, 1985).

DELATTRE, L., *Le Pays Wallon* (Brussels, 1929).

DELHAYE, J. P., Ducastelle, J.-P., Duvosquel, J.-M., and Sonneville, M., *Hainaut occidental: Mémoire ouvrière*, iv (Brussels, 1985).

DELOGE, A., *Gabrielle Petit: Sa vie et son œuvre* (Brussels, 1922).

DELPIERRE, Y., *Considérations sur la vie de la femme au pays noir* (Brussels, 1925).

DELSINNE, L., *De Belgische Werkliedenpartij van haar oorsprong tot 1894* (Ghent, 1955).

DELWICHE, M. and Groff, F., *Les Gueules noires* (Brussels, 1985).

DE ROP, J., *De Traditie* (Amsterdam, 1963).

DESAMA, C., *Population et révolution industrielle: Évolution des structures démographiques à Verviers dans la première moitié du 19e siècle* (Paris, 1985).

DE TROYER, F., dir d'un collectif, *Brabant wallon: Mémoire ouvrière*, i (Brussels, 1985).

DE VROEDE, M., *De Vlaamse beweging in 1855–56* (Brussels, 1960).

DE WEERDT, D., *De Belgische socialistische arbeidersbeweging op zoek naar een eigen vorm, 1872–1880* (Antwerp, 1972).

——*En de vrouwen? vrouw, vrouwenbeweging en feminisme en Belgie, 1830–1960* (Ghent, 1980).

——*De Gentse textielbewerkers en arbeidersbeweging tussen 1866 en 1881* (Leuven, 1959).

——*Geschiedenis van de socialistische arbeidersbeweging in Belgie* (Antwerp, 1960).

——Galla, G., and Van der Wildt, F., *100 Jaar socialistische vrouwenbeweging* (Brussels, 1985).

DOMMANGET, M., *Histoire du Premier Mai* (Paris, n.d.).

DROZ J. (ed.), *Histoire générale du socialisme*, ii. *De 1875 à 1918* (Paris, 1974).

DUEZ, G., *Vincent Van Gogh au Borinage* (Mons, 1986).

DUMONT, G. H., *La Vie quotidienne en Belgique sous le règne de Léopold II (1865–1909)* (Paris, 1974).

EATON, E. T., *The Belgian Leagues of Christian Working Class Women* (Washington, DC, 1954).

EDWARDS, T., *Belgium and Luxembourg* (London, 1951).

ELIAS, H. J., *Geschiedenis van de Vlaamse gedachte* (Ghent, n.d.).

EVRARD, R. and Descy, A., *Histoire de l'usine de Vennes, 1548–1948* (Liège, 1948).

FAUVIAU, H., *Le Borinage: Monographie politique, économique, sociale* (Frameries, 1929).

FITZMAURICE, J., *The Politics of Belgium: Crisis and Compromise in a Plural Society* (New York, 1983).

FLAGOTHIER-MUSIN, L., *Liège: Mémoire ouvrière*, vi (Brussels, 1985).

FOHAL, J., *Verviers et son industrie: Il y a quatre-vingt-cinq ans: 1843* (Verviers, 1928).

FONTAINE, A., *Constantin Meunier* (Paris, 1923).

FOUCAULT, M., *Discipline and Punish: The Birth of the Prison*, trans. Sheridan, A. (New York, 1977).

FOURMANOIT, L., *Des Luttes . . . des hommes . . . et du Borinage, 1910–1925, chronique* (Saint-Ghislain, 1981).

FOURMANIER, P. and Denoël, L., *Géologie et industrie minérale du pays de Liège* (Paris/ Liège, 1930).

Frère Julien, *Mon Pays au travail* (Namur/Brussels, 1952).

GARRY, B., *Namur, Dinant, Philippeville: Mémoire ouvrière*, ix (Brussels, 1985).

GÉRARD, J., *La Vie quotidienne au temps de Léopold I* (Brussels, 1963).

GEYL, P., *History of the Low Countries: Episodes and Problems* (London, 1964).

GIEGER, R. G., *The Anzin Coal Company: Big Business in the Early Stages of the French Industrial Revolution* (Newark, NJ, 1974).

GOFFIN, M.-L., *La Belgique vue par Victor Hugo* (Brussels, 1945).

GORDON, E., *Women and the Labour Movement in Scotland, 1850–1914* (Oxford, 1991).

GRAVES, R., *Goodbye to All That* (New York, 1957).

GRIFFIS, W. E., *The Story of the Walloons: At Home, in Lands of Exile, and in America* (Boston, Mass., 1923).

GUILBERT, M., *Les Femmes et le syndicalisme avant 1914* (Paris, 1966).

HALÉVY, E., *Histoire du socialisme européen* (Paris, 1948).

HAMMACHER, A. M. and Hammacher, R., *Van Gogh: A Documentary Biography* (New York, 1982).

HAUPTMAN, P., *La Philosophie sociale de Pierre-Joseph Proudhon* (Grenoble, 1980).

HAUSE, S., *Hubertine Auclert: The French Suffragette* (New Haven, Conn., 1987).

HENNEAUX-DEPOOTER, L., *Misères et luttes sociales dans le Hainaut: 1860–69* (Brussels, 1959).

HENROT, T., *Belgique* (Paris, 1958).

HILDEN, P. J., *Working Women and Socialist Politics in France: A Regional Study, 1880–1914* (Oxford, 1986).

HILEY, M., *Victorian Working Women* (Boston, Mass., 1980).

HOBSBAWM, E., *Industry and Empire* (Harmondsworth, 1975).

HOLLAND, C., *Flanders and Hainaut* (London, 1925).

HOSTE, L., *Gent. Poppenspelstad: een bijdrage tot de geschiedenis van het Gentse poppenspel* (Ghent, 1979).

HROCH, M., *Social Preconditions of National Revival in Europe: A Comparative Analysis of the Social Composition of Patriotic Groups among the Smaller European Nations*, trans. Fowkes, B. (Cambridge, 1985).

HUIZINGA, J. H., *Mr. Europe: A Political Biography of Paul Henri Spaak* (New York, 1961).

HUTCHINSON, W. (ed.), *Belgium the Glorious: Her Country, her People*, i, ii (London, n.d.).

JACQUEMYNS, G., *Histoire de la crise économique des Flandres (1845–1850)* (Brussels, 1929).

JAMES, H., *The German Identity, 1770–1990* (New York, 1989).

JOHN, A., *By the Sweat of their Brow: Women Workers at Victorian Coal Mines* (London, 1984).

JORIS, F., *La Presse Verviétoise de 1850 à 1914* (Leuven/Paris, 1982).

KEYMOLEN, D., *Deroepsarbeid voor vrouwen van betere stand in Belgie omstreeks 1860. een bijdrage tot de mentaliteits-en onderwijs geschiedenis* (Ghent, 1981).

——Castermans, G. and Smet, M., *De Geschiedenis geweld aangedaan. de strijd voor het vrouwenstemrecht, 1886–1948* (Antwerp/Amsterdam, 1981).

——*Vrouwenarbeid in Belgie van ca. 1860 tot 1914* (Leuven, 1977).

KOSSMAN, E. H., *The Low Countries, 1780–1940* (Oxford, 1978).

KOSSMAN-PUTTO, J. A. and Kossman, E. H., *The Low Countries: History of Northern and Southern Netherlands* (n.p., 1987).

——and Witte, E. (eds.), *Historical Research in the Low Countries, 1981–83: A Critical Survey* (Leiden, 1985).

LEBRUN, P., Bruwier, M., Dhondt, J., Hansotte, G., *Essai sur la révolution industrielle en Belgique, 1770–1847* (Brussels, 1981).

——*L'Industrie de la laine à Verviers pendant le XVIIIᵉ siècle* (Liège, 1948).

LEHNING, A., *From Buonarroti to Bakunin: Studies in International Socialism* (Leiden, 1970).

LIEBMAN, M., *Les Socialistes belges, 1885–1914: La révolte et l'organisation* (Brussels, 1979).

LIJPHART, A. (ed.), *Conflict and Coexistence in Belgium: The Dynamics of a Culturally Divided Society* (Berkeley, Calif.: 1981).

Lis, C., *Social Change and the Laboring Poor: Antwerp 1770–1860*, trans. Coonan, J. (New Haven, Conn., 1986).

Lloyd, R. (trans. and ed.), *Selected Letters of Charles Baudelaire: The Conquest of Solitude* (London, 1986).

Lyon, M., *Belgium* (London, 1971).

Mabille, X., *Histoire politique de la Belgique: Facteurs et acteurs de changement* (Brussels, 1986).

MacDonnell, J. de C., *Belgium, her Kings, Kingdom and People* (London, 1914).

MacOrlan, P., *Le Bal de Pont du Nord: La nuit de Zeebrugge* (Paris, 1950).

Mahieu, R. G. W., *Les Hommes de fosses au Borinage* (Hornu, 1987).

Mahieu-Hoyois, F., *L'Évolution du mouvement socialiste Borain (1885–1895)* (Leuven/Paris, 1972).

Marchal, L., *Histoire de Wallonie* (Brussels, 1952).

Marre-Muls, A. M., Dept, F., and Lansman, E., *Alexandre-Louis Martin, peintre hennuyer* (Morlanwelz, 1984).

Masereel, F., *Mons pays: Cent bois gravés* (n.p., 1964).

Mathews, A. J., *La Wallonie 1886–1892: The Symbolist Movement in Belgium* (New York, 1947).

Mathieu, J., *Histoire sociale de l'industrie textile de Verviers* (Verviers, 1946).

Messiaen, J.-J. and Musick, A., *Huy-Waremme: Mémoire ouvrière*, v (Brussels, 1985).

——*Verviers: Mémoire ouvrière*, xi (Brussels, 1985).

Milward, A. S. and Saul, S. B., *The Economic Development of Continental Europe, 1780–1870* (London, 1973).

Mokyr, J., *Industrialization in the Low Countries, 1795–1850* (New Haven, Conn., 1976).

Monmarché, M. and Tillion, E. L. (eds.), *Toute la Belgique, 1830–1930* (Paris, 1929).

Moses, C., *French Feminism in the Nineteenth Century* (Albany, NY, 1984).

Murphy, A. B., *The Regional Dynamics of Language Differentiation in Belgium: A Study in Cultural-Political Geography* (Chicago, 1988).

Namier, L., *1848: The Revolution of the Intellectuals* (New York, 1964).

Neuville, J., *La Condition ouvrière au XIXe siècle*, i. *L'Ouvrier objet* (Brussels, 1976).

——*La Condition ouvrière au XIXe siècle*, ii. *L'Ouvrier suspect* (Brussels, 1980).

——*L'Évolution des relations industrielles en Belgique: L'Avènement du système des 'relations collectives'*, i (Brussels, 1976).

Ossowski, S., *Class Structure in the Social Consciousness*, trans. Patterson, S. (New York, 1963).

d'Othée, J., *Le Centenaire de la mise en exploitation (en 1843) de la ligne de chemin de fer de la vallée de la Vesdre* (Verviers, 1949).

Paxton, R., *Europe in the Twentieth Century* (New York, 1975).

Pector, D. and Fourier, E., *1886: La révolte des damnés de la terre! Le soulèvement ouvrier dès mars 1886 dans les pays de Liège et de Charleroii* (Charleroi-Brussels, 1986).

Peeters, E., *Kent U Belgie?* (Brussels, 1959).

Pereira-Roque, J., *De Démographie de la Belgique au XIXe siècle* (Brussels, 1974).

PÉRIN, A.-F., *Théâtre ouvrier en Wallonie, 1900–1940* (Brussels, 1979).

PICARD, L., *Geschiedenis der Vlaamse en grootnederlandse gedachte* (Antwerp, 1963).

PIRENNE, H., *Histoire de Belgique, vii. De la révolution de 1830 à la Guerre de 1914* (Brussels, 1932).

PLESSY, B. and Challet, L., *La Vie quotidienne des mineurs au temps de Germinal* (Paris, 1984).

POLASKY, J., *Revolution in Brussels, 1787–1793* (Brussels, 1987).

POLLARD, S., *Peaceful Conquest: The Industrialization of Europe, 1760–1970* (Oxford, 1981).

——and Holmes, C. (eds.), *Documents of European Economic History, i. The Process of Industrialization, 1750–1870* (London, 1968).

POOVEY, M., *The Proper Lady and the Woman Writer* (Chicago, 1984).

POSTER, M., *Critical Theory of the Family* (New York, 1980).

POTY, F., and Delaet, J.-L., *Charleroi: Mémoire ouvrière, iii* (Brussels, 1985).

PROST, E., *Historique de l'industrie houillère belge* (Renaix, 1927).

PUISSANT, J., *L'Évolution du mouvement ouvrier socialiste dans le Borinage* (Brussels, 1982).

RANGER, T. and Hobsbawm, E. (eds.), *The Invention of Tradition* (Cambridge, 1983).

SABBE, E., *De Belgische vlasnijverheid, ii. van het verdrag van Utrecht (1713) tot het midden van de XIXe eeuw* (Kortrijk, 1975).

SCHAMA, S., *The Embarrassment of Riches: An Interpretation of Dutch Culture in the Golden Age* (New York, 1987).

SEELING, H., *Les Wallons pionniers de l'industrie Allemande*, trans. Pauguet-Dorr, J. (Liège, 1983).

SIMENON, G., *Mémoires intimes, suivis du livre de Marie-Jo* (Paris, 1981).

SINGER, C. (ed.), *A History of Technology, iv. The Industrial Revolution, 1750–1850* (Oxford, 1958).

SLADE, R., *The Belgian Congo* (London, 1960).

SOWERWINE, C., *Sisters or Citizens? Women and Socialism in France since 1876* (Cambridge, 1982).

STENGERS, J., *Combien le Congo a-t-il coûté à la Belgique?* (Brussels, 1957).

——*La Place de Léopold II dans l'histoire de la colonisation* (Brussels, 1950).

STEWART, M. L., *Women, Work and the French State: Labour Protection and Social Patriarchy, 1879–1919* (Kingston, Ont., 1989).

THIBAUT, W., *Les Républicains belges, 1787–1914* (Brussels, 1961).

THOMAS, E., *Voix d'en bas: La poésie ouvrière du XIXe siècle* (Paris, 1979).

TREMPÉ, R., *Les Mineurs de Carmaux, 1848–1914* (Paris, 1971).

TORGOVNIK, M., *Gone Primitive: Savage Intellects, Modern Lives* (Chicago, 1990).

VANDERBROEKE, C., *Sociale geschiedenis van het Vlaamse volk* (Leuven, 1982).

VANDER LINDEN, H., *Belgium: The Making of a Nation*, trans. Jane, S. (Oxford, 1920).

VAN DER WEE, H., *De Industriele revolutie in Belgie, historischen aspecten van de economische groei* (Antwerp, 1972).

VAN GOGH, V., *The Complete letters, i* (ed. New York Graphic Society; Greenwich, Conn., 1959).

VAN HOUTTE, F.-X., *L'Évolution de l'industrie textile en Belgique et dans le monde de 1800 à 1939* (Leuven, 1949).

VAN HOUTTE, J. A., *Esquisse d'une histoire économique de la Belgique* (Leuven, 1943).

——(ed.), *Un Quart de siècle de recherche historique en Belgique, 1944–1968* (Leuven, 1970).

VAN ISAEKER, K., *De Internationale te Antwerpen, 1864–77* (Antwerp, 1964).

VAN KALKEN, F., *Commotions populaires en Belgique (1834–1902)* (Brussels, 1936).

VAN NECK, A., *Les Débuts de la machine à vapeur dans l'industrie belge, 1800–1855* (Brussels, 1979).

VANVAL, J., *La Houillère: Le Travail des mineurs de fond vers 1900* (Liège, 1975).

VAN VELTHOVEN, H., *De Vlaamse kwestie, 1830–1914: macht en onmacht van de Vlaamsgezinden* (Courtrai-Heule, 1982).

VANWEEHAEGHE, S., *De Socialistische vrouwen, de socialistische Vooruitziende vrouwen en 'Stem der Vrouw'; schets van het ontstaken en de evolutie van de socialistische vrouwenbeweging en haar orgaan*, 2 vols. (Ghent, 1983).

VAN WERVEKE, H., *Gand: Esquisse d'histoire sociale* (Brussels, 1946).

VANZYPE, G., *L'Art belge du XIXe siècle à l'exposition jubilaire du cercle artistique et littéraire à Bruxelles en 1922* (Brussels, 1923).

——*L'Art belge du XIXe siècle à l'exposition de Paris en 1923* (Brussels, 1924).

VERHAEREN, E., *Pages belges* (Paris, 1926).

VERNIERS, L., *Bréviaire des belges* (Brussels, 1944).

VERSTAPPEN, J., *150 Jaar Belgie: volksleven, 1830–1980* (Bruges, 1980).

VERSTRAELEN, J., *Introduction à l'histoire du mouvement ouvrier*, trans. Fievez, M. (Brussels, 1949).

WALGRAVE, V., *Onze Vlaamse volksbeweging* (Tielt, 1949).

W-allons-nous? numéro spécial: Cris et images du Borinage (Oct, 1981).

WATELET, H., *Une Industrialisation sans développement: Le Bassin de Mons et le charbonnage du Grand-Hornu du milieu de XVIIIe au milieu du XIXe siècle* (Ottawa, 1980).

WHEELWRIGHT, J., *Amazons and Military Maids* (London, 1990).

WITTE, E. and Craeybeckx, J., *La Belgique politique de 1830 à nos jours: Les tensions d'une démocratie bourgeoise*, trans. Govaert, S. (Brussels, 1987).

—— ——Meynen, A., *Politieke geschiedenis van Belgie van 1830 tot heden* (Antwerp, 1990).

YOURCENAR, M., *Dear Departed: A Memoir*, trans. Ascher, M. L. (New York, 1991).

Articles

DE BEUGER–VAN LIERDE, F., 'À l'Origine du mouvement féministe en Belgique: "l'Affaire Popelin"', *Revue Belge de Philologie et d'Histoire/Belgisch Tijdschrift voor Filologie en Geschiedenis*, 50 (1972), 1128–37.

BREPOELS, J., 'De Belgische Werkleidenpartij, een halve eeuw oud', in Brepoels, L. H., Schaevers, M., Vandenbroucke, F. (eds.), *Eeuwige dilemma's honderd jaar socialistische partij* (Leuven, 1985), 11–33.

BURKE, G., 'The Decline of the Independent Bal Maiden: The Impact of Change in

the Cornish Mining Industry', in John, A. (ed.), *Unequal Opportunities: Women's Employment in England, 1800–1918* (Oxford, 1986), 179–206.

CLARK, S., 'Nobility, Bourgeoisie and the Industrial Revolution in Belgium', *Past and Present* 105 (Nov. 1984), 140–75.

COLEMAN, D. C., 'Proto-Industrialization: A Concept too Many', *Economic History Review*, 36 (1983), 435–48.

CONTINHO-WIGGELENDAM, A., 'Women's Emancipation around the Turn of the Century and Opposition to it', *Netherlands Journal of Sociology*, 19 (Oct., 1983), 113–32.

COPPEJANS-DESMEDT, H., 'Economische opbloei in de Zuidelijke Nederlanden', *Algemene geschiedenis der Nederlanden 8* (1955), 273–80.

———'The Belgian Textile Industry on New Roads through the Adoption of New Mental Attitudes', *Low Countries History Yearbook* (1981), 106–23.

———(ed.), 'Histoire économique de la Belgique: Traitement des sources et état des questions', *Archives et bibliothèques de Belgique/Archief-en-bibliotheekweezen in Belgie*, numéro spécial, *Actes du colloque de Bruxelles, 17–19 nov. 1971* (Brussels, 1973).

CRAEYBECKX, J., 'De Agrarische wortels van de industriele omwenteling', *Revue Belge de Philologie et d'Histoire/Belgische Tijdschrift voor Filologie en Geschiedenis* (1963), 397–448.

———'Les Débuts de la révolution industrielle en Belgique et les statistiques de la fin de l'empire', *Mélanges offerts à G. Jacquemyns* (Brussels, 1968).

DE BELDER, J., 'Changes in the Socio-Economic Status of the Belgian Nobility in the 19th century', *Low Countries History Yearbook (Actae Historiae Neerlandicae)* 15 (1982), 1–20.

DEBROCK, W., 'De Kinderen van het proletariaat en de kunst', in Brepoels, J., Huyse, L., Schaevers, M., and Vandenbroucke, F. (eds.), *Eeuwige dilemma's: Hunderd jaar socialistische partij* (Leuven, 1985), 235–43.

DENECKERE, G., 'Staatagitatie, een versluierde geschiedenis, het oproer in 1886 anders bekeken', *BTNG/RBHC* 20 (1989), 253–91.

DENYS, L., 'Trends in de sociaal-economische toestand van de Belgische arbeiders rond 1886', *BTNG/RBHC* 5 (1974), 361–426.

DESAMA, C., 'Démographie et industrialisation: Le modèle verviétois (1800–1850)', *Revue du Nord* 63 (1981), 147–56.

DEVLEESHOUWER, R., 'Le Consulat et l'empire: Période de "take-off" pour l'économie belge?', *Revue d'Histoire moderne et contemporaine* 42 (1970), 610–19.

DE WEERDT, D., 'Arbeiders toestanden van 1850 tot 1876', in Dhondt, J. (ed.), *Geschiedenis van de socialistische arbeidersbeweging in Belgie* (Antwerp, 1960), 213–24.

———'Loon en levens vooraarden van de fabrieks arbeiders, 1789–1850', in *Geschiedenis van de socialistische arbeidersbeweging in Belgie* (Antwerp, 1960), 71–82.

DHONDT, J., 'The Cotton Industry in Ghent during the French Occupation', in Crouzet, F., Chaloner, W. H., and Stern, W. M. (eds.), *Essays in European Economic History* (London, 1969), 53–67.

———'Notes sur les ouvriers industriels gantois à l'époque française', *Revue du Nord* 36 (1954), 309–24.

——and Bruwier, M., 'The Low Countries 1700–1914', in Cipolla, C. (ed.), *Fontana Economic History of Europe: The Emergence of Industrial Societies*, i (London, 1970), 329–66.

DODGE, P., 'Voluntaristic Socialism: An Examination of the Implications of Hendrik De Man's Ideology', *International Review of Social History* 3 (1958), 385–444.

DOUXCHAMPS-LEFÈVRE, C., 'L'Éxploitation houillère dans la région de Charleroi au début du XVIII^e siècle', in Trenard, L. (ed.), *Colloque Internationale: 'Charbons et sciences humaines'*, *Université de Lille, mai 1963* (Paris, 1966), 103–16.

GÉRIN, P., 'Louise Van den Plas et les débuts du "féminisme chrétien de Belgique"', *BTNG/RBHC* 1 (1969), 254–75.

GUBIN, E., 'L'Industrie linière à domicile dans les Flandres en 1840–1850: Problèmes de méthode', *BTNG/RBHC* 14 (1983), 369–402.

GUIGNET, P., 'Le Cheminement incertain d'une incomprehension: Camille Desmoulins et le peuple belge en révolution (1789–1790)', *Revue du Nord* 66 (Apr.–Sept. 1984), 543–56.

HARPER, P. H., 'Votes for Women? A Graphic Episode in the Battle of the Sexes', in Million, H. and Nochlin, L. (eds.) *Art and Architecture in the Science of Politics* (Cambridge, Mass., 1978), 150–61.

HAVELANGE, C., 'Quelques aspects du discours médical pendant la seconde moitié du XIXe siècle: L'Exemple de la province de Liège', *BTNG/RBHC* 16 (1985), 175–211.

HECQ, F., 'Quand j'étais petite', *Chronique* (Apr.–May 1984), 8–9.

HILDEN, P. J., 'Re-writing the History of Socialism: Working Women and the Parti Ouvrier Français', *European History Quaterly*, 17 (1987), 285–306.

——'The Rhetoric and Iconography of Reform: Women Coal Miners in Belgium, 1840–1914', *Historical Journal* (spring, 1991), 411–36.

HOBSBAWM, E., 'Should the Poor Organise?' *New York Review of Books* (23 March, 1988), 44.

JAUMAIN, S., 'Un Métier oublié: Le Colporteur dans la Belgique du XIX^e siècle', *BTNG/RBHC* 16 (1985), 307–56.

JOURET, A., 'La Grève des mineurs borains de 1912', *BTNG/RBHC* 4 (1983), 42–60.

KAPLAN, T., 'Women and Spanish Anarchism', in Bridenthal, R., and Koonz, C., *Becoming Visible: Women in European History* (Boston, Mass., 1977), 402–21.

VAN KERKHOVEN, J. (ed.), 'Le Mouvement ouvrier chrétien, vu de Flandre', *Contradictions*, 2 (1986).

KEYMOLEN, D., 'Feminisme in Belgie: de eerste vrouwelijke arsen (1873–1914)', *Bijdragen en mededelingen betreffende de geschiedenis der Nederlanden*, 190 (1975), 38–58.

——'Vrouwen emancipatie, 1844–1914', in Van Houtte, J. A., Niermeijer, J. F., Presse, J., Romein, J., and Werveke, H. (eds.), *Algemene geschiedenis der Nederlander*, xiii (Amsterdam, 1978), 66–76.

KRUITHOF, J., 'De Grootte van het Belgische proletariaat tijdens de eerste helft van de negentiende eeuw', in Dhondt, J. (ed.), *Geschiedenis van de socialistische arbeidersbeweging in Belgie* (Antwerp, 1960), 53–68.

KEYPERS, J., 'Het Vroegsocialisme tot 1850', in Dhondt, J. (ed.), *Geschiedenis van de socialistische arbeidersbeweging in Belgie* (Antwerp, 1960), 93–149.

LANDES, J. B., 'Representing the Body Politic: The Paradox of Gender in the Graphic Politics of the French Revolution', in Melzer, S. E., and Rabine, L. W., *Rebel Daughters: Women and the French Revolution* (Oxford, 1992), 20–32.

LAUREYSSENS, J. M., 'Financial Innovation and Regulation: The Société Générale and the Belgian State after Independence', *BTNG/RBHC* 20 (1989), 223–50.

LEFEBVRE, C., 'Socialistes belges et français de la fin de l'empire au début de la république', *Revue du Nord* 37 (1955), 191–8.

LIEBMAN, M., 'La Pratique de la grève générale dans le Parti Ouvrier Belge jusqu'en 1914', *Le Mouvement Sociale* (Jan.–Mar. 1967), 41–62.

LINARD DE GUERTICHIN, A., 'Les Ingénieurs des mines français en Belgique de 1795 à 1814', in Trenard, L. (ed.), *Colloque internationale: 'Charbons et sciences humaines', Université de Lille, mai 1963* (Paris, 1966), 177–26.

MEDICK, H., 'The Proto-Industrial Family Economy: The Structural Function of Household and Family during the Transition from Peasant Society to Industrial Capitalism', *Social History* 3 (Oct. 1976), 291–315.

MICHEL, J., 'La Chevalerie du Travail: Force ou faiblesse du mouvement ouvrier belge?', *BTNG/RBHC* 9 (1978), 117–64.

NEUVILLE, J., 'Il y a cent ans naissait le syndicat des Broederlijke Wevers', *Étude Sociale*, ix. *La Pensée Catholique* (Brussels, 1957).

OUTRAM, D., '*Le Langage mâle de la vertu*: Women and the discourses of the French Revolution', in Porter, R. and Burke, P. (eds.), *The Social History of Language* (Cambridge, 1987), 120–35.

PASLEAU, S., 'Une Population dans le développement économique: La Formation d'un prolétariat industriel, Seraing, 1846–1914', *BTNH/RBHC* 20 (1989), 544–8.

POLASKY, J., 'From Stone Throwers to Hearth Tenders, Women in Revolutionary Belgium', *History Workshop Journal* (spring, 1986), 87–105.

——'Revolution, industrialization, and the Brussels commercial bourgeoisie, 1780–1793', *BTNG/RBHC* 10 (1979), 205–35.

——'Utopia and domesticity: Zoë Gatti de Gamond', *Proceedings of the Western Society for French History* (Lawrence, Kan., 1984), 273–81.

VAN PRAAG, P., 'Emilie Claeys, 1855–1943', *Tijdschrift voor Sociale Geschiedenis* 11 (June 1978), 177–96.

PUISSANT, J., 'Quelques témoignages sur l'émigration hennuyère, 1884–1889', *Bulletin des séances/Mededelinginder Zittingen* 3 (1973), 443–63.

REARDON, J. A., 'Colonization in Reverse: The Legal Position of Belgian Workers in Roubaix, France, in the 19th century', in *Proceedings of the 7th Annual Meeting of the Western Society for French History, 1–3 Nov. 1979* (Omaha, Nebr., 1979), 106–16.

REBÉRIOUX, M., 'Le Socialisme belge de 1875 à 1914', in Droz, J. (ed.), *Histoire générale du socialisme* ii (Paris, 1982), 321–31.

DE SCHAEPDRIJVER, S., 'Reglementering van prostitutie, 1844–1877: opkomst en ondergand van een experiment', *BTNG/RBHC* 16 (1985), 473–506.

SCHOLLIERS, P. 'Verschuivingen in het arbeidersconsumptiepatroon, 1890–1930',
BTNG/RBHC 13 (1982), 273–313.

SCHWARZ, L. D., 'The Formation of the Wage: Some Problems', in Scholliers, P. (ed.),
Real Wages in 19th and 20th century Europe: Historical and Comparative Perspectives
(New York, 1989), 21–39.

SEN, A., 'More than 100 Million Women are Missing', *New York Review of Books*
(20 Dec. 1990), 61–6.

STEINBERG, M., 'La Fondation du P.O.B., et le ralliement de la classe ouvrière à
l'action politique, 1882–1886', *Contradictions* 44 (1985), 3–20.

STENGERS, J., 'Belgian National Sentiments', in Lijphart, A. (ed.), *Conflict and Coexist-
ence in Belgium: The Dynamics of a Culturally Divided Society* (Berkeley, Calif.,
1981), 46–60.

——'La Belgique de 1830, une 'nationalité de convention' . . .?', in Hasquin, H. (ed.),
Histoire et historiens depuis 1830 en Belgique (Brussels, 1981), 7–19.

——'Le Vocabulaire national dans le Royaume des Pays-Bas (1815–1830)', in
Colloque historique sur les relations belgo-néerlandaises entre 1815 et 1945, Brussels,
10–12 Dec. 1980, *Acta* (Ghent, 1982), 9–28.

STRIKWERDA, C., 'The Divided Class: Catholics vs. Socialists in Belgium, 1880–1914',
Comparative Studies in Society and History 30 (Apr. 1988), 333–59.

SZTIJNBERG, M., 'L'Interpretation belge des decisions de l'Internationale sur le
ministerialisme (1909–1911)', *International Review of Social History* 10 (1965),
246–67.

TILLY, L., 'Introduction', Grafteaux, S., *Meme Santerre, a French woman of the people*,
trans. Tilly, L. and Tilly, K. (New York, 1985).

VAN DER LINDEN, M., 'The National Integration of European Working Classes,
1871–1914', *International Review of Social History* 33 (1988), 285–311.

VANDERMOTTEN, C., 'Tendances longues de l'évolution de la production, de l'emploi,
et de la productivité industrielle en Belgique: 1840–1978', *Cahiers économiques des
Bruxelles* 86 (1980), 301.

VAN DER WEE, H., 'De Industriele revolutie in Belgie', *Historische Aspecten van de
Economische Groei* (Anvers-Utrecht, 1972), 168–208.

VAN TIGGELEN, P. J., 'Les Émeutes de nov. 1871 à Bruxelles et la révocation du
ministre d'Anethan', *BTNG/RBHC* 15 (1984), 165–200.

VERMEULEN, U., 'Het Beeld van de Eerste Internationale in de Belgischeburgerlijke
pers (1865–1877)', *BTNG/RBHC* 5 (1974), 447–92.

WATELET, H., 'Le Charbon et la croissance économique et sociale', in Trenard, L.
(ed.), *Colloque international: 'carbons et sciences humaines'*, Université de Lille, mai
1963 (Paris, 1966), 127–40.

WITTE, E., 'Political Power Struggle in and Around the Main Belgian Cities, 1830–
1848', *Acta Historiae Neerlandicae* 8 (1975), 103–22.

ZOLBERG, A. R., 'The Making of Flemings and Walloons: Belgium 1830–1914',
Journal of Interdisciplinary History 5 (1974), 21–38.

Unpublished Theses and Dissertations

BAY, E., 'The Royal Women of Abomey', Ph.D. thesis (Boston, Mass., 1977).

BONAVENTURE, R., 'Parti socialiste et mouvement syndical à Verviers de 1893 à 1914: Histoire d'une évolution originale', Ph.D. thesis (Liege, 1961–2).

CANNING, S. M., 'A History and Critical Review of the Salons of "Les Vingt" 1884–1893', Ph.D. thesis (Pennsylvania, 1980).

EL KEFI-CLOCKERS, C., 'La Population féminine active de l'industrie textile verviétoise . . . 1856', Mémoire de license (Liège, 1976).

WELLENS, H., 'Vrouwenbeweging en vrijzinnigheid in Belgie rond de eeuw wisseling (1892–1914)', Licentiaat in de moraal wetenschap (Rijkuniversiteit, Ghent, 1982–3).

Index

Index

tobacco industry:
 mechanization of 192–3
 women workers 181, 192–3
 see also cigar-makers
torteuses 113
 see also miners
Tourcoing 182
Tristan F. 221
truck system 82, 82 n.
Twain, Mark (Samuel Clemens) 37
typhoid 63, 96

United Men and Women Flax-Workers'
 Union 270 82
 women leaders 280–1
United States 151, 162, 171
 and Belgian constitution 43
 and emigration 54–5
 and women 222, 222 n.

Val-St.-Lambert 186, 187
Valette, A. 268
Van Beveren, C. 271–2, 280
Van den Heuvel, J. 262
Van den Plas, L. 297, 300, 301
Van Gogh, V. 87, 90, 92, 102–3, 120,
 308
Van Kol, H. 265, 274
Van Kol, N. 246, 265, 268, 274–5, 277,
 278, 281, 282, 286
Van Langendonck, E. 282, 284–5, 286, 288,
 290
Vandervelde, E. 238, 242 n., 263, 274–5,
 277, 283, 283 n., 289, 296, 305
 Congo 316
Vandervelde, L. 274–5, 283–4, 284 n., 294,
 305
Verviers 33, 35, 42–3, 57, 70, 162, 166,
 182, 200–28, 232
 alcohol in 76
 anarchism in 84, 201–2, 202–28
 birth-rate in 70
 climate 72
 cost-of-living 73
 illegitimacy 70
 infant mortality 70–1
 life expectancy 70–1
 literacy 75, 227, 229
 public charity in 74
 radical politics in 78, 84–6, 163, 199
 sociability in 75, 76
 socialism in 86, 241, 249
 solidarity 234, 261

women's rights 86, 199, 200–3, 205–28,
 231–2, 249—53, 295
 working class 69, 85, 201, 201 n., 202–3,
 261
 workers' housing 70, 71–3, 225
Vesdre River 43, 71, 72, 202
Vesdre Valley Federation 215, 217, 220,
 223, 226
Vlaamse Federatie van Socialistische
 Vrouwen 294
Vlaamse Socialistische Partij 241
Vlasbewerker 182, 271–6, 279, 281–2
Vleminckx, Dr J. F. 149, 152–3
Het Volk 298
Volkaert, V. 283
Volksvriend 78
Vooruit 33, 84, 162, 261, 262, 279–80, 282,
 293, 298
 Brussels leaders and 289–90
 feminists and 288
 girls' Sunday school 265
 reform legislation and 264
 social life of 262, 263
 strikes 290, 292
Vooruit 265
 workers and Africans 315
De Vrouw 265, 274
 men and 265

woman question, the 11, 46–7, 129, 132,
 139
women workers:
 accidents 50, 89
 alcohol and 66, 76, 168, 189
 attitudes towards 32, 33, 36, 42, 46, 48–
 9, 50, 58–9, 64, 66–7, 73, 75, 77, 88,
 89, 92–3, 98 n., 114, 122, 125, 127,
 129, 130, 131, 133–4, 143–53, 155–7,
 161, 167, 168, 171, 175, 177, 181, 188,
 189, 197, 198–99, 205–28, 230, 232,
 266–7, 300
 Catholic workers' movement and 34
 charity and 53
 competition for men's jobs 190, 192–3,
 209, 217, 220
 diet 62, 73, 100, 183
 domestic lives 58, 94, 100, 102, 155, 168,
 183, 185, 251, 272
 economic independence 67, 80, 83, 89,
 133, 139, 144, 149, 155, 207, 209,
 210 n., 214, 218, 221–3, 225, 228, 254,
 275–6
 education 65, 93, 133, 173, 246